3

On Wings of Diesel

On Wings of Diesel

Trucks, Identity and Culture in Pakistan

Jamal J. Elias

ONEWORLD
OXFORD

A Oneworld Book

Published by Oneworld Publications 2011

Copyright © Jamal J. Elias 2011

ISBN 978–1–85168–749–7 (Hardback)
ISBN 978-1-85168-811-1 (Paperback)

Typeset by Glyph International, Bangalore, India
Cover design by www.vaguelymemorable.com
Printed and bound by Bell &Bain Ltd., Glasgow

Oneworld Publications
185 Banbury Road
Oxford, OX2 7AR
England

Contents

Acknowledgments

Many people facilitated my research in Pakistan over a period of several years. In particular, I would like to thank the members of my family in Islamabad as well as Shehryar and Erum Lodhi, Risha and Aliyah Mohyeddin, Nadeem Akbar, and Inayat, Shahnaz and Maya Ismail for their warmth and hospitality.

Among the numerous individuals who have helped shape my ideas on this subject and facilitated my research, I would especially like to express my gratitude to David Alesworth, Tahir Andrabi, Shahzad Bashir, James Caron, Iftikhar Dadi, Arindum Dutta, Jürgen Wasim Frembgen, Michael Kasper, Mark Kenoyer, Maria Khan, Kishwar Rizvi and Andy Rotman.

Financial support for this project was generously provided by the University of Pennsylvania and Amherst College. I also received funding for the project from the Council of American Overseas Research Centers but was unable to use the funds for their intended purposes because of changes in US governmental policies governing research in Pakistan occasioned by political circumstances. Some of the material on truck design and decorative styles was published previously in the journals *RES* and *Material Religion* and appears here in reworked form. Oneworld Publications has gone to some length to make this, their first illustrated book, a special volume, and I am grateful to Novin Doostdar and Juliet Mabey for their efforts in this regard.

During the course of this research, a major earthquake ravaged northern Pakistan and Kashmir in 2005, killing over 80,000 people and rendering more than 3 million homeless. The earthquake was centered in a part of the country heavily represented in the trucking industry, and I was a direct witness to its tragic impact on the lives of many people. This book is dedicated to the victims of that catastrophe, and all author's proceeds will be donated to victims' relief funds.

Finally, I would like to thank Mehrin Masud-Elias for many, many things, but in particular for being such a wonderful and humorous traveling companion, whether dealing

with a driver who clutched a holy relic rather than the steering wheel each time an accident seemed imminent, or carrying herself as the only woman in public in a village of turbaned, bearded and heavily-armed men, or keeping a straight face in other, more comedic circumstances.

Guide to Transliteration

I have attempted to follow a simplified system of transliteration to render Urdu, Punjabi, Pashto, Persian and Arabic words in the Latin script. With very few exceptions, I have standardized all words to popular Urdu pronunciation in recognition of that language's status as the official as well as common language of Pakistan. Punjabi is standardized to the dominant western (Lehnda) dialect, and Pashto to the northeastern dialect of the Peshawar valley and Swat. Where English vocabulary items have entered the local language, I have treated them as native words and transliterated them accordingly. The following is provided as a guide:

a – a flat vowel, as in the second vowel in 'mother' or 'uncle'; sometimes also pronounced as in 'can' or 'ran', especially in English loan words and by Pushtuns, Hindko speakers and Kashmiris
ā – a long vowel, like the first vowel in 'father'
ḍ – a hard *d*, similar to the English *d* in 'driver'
ē – a long vowel, as in 'say'
gh – similar to *r* in French, as in '*mère*'
ī – a long vowel, as in 'speed'
kh – as in the German word '*nicht*', similar to *rr* in French
ṇ – at the end of a word, it is a nasalization of the previous vowel, as in the French '*fin*' or '*avant*'; in the middle of a word it sounds closest to a nasalized *ṛ*
ō – a long vowel, as in 'road'
q – normally pronounced as *k* as in 'cat', but sometimes pronounced as it is in Arabic, as a lingual–glottal *k* from the back of the throat (a close approximation is the *gc* in 'kingcup')
ṛ – a rolled *r*, close to a hard *d*
ṭ – a hard *t*, as in 'truck'
th – a soft *d*, as in 'though' or 'the'
ū – a long vowel, as in 'moon'
zh – similar to the French *j*, as in 'jardin'

' – a distinctive Arabic consonant that is almost never pronounced in Pakistan, where it simply lengthens the preceding vowel. If it appears at the beginning of the word it is not pronounced at all. I reproduce it here because it only appears in Arabic loan words, in which it is a vital consonant.

' – another distinctive Arabic letter representing a glottal stop similar to the middle consonant in 'bottle' or 'matter' when pronounced with a stereotypical and exaggerated Cockney accent. In most Pakistani languages it is either not pronounced or sounded as a *y*.

An *h* after a consonant indicates that the previous consonant is aspirated (as in the English word 'think' or 'bath'). In the case of sounds (e.g. 'cheese') where the *h* is necessary to represent an existing English sound, I have differentiated between two transliterated consonants through underlining in the case of the aspirated sound (e.g. *khudā* [God] versus *khānā* [food]).

List of Illustrations

Unless otherwise noted, all photographs are by the author.

1

Beginnings

I only got to have four days of this fleeting life:
Two were spent in a Nissan, two waiting for a Hino.
Truck verse

 My first memory of a Pakistani truck dates from shortly after my ninth birthday. My grandmother, uncle and three cousins were killed in a car accident a few miles from my house as they set out for Lahore after spending the summer holidays with my family at our home in Shinkiari, an alpine town in the Hazara region of northern Pakistan. There being no real undertakers or funeral homes in Pakistan at the time, certainly not in the Himalayan foothills, it was left to my parents to arrange transportation of their bodies to the cemetery on my mother's family farm, a little under 400 km away. Among the many vivid memories of that tragic day in the life of my family, I clearly recollect the arrival of a truck, where it parked in our driveway, the loading of the bodies in rough wood coffins packed with ice, and the departure of a small caravan composed of that truck and our car, together with the cars of family friends and associates. The journey was undertaken at night, and I distinctly recall how, every time I woke up from my short naps in the backseat, the headlights lit up the back of the truck, temporarily serving as a hearse.

I have several other childhood memories of trucks, most of them involving family moves from one house to the next, or else the delivery of furniture or other heavy goods. In none of those memories does the decoration of trucks feature prominently, if at all. Perhaps it is because three or four decades ago Pakistani trucks were not the riot of color and design they have come to be since then. I suspect, however, that it was because they were trucks, and they looked the way trucks were supposed to look in their own context, and therefore were unremarkable.

1

As is often true of scholarship, I embarked on my study of Pakistani trucks somewhat by accident. I had gone to Pakistan in the summer of 1998 to conduct research on the Sufi master Sayyid Ali-ye Hamadani (d. 1385 CE), who is popularly revered for bringing Islam to Kashmir. In connection with this project, I had to travel by road between Islamabad and Khaplu, a little mountain town in a remote end of the district of Baltistan. This was hardly my first journey into the mountains of northern Pakistan, nor my first road trip, although perhaps a constellation of events in my life made me feel more like a tourist than I normally would have, and therefore to look at my surroundings with fresh eyes. Like most tourists in Pakistan, I took photographs of the trucks that happened to come across my path, though I did this more with an eye toward color and kitsch than any real interest in the trucks themselves. Over the course of six days going up and down the Karakorum Highway and the road from Gilgit to Khaplu, I began to see patterns and order to the decoration of trucks.

On my return to the United States, I came to the realization that Pakistani vehicle decoration was a worthy (and exciting) object of study, and arranged to return to Pakistan in 1999 for the express purpose of researching the topic. During that research trip, and subsequent trips over the summer of 2001, winter of 2003 and summer of 2007, I conducted interviews with truck drivers, owners, the various professionals involved in the production, decoration and maintenance of the vehicles, representatives of the truckers' unions and others peripherally involved in the world of trucks in Pakistan. My fieldwork was originally focused on Karachi and Rawalpindi (the twin city to the capital of Islamabad), although I explored other locations in what is a large and culturally diverse country. In the end, it is the environs of Karachi and those of Islamabad–Rawalpindi that remained at the center of the project, for very good reasons. Karachi is Pakistan's financial center and major seaport. It is also the most cosmopolitan city with large populations of immigrants from other parts of the country. Not only is Karachi home to a very large number and variety of trucks, but their owners and operators as well as designers are transplants from different areas. Consequently, Karachi has trucks representing Pakistan's regional styles as well as hybrids unique to Karachi. The Islamabad–Rawalpindi area does not possess the population or commercial weight of Karachi, but it is one of the major crossroads in the country. It is here that the Karakorum Highway, the main commercial artery connecting Pakistan to China, splits off into the east–west route going to Peshawar and on to Kabul in Afghanistan in one direction, and toward Lahore and the agricultural and industrial heartland of Punjab in the other. It is also here that local and imported goods from the ports of Karachi and Gwadar come to be distributed further north, as do agricultural produce and construction materials from Baluchistan.

▷

Plate 1: Mirror on a truck in the Balochi style (Karachi 2001)

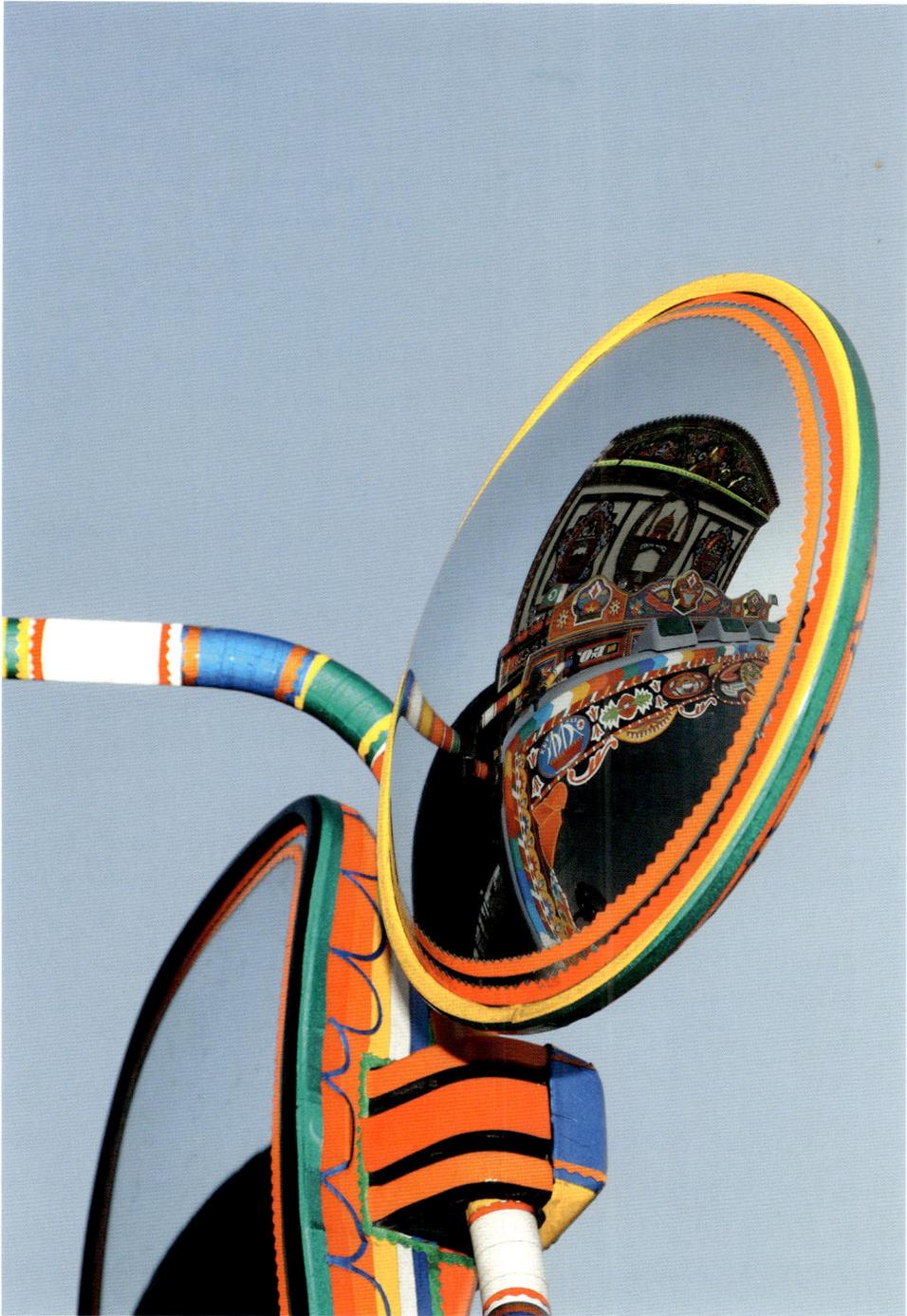

Vehicular Art

The decoration of vehicles is, of course, a common practice in a number of countries in addition to Pakistan and Afghanistan. Minor decoration of vehicles is common throughout the world, and ornately decorated ones are seen in several countries, such as India, the Philippines, Indonesia, and countries in Central and South America. What makes the case of Pakistan and Afghanistan unique, however, is the pervasiveness of vehicle decoration, since decoration of a variety of sorts is employed heavily on virtually all privately and fleet-owned commercial vehicles. These include not only the well-known trucks and buses, but also minivans, share taxis (commonly referred to as *suzūkīs*, since they are made by adding a passenger compartment with two bench seats to a small Suzuki pickup), animal carts (especially the two-wheeled horse-drawn carriages called *ṭongas*), and even juice vendors' push carts.

Though decoration is pervasive, with the exception of work on trucks, buses and *suzūkīs*, most forms of vehicular decoration are informal and non-systematic, in that the decoration is often done by artisans who work on different kinds of vehicles and other material objects, and the vehicles themselves do not follow identifiable patterns in the decoration itself beyond similarities imposed by the very physicality of the vehicle (e.g. a wheel is a wheel). Trucks, buses and *suzūkīs* share motifs and materials, although they are worked on in different coachwork shops and by different artists, and there are important differences in the decorative motifs involved.

Virtually all privately owned trucks in Pakistan are decorated, and the cost of getting the coachwork completed (which includes decoration) can easily reach US $7000 (Rs. 400,000 in 2007 figures) on a Bedford to US $16,000 on a newer Japanese truck decorated in the Balochi style. Such figures are several times the annual per capita income of the country. The bodywork normally requires an almost complete rehabilitation every five years, making truck decoration not only a massive financial economy but also the single most important aspect of the visual regime of one of the largest Islamic societies in the world. Very clearly, the motivations behind truck decoration transcend the purely economic or the aesthetic, and involve complex notions of the personal and collective identities of the individuals who pay for the decoration, just as the nature of the decoration says a great deal about their religious, social, political and other attitudes and dispositions.

State of Scholarship

Attention was first focused on the study of truck decoration in Afghanistan rather than Pakistan in the early 1970s, when several scholars were drawn to truck painting as a form of art. Research on Afghan trucks came to an end in the late 1970s, no doubt as a direct result of the Soviet invasion and subsequent civil war in that country. Until that time,

▷
Plate 2: Bedford truck in the Rawalpindi style (Ghora Gali 2001)

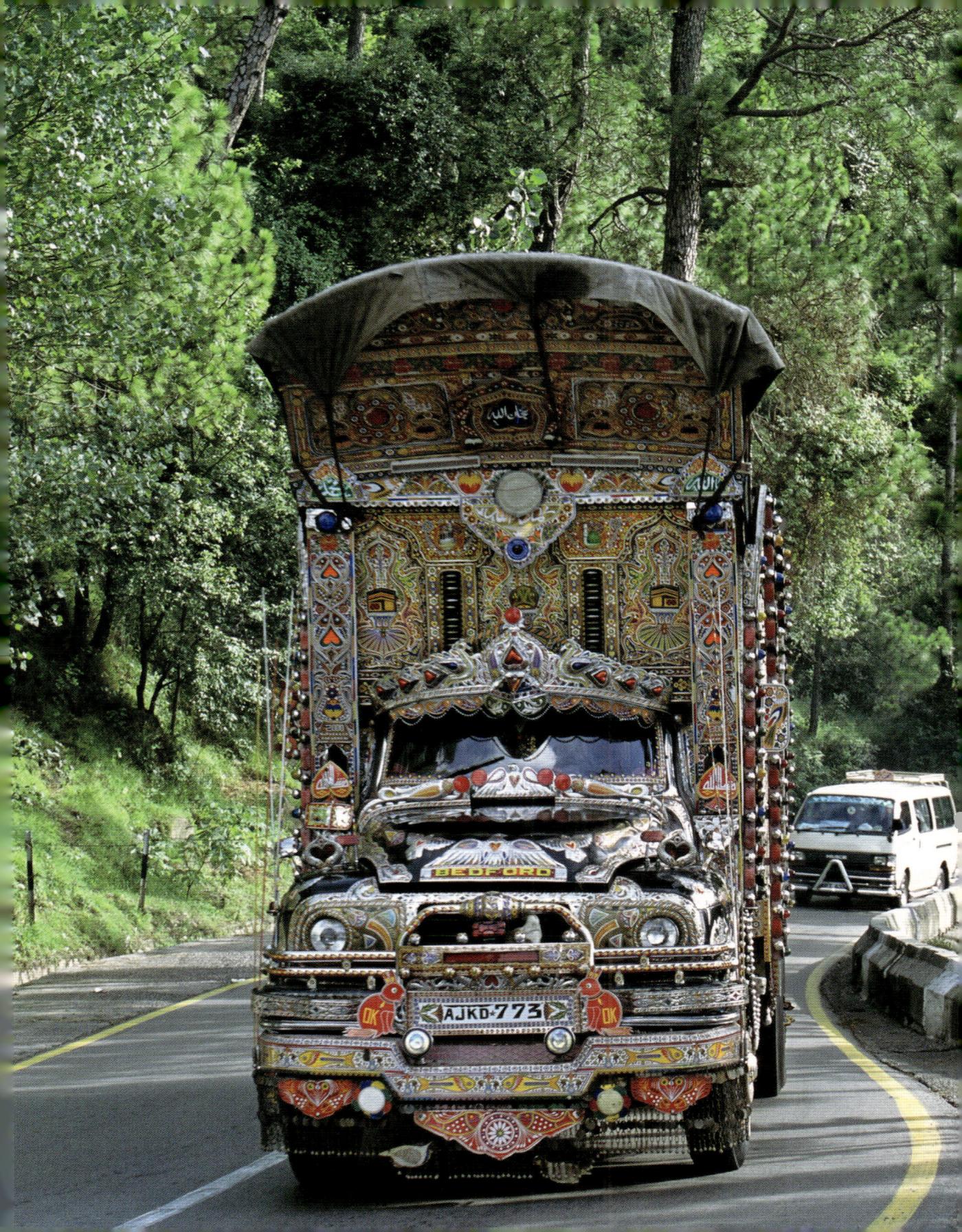

the porous and generally peaceful nature of the Afghanistan–Pakistan border had allowed Pakistani truck painters and body makers to work in Afghanistan, even though the numbers involved in the industry in Afghanistan appear to have been lower than they were east of the border. At the same time, a long tradition of ethnographic research in Afghanistan (especially by Francophone scholars) had the effect of treating the truck decorating industry as a predominantly Afghan, and especially Pushtun (Pakhtun), phenomenon. In the aftermath of the Soviet invasion, as much as one-fifth of Afghanistan's population fled to Pakistan as refugees, where many of them remained for over two decades. The impact on bazaar and other economic activity in Afghanistan was equally severe, especially during the period of civil war that followed the Soviet withdrawal. Consequently, not only did the study of truck decoration shift from Afghanistan to Pakistan, but so did almost all of the economy and culture of truck decoration.

Many of the publications dealing with trucks – and with vehicle decoration in Pakistan in general – focus almost exclusively on the striking visual aspects of the decoration and ignore their semiotic value or the culture of trucks and trucking. Some of these works, such as two coffee-table style picture books entitled *Afghan Trucks* and *Art on Wheels*, do so by design.[1] A third picture book by Jürgen Grothues, entitled *Automobile Kunst in Pakistan*, has a short but informative introduction and shows a clear concern for the content of the images. However, the images are devoid of context and provide no ethnographic or historical details, and therefore are of little academic value except (as Blanc's book is for an earlier era) in providing indexical photographic evidence of the period in which the pictures were taken.[2] Similarly, some magazine and journal articles are more concerned with emphasizing the remarkable and the exotic than with nuanced explorations of the subject.[3] The text accompanying their many pictures tends to be reductionist, misleading and offensively patronizing. Decoration, it seems, is a direct consequence of the truckers' bleak and difficult lives:

> Hard, at times tragic, the life of the road and its sad man is brightened up by the garlands, the bouquets of roses and tulips, that cover the sides of the truck. The Afghan truck is like a mobile gallery of paintings in an environment of deserts and arid mountains.[4]

Or else:

> A big plain wooden box of a truck is too impersonal for the highly colored and embroidered Afghan people. Obviously, a few touches are needed to make the new owners feel comfortable with the truck … They paint everything – that is, everything they don't have.[5]

There are notable exceptions to the casual and dismissive treatment of the importance of truck decoration in Afghanistan and Pakistan. In 1975 Hasan-Uddin Khan wrote the first significant article to treat truck decoration as a subject involving actors possessing their own motivations and with functions that go beyond the purely aesthetic.[6] The first sustained monograph on the topic is a doctoral dissertation written in Paris in 1978 by Marie-Bénédicte Dutreux.[7] Drawing on a year of field work mainly in Kabul, Dutreux's study attempts to follow individual truck artists and the environment in which they work, and to treat motifs in truck decoration in a formal manner, cataloging them by type and, to some degree, by location. It is an important piece of research because of its documentation of truck painters working in Afghanistan in the mid-1970s and for the insights it provides into the organization of truck decoration as a trade. However, the exclusive focus on Afghanistan represents a problem, since at no point was Afghanistan the primary location in the economy or culture of truck decoration. In the mid-1960s, Centlivres-Demont lists only a handful of workshops existing in Kabul, and states that the painters are either Pakistani or trained in Pakistan.[8] There is no discernible point in the 1970s at which the majority of decorated trucks were found in Afghanistan, and by the end of that decade the industry moved completely to Pakistan. As such, research on Afghanistan falls short of describing the scope of truck decoration in the much larger economy of Pakistan.

It was in 1980 that the most important early article on Pakistani truck art was published by two ethnographers.[9] Focusing their research on truck workshops in Rawalpindi, Rich and Khan explored the structure of truck painting as a trade, and attempted to lay to rest some of the conventional truths held concerning truck decoration and its organization as a profession. This article is invaluable for the information it provides about the organization of the trade of truck decorating in Pakistan at the time when the phenomenon first began to explode and for its focused ethnographic findings. It suffers one serious methodological flaw, in that it treats the truck drivers (together with the artists) as the principal decision-makers in truck decoration. As I discuss in some detail in Chapter 6, drivers have very limited say in the decorative program; the majority of decision-making is done by the owner – who pays all the bills – in consultation with the principal artist, whose own participation in decision-making varies in proportion to his reputation.

Following the publication of Rich and Khan's essay, though not as a direct consequence of their work, the focus of studies on truck decoration switched almost entirely from Afghanistan to Pakistan. In 1989, A. Lefebvre wrote an article discussing the semiotics of Pakistani trucks. Though brief, it represents the first attempt to treat the visual aspects of decoration in anything except a purely formal fashion.[10] Finally, in 1995, Anna Schmid published a monograph to accompany an exhibition at the Museum of Folk Art

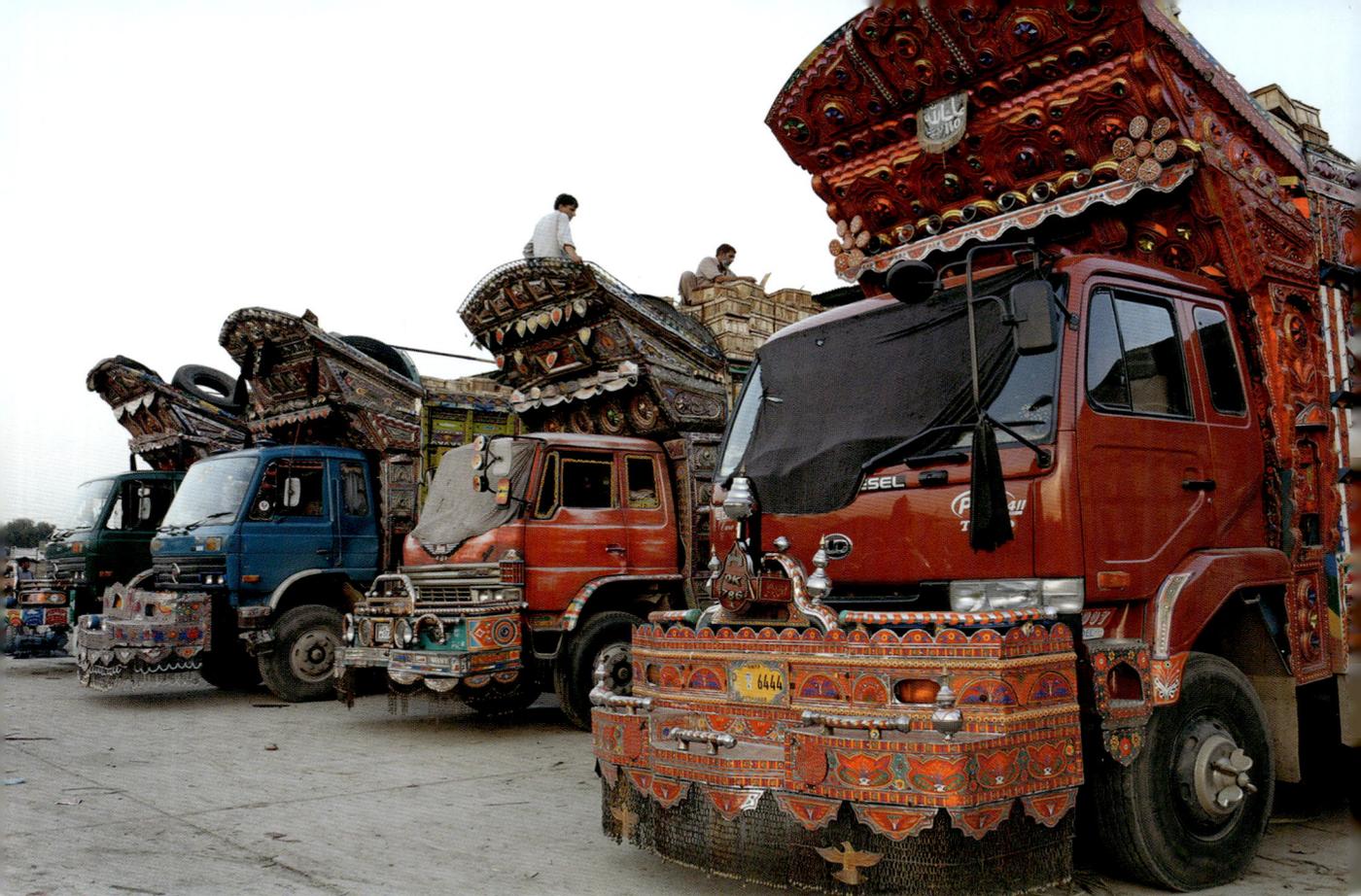

△
Plate 3: Trucks parked at the main produce market in Rawalpindi (Rawalpindi 2003)

in Hamburg.[11] Schmid's publication remains the largest study of Pakistani trucks to date; she focuses on the world of trucks and trucking but also provides details on the symbolism of designs and includes a brief discussion of the religious world of the truck drivers. Like Dutreux's earlier work on Afghanistan, it constitutes an ethnography of sorts, describing truckers and truck designers but not making any serious attempt to place them or truck art within the context of a larger society. Schmid was the first writer on Pakistani trucks to mention the distinction between the decorative motifs (but not their significations) on the different sides of the truck, but her understanding of the symbolic value of various motifs is sometimes too general or even incorrect. Dutreux's earlier monograph attempts a systematic study of the motifs used in truck design, but it suffers on account of serious errors in translating Pashto, Persian and Urdu writing on trucks, thereby coming to erroneous conclusions as to the significations of truck decoration.

No one has engaged in a systematic history of truck decoration in Afghanistan and Pakistan, situating the phenomenon within its social contexts and seeing in it a process of change reflecting events within the wider society. Put differently, none of

the writers on trucks in Pakistan and Afghanistan sees truck decoration as anything more than a static form of folk art, which perhaps reflects the aesthetics and desires of individuals but does not react to social realities except in the most rudimentary of ways.

Some writers have suggested that the tradition of truck decoration derives directly from the adornment of animal carts and camel litters, although this is undocumented and even a cursory glance shows that there is little similarity in the motifs and their location on the vehicle. Photographic data would suggest that there has been an evolution from very basic decoration as early as the 1960s to the ornate and pervasive phenomenon that modern Pakistani truck art has become. Techniques and motifs have evolved and changed, but certain basic elements of design have remained constant. Truck decoration, it appears, evolves linearly in terms of the technical aspects of design, but dynamically in reflecting changes in religio-political social environments.

There are several aspects to the study of vehicular art, and particularly truck decoration, in Pakistan. The first, and the one reflected in the majority of existing scholarship on the subject, is the formalistic description and analysis of decorative elements and motifs. Another is the ethnographic or sociological study of truck decorating as a trade, also reflected in the work on Pakistani and Afghan truck decoration that is already available. What is lacking in both these approaches is a recognition of vehicular art as a legitimate form of cultural expression and its status as a scopic or visual regime unto itself in addition to being an expression of a wider visual regime of the culture to which it belongs.

The study of automotive culture and vehicle decoration is still rather limited, despite the fact that the average bookstore has shelves filled with colorful volumes on the automobile, and the wealth of publications on technical and economic aspects of the automotive industry. Some significant anthropological work has been done on the subject in a number of places around the world, although the majority of writing on the culture of the vehicle still treats it as a subsection of the study of leisure activities.[12] The most important scholarship to take seriously the *habitus* of the individuals involved in a culture of vehicular customization and decoration deals with 'low rider' culture among Chicanos in the southwestern United States. In particular, Brenda Jo Bright explored how 'low riders', as a form of ethnic popular art, allowed Chicanos to create alternate cultural expressive spaces for themselves in the United States. As she notes, '[c]ar customizing exhibits complex interrelations between consumer culture, surveillance, gendered race and class positions, and craft skills'.[13]

There are crucial distinctions between the societal function and significances of Pakistani truck decoration and vehicular cultures such as low riders, hot rods, art cars, 'chromed out' trucks in the US or electric light trucks (*Dekotora*) in Japan. All these

examples – including low riders that clearly fulfill significant cultural functions within the Chicano community – are leisure activities and, in most cases, are associated with identifiable subcultures. I do not wish to trivialize the role of leisure or to dismiss the importance the aesthetic holds for the individual or the community. However, there are central differences between such forms of vehicle decoration, which are primarily individual artistic expressions (with all the complex issues that assertion implies), and others that are corporate or communal, and are artistic expressions as only *one* of their primary functions. The latter category includes the Pakistani truck, but also similar forms of decoration in places such as the Philippines, Haiti and Central America.

Pakistani trucks, for all their ornateness, color, and the care that is lavished on them by their owners and drivers, are first and foremost *working* trucks. These are not hobby vehicles designed to win prizes at truck shows; indeed, to this day, truck shows have not caught on as a popular concept in Pakistan. Trucks remain defined principally by their utilitarian value, as haulers of goods and makers of money; decoration is of secondary importance and never assumes status as the primary function of the truck. At the same time, truck decoration is pervasive in Pakistan and does not represent the preoccupation or artistic expression of a subculture, unless truckers and trucking are themselves accorded subculture status, which they do not warrant since they do not represent a particular

Plate 4: Tractor-trailer truck being washed at a truck stop (Karachi 2003)
▽

Plate 5: Detail of the back of a water tanker (Karachi 2001). The epigraphy reads: 'I'm not worried – I'll be back/ Either today or tomorrow – I'll return' (parēshān na thī mēṇ val āsāṇ/aj āsāṇ yā kal āsāṇ)

ethnic, linguistic or communal group, nor are they held together by anything other than their involvement in the transportation industry.

Truck decoration in Pakistan is therefore exactly that, the decoration of regular trucks in a large and varied society. The Pakistani truck is a cultural vehicle – not in the same sense as a Chicano 'low rider' that gets invested with notions of collective identity among a subculture or ethnic group, but in the sense that it carries in it and on it an array of cultural messages and expectations. It is also the most widespread expression of visual material culture in the country, saying more about the visual regime of Pakistan than other forms of art and visual expression that are traditionally treated as legitimate windows into the beliefs, practices and dispositions of members of Pakistani society at an individual and collective level. At the same time, the evolution of truck decoration reflects social processes of hybridization that are often the result of collective creativity in everyday life and in all forms of development, not just in the arts.[14]

My purpose in conducting this study is multifold: at the broadest level, it is to provide a comprehensive introduction to an exceptionally compelling and pervasive form of

popular art. I am also interested in the exploration of how people respond to religious and political imagery in one Islamic society. I am not particularly concerned with the explanation of the responses themselves, but rather with analyzing their syntax, symptoms and signification, and to examine the structures that elicit these responses. Underlying this analysis is the belief that images elicit responses, and that these responses might be dulled as a consequence of reproduction or familiarity through overexposure, but that this familiarity does not eradicate the response itself. I follow David Freedberg and Alfred Gell in framing ideas concerning visual stimulus and response, and by 'response' I mean the symptoms of the relationship between an image or visual object and its beholder:

> We must consider not only beholders' symptoms and behavior, but also the effectiveness, efficacy, and vitality of images themselves; not only what beholders do, but also what images appear to do; not only what people do as a result of their relationship with imaged form, but also what they expect imaged form to achieve, and why they have such expectations at all.[15]

For Freedberg, as for many other scholars of art and anthropology, the impulse to decorate is innate to human nature. 'Not only do we need material images, we cannot refrain … from making a shape we can recognize out of the shape that is merely suggestive; we cannot refrain from filling the blank wall and from enclosing a figure in the empty frame.'[16] In the case of truck decoration in Pakistan, the relationship between visual form and response becomes particularly complicated since, as I will clarify later, the creation of the visual object is a corporate or aggregate enterprise in which the truck designer (or artist) shares agency with the owner and truck driver who, at the same time, constitute the primary audience for this form of art. As such, the expectations of what the viewer will receive from the imaged form guides the process of artistic creation, though (and this is not at all surprising) the finished product has significations that are not predicted by either the artist or the primary audience.

The major purpose of this book is to explore the function of visual culture as a window into the structure and politics of contemporary societies. Although there are several excellent examples of this for a number of contexts, including Pakistan's neighbor India, such studies are sadly lacking for the Islamic world, no doubt due in part to the common misperception that Muslims are opposed to representational art and are therefore somehow less 'visual' than others and are more attuned to words and text (since such arguments frequently work on the assumption that there is a binary of the textual versus the visual). If one were to accept the premise that Muslims, more so than others, are a 'textual' people, one would have to contend that the majority of Muslims

have not, until very recently, participated in any substantive way in the life of their own societies, since it is only within the last fifty years (if that) that a majority of Muslims have acquired basic literacy. In the case of Pakistan, close to half the population still does not possess the ability to read with competence. The obvious conclusion to be drawn from this observation is that, since it is nonsensical to think that the majority of Pakistanis are not participants in their own culture, the visual (as well as the somatic and auditory, among other forms of experience) must play a very large part in their lives at all aggregate levels. And yet the scholarship on modern Pakistani society, politics and religion privileges written and literate discourse to the almost complete exclusion of what lies beyond print.[17]

My discussion of truck decoration and truck culture is strongly influenced by the writings of Bourdieu, in particular his invaluable concept of *habitus*, defined as:

> systems of durable, transposable *dispositions*, structured structures predisposed to function as structuring structures, that is, as principles of the generation and structuring of practices and representations which can be objectively 'regulated' and 'regular' without in any way being the product of obedience to rules.[18]

Habitus can be understood as the 'sedimented residue of past social interaction which structures ongoing interaction'.[19] Despite their durability, human dispositions are not fixed, but are multiple and change over time; nor is a *habitus* a fixed system or overarching structural matrix that strips the individual of all agency. Furthermore, individuals are not necessarily familiar with their own dispositions and beliefs, such that they are normally hidden from themselves, which provides a working explanation of how the relationship between the *habitus* of separate groups within a particular society is both a product and determinant of economic and social class as well as of power, and of why structures of inequality can persist in a hidden way.

It is the notion of *habitus*, the naturalizing of beliefs, attitudes and practices, that underlies much of the analysis of this book and helps situate attitudes toward religion, class, history and politics (as well as other things) in relation to socioeconomic determinants such as education, literacy and technology. The second chapter provides a brief historical overview of Pakistani society in order to explicate certain key aspects of individual and collective attitudes in the society. The chapter also describes the religious situation in the country, since Pakistan is an intensely religious society and religion – in a variety of normative and vernacular forms – plays a vital and visible societal role and is also a major factor in truck decoration, as it is in the *habitus* of truckers. Religious factors, like ethnic ones, help determine the dispositions and range of options of individuals as they attempt to negotiate their place in society. Literacy and class are pivotal factors in shaping options

and attitudes, and the third chapter outlines the nature of education in Pakistan, arguing that unequal access to education and a multi-tiered school system are critical factors in the construction of social as well as economic class in Pakistan, which is itself a contributing factor in the world of trucks and truckers. The fourth and fifth chapters outline the place of trucks in Pakistan's transportation system and of truckers in Pakistani society, briefly describing the importance of trucks in the transportation industry, attitudes of truckers toward trucks and their decoration, and the place of truckers in the class structure of the society, which has a direct bearing on the place trucks occupy in Pakistan's visual regime.

The four chapters after that deal with truck decoration itself, discussing the topic formally in terms of its themes and styles in the sixth chapter. Chapters 7 through 9 explore the shifting nature of elements of truck decoration, such as religious images and epigraphy, spatial locators, and portraiture, as signifiers in a visual regime. The final chapter examines the place of truck decoration in terms of wider (and primarily bourgeois) circles of art and design in Pakistan, underlining the distinction between artisanal trades and arts that are reconfigured as *folk* within urban bourgeois categories and the usages of such arts and artifacts within the spheres of their own production. One essential dissimilarity in their place in these two spheres is between the status of truck art as design in the arena of so-called 'folk arts' on the one hand, and the epigraphically indexed nature of decorated trucks within the world of truckers on the other.

Over the course of this book I resort to the use of many terms that are employed more or less unproblematically in everyday speech but are subjects of argument among social and art theorists. Words such as *modern* (and *modernity*), *vernacular*, *popular*, *art*, *design* and *aesthetic* stand out prominently among them. In speaking of art and aesthetics I am intentionally avoiding questions that I know are central to the rich fields of art theory and criticism as well as to art history. Without subscribing to the maxim 'I can't tell you what art is but I know it when I see it', I believe many of the questions of artistic intentionality and agency that are critical to the definition of Western modern art (and to its distinction from the art of earlier epochs) have limited bearing on the nature of art in the alternative modernities occupied by the majority of the population in developing countries, as well as to the visual culture-centered methodologies I am employing in this book. My failure to engage such questions, or with questions of beauty or of aesthetic and utilitarian value might reflect my own pusillanimity, but I see it as the result of a conscious choice regarding method. The final chapter of this book addresses some questions regarding the relation between artistic ownership of truck decoration and 'truck art' as design in those economically advantaged circles of Pakistani consumerist society that I have labeled the Anglophone bourgeoisie.

Conventional class divisions are even less meaningful in the study of Pakistan than they are in many other developing societies, since vast disparities in income are compounded by linguistic and ethnic class differences. The concept of a middle class is very problematic in a society where 95 percent of the population lives on a household income of less than Rs. 25,000 per month (US $315), which is less than half the starting salary of someone working at a private bank. Two-thirds of the population has a monthly household income of less than Rs. 15,000 (US $200).[20] In my usage, middle classes are those sections of society that have regular and reliable bases of employment that provide enough surplus income to buy non-essential commodities on occasion. The Anglophone bourgeoisie comprises a section of the middle classes but also includes (in violation of the traditional meaning of a bourgeoisie) members of the urban upper class who are Anglophone. As discussed in Chapter 3, English represents a language that far surpasses Urdu and the regional vernaculars (Punjabi, Pashto, Sindhi, Balochi, etc.) in its prestige, and the ability to speak English is associated with access to material wealth, but even more so to status as an arbiter of taste and culture.

I chose the term *vernacular* over *popular*, particularly in my analysis of Islam as it is practiced in Pakistan and to distinguish it from *official* or *normative* religion, where the use of the latter terms implies the assumption (or acceptance) that a religion is synonymous with institutional structures. Eschewing terms like *popular* or *folk* religion lends greater legitimacy to the nature of non-official belief and practice, or religion as it is lived.[21] The pervasive and continuing tendency to view Islam through a lens that emphasizes logocentrism and orthopraxy has meant that the actual, lived forms of Islam have largely been ignored by scholars of religion, and it is these vernacular forms that are reflected in the visual regime of Pakistani truck decoration. But *vernacular* commends itself as a term in other contexts also, as is discussed at some length by Kajri Jain in her study of the economies of Indian calendar art. The notion of a *vernacular* avoids the romantic evocation of a primordiality or prater-authenticity that inhabits words such as *tradition*, *native*, or *local*; instead, it allows for the hybridization and heterogeneity that is essential to modern existence even among those referred to as 'the masses' in works on South Asia. Put differently, the concept of vernacularity reminds us that the people being referred to do not inhabit the past nor do they possess a particularly pure unbroken connection with that so-called traditional past for which they are to be commended or condemned. The concept of the *vernacular* is especially useful in the study of South Asia because it functions well 'as a category that can be associated with location but is not tied to it, steering clear of both the valorization of the [village] … and the equally ideologically loaded "urban turn" being celebrated at the turn of the millennium'.[22] As a concept, the vernacular transcends the particularities of the local in a large and varied multiethnic society.

As distinct from *vernacular*, I employ the term *popular* to denote the status of a thing or idea in a temporally confined space, where popularity does not denote objects or themes (e.g *popular* art or *popular* culture) but an attitude or action.

> We cannot narrow it down to a particular type of goods or messages, because the sense of one or the other is constantly altered by social conflicts. The fact that an object has been produced by the people or is consumed avidly by them does not guarantee its popular character forever; popular meaning and value are gained in social relations. It is use, not origin, the position and capacity to arouse popular acts and representations that confer that quality.[23]

At the same time, the term *popular* – especially when used by those who do not apply it to themselves, their tastes or their goods – connotes a rustic inferiority or a proletarian coarseness as distinct from a refined exclusivity. The *popular* in such instances might be romanticized or evoke a certain nostalgia, but it is always condescended to. In the case of vehicular arts as well as trucker culture in Pakistan, the conception of the *popular* (or the *folk*) has been instrumental in framing the parameters within which they have been defined, appreciated and – to some degree – appropriated by the urban Anglophone bourgeoisie as it searches for a 'folk' Pakistani art culture with which it can identify. The quest for truck art by the art collector, tourist, gallery visitor and decorator of the bourgeois home is, in many ways, the quest for Pakistan's identity.

2

History of a Dystopic Utopia

But I put no faith at all in people's
Intentions and the occasions flags give rise to,
They're just plain fake, not like the pure forms
Of my dream: morphed into an airborne object
And the land's actuality – a flag exists only
As the wind's unadulterated intention
Semezdin Mehmedinović[1]

School textbooks – those most potent vehicles for the development of national sensibilities – present the history of Pakistan as a strange amalgamation of nativism and an immigrant Islamic triumphalism. History begins with the Aryan invasion, then the Indus Valley civilization, and sometimes includes discussions of Alexander and his battles or of the Buddhist king Ashoka, who ruled from Taxila, on the outskirts of the Pakistani capital of Islamabad (though a link between the two cities is never made). History then jumps forward to the Arab conquest of Sindh in 711 CE, and from then on there is a march of Islamic dynasties until the arrival of the British. The central theme in nationally sanctioned, popular understandings of Pakistani history is the story of Islamization. In its own history books and its own rhetoric, Pakistan is not a land but an idea.

The conquest of Sindh by the Umayyad general Muhammad ibn Qasim (d. 715 CE) is seen as marking the establishment of Muslim rule in South Asia, and ultimately of Pakistan itself, and is treated by history textbooks as the first of a series of military interventions motivated by the desire of just Muslim rulers to right the wrongs of local Hindu despots. In actual fact, the Arab conquest of Sindh had little lasting impact on the later Islamization of present-day Pakistan, except in the sense that it facilitated Indian ocean trade to some extent and allowed cultural and religious exchange to piggy-back on top of that trade. Muhammad ibn Qasim was recalled from Sindh to die in ignominy four years after his first arrival, his successor died almost immediately after he took up

17

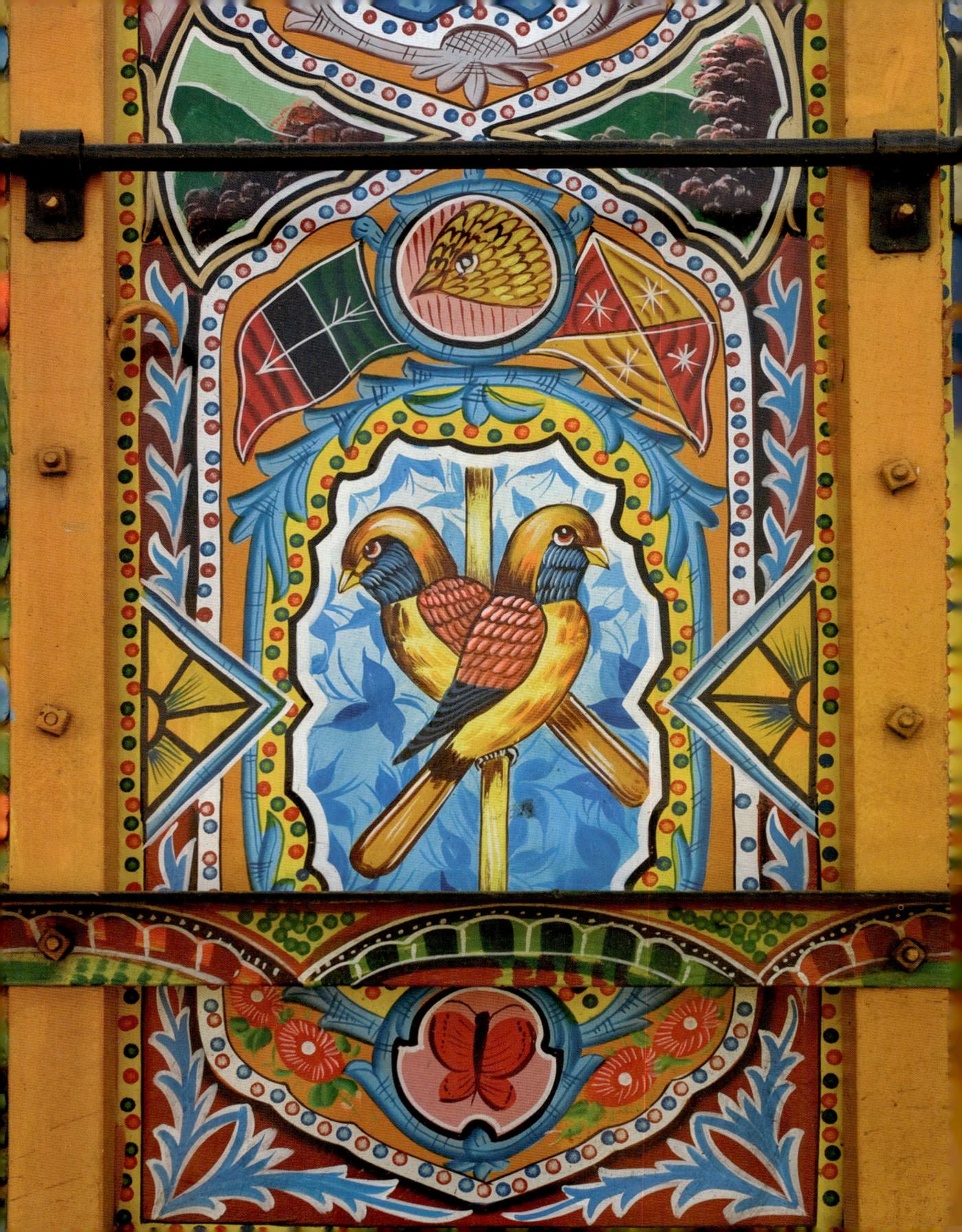

his post, and before long the region fell back under the rule of nominally Muslim indigenous families. By the tenth century, Islamic Sindh had split into two separate entities, Multan in the north and Mansura in the south, and was soon incorporated into the Fatimid Isma'ili state.[2]

Early Islamic Sindh was hemmed in the north by Hindu kingdoms and belonged very much to the Islamic maritime world connecting the Indian Ocean to the Mediterranean Sea rather than to the subcontinental landmass of which the largely landlocked country of Pakistan forms a part. Nevertheless, Muhammad ibn Qasim is celebrated as the first Muslim ruler in South Asia and even the 'founder of Pakistan'[3] who gives his name to the country's second busiest seaport.

The appropriation of ideological aspirations of 'Pakistan' as a home for the Muslims of British India by a nation state that sits on the extreme periphery of that former British colony is but one of the strange consequences of the fractured end of British colonial rule, and one which holds some similarities to aspirations for a biblical Zion or a Chicano Aztlán in other imaginings. The departure of the British saw the creation of two hostile states, one with a Muslim majority and the other with a Hindu, where the Hindu-majority nation of India took its name from a river that flows like an aortic artery through the length of Pakistan, and Pakistan saw virtually all centers of Muslim civilization lost across the Indian border. Pakistani nationhood expends substantial energy on making sense of this dilemma and on the task of turning a periphery of Islamic civilization into a center through the process of historical imagining of an astigmatic sort: Pakistan lays claim to status as the cultural successor to the Mughal Empire and its predecessors, but does so without directly evoking either a sense of ownership or of loss of the cultural centers (Delhi, Lucknow, Patna) or of the artifacts (the Taj Mahal or important educational institutions) of Mughal civilization. Pakistan's national claim is to Islam and 'Muslimhood' with only the most tenuous appeals to historicity or consciousness of the fate of place.

The many existing discussions that treat Pakistan's history and independence movement in the same context as those of India ignore the pre-Partition trajectories of the territories that were to become the two states. The very different histories of Pakistan and India have direct bearing on their contemporary societal dynamics. As is well known – and does not bear discussion here – British rule radiated westward from Calcutta (Kolkata) and eastward from Bombay (Mumbai). Bombay became the headquarters of the British East India Company in 1687 and later the seat of the Bombay Presidency. Calcutta was a center of British military might, starting with the establishment of Fort William in 1702, and served as the capital of British India beginning in 1772. It continued in that status until 1911 when the seat of the Raj was moved to Delhi, made 'New Delhi' under the planning of Edwin Lutyens to distinguish it from the 'old' Delhi of successive Islamic

◁
Plate 6: Detail of the side of a Bedford truck (Rawalpindi 2003)

dynasties whose artifacts (Lodhi Gardens, Jantar Mantar, Humayun's Tomb, and so on) were included within the expanse of the British city.

In contrast to the long colonial encounter of Bengal, Gujarat, Maharashtra and other central parts of India, the territory that now constitutes Pakistan experienced British colonialism in a markedly different fashion. Sindh, Pakistan's second most populace province and home to Karachi (the commercial center, first capital of Pakistan and its only truly cosmopolitan city) was conquered by the British from the Balochi Talpurs in 1843 and subsequently became part of the Bombay Presidency. It was made its own province in 1936, barely a decade before independence. Punjab, the most populous province, was conquered from the Sikhs in 1849. And even though Lahore, the capital of the Sikh kingdom of the Punjab and a major cultural center, saw a concerted series of architectural and developmental projects under British rule, the province itself was never integrated in the British Empire in the same way as the central provinces of British India were. Punjab remained a 'non-regulatory' province for much of its colonial history, without its own legislature and without the extension of British colonial law to social and personal affairs. Consequently, not only was much of the Punjab left largely unaffected by the modernizing impact of colonial law, but the authority of indigenous elites, and the authoritarian structures that sustained them and through which they adjudicated among the wider population, were strengthened under colonial rule and given a stamp of legitimacy that they previously lacked.

The parts of the western Punjab apart from Lahore were even less integrated into the civil structures of British India, the major British interest (and hence its investment) in the region being military on account of its hostilities with the Afghans and Russians in Central Asia. In 1901 the territory west of the Indus river was formed into a new province with the strange and somewhat offensive title of the North West Frontier Province (NWFP), a name that persisted until 2010 despite the desire of a majority of the province's residents to change it to Pakhtunkhwa (the province is now officially named Khyber Pakhtunkhwa, although the name change is still too recent to have had any social or political impact). The border between the Punjab Frontier (subsequently NWFP) and Afghanistan, known as the Durand Line after the then- Foreign Secretary of British India, was established in 1893 in a treaty, to which Afghanistan agreed under some duress. Finally, Baluchistan, the largest but least-populated Pakistani province, was annexed by the British through a series of treaties with local rulers beginning in 1876. Baluchistan was not declared a British territory until 1887, and it was not until 1958 that Gwadar, a coastal town currently being developed as a deep-sea port, was purchased by the government of Pakistan from the Sultanate of Oman. In short, the parts of South Asia that today form Pakistan had a substantially shorter colonial experience than many of the provinces that became independent India. Furthermore, this experience

was different in kind, in the sense that they were less integrated at an administrative level and were treated largely as a collection of military administrative centers, their hinterlands, and frontier zones.

Not surprisingly, the distinct and disparate colonial experience of the northwestern reaches of British India had a direct impact on the participation of those territories in the struggle for independence. Compared to the organized and sustained political agitation in Bengal, Bihar, the United Provinces (formerly the North-Western Provinces and Oudh), Gujarat, the Bombay Presidency and several other areas, most of the future provinces of Pakistan were lukewarm and somewhat tangential in their agitation against British rule. It is beyond the scope of this book to go into a detailed discussion of the birth of Pakistan, but there can be little historical debate on the fact that the Muslims in British India had no shared vision of whether or not they wanted an independent Islamic state and, if so, what its territorial extent and nature of government might be. The Muslim leadership was divided in an uneasy balance between a motley crew of landlords and intellectuals who, through the Muslim League, cast itself as the sole voice of the Muslim population and demanded a separate homeland, though with no clear geographic demarcation; the religious leadership which, for the most part, opposed the creation of a separate state; and Muhammad Ali Jinnah, called Quaid-i-Azam ('The Great Leader') by Pakistanis. A British-educated and personally secular lawyer, Jinnah appears to have been one of the few leaders to understand the narrow range of options available to the Muslim population of British India and he attempted to steer a course which would neither make the British throw up their hands and cast their lot with the Hindu-dominated Congress Party nor make the Muslim League so disillusioned with the small concessions it was gaining that it abandoned the path of political compromise. It is unclear what Quaid-i-Azam envisioned as the political future of British India's Muslims, for he played his cards close to his chest. Whatever his ambitions may have been, he was publicly adamant that Pakistan would be a pluralistic society where religious (and, presumably, ethnic) minorities would not just be tolerated but would be full participants in the new nation.

As the events surrounding the end of British colonial rule in South Asia transpired, the Pakistan that came into existence in 1947 was not the Pakistan of Quaid-i-Azam's imagining.[4] Of all the historic centers of Islamic culture in South Asia, the only one of any significance to find itself in the new state was Lahore; Delhi and the heartlands of Mughal culture fell outside its borders, and the princely states of Kashmir and Hyderabad in the Deccan were annexed by India. Pakistan consisted of East Bengal, West Punjab, NWFP, Sindh and Baluchistan, much of which had been peripheral not just to the defining centers of Muslim Indian culture but also to the Pakistan Movement.

In the absence of an indigenous administrative elite, a unified national vision, a shared language or even contiguous national territory (East and West Pakistan were separated

by approximately 1700 km of India), the leadership of the new country was taken up by an educated elite that had emigrated from areas that went to India in the partition of 1947. Native speakers of Urdu – which was declared the national language of Pakistan by decree rather than referendum – these refugees possessed the educational, linguistic and civil service skills that were in short supply in the new country, and they forged an alliance with the more cosmopolitan sections of the Punjabi and Sindhi landed gentry to form the new ruling class. For recent arrivals from the urban centers of Delhi, Bombay, Lucknow and Hyderabad, West Pakistan was the Wild West, populated by coarse, rugged gun-toting peasants and tribesmen, virtually none of whom could speak the official language, let alone be trusted with affairs of state. The capital was situated in Karachi, the most 'Indian' of Pakistan's cities and far from the densely populated regions of West Pakistan, not to mention the even more densely populated province of East Pakistan (today the independent country of Bangladesh).

In light of these challenges inherent to the creation of the state, it is small wonder that Pakistan has struggled from its very birth to transform itself from a dominion cobbled together out of British provinces into a nation state with a stable government. Jinnah died on 11 September 1948, less than thirteen months after Pakistan's independence, and a series of ineffectual governments quickly turned to the military to help shore themselves up. In 1958 Pakistan suffered its first military coup, which began a cycle in which military rule alternates with episodes of weak civilian leadership by politicians who serve at the pleasure of the army which has – by accident and design – emerged as the most powerful institution in Pakistani society and the only one that transcends regional or ethnic loyalties.[5]

Contemporary Pakistan still bears the marks of its checkered colonial and early national history, especially in its failure to address the lack of integration and representation of its disparate provinces. The resentments in East Pakistan over unequal representation reached a crisis that led to a civil war in 1971, with appalling human costs, and resulted in the creation of the new country of Bangladesh. But similar resentments linger among other groups and attain crisis proportions on occasion. The Balochis feel marginalized, overrun by immigrants belonging to other ethnic groups, and undercompensated for the vast mineral resources exploited for national rather than provincial needs; the Pushtuns and Sindhis share a sense that Punjab dominates them to the point that they are treated like colonies.[6] The Punjabis, largely insensitive to the concerns of smaller provinces and ethnic groups, feel that they are already making enough concessions for the sake of national unity and resent the prospect of making any more. The Urdu-speaking immigrants from India, acutely aware of their vulnerability as new arrivals in a land where ethnicity is a major determinant of identity and national voice, have organized themselves into a hybrid communal group called the Mohajirs. The name

applies only to Urdu-speakers and not to the many Kashmiris, Punjabis and Bengalis who came to Pakistan as refugees at the time of Partition. The name is also religiously charged, since it was the epithet of those Muslims who accompanied the prophet Muhammad when he was forced to leave his birthplace of Mecca for sanctuary in the city that came to be called Medina. The designation of 'Mohajir' claims for these immigrants a sanctified position in Muslim collective memory, likening the abandonment of homes in India and the self-sacrificing migration to Pakistan with the experiences of the most privileged group within the nascent Muslim community of the early seventh century. It also makes a direct link between the birth of Islam and the birth of Pakistan, thereby begging the question of whether or not Pakistan, by its very nature, must be a Muslim nation.

Successive governments of Pakistan have attempted to reinforce the ideology of the nation state by making alternating, and often contradictory, concessions to different interest groups within the country. The shifting loyalties of landlords and chieftains in various parts of the country are secured by ensuring that social development does not

Plate 7: Detail of a Bedford truck showing a portrait of Jinnah in reflective tape (chamak paṭṭī) over metal (Rawat 2003)
▽

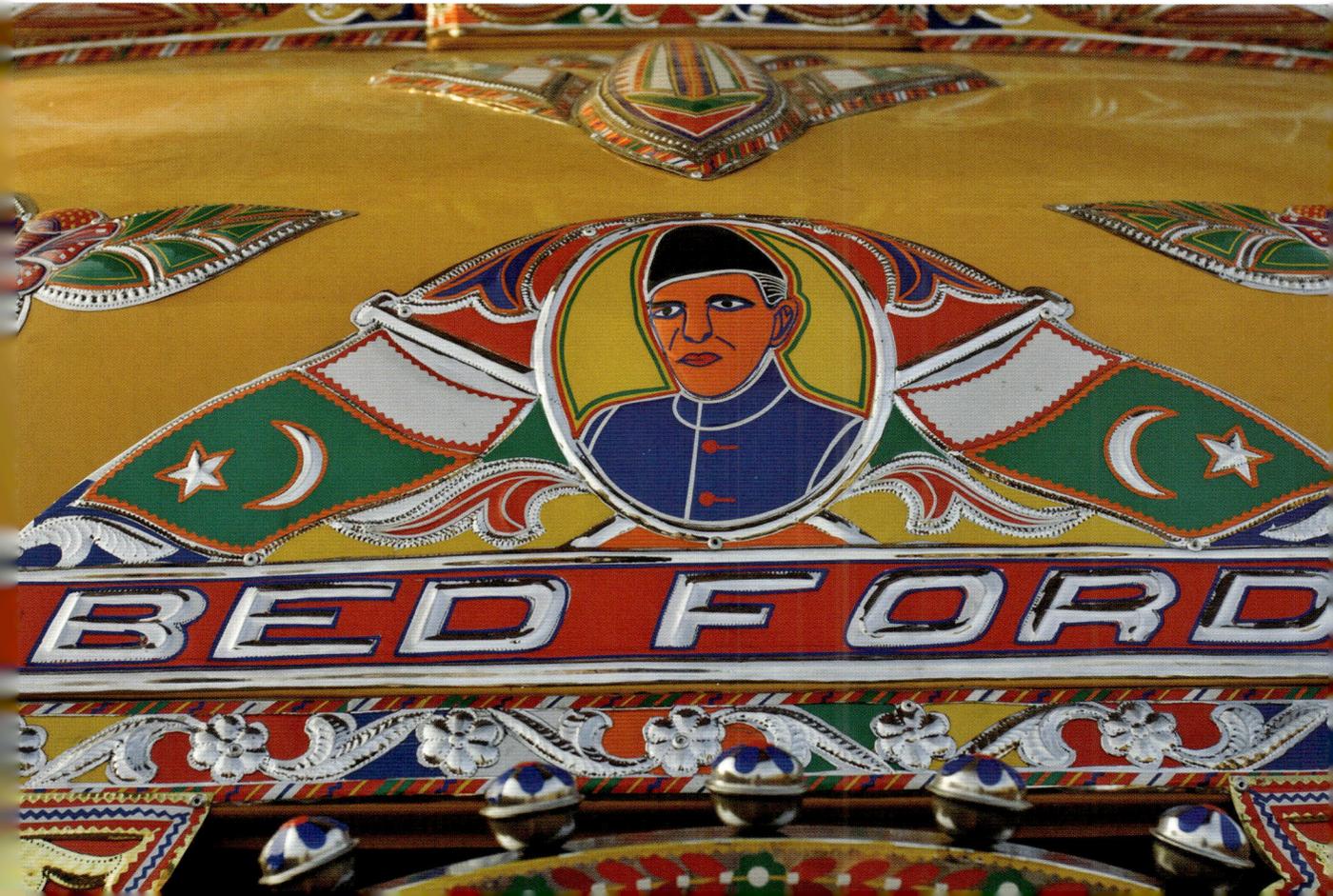

occur in a manner that would threaten local power hierarchies or patterns of resource distribution. In turn, these local and regional voices, which frequently represent communal and ethnic sub-nationalisms and pose a threat to national unity, are kept in check by patronizing religious parties and interests. The practice of playing religious interests against ethnic sub-nationalisms and regionalisms has contributed to an ongoing failure to bring the majority of the populace fully into a shared national identity or even to articulate a national vision to which the majority should aspire.

Islam and Pakistan

Pakistan is an overwhelmingly Muslim country with approximately 96 percent of its more than 170 million citizens professing some form of the religion. Islam is a visible and tangible part of public life, is part of the country's official name as the Islamic Republic of Pakistan, is in its legal system and in the conduct of civil life at formal and informal levels. At the same time, religious identity and practice are varied along predictable lines of sectarian, class and gender affiliation, as well as in more informal ways that reflect the hybridized identities prevalent among modern human subjects in all societies. Hindus and Christians account for almost all of the small minority of non-Muslims

Plate 8: Detail from the side of a truck (Rawalpindi 2003)
▽

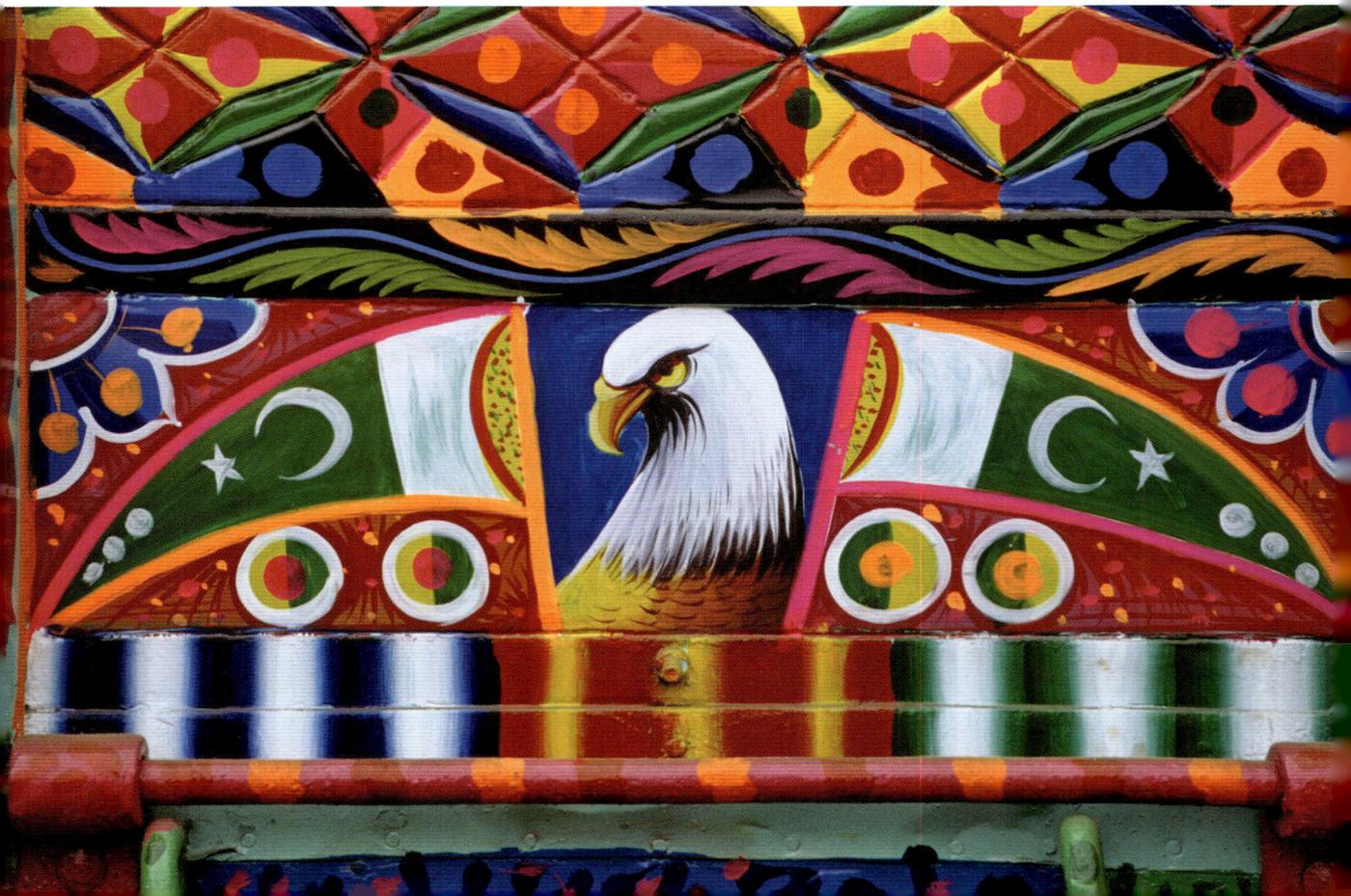

(there are very small populations of Zoroastrians, Sikhs, Baha'is, and others). Neither Hindus nor Christians are especially visible in society, although historically Christians are better integrated and more tolerated than are Hindus, who are concentrated in the urban centers of Sindh and in remote parts of that province as well as in Baluchistan.

The most formal religious divisions among Muslims follow sectarian lines, the majority professing adherence to various forms of Sunnism and approximately 20 percent to Shi'ism. The Shi'a are themselves predominantly Imami or Isna 'ashari Shi'as, the so-called 'Twelvers', sometimes referred to as Ja'faris in Pakistan. Twelver Shi'as are widely dispersed throughout the country, with sizable populations among Punjabis, Mohajirs, the peoples of the Northern Areas (especially around Gilgit and Skardu), as well as among the Pushtuns of the Kurram Agency of the Federally Administered Tribal Areas. A minority of the Shi'as are Isma'ilis of either the Nizari (Aga Khani) or Musta'li (Dawudi Bohra) sects. The latter is entirely urban and concentrated in Karachi, while the former is divided between Karachi and the Northern Areas, especially Hunza and its surrounding valleys. Only the Twelver Shi'as are significant for their impact on truck culture, both on account of their population as well as the fact that they are present in significant numbers in areas of the Punjab (the Potohar plateau and the Murree hills) that are active in the transportation industry.

The majority of Sunnis have no conscious sectarian identity beyond being Sunni, although they nominally follow the Hanafi legal school and the confessional tradition of the *'ulama* of the Barelvi tradition. This distinguishes them from other Sunnis, in particular the Deobandis (who have become particularly visible and politically important since the 1970s), the Tablighi Jama'at, and the Ahl-e Hadis. The reformist movement of the Ahmadiyya, though Sunni in origin, is considered heretical in Pakistan and has been the victim of a systematic pattern of discrimination and persecution.[7]

At a practical level, the major fault-line in Muslim practice and identity in Pakistan, particularly among the Sunnis, is between those who believe in intercessory models of religious life and salvific expectation versus those who deny any intercessory power except that of Muhammad (and sometimes not even that). As in the rest of South Asia and the majority of the Muslim world, vernacular religious beliefs and practices allow for the essential participation of a multitude of saintly figures – living, dead, as well as mythical – who function as the loci of devotional practices and aspirations. Sufi saints serve this role for Sunnis more so than Shi'as, who accord a privileged saintly status to descendants of the Prophet, though these figures do not by any means constitute the entirety of the Shi'a saintly pantheon. Some Sufi saints, such as Ali Hujwiri (better known in Pakistan as Data Ganj Bakhsh, d. 1077 CE) or Baha ud-din Zakariya (d. 1267 CE), were scholarly figures of international renown. Others, such as Lal Shahbaz Qalandar (d. 1274) or Mehr Ali Shah (d. 1937), are of regional significance but have emerged –

through the migration of their devotees, patronage by political figures, as well as the elevation of Sufi devotion to a form of 'national' Islam in Pakistan – as national saints. Still others are of local importance and tend to be unknown outside a limited geographic area.

The key element in the importance of saints is their possession of charismatic religious power called *barkat* (Arabic: *baraka*) which, in vernacular religion, is linked in an unacknowledged dialogic relationship with notions of the evil eye. *Barkat* is a commodity, formally imparted to the saintly individual by God, which can then be passed on to others in two forms. In the first form, contagious *barkat* is passed from the saint to a disciple, either intentionally on the part of the saint or else through the use of a ruse on the part of the receiver who 'steals' the charismatic commodity. Contagious *barkat* can be passed on to others either in contagious or non-contagious form. Non-contagious *barkat* is the variety that is sought by the vast majority of devotees as a form of good fortune or a guarantee against ill; once received, its effective power is limited to the recipient and cannot be passed on to others. *Barkat* is frequently obtained through shrine visitation, where the petitioner prays and makes a financial offering, sometimes in combination with a vow.

Shrine devotion is a religious practice that occurs almost entirely on the devotee's own terms. Important festivals aside, there is no real schedule of visitation and it can occur at the convenience or need of the devotee. Similarly, the petitioner is free to choose which shrine he or she visits, since the only impediments to visiting multiple shrines are the resources of the devotee and his or her sense that devotion to several shrines will be perceived as a sign of infidelity by the saintly person being visited (such a sensibility is rarely encountered). In contrast to shrine visitation, devotion to living Sufi leaders, or Pirs, can be much more structured in its requirements, especially if the Pir in question interacts with visitors on an individual basis or if the devotee is a formal disciple of the Pir. In other cases, especially those of holy figures who gain a reputation as possessors of *barkat* on account of an apparent psychological or physical abnormality, visitation follows the same informal patterns as it does for shrines with no living Pir.

The desire for *barkat* is frequently very informal and one of several components in living a virtuous and successful life: believers in the system seldom make offerings in a formal economic exchange whereby *barkat* – as a commodity – is acquired as a fair trade for money or for the flowers and shrouds one leaves at shrines after purchasing them from nearby shops. These rituals are viewed as pious acts, like the practice of purchasing cauldrons of food from soup kitchens and distributing them at the shrine, with the hope that they will be viewed by the possessor of *barkat* (and by God) as evidence of sincerity and virtue and will therefore increase the likelihood of petitions being granted.[8]

▷

Plate 9: Detail of the side of a truck with a representation of Allama M. Iqbal, considered the ideological founder of Pakistan (Rawalpindi 2003)

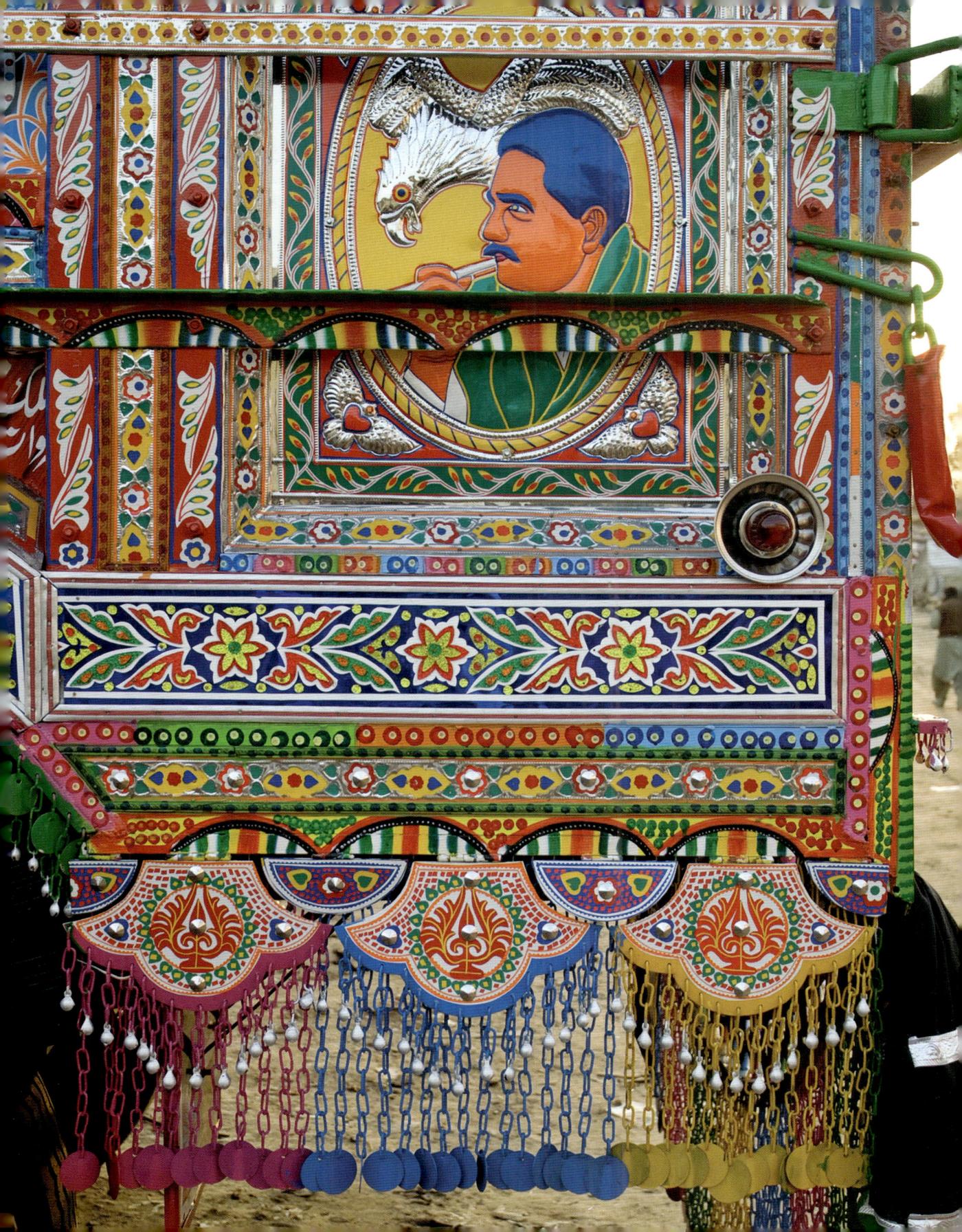

Closely related to the practice of acquiring and guarding *barkat* is the pervasive belief in the evil eye, normally referred to as *nazar* but also called *nazar-e bad, chashm-e bad, bad chashm* or *zakhm chashm*. Belief in the evil eye is common in many societies around the world and remains ubiquitous in Islamic communities all the way from the Atlantic Ocean to Bangladesh and from sub-Saharan Africa to the inner Asian steppes. In South Asia, the belief is not limited to Muslims but is widespread among other religious and communal groups. Evil eye belief, as it exists in Pakistan, centers around the conviction that a malevolent force can be transmitted through envy and covetousness and can bring harm. In the commonest understanding, this force is not transmitted intentionally but rather rides the admiring or envious gaze of an onlooker and brings harm to the one looked upon. In most cases, such harm does not affect the person directly, but constitutes misfortune nonetheless by harming someone or something dear to them, most commonly children, animals or property.[9] The evil eye, as *nazar* (lit. 'look' or 'glance'), is not necessarily caused by *looking* in the literal sense but can also occur through thinking or speaking about someone covetously or enviously, as a result of which the victim is said to be 'struck by *nazar*' (Urdu infinitive: *nazar lagnā*).

Not only the potential prey of the evil eye but also its inadvertent transmitters are conscious of its autonomous power as a malevolent force, and it is normal for people to use prophylactic formulas while expressing admiration for the good fortune of others. Such utterances include phrases such as *nazar na lage* ('May *nazar* not strike') and *chashm-e bad dūr* ('Evil eye, be gone!'), but the most widespread formula is *Ma'shallah* ('As God wishes'), used for the same purpose across the Islamic world. In the event that the admirer fails to utter such an aphorism, it is spoken by the recipient of the admiration or by a third party.

Although the evil eye's effective independence from the admiration or envy of the gazer is a universal belief, there is ambivalence concerning whether or not the gazer is actually innocent in the process. Envy, jealousy and covetousness, as negative qualities, necessarily impute a degree of guilt to the gazer, such that he or she can be seen as being responsible for allowing or enabling the evil eye to attach itself to its victim. This is seen, however, as distinct from *intending* someone else harm, a practice that is also common in Pakistan through the widespread use of spells, curses and incantations. Magical spells, normally referred to as *tawnā* or *ṭōṇā*, have the same results on the victim as do inadvertent attacks of *nazar*, and are avoided through similar means.[10]

In many respects, *nazar* – as bad fortune – represents the opposite of *barkat*. Good and bad fortune can be acquired or avoided through ritual actions and the use of talismans that are believed to yield desired apotropaic or prophylactic results. In many respects, *barkat* can be seen less as a desire to acquire good fortune than to avoid bad fortune, since good fortune is often nothing more than the continuance of a positive status quo, and

bad fortune any departure from it through falling victim to the power of an omnipresent and pervasive malevolent force that attacks through *nazar* and *tawnā*. This explains the common practice in Pakistani society of prominently displaying declarative formulas such as 'This is from the grace of my Lord' (*hāzā min fazl rabbī* in Urdu pronunciation of the Arabic) and 'God is the best of all providers' (*Allah khayr ur-rāziqīn*) on homes and vehicles, since a public affirmation of one's existence in a divinely willed state of *barkat* provides a powerful prophylactic against the power of the evil eye.

As discussed in later chapters, many truckers are active believers in the evil eye and the similar dangers of spells and curses, and employ a variety of visual signifiers on their trucks to guard against misfortune. Among the subsection of the trucking community that follows intercessory forms of Islam, shrine visitation and offerings are perceived as vital to the success and wellbeing of the truck and the safety and livelihood of the people associated with it. It is the norm for the owners of such trucks to take the vehicle to a shrine as soon as they take delivery of it from the workshop and to make an offering – in the form of an animal sacrifice and a financial donation – before actually putting the vehicle into service. Such consecration of the vehicle and consequent apotropaic and prophylactic value is taken extremely seriously; over the course of my fieldwork I encountered several cases of trucks that, for a number of reasons, had to be placed in service before they could be taken to the shrine normally patronized by the owner. In all such instances, the truck was taken to a shrine near the workshop for immediate consecration, with the expectation that it would be taken to the important shrine at the first opportunity.

In addition to visitation of major shrines or those of particular importance to the truck owner or driver, for *barkat*-seeking and *nazar*-avoiding drivers, the map of Pakistan is dotted with sacred sites (*mazārs*) where they make financial offerings as they ply the roads. The managers of such shrines recognize the importance of the trucking industry to their own financial wellbeing, and make it convenient for drivers to offer money without taking too much time out of their schedule. In most instances, such shrines place a shack or kiosk beside the road, and drivers ball up paper currency and throw it out of the window for the offerings to be collected by attendants at the 'satellite shrine'. In at least two examples – one near Taxila on the highway from Islamabad toward Peshawar and the second near Jhelum in the opposite direction – the satellite shrine has modified itself as the road has been expanded. When the highway was a two-lane road, attendants stood at either side of the road to collect money. When it was expanded into a divided highway, shrine attendants positioned themselves in the island between the two sets of lanes. Finally, when the motorway was built some distance away from the old highway, a new satellite shrine was established next to it so as not to lose contributions from traffic that had been diverted to the new road.

As mentioned above, devotion to Pirs and shrines is part of a broad pattern of religious practice in Pakistan and is not limited to a particular clearly defined sectarian group. The charismatic reputation of such individuals and spaces transcends sectarian divisions, and even religious ones, such that there are shrines in Pakistan that are visited by Sikhs, Hindus and Christians in addition to Muslims.[11] Among Sunnis, the only clerical school that sanctions shrine visitation and devotion to saints is the Barelvi one, although it must be emphasized that the specific rulings of Barelvi religious scholars (*'ulama*) have little actual bearing on the beliefs and practices of the vast majority of Muslims who adhere to an intercessory form of Islam. As such, adherence to intercessory versus non-intercessory models of religious belief and expression among Pakistani Muslims is not a direct result of scholarly teaching but of a constellation of beliefs.

Despite the pervasiveness of belief in the evil eye and other forms of directed misfortune as well as the almost corollary belief in the ability to acquire good fortune as a commodity, many Pakistani Muslims express ambivalence concerning the religious legitimacy of such beliefs and even more so concerning their attendant rituals. Disapproval of the pursuit of *barkat* is less pervasive than the strong opposition to magical and *nazar*-related practices, which appears to be found equally among Shi'as and Sunnis and is only tenuously related to adherence to non-intercessory forms of religion. Perhaps the spiritual economy that twins *barkat* and *nazar* threatens the rational underpinnings of a more normative religious understanding in which reward is linked directly to moral action. After all, even a thief has a need for defence against misfortune, and can utilize exactly the same prophylactic measures as do more upstanding members of society.

Pakistan's Sunnis are nominally divided into four denominations or confessions although, as I've already mentioned, these formal identities mean very little to a majority of the population.

Barelvi

The Barelvi Sunni movement takes its name from the town of Bareilly in Uttar Pradesh, India, and is based on the teachings of Ahmad Riza (or Raza) Khan (d. 1921).[12] Ritual veneration of the prophet Muhammad and of certain Sufi saints constitutes a central feature of Barelvi belief, to the point that Ahmad Riza Khan and many of the Barelvi leaders after him openly considered those Muslims, such as the Deobandis and the Ahl-e Hadis, who do not engage in such ritual veneration, to be deficient in both faith as well as practice. As such, despite embracing what might appear to be a religious model that tolerates a wide range of practices and beliefs, in reality the Barelvis have not always demonstrated such an openness of spirit. Ahmad Riza Khan was personally inculpated in having the Ahmadiyya declared a heretical sect, and Barelvis continue to be embroiled

with the Deobandis in a direct competition over the jurisdiction of mosques and other resources, a contest that sometimes turns violent.

Deobandi

Although the Barelvis claim to represent the beliefs of a greater portion of the population, it is the Deobandi movement that is most visible in contemporary Pakistan and exerts a palpable influence on public life. The Deobandis are a seminary-based group in the most formal sense, since their origins lie in a *madrasa* named the Dar ul-'ulum and founded in the Indian town of Deoband in 1866. The express purpose of the Dar ul-'ulum – which has spawned a large number of *madrasas* since its own founding – was to train cadres of capable and well-educated *'ulama* to serve as the torch-bearers of Muslim reform. The Deobandi curriculum is very well defined, with specific requirements to advance from one stage to the next and a tight-knit sense of collegial loyalty between faculty as well as students, in no small degree due to the close relationship of the early Deobandis to the Chishti Sufi order.[13]

The most important development in the Deobandi movement as it impacts everyday life in Pakistani society is the growth of a religio-political movement within it, that of the Jami'at-e 'Ulama'-ye Islam (henceforth the JUI). This subgroup had sided with the Muslim League in the last days of British colonial rule and established itself as a small political party after the independence of Pakistan. Through the first half of Pakistan's history, the JUI enjoyed a minor degree of popular support, much less than the major religious party, the Jama'at-e Islami of Mawdudi, although even that party has never succeeded in garnering a substantial portion of the national popular vote. As such (and like other religious parties), the JUI has thrived by maintaining and shifting alliances with larger coalition partners. In so doing, they have displayed a talent for compromising on what one might assume to be non-negotiable points of principle for members of a religious organization with a platform such as theirs: in the 1970s, they were allied with the secular regional sub-nationalist (and arguably socialist) movement of the National Awami Party against the Pakistan Peoples Party of Z.A. Bhutto. A decade later they were allied with Bhutto's daughter, Benazir Bhutto, against the Muslim League. This attitude of *realpolitik* has characterized not just the JUI but all Deobandi groups. 'None of [them] has a theoretical stance in relation to political life. They either expediently embrace the political culture of their time and place or withdraw from politics completely.'[14]

The JUI saw its fortunes take a sharp turn for the better with the coming to power of General Zia ul-Haq in 1977. Zia's rule coincided with the war against the Soviet occupation of Afghanistan, a pivotal period in Pakistan's history that continues to play a decisive role in the country's society and politics to this day. General Zia generously

patronized the JUI and other Deobandis, in order to lend religious legitimacy to his regime as well as to secure Pakistani governmental influence over Afghan resistance fighters based in and recruited from the many refugee settlements in Pakistani territory. Under state patronage, Deobandi *madrasas* flourished during this period and were allowed – in their curricula, setting of social policy at the local level, as well as in land grabbing – to challenge the authority of federal as well as provincial ministries in educational, social and security affairs. The immense influence of the Deobandi *'ulama* affiliated with the JUI extended to the creation and continued fostering of the Taliban movement in Afghanistan, since both the upper echelons as well as the rank and file of the first Taliban movement were educated in Deobandi *madrasas*.[15]

Largely as a consequence of Pakistan's covert operations in Afghanistan, which were publicly couched in the language of conflict between Islam and *kufr* (infidelity of a necessarily evil sort), charismatic public figures in the JUI became the public voices of an increasingly irredentist and interventionist politicized Islam that saw the need to 'liberate' Muslim societies from foreign as well as morally deficient indigenous rule, and envisioned a religious revolution that began with Afghanistan, Pakistan and Kashmir, but also included Uzbekistan, Tajikistan, Xinjiang and Chechnya as part of the first phase of revolutionary struggle. The involvement of Deobandi clerics and the JUI with the Pakistani military has continued to be very deep, even after the death of General Zia ul-Haq in 1988 and into a period when the Pakistani government is engaged in a highly publicized military and propaganda campaign against militant religious groups in Pakistan. Many figures of the movement, including Maulana Fazlur Rahman (head of the JUI) and Maulana Sami ul-Haq (the director of the Dar ul-'ulum-e Haqqania at Akora Khattak, which trained many high-ranking members of the Taliban including Mullah Umar), have served as members of the Pakistani senate. At the same time, they have openly made threats to the Pakistani state and society – including the threat of deadly violence directed against civilian targets – but have suffered no legal censures, even under the military rule of General Musharraf.

Very few members of the wider Pakistani society actually attend Deobandi *madrasas* for their primary education or read their publications, but Deobandi influence is extensive on account of the visible presence and media savvy of large cadres of mid- and low-level *'ulama*. Their informal influence on society is even greater because a significant (but undetermined) portion of Pakistanis with higher education receive it through Deobandi institutions. In an environment characterized by little economic development and severely limited employment opportunities for individuals with non-technical higher degrees, noticeable numbers of young men choose to enroll in seminaries because status as low-level religious scholars carries the prospect of a degree of social standing as well as a meager monetary stipend. Within the informal structures of society, where

literacy and access to information are limited and the formally 'learned' listened to by the unlettered or poorly educated majority, such newly minted members of the *'ulama* play an important role in shaping public opinion.[16]

Ahl-e Hadis

The Ahl-e Hadis share the Deobandis' commitment to a reform of Muslim practice and thought as a means of revitalizing Muslim society. They differ from them in giving primacy to the direct use and interpretation of religious texts over the development and replication of knowledge through scholastic traditions that the Deobandi seminaries espouse. In its origins, the Ahl-e Hadis demonstrated a literalism and absolute reliance on the textual sources of the Qur'an and Hadith, such that its appeal was largely restricted to an educational and social elite which saw itself as ridding Islam of superstitious and anti-rational corruptions. Over time, the distinction between them and the international Salafi movement (spreading from Saudi Arabia) has become blurred, and in modern times when Pakistan's local economies are intertwined with those of the Gulf Arab states and Pakistanis frequently visit and work in the Arabian Peninsula and possess a degree of familiarity with aspects of Gulf Arab society, the distinction between the two movements is even more difficult to maintain. Most Salafis consider the Ahl-e Hadis completely distinct from themselves, however, regarding the latter as antinomian (*ghayr muqallid*) because they do not follow one of the four prescribed Sunni schools of law.

Tablighi Jama'at

The origins of the Tablighi Jama'at (Society for Communication or Proselytization) lie in a place south of Delhi named Mewat. The population of this region, the Meos, has historically practiced a very syncretic form of Islam incorporating Hindu rituals, the use of Hindu first names and other practices viewed with disfavor by more normative South Asian Muslims. Syncretic practice is not uncommon in the history of Islam in South Asia or in many other parts of the world, but it has drawn frequent criticism from the more orthodox members of the Muslim community. As such, Mewat was a target for religious reformers during the end of the nineteenth and first quarter of the twentieth centuries, a period that saw significant reformist and revivalist activity among Indian Muslims and Hindus alike. Mawlana Ilyas (1885–1944), a second-generation religious scholar with strong ties to the Deobandi school of Sunni thought, began to preach what was to become the Tablighi Jama'at movement as a way of bringing the Muslims of Mewat in line with his own conception of a normative form of Islam. This reform was not just a matter of making the Meos conform in matters of ritual and doctrine, but also to inculcate in them a notion of so-called 'true' Islamic ethics.

The formal beginnings of the movement probably date from a community meeting (*panchāyat*) in Mewat on 2 August 1934 when Mawlana Ilyas first outlined the fundamental principles of the Tablighi Jama'at in fifteen points.[17] They were condensed later into Six Points or Six Principles (*chē bātēṇ* or *usūl*): (i) the Islamic credal formula (There is no god but Allah, and Muhammad is the messenger of Allah) is an individual covenant with God which has to be understood in its true meaning and with all its implications; (ii) prayer is the most important ritual obligation of a Muslim and should be performed in a congregation whenever possible; (iii) religious knowledge ('ilm) and remembrance of God (*zikr*) are obligatory for every Muslim, and both derive from study of the Qur'an; (iv) respect for all Muslims is imperative (kind treatment of all non-Muslims is encouraged but it is not an explicit principle); (v) sincerity of purpose (*ikhlās-e niyyat*) is obligatory, in the sense that all acts must have appropriate intentions since, in the absence of ritual intentionality, even good acts will not be rewarded by God; and (vi) members must donate time (*tafrīgh-e vaqt*).

The last principle refers to the obligation of members of the Tablighi Jama'at to take time from their regular lives to travel and actively engage in spreading the message of the movement in the Muslim community. The sixth principle is also referred to as *tablīgh*, emphasizing its centrality as a doctrine. Depending on the interpretation, a follower of the movement is required to spend between one day and four months a year traveling to call people to the movement (other teachings state that this obligation can be met by traveling as a missionary for four months cumulatively during the course of one's lifetime). Local, regional and international travel as *tablīgh* has come to fulfill the Muslim obligation to 'strive in the path of God' (*jihād fī sabīl Allah*) in Tablighi understanding.

Followers of the Tablighi Jama'at are forbidden from actively participating in politics, a stand that has occasionally put them in conflict with religious political parties in Pakistan. Nevertheless, although there is no political party formally representing the Tablighi Jama'at, followers and sympathizers constitute a very large vote bank that is courted by formally religious and center-right parties and political movements. The Tablighi Jama'at has a very loose organizational composition, and its hierarchical structure does not seem to extend much beyond the upper echelons of its leadership. In Pakistan there is no external way of identifying members of the movement except through conversation or when they occasionally approach other Muslims, encouraging them to join the Tablighis in congregational prayer.

The 'Ulama and Pakistan

The important Sunni movements of the Barelvis and Deobandis, as well as those of the Ahl-e Hadis and the Tablighi Jama'at, emerged out of the reformist atmosphere of the

nineteenth and early twentieth centuries. In most cases, the clerical class of the *'ulama* viewed itself as the defender of religion against secularization and westernization as well as against corruption through the practices of competing groups. Despite what has been suggested by more than a few scholars, the *'ulama* were neither uniformly opposed to the creation of Pakistan, nor were they all apolitical *de facto* supporters of the state during the colonial period.[18] Their involvement in the formation of Pakistan and in its subsequent societal developments has been complex and is difficult to summarize in a brief discussion.

What is critically important to understand – and is frequently overlooked by scholars dealing with Pakistan – is that the high-ranking *'ulama* have a very limited direct influence on the *habitus* of the wider population. This phenomenon is partially attributable to the lack of an institutionalized formal clergy in Sunni Islam, but it is due to an even greater degree to the specific makeup of Pakistani society, which still lacks a comprehensive educational infrastructure and retains the historical ethnic distinctions which separate the majority of the traditional *'ulama*, who are Urdu-speaking and frequently from Mohajir families, from the bulk of the indigenous population. It is the substantially more radicalized and charismatic lower echelons of the clergy who prove to possess a greater influence in shaping religious and social opinions. In addition to the politicized leadership of the JUI mentioned above, many smaller, more radicalized groups exist within Pakistan, most of them (but certainly not all) with pedigrees that go back to the Deobandi school.[19]

The low-level *'ulama*, and especially preachers in local mosques, are responsible for extolling a Muslim ideology that, in recent times, has come to reflect a sense of interminable conflict between pious Muslims and all others, particularly the West and India. On the topics of Afghanistan and Kashmir, their preachings have coincided handily with the interests of Pakistan's security establishment, which not only tolerates the existence of radical religious groups but, by most accounts, is intertwined with them. Figures such as Sami ul-Haq, an outspoken professor of anti-state violence and sympathizer of the Taliban at a time when Pakistan had declared them members of a criminal organization, are fêted members of the political establishment. The close relationship between radical clerics and the government allowed a member of the JUI to usurp land and build a multi-storied mosque with attached residential seminary at the physical heart of the Pakistani government, in the section of Islamabad where all major ministries – as well as the headquarters of the main intelligence agency – are based. 'Abdul 'Aziz and 'Abdur Rashid, the two sons of the founder of this complex popularly referred to as the Lal Masjid ('Red Mosque'), successfully stockpiled weapons and used their seminarians to act as religious vigilantes throughout Islamabad in 2006 and 2007. The military government ruling Pakistan at the time tolerated the Lal Masjid's activities, and members of the government, military and intelligence establishments remained regular visitors to the

mosque until followers of 'Abdul 'Aziz and 'Abdur Rashid kidnapped a number of Chinese nationals. The government, which had heretofore ignored the intimidation and destruction of video rental shops and other businesses, the physical assaults on policemen and the continued occupation of a children's library by vigilantes from the mosque, reacted to the attack on citizens of its closest ally by laying siege to the mosque complex. After eight days, the army stormed the complex with significant loss of life.

The exact number of dead and wounded remains a matter of conjecture but is not likely to number more than 200.[20] However, many sections of the Pakistani populace remain firmly convinced that thousands of innocents had been massacred by the government in their unjust and excessive deployment of force against a mosque, and in the weeks immediately after the Lal Masjid incident there was near unanimity in this position among the truckers I interviewed.

The mosque's specific Deobandi affiliation did not matter to the wide spectrum of Pakistanis who viewed the Lal Masjid incident as an example of an affront by a non-representative government against people of faith and piety. Politicized Islam among the majority of Pakistanis – and definitely among the Sunnis – transcends sectarian affiliation. Under these circumstances, Tablighis, Deobandis and those with a poorly defined

Plate 10: Faisal Mosque in hammered metalwork on a Bedford truck (Rawat 2003)
▽

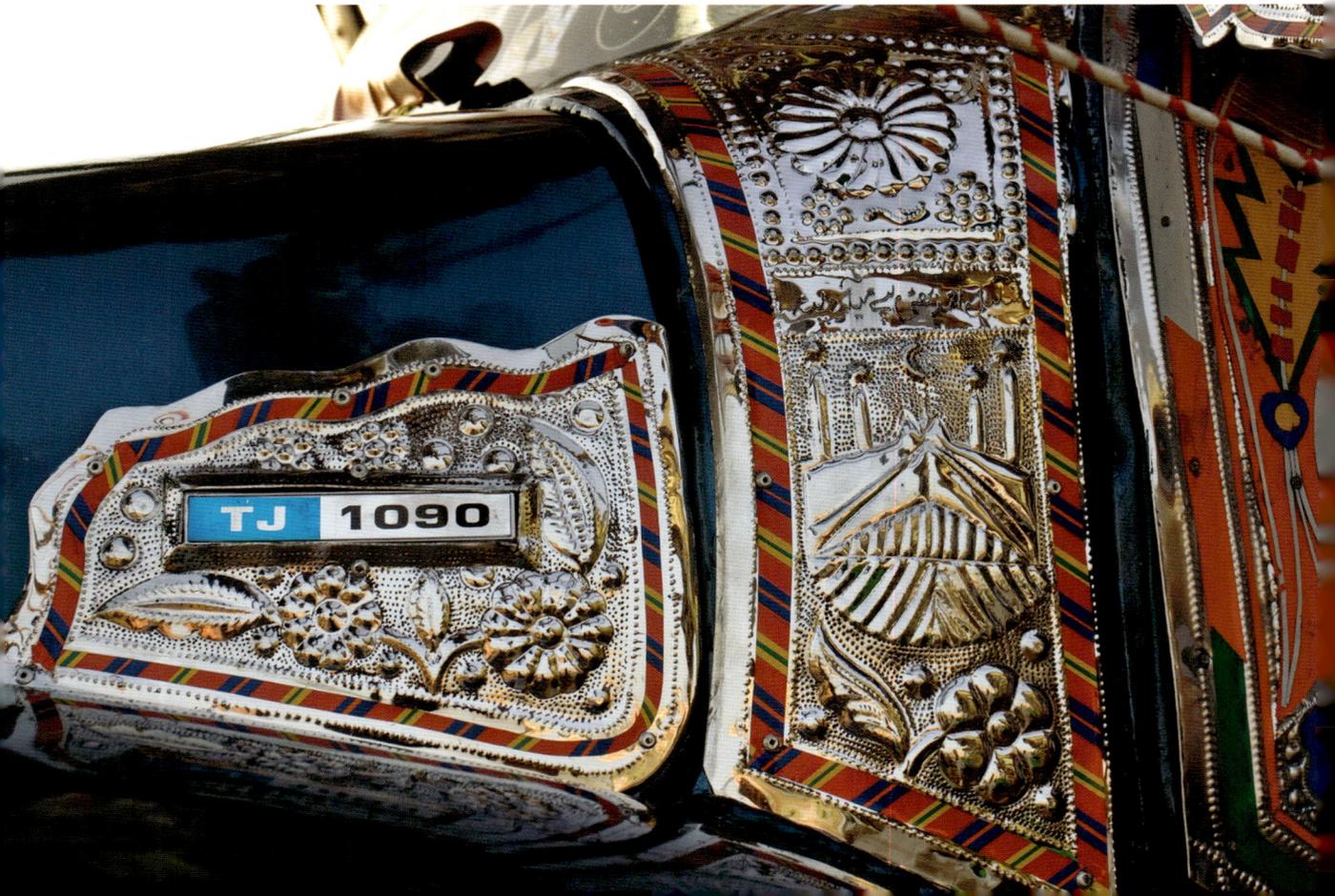

sense of formal religious identity begin to resemble each other in a hybridized religious identity which is characterized by very general principles and beliefs. More than anything else, it functions as a vote or opinion bank, which religious parties can rely on for the support of a broad swath of the population in local and national affairs, if not in actual elections. Very frequently, the truckers I interviewed were expressly apolitical in their views, and even more of them consciously avoided any form of political expression because they felt that it invited unwanted attention from the police or other sections of the state apparatus. Nevertheless, as will be seen in Chapter 8, the period of rapid growth in politicized religion in Pakistan also corresponds to a more complex use of religious signifiers in the visual regime as represented through trucks.

The general population is often seen by elites and some scholars either as uncritically submissive to the politicized Islamists or else to be opposed to them in a manner that lacks any complexity. In fact, individual understandings of religion, modernization and Islamization are very complex and reflect a process of negotiation for status and agency at both the individual and collective levels. Complexities of class play a crucial role in these dynamics, and the ways individuals negotiate their circumstances depends to a large degree on their access to status and education which continue to be particularly fraught social identifiers in Pakistani society.

3

Education and the Boundaries of Class

Just look at how we play the flute:
An Arab tune set to an Indian scale.
Eyes clouded with European ways –
Our nature royal, our fate that of a slave.
Iqbal

The individual and collective dispositions of human actors are shaped to a large extent by their position in society at local, regional, national (and transnational) levels, with which they negotiate, responding consciously and unconsciously to the structures and ideas that constrain and sustain them. Among the many such factors that influence individuals in most societies, and very much so in Pakistan, social and economic class plays a central role, and is directly related to questions of literacy and education, which have far-reaching implications not just for the ability to negotiate one's place in society, but also in structuring one's attitudes and actions. Education functions as a strong determinant of class structure in Pakistan as well as religious and social attitudes, which are essential elements in the nature and function of truck decoration.

One of the most significant failures of the Pakistani state over its history has been in providing comprehensive public education to its citizens. Until very recently, a miniscule percentage of the national budget went toward education, and although there has been an increase in spending over the last decade, spending on education still remains at 2.5 percent of the national GDP.[1] Spending is skewed in favor of higher education, especially in the sciences, which are perceived as essential to national security and prosperity

in ways that primary and secondary education are not. State expenditures on education are supplemented by the existence of a variety of private schools, a small handful of which cater to the elite, while the majority, both secular and religious, are designed to bring basic education to the poor and the lower-middle classes.

The Meaning of Literacy

The 1981 Population Census of Pakistan indicated a literacy rate of 26.2 percent with literacy defined as the ability to 'read a newspaper and write a simple letter in any language'.[2] By the time of the Population Census of 1998, literacy rates had risen to 43.9 percent, and most indicators suggest that literacy has increased at a faster rate since then.[3] There are marked disparities across gender, between provinces and urban versus rural areas, although many regions show substantial improvement in the seventeen years between the two censuses. At an aggregate level, males were more than twice as likely to be literate in 1981; this ratio improved slightly in 1998, with male literacy rates of 54.8 percent versus female rates of 32 percent. The national urban literacy rate is almost twice that of the rural rate (63.1 versus 33.6 in 1998), although this is markedly improved from the situation in 1981 when the ratio was 47.1 to 17.3.

The biggest inequalities are between urban and rural areas, especially remote parts of Baluchistan and the Federally Administered Tribal Areas (FATA) bordering Afghanistan, where the disparity in literacy across genders is also the worst. The urban literacy rate for the whole of Pakistan was 63.1 percent in 1998 as compared to a rural rate of 16.8 and 17.5 in FATA and Baluchistan respectively. In the case of FATA, female literacy is one-sixth that of males. The enormous disparities across regions are brought home by the fact that the literacy rates of rural people from Baluchistan are less than a quarter of the combined urban and rural rate for Islamabad (17.5 versus 72.9 percent).

The substantial differences in literacy rates are indicators of disparities in other forms of development, including the availability of health care and employment, and are primary reasons for the high levels of migration from poor rural areas to the cities, including the migration of individuals involved in all aspects of the trucking industry. The varying and low overall level of literacy also has a direct impact on the nature and processes of truck decoration, since epigraphy plays a central role in the scopic regime of trucking culture and the place it occupies in a wider, national visual regime. Truckers use writing of a variety of sorts for religious and informational purposes and as complex signifiers of their place in society. Most people directly involved in truck decoration belong to less educated sections of society, and the significance of writing (and reading) on trucks – even at the level of the intended audience's ability to read the epigraphy – is

not as straightforward as literacy statistics would imply. In the first place, Pakistan's literacy figures are very likely optimistic calculations of the level of functional literacy, with practical literacy levels being much lower. As an indicator of the unreliability of statistical indicators in this context, in 1981, 38 percent of Pakistanis supposedly could read the Qur'an.[4] This is a mathematical impossibility; were it to be true, it would mean that while only 26.2 percent of the population could read *any* language, 38 percent (a larger number) could read a *foreign* language, since the Qur'an is read in Arabic, a language spoken and understood by a negligible number of Pakistanis.

The remarkable statistic of purported Qur'anic literacy indicates that both literacy and religiosity are important status markers in Pakistani society, such that large numbers of illiterate people claim (and maybe even believe) that they can read. In the Pakistani social context 'reading' the Qur'an frequently means being able to mouth the words; a majority of the population learns how to recite some portion of the text in Arabic, and a significant minority sits with members of the clergy (*maulvis*) and systematically makes its way through the Arabic text over a period of years. 'Reading' the Qur'an is a ritual act, almost never accompanied by learning to read Arabic or committing the entire text to memory. In Pakistani society (as elsewhere in the Muslim world), the moment when a child finishes his or her first 'reading' of the Qur'an is an occasion of celebration, marking in an informal way an important step toward his or her entry into Muslim adulthood. Among people who cannot read, it is extremely common to pass one's finger along the lines of the Qur'anic text, since this – in and of itself – is regarded as a pious act.

Reading the Qur'an represents a particular kind of contextual literacy, in that what surveyed individuals mean by *reading* is different from the standards of literacy established by the Government of Pakistan. Although there is no empirical evidence to verify this, it is likely that there is a similar dissonance between the surveyors' understanding of literacy and that of the individual at (or just below) the threshold of literacy. Illiteracy has a strong pejorative connotation in Pakistani society, and to be called *unpaṛh* (illiterate) goes hand in hand with being dubbed *jāhil*, meaning 'ignorant' but carrying a particular sharpness in Islamic society since it implies an archetypal form of ignorance which characterized Arab society before the advent of Islam. From conversations with many Punjabi-, Balochi- and Pashto-speaking Pakistanis, it is clear to me that many people claim to be literate – 'to know how to read' – if they recognize letters of the alphabet and can sound out words, even with difficulty. Theirs is a form of contextual literacy that does not allow them to read the newspaper and write basic letters as the census data claims they can, but does enable them to recognize certain importance words and phrases, the majority of which are of religious significance.

Two-tiered Education

Literacy rates serve as the most tangible signifier of notions of educatedness in Pakistani society, where the term *paṛhā likhā* – best translated as 'lettered' or 'well-educated' depending on the context – is a source of status. Access to being 'well-educated' primarily comes from formal education which, as elsewhere, is valued as a means of upward mobility in both economic and social ways. But education in Pakistan is fraught with certain complexities as a consequence of the country's multiethnic social makeup as well as its colonial legacy which has privileged English and Urdu in peculiar ways.

At the moment of its independence in 1947, Pakistan inherited a multi-tiered system of education from the British which has only become more complicated with the growth of indigenous professional middle and military classes. The very top is occupied by private schools originally designed either to educate British and Anglo-Indian children or else to teach – and, to a degree, civilize – the children of the feudal aristocracy of the Punjab and its frontier (now the province of Khyber Pakhtunkhwa, formerly NWFP). The most distinguished example of the first sort is Karachi Grammar School and of the latter Aitchison College in Lahore, formerly named Chiefs' College in unabashed recognition of its purpose. Below these is a range of private English-medium

Plate 11: Painting of a boy in prayer on the door of a truck in the 'disco' style (Deh Movach, Karachi 2003)
▽

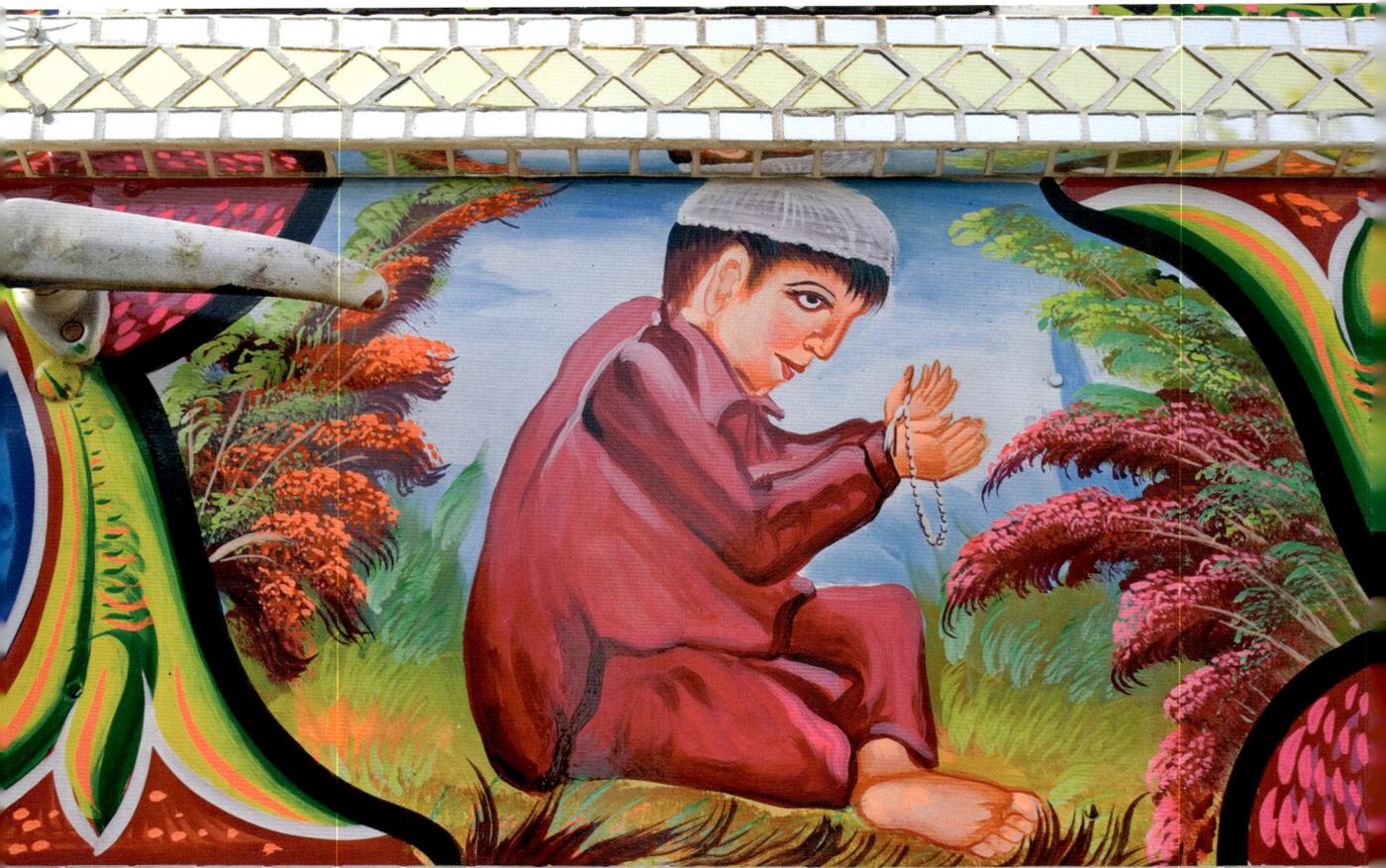

schools either run by Catholic missionaries or else by large state corporations, the military or the federal government as part of a program of elite schools.[5] Catholic schools do not engage in any formal proselytizing, but rather they serve an exclusively educational function, occasionally helping out the economically and socially disenfranchised Christian community with free or subsidized schooling. Catholic institutions have traditionally been especially important in educating the girls of Pakistan's social elite.

A new arrival on Pakistan's educational scene are small, elite English-medium schools that promise a quality of education that rivals (or betters) that provided by the very top tier of the established private schools. In many cases, these institutions are run at a profit and operate out of small campuses with very limited facilities, particularly in terms of playgrounds and other open areas. Some of them, such as the Shaykh Zayed International School and Froebel's International School in Islamabad, are expensive to the point of being beyond the financial reach of high-ranking civil servants. Such schools are still too new to have an established alumni base, and it remains to be seen whether or not having attended such schools will confer the social cachet attached to the prestigious schools dating from the colonial period.

Somewhat below the secular private schools and missionary schools in the social hierarchy, and perhaps also in the quality of education they provide, are schools for boys run by the Pakistani military. Some – like Army Burn Hall School in Abbottabad and Lawrence College in Ghora Gali – were taken over in the 1970s from Christian missions as part of a wider project of nationalizing education. Others, such as the Pakistan Air Force Public Schools in Sargodha and Lower Topa, were set up for the specific purpose of serving as feeder schools for the military. In addition to the military schools, institutions such as the national railways, tobacco company, Water and Power Development Authority (WAPDA) and steel corporations open schools for the children of their executives, although in all cases they admit anyone who is qualified, has sufficient social connections, and can pay the necessary fees.

Below these elite schools are federally funded public schools for both sexes that teach in English, and below them are a range of Urdu-medium schools funded at the federal and provincial levels. In the last decade, these schools are being paralleled and even overshadowed by a network of private schools that provide affordable alternatives to the fractured public system of education. Even though the majority of Pakistanis do not speak either Urdu or English as their first language, with the exception of a few schools in the provinces of Sindh and Khyber Pakhtunkhwa (NWFP) that teach in Sindhi and Pashto, there is no schooling in the native languages of the majority of the population. As such, the division is between instruction in English and in Urdu and, in many ways, between the acquisition of two second languages as a key to class mobility.

Urdu

Urdu emerged as the language identified with Muslim nationalistic aspirations in British India and therefore carried special ideological significance for the politicians of the Muslim League who were the main agitators behind the creation of Pakistan and who dominated its early leadership. For a variety of reasons, both historical and political, they believed that Urdu was the best choice as the national language of the new state, despite the fact that it was spoken by less than 10 percent of the residents of what is now Pakistan. The first educational conference held in Karachi at the end of November 1947 established Urdu as 'the lingua franca of Pakistan' and made its teaching compulsory throughout the country.[6] The heavy-handed promulgation of Urdu as a national language was met with substantial resistance and furthered the legitimacy of ethnic sub-nationalisms throughout the country, not just in East Pakistan (now Bangladesh), a predominantly Bengali-speaking region with the largest population of any Pakistan province by quite a margin. The only groups that seemed to benefit from the adoption of Urdu were the Mohajir Urdu-speaking bureaucratic and business elite, which had emigrated from India, and the Punjabi landed gentry, which already possessed close educational and cultural ties with the Mohajirs and reinforced them in post-independence Pakistan through mutual patronage and intermarriage.[7] Even though English remained the language of true power and prestige, Urdu became the marker of urban middle-class success, the language of the intermediaries between the national elite and the disenfranchised rural population for whom, in the absence of successful language and education policies, Urdu remained quite foreign.

Over time and with much difficulty, including the horrifically tragic war for Bangladesh's independence in which ethnic language rights played a central role, Urdu has emerged as *the* language of Pakistan's middle-classes. The language is spoken by everyone with an elementary school education or with sustained exposure to national media, which is almost entirely in Urdu. It also carries strong nativistic and nationalistic connotations for the middle-classes, who see it simultaneously as a 'Muslim' language and as one of civilization since it is directly connected with Mughal culture, the world of the north Indian Muslim elite until the end of the nineteenth century and, in very real ways, the culture inherited by the urban elite that emigrated from India. The prestige of Urdu is most apparent in the Punjab, where fluent Punjabi-speakers frequently use Urdu and formally promote the language to the exclusion of Punjabi, which they regard as cruder and less civilized or literary.[8] Although Pushtuns, Sindhis and Balochis possess a greater sense of pride in their own languages, and regional languages are important markers of ethnic identity for them, the prestige of Urdu has exerted itself on them as well: with very few exceptions, facility in Urdu is necessary for accessing services from

the state or non-state agencies, including employment, education, medical care and legal recourse.

The linguist Tariq Rahman gives an excellent summary of the checkered fate of Urdu and its relationship to English in Pakistani society:

> Urdu, then, is very much at the centre of three highly explosive issues in Pakistani politics: ethnicity, militant Islam, and class conflict. The state teaches Urdu to counter ethnicity but this has two contradictory effects: first, it strengthens ethnic resistance because it keeps the grievance of suppressing ethnic languages alive; second, it strengthens the religious right because Urdu is associated with, and is used by, the religious right in Pakistan. But the religious right does not represent religion alone. It also represents the class-wise distribution of power (and resources which are a consequence of it) … The upper echelons of liberals and leftists, who should have favoured Urdu and the indigenous languages of the people, have generally favoured English. While this keeps the religious lobby at bay for the present, it creates grounds for a future struggle for power … Much of the indignation against the Westernized lifestyles of the elite, though couched in the idiom of religion, is really an expression of the anger of the dispossessed. As Urdu (*vis à vis* English) is one of the symbols of the dispossessed in most of the urban centres of the country, it is intimately connected with class politics as well as ethnic politics in Pakistan.[9]

It is this combination of factors – the promise of national authenticity contrasted with a deracinated elite, as well as the recognition that Urdu represents the only prospect for economic advancement for individuals from marginal or economically disadvantaged groups – that insures the pervasive use of Urdu and the demand for schooling in it.

Despite the fact that the overwhelming majority of students attend Urdu-medium schools, be they public or religious, the lion's share of government spending on secondary education goes to the English-medium public schools, which are themselves at the bottom rung of the schools that use English as a medium of instruction. The disparity in educational systems and standards is so great as to make the distinctions caste-like, a form of educational apartheid which stays with most people for the rest of their lives.[10]

English and English Schools

The Pakistani state has invested heavily in the maintenance of a separate system of education for the financial and power elite, expending disproportionate funds on the upper end of its multi-tiered system. On the one hand, this situation indicates that the Pakistani government does not have much faith in its own system of public education.[11]

On the other, it represents an explicit acknowledgment of the crucial role fluency in English plays in stratifying Pakistani society, and acceptance of a multi-tiered class structure with an almost insurmountable chasm between English-speakers and those whose educational aspirations do not, or cannot, extend beyond what is taught in Urdu-medium schools. No recent figures are available comparing expenditures on Urdu versus English schools; however, in 1999 it cost Rs. 2.66 million to open three Urdu-medium primary schools in Islamabad, one of the most expensive markets in the country. In contrast, it cost Rs. 10 million for a military school in Larkana (Sindh), where land prices are much cheaper,[12] and even this school does not rank anywhere near the top among the government-subsidized English schools.

Forty years ago, before elite private schools had multiplied in number in urban areas, access to English-medium schools was already an important method of maintaining class distinction in Pakistan:

> In fact, there is a lot of evidence that the products of such schools came from richer and more powerful families than their vernacular-educated counterparts and did consider themselves superior to them even without reference to their privileged schooling. Schooling, however, gave them an obvious marker of elitist identity: the spontaneous and natural use of Pakistani English in an accent nearer to the British pronunciation than that of other Pakistanis. Moreover, what increased their self-esteem was the fact that they did, indeed, fare better in the Inter Services Selection Board (ISSB); the armed forces academies; the superior civil services examinations, and other elitist jobs in the sixties. Moreover, they felt that no drawing room, however posh; no club, however exclusive; no organization, however elitist — both in Pakistan and abroad — was closed to them. English was much more than a language; it was a badge of status; a marker of elitist upbringing. It gave confidence and even without wishing to sound snobbish, the fluent speakers of English from the English-medium schools (especially from the elitist missionary schools who spoke even better English than their counterparts from the cadet colleges) appeared snobbish to others.[13]

The division between English and Urdu education is caste-like at its extremes, but there is a degree of class overlap between the bottom tier of state and private English-medium schools and the top tier of Urdu ones, with the latter found only in urban areas. In these circumstances, the choice to attend an English school — where the medium of instruction is English in only the most liberal sense of the term, and where students do not normally acquire any real fluency in the language — is one based on an aspiration for a large step forward in socioeconomic advancement. Students as well as faculty in the lower tier of English-medium schools frequently possess the same

▷

Plate 12: Detail of the side of a truck (Turnol 2003)

orientations and beliefs as those who attend Urdu schools, comprised of conservative and slightly xenophobic attitudes normally associated with those who possess a *madrasa* education.

Religious Education in Pakistan

Conventional wisdom (including that of many supposed experts) holds that Islamic religious schools, or *madrasas*, constitute a major factor in the education of Pakistan's population, especially among poorer sections of society. As the argument goes, the failure of the Pakistani state to provide secondary schooling for the poor as well as for residents of remote areas of the country has allowed religious schools to flourish in the gap. Such schools not only fail to teach students the standard curriculum set by the Pakistan Federal Ministry of Education, but in its place, they teach a virulent and narrow-minded form of Islam that demonizes other religions and Pakistan's neighbor India, and, generally speaking, fails to impart to their students any skills by which to integrate and advance in civil society, thereby further destabilizing Pakistani society and moving it a step closer toward a Taliban-style benighted Islam. According to this understanding of the nature of religious education in Pakistan, religious education in *madrasas* forms the only schooling available to the majority of individuals from the very class to which most truckers belong, whether they are owners, drivers or artists.

The belief in the pervasive presence of *madrasa* education in Pakistan and in its potential malevolence is widespread. *The 9/11 Commission Report* has the following to say about the role of *madrasas* in Pakistani society:

> Pakistan's endemic poverty, widespread corruption, and often ineffective government create opportunities for Islamist recruitment. Poor education is a particular concern. Millions of families, especially those with little money, send their children to religious schools, or madrassahs. Many of these schools are the only opportunity available for an education, but some have been used as incubators for violent extremism. According to a Karachi's police commander [sic], there are 859 madrassahs teaching more than 200,000 youngsters in his city alone.[14]

A very similar attitude is expressed in an influential report published in 2002 by the International Crisis Group:

> Madrasas provide free religious education, boarding and lodging and are essentially schools for the poor. Over one and a half million children attend madrasas. These seminaries run on public philanthropy and produce indoctrinated clergymen of

various Muslim sects. Some sections of the more orthodox Muslim sects have been radicalized by state sponsored exposure to jihad, first in Afghanistan, then in Kashmir. However, the madrasa problem goes beyond militancy. Students at more than 10,000 seminaries are being trained in theory, for service in the religious sector. But their constrained worldview, lack of modern civic education and poverty make them a destabilizing factor in Pakistani society. For all these reasons, they are also susceptible to romantic notions of sectarian and international jihads, which promise instant salvation.[15]

Similarly, Ahmed Rashid, the respected and best-selling Pakistani expert on radical Islam and politics in Pakistan and Afghanistan, cites an unspecified intelligence report when he writes in his book on the Taliban that 'in 1988 there were 8,000 *madrassas* and 25,000 unregistered ones, educating over half a million students'.[16] Similar views on *madrasas* and education in Pakistan are reflected in media reports that rely on Pakistani policy makers, civil servants and police reports as authoritative sources for the state of religious education. These largely unsubstantiated claims vary widely in their estimates of *madrasa* attendees, from 10 percent of all Pakistani students to a ridiculous 33 percent.[17] In turn, much of the scholarship on education in Pakistan relies on reports in the English-language press for statistics on *madrasas*. An article on the subject in *Foreign Affairs* placed the number of *madrasas* in Pakistan between 40,000 and 50,000 without providing the source of this figure.[18] More scholarly and sustained studies on education and religion in Pakistan also frequently rely on unsubstantiated newspaper reports of the popularity of *madrasas* and their relationship to radical politics. Four unavoidable conclusions are to be drawn from such reports: (i) the popularity of *madrasas* is a direct result of the failure of the government of Pakistan in providing widespread public education throughout the country; (ii) *madrasas* teach a politicized, intolerant and virulent form of Islam in a way that other educational institutions do not; (iii) the number of *madrasas* is growing as is their enrollment; and (iv) their growth is directly linked to the growth of virulent Islamic ideologies in Pakistani society.

In fact, almost all the empirical research on Pakistan suggests that the role of *madrasas* is not that of widespread, threatening incubators of a virulent and violent form of politicized Islam. Enrollment in *madrasas* is orders of magnitude less than the urban elite of Pakistan holds to be the case – though these numbers are subsequently bandied about in political and ethnographic scholarship on Pakistan. As Tahir Andrabi, Jishnu Das, Asim Ijaz Khwaja and Tristan Zajonc make clear in their landmark study of religious school enrollment in Pakistan, at the beginning of the twenty-first century, religious schools accounted for less than 1 percent of total school enrollment in Pakistan, a percentage that has not increased significantly in the years since 9/11. Even in districts

bordering Afghanistan, which have the highest rate of *madrasa* enrollment, the figure is less than 7.5 percent.[19]

There is no doubt, however, that the percentage of enrolled students who attend *madrasas* is much higher in the Pushtun-majority regions bordering Afghanistan than it is in other parts of the country. The districts with the ten highest *madrasa* enrollment rates are all Pashto-speaking, and all fourteen districts that have *madrasa* enrollment figures above 2 percent of total school enrollment are either in Pashto-speaking parts of Khyber-Pakhtunkhwa province or in areas of Baluchistan with a majority Pushtun population. No reliable figures on school enrollment by type are available for the FATAs bordering Afghanistan, which account for 2.4 percent of Pakistan's population (according to the 1998 census), but it is likely that those statistics would parallel those of other Pashto-speaking areas, while at the same time reflecting much lower numbers of actual enrollment, as suggested by their low overall literacy rates.

The question of education in the tribal areas and in the federal provinces of Baluchistan and Khyber Pakhtunkhwa is relevant to the subject at hand because a large (but indeterminate) percentage of truckers belong to these areas, either as current residents or as migrants from them to other areas of Pakistan, particularly Karachi. And although a statistical survey of the demographics of truck owners, drivers and artists is beyond the scope of this research, interviews as well as the observation of the place of origin of trucks as reflected in their license registration suggests that Pushtuns from Khyber Pakhtunkhwa and Baluchistan are very well represented among inter-city truckers, rivaled only by individuals from the Hindko-Punjabi-speaking districts of Haripur, Abbottabad and Mansehra in Khyber Pakhtunkhwa and Muzaffarabad District in Azad Kashmir (Pakistan-Administered Kashmir).

Not only does empirical research indicate a rate of *madrasa* enrollment as a percentage of total enrolment in Pushtun areas at twice the national average, but it is also clear that there was a marked increase in *madrasa* enrollment rates during the years of military rule under General Zia ul-Haq. The Zia years coincided with the war against the Soviet occupation of Afghanistan, and the anti-Soviet resistance relied heavily on the recruitment and training of religious militias drawn from the Afghan refugee population in Pakistan which was settled mostly in Pushtun-majority regions close to the border. This period also witnessed the formal Islamization of Pakistani society, with an increased emphasis on the Islamization of national institutions, including education. Among other policies, the Zia government recognized *madrasa* certificates as equivalent to those from schools run by the Federal Ministry of Education, even though the latter had no oversight of the *madrasas* (this situation continues to the present day despite feeble attempts at *madrasa* reform under General Musharraf).[20]

Perhaps coincidentally, the Zia years also saw a qualitative change in the amount of truck decoration in Pakistan.

Further proof of the relationship between *madrasas* and the war in Afghanistan lies in the finding that the largest jump in *madrasa* enrollment occurred among students who were in elementary school in the period between 1989 and 1993, which coincides with the withdrawal of the Soviet Union from Afghanistan and the subsequent rise of the Taliban who, through their very name, legitimized themselves as *madrasa* students (*talib*, pl. *taliban*, means 'student').[21]

Madrasas and Public versus Private Education

There is a real correlation between the influence of *madrasas* on the one hand and belonging to particular districts of Pakistan on the other, but it would be reckless to assume that being Pushtun necessarily implies close identification with particular Islamist ideologies (and, conversely, that being Punjabi or Sindhi implies holding less militant religious views). The correlation between religious militancy and *madrasa* education is unproven. In fact, evidence suggests that the majority of Pakistani families who send a child to a *madrasa* do not make the choice for ideological reasons. Only 23.5 percent of families that have a child in a *madrasa* have no children in non-religious schools; almost 50 percent of families send their children to both *madrasas* and public schools, and another 28 percent enroll their children in *madrasas* as well as private schools, or else all three categories of schools simultaneously. In contrast, of households with one child, or more, in private school, almost 48.5 percent enroll all their children in private schools, and another 49.6 percent send them to a combination of public and private schools, with functionally none sending them to *madrasas*.[22] In other words, if one can draw conclusions about family ideology from the schools the children attend, people who send their children to private schools are more ideologically driven than those who send them to *madrasas*, since families that send one child to a private school are more than twice as likely to send all their children to private school than families who send one child to a *madrasa* are likely to send all their children there.

This refutes conventional wisdom on the blanket correlation between attending a *madrasa* and family poverty, as well as between *madrasa* attendance and politicized Islamist ideology. Although it is true that in situations where other schooling options are unavailable (such as in remote rural areas), a higher fraction of children goes to *madrasas* and the percentage doing so is higher among the poor than the rich, the numbers are still very small, standing at less than 4 percent. In areas where public and private schools are available, family income has no significant impact on whether or not one belongs to that 1 percent of the population that sends children to *madrasas*.[23]

One of the most remarkable conclusion of the Andrabi, Das, Khwaja and Zajonc study is that enrolling a child in a *madrasa* is one of the least important concerns when families are deciding to send their children to school:

> [T]he schooling decision for an average Pakistani household in a rural region consists of an enrollment decision (Should I send my child to school?) followed by a private/ public decision, with a *madrasa* as a possibility. When there are no nearby schools, households exit from the education system altogether, although there is evidence of an increase in the market share of *madrasas* among the poor in these settlements. When both private and public schools are available, richer households exit to the private system, but there is no difference in *madrasa* shares with household.[24]

The low rate at which families choose to send children exclusively to *madrasas* refutes the argument that the choice of religious as opposed to public (or non-religious private) schools is an indicator of a growing influence of radical Islam in Pakistani society; if this were true, it would be irrational for such families to send some of their children to public or non-religious private school.[25] Very clearly, *madrasas* constitute an important factor in the formulation of attitudes toward religion and society in Pakistan, and are arguably twice as important among Pushtun-majority regions than in others, but they are not the most important factor in the way education impacts Pakistani society. In actual fact, the most dramatic growth in the educational sector in Pakistan appears to be among what might be termed 'secular' private schools, which have been growing in number so rapidly that, by 2005, a third of all primary school students were enrolled in such institutions.[26] The growth in secular private schools (many of which are coeducational, especially at the primary level) reflects failures in the ability of the Pakistani state to provide education – or *desired* education – to its citizens, rather than a wish on the citizen's part to reject government-funded curricula in favor of one that is more ideologically compatible with their religious or political views. *Madrasas* are not in great demand. The majority of Pakistanis – and the overwhelming majority of those with schooling – attend non-religious public and private schools, the differences between which contribute to and mirror socioeconomic stratifications in Pakistan.

The educational situation of Pakistan not only reflects an existing class stratification but also simultaneously contributes to it and to changes within it. In all socioeconomic strata, education is clearly seen as a mark of relative status and a means of economic and social advancement. At the same time, the multi-tiered system of education maintains a class distinction between those who function with facility in English at one extreme and those who aspire to function in a literate Urdu world at the other. In many important respects, the Anglophone elites of Pakistan live in a world apart from the remainder of

the population, a system of cultural apartheid which is reflected in religious and social attitudes. Textbooks used in Urdu-medium schools (not just in *madrasas*) reflect a hyper-nationalistic and xenophobic view of the world and contain outright misrepresentations of the role of Islam in world history.[27] Although the state-sanctioned textbooks used in English schools also reflect a nationalistic and religiously charged view of the world, they do not normally combine this with the denigrating comments about other cultures and religions that the Urdu textbooks do.

Educational differences between those with English and Urdu schooling closely parallel differences in social, political and religious attitudes, with the students from elite English schools being far more likely to hold cross-culturally familiar, liberal attitudes on issues than their Urdu-educated counterparts. In a survey conducted in 2003, students as well as teachers at a variety of schools were asked questions concerning the legitimacy of discrimination against minorities and support for Kashmiri independence (a live issue among the majority of Pakistanis): 39.6 percent of students in Urdu schools supported the idea of taking Kashmir from India in open war, and 33 percent supported using religious militants (Jihadis) to fight the Indian army. When asked if followers of the Ahmadiyya sect should be given opportunities equal to those given other citizens of Pakistan, only 44 percent said 'yes' (with 34 percent saying 'no' and a further 22 percent answering 'I don't know'). In contrast, 26 percent of students in elite English schools supported a war with India to liberate Kashmir, and only 23 percent supported the use of Jihadis. On the issue of religious discrimination the difference between the two student bodies is remarkable, with only 9.5 percent of students in elite schools approving of discrimination against the Ahmadiyya. The difference in attitudes between the teachers of the school systems is not as wide: 20 percent of Urdu school teachers supported all-out war to liberate Kashmir and 19 percent supported the used of Jihadis (substantially lower than their students) versus 26 and 38 percent among teachers in elite English schools; 65 percent of Urdu school teachers supported discrimination against the Ahmadiyya versus 37 percent of their English school counterparts.[28]

In all cases, there is a high degree of agreement among the educational and age categories over the issue of Kashmir and whether or not it should be 'liberated' from India through direct or proxy warfare. Kashmir has been the single most important national issue among Pakistanis over a period of decades, and therefore it should not be much of a surprise to see that a large percentage of the population holds similar views on the subject. The big differences between students with an elite English-language education and all others – even the teachers in their schools – is over issues of social and religious liberalism. When it comes to such issues, Pakistanis live in a situation of attitudinal apartheid, with elite attitudes toward religious tolerance, gender equality and disapproval of religious discrimination reflecting a set of values that is not shared by the rest of the

population, which is comprised of the Urdu-educated, the nominally educated, the state English-educated, as well as the teachers from less-than-elite classes who teach in elite schools. It is sections of the elites that have embraced truck decoration as an example of national kitsch, although, as I argue in the final chapter, they have done so without any real appreciation for what the truck represents in the *habitus* to which it belongs.

The world of truckers is one where Urdu represents the language of the educated, with a substantial number of drivers, and even some owners and artists, having a limited ability to speak, read or write the language. The use of Urdu on trucks, particularly in the case of poetry or aphorisms, represents an often conscious attempt at self-representation in terms that project class aspirations refracted through education: to know Urdu poetry and to request an artist to write it on your truck is to show that you are not an unlettered *unparh*. This also holds true in a slightly different way for the extensive use of English language words. Naturalized English loan words are very common in all Pakistani languages and do not reflect personal choices or class aspirations; however, trucks frequently display conscious and formal English usages (eg. 'Good luck!' written in Latin script, or *king āf dī rōḍ* in Urdu letters). A display of knowledge of the English language makes an aspirational claim on behalf of the trucker, indicating that the anglophone world and all it represents in Pakistani society is not entirely alien to him.

I have not encountered any pattern by which a history of *madrasa* versus public school education reflects itself in the *habitus* of truckers. Indeed, as I've suggested earlier, it would seem that *madrasa* education lacks a direct impact on the truckers themselves, and only comes through in the degree to which they are influenced by the teachings and preachings of low-level members of the clergy who are themselves products of the *madrasa* educational system. Chapter 6 discusses religiosity as expressed through trucks in some detail; in no instances do the signifiers on trucks correlate to the specific views of members of the *'ulama* or the new cadres of Islamist preachers. Explicitly politicized forms of religiosity are rare, as are specific references to contemporary religious movements except in the case of avowedly missionary groups such as the Tablighi Jama'at. But religious signifiers abound on trucks nonetheless, and choices concerning epigraphic content as well as the presence or absence of religious images is indicative of variations of *habitus* among Pakistan's truckers, as well as of shifts in the national visual regime.

4

Trucks and Transportation

My heart, my companion –
The orders have come for us to leave home.
I call down every street
I look in every town
To find some sign, some trace
of a familiar face
I ask every stranger
the way to my own place.
In a nameless street
the days turn to nights
in meaningless conversation.
What can I say –
a night of sorrow is nothing but torture.
I would consider it a blessing
If these days would count
I would not mind dying
If I only had to do it once.
 Faiz

Pakistan has no viably navigable rivers and has not developed its rail system. Road travel is therefore vital to Pakistan's economy, comprising a network of approximately 258,000 km of roads of which 60 percent are paved.[1] The road density, especially of paved roads, is highest in the heavily populated parts of Punjab, Sindh and Khyber Pakhtunkhwa (NWFP). Even though sparsely populated Baluchistan has a road density per capita five times higher than the Punjab, good roads are few and far between, primarily serving to connect economic centers with the rest of the country rather than connecting population centers within Baluchistan to each other.

There was a substantial growth in the road network in the last decade of the twentieth century, with a 20 percent increase between 1995 and 2000, and with an emphasis on

higher-quality roads. The expansion of the network has been very slow since then, with a growth of less than 5 percent between 2000 and 2005. The current emphasis is on improving the existing roadways, building bypasses around cities, as well as constructing motorways and highways. There are only two multi-lane motorways in the country – the 367 km, six-lane, M-2 connecting Islamabad to Lahore plus a 53 km spur (M-3) forking off to the industrial city of Faisalabad, and the 155 km, four-lane, M-1 between Islamabad and Peshawar.[2] The main road artery in the country, the 1819 km Indus Highway (N-5) connecting Karachi, Lahore, Islamabad and Peshawar, and reaching the border with Afghanistan at Torkham, is only two lanes wide for most of its length, and parts of it are still only one lane. The same holds true for the Karakorum Highway

Plate 13:
The road system of
Pakistan
▽

Information derived from: "Pakistan Transport Plan Study, Final Report," Japan International Cooperation Agency (JICA) and National Transport Research Centre (NTRC), Ministry of Communications, Government of Pakistan, March 2006

(N-35), which joins the Islamabad-Peshawar road at Hasanabdal and snakes 806 km to the Chinese border at the Khunjerab Pass. The three other major highways, the first (N-25, 813 km) connecting Karachi with Quetta and continuing to the border with Afghanistan at Chaman, the second (N-40, 610 km) connecting Quetta with the Iranian border at Taftan, and the third (N-10, also known as the Makran Coastal Highway, 653 km) connecting Karachi with the new national commercial port at Gwadar, are all one lane for most of their lengths. There is a plan to make a multi-lane motorway connecting Karachi to Faisalabad (and on to the existing motorway) and another that would connect this highway with Gwadar, but these projects are a very long way from completion.

The majority of the remaining roads are single-lane ones of questionable quality, with broken shoulders, poor or no signage, and no form of barrier to prevent people and animals from wandering into traffic. Many roads have sunk because they are carrying heavier traffic and loads than those for which they were designed, and so have broken shoulders and are deeply rutted and potholed. With the exception of the motorways, all roads are open to every form of traffic, such that trucks, buses and cars travel along-side small motorcycles, motorized rickshaws, bicycles, animal carts, hand-carts and pedestrians. It is not uncommon to be traveling down a deserted highway at night only to suddenly find the lane occupied by a camel or donkey cart with no lights or reflectors whatsoever. Consequently, not only is it very dangerous but also frequently unfeasible to travel at high speeds. The situation favors the continued popularity of smaller trucks, such as the venerable Bedford J-7 'Rocket' as well as the mid-sized Japanese diesels that are slowly supplanting the Bedfords. It also allows – even if it doesn't actually encourage – extensive truck decoration, including moving ornaments such as pinwheels and cloth banners that would be destroyed if the trucks traveled at high speeds. According to official estimates, under free traffic flow conditions, the average Pakistani truck travels at only 40–50 km per hour, far slower than speeds typical of more developed countries.[3]

Road Transport

Road travel constitutes the major form of transportation in Pakistan since the country has chosen not to invest in railways in any substantial way. Almost no railway track has been laid since Pakistan gained its independence from the British in 1947. Beyond converting the sparse network to a modern gauge, little effort has been made to increase the number of tracks on major routes or to make more areas of the country accessible by rail. The most reliable statistics place the total number of railroad lines at 7791 km, most of which are concentrated in the flattest parts of the provinces of Punjab and Sindh.

In contrast, there are 258,000 km of roads plied by more than 2,283,381 trucks.[4] Consequently, 96 percent of freight and 89 percent of passenger transport is carried by the road system, the remainder using a combination of rail and air transport, which has been growing at a high rate.[5] Over the 1990s, transportation volumes grew at the rate of 12 percent per year for freight and 5 percent per year for passengers.

The rate of increase of registered motor vehicles has been gradual in recent years, standing at approximately 4.3 percent per year, with an estimated number for 2010 of 3.28 million.[6] Half of all vehicles are motorcycles and motorcycle rickshaws; of four- (and more) wheeled vehicles, trucks accounted for 37 percent of registered vehicles in 2005.[7] Pakistan's governmental planning projects a very high rate of growth in the national vehicle fleet, with the number of trucks quadrupling by 2025.[8]

Types of Trucks

More than half of all trucks in Pakistan are smaller two-axle vehicles such as the old Bedford Rocket and newer Japanese vehicles. The Rockets – the iconic object of Pakistani truck decoration – is steadily losing out to these newer, more efficient vehicles, and is likely to disappear from long-haul trucking within the next decade. Tractor-trailers still represent a minority of Pakistani trucks, but like two- and three-axle trucks they, too, are normally owned by small entrepreneurs. Very few large fleets operate in Pakistan, the largest being the NLC (National Logistic Cell) – a governmental corporation closely linked to the military and established during the war against the Soviets in Afghanistan – which possessed a fleet of 2000 trucks in 1989 and has been growing at a rapid rate.[9]

The majority of Pakistani trucks are not new when they enter service, but are imported as used vehicles and rebuilt in small workshops to the specific needs of Pakistan's trucking industry. Furthermore, a long-standing regime of import restrictions and high tariffs has prevented new and fully constructed trucks from being imported for commercial use, a situation that favors the small Bedford Rocket, which is assembled locally. A small truck with a 7-ton capacity and a 98 bhp engine, it has remained virtually unchanged since the 1950s. It was, for many years, the standard Pakistani truck, accounting for 90 percent of total truck sales in 1979. With the relaxation of important restrictions, however, the market share of the Bedford Rocket plunged to less than 50 percent within six years.[10]

Despite the decline in new sales of Bedford trucks, as recently as 1989 they still accounted for 76 percent of trucks on the road, and although more recent figures are not available, Bedford Rockets are ubiquitous in the densely populated parts of Sindh, Punjab and Khyber Pakhtunkhwa, and also in the more mountainous north where they have an

advantage over larger, heavier vehicles. The remaining 24 percent of the trucks are newer Japanese imports manufactured primarily by Hino and Nissan. Of these, the majority (14 percent of trucks on the road in 1989) are two-axled vehicles with an official capacity of around 12 tons and a power range between 140 and 220 bhp; 3 percent are larger three-axled trucks, 3 percent are tractor-trailers, and the rest are an assortment of smaller trucks.[11]

The difference in price between a new and used truck is a significant factor in purchase decisions, with the average price of a two-axle truck in 2005 standing at Rs. $2.75 million.[12] Tractor-trailer trucks cost roughly twice the price of the next most expensive category of vehicle, at Rs. 4 million in 2007.[13] The same year, a new 7961 cc Hino truck chassis, with an official load capacity of 17 tons, which is subsequently modified in Pakistan to carry 25 tons, was sold by the official dealership network for a list price of Rs. 2.425 million.[14] In comparison, a reconditioned Hino chassis in excellent condition cost roughly Rs. 1.9 million.[15] The expense of building up and decorating the chassis to the point of having a fully functional Hino truck was between Rs. 600,000 and 1 million, with the majority of trucks costing toward the lower end of that range.

In comparison, a Bedford Rocket chassis in good condition could be acquired in 2007 for approximately Rs. 800,000, with anywhere from Rs. 200,000–400,000 going to build it up, the difference in prices being partially accounted for by the condition in which the used vehicle was purchased.[16]

The commonest materials carried aboard trucks – in terms of simple weight – are related to construction (ballast, gravel, stone and cement). Fruit comes immediately after this, and when transported weight is correlated with the distance traveled, fruit is easily the single largest commodity transported by truck, with cement a distant second (followed by fertilizer).[17] Pakistan has very few refrigerated trucks, and fruit travels very long distances since temperate fruits only grow in the area around Quetta in Baluchistan, the valleys of the Northern Areas, and in Swat and Hazara; consequently the losses through spoilage are a significant drain on revenue.

Overloading is a rampant problem with repercussions for the quality of roads, since the actual wear and tear on the roads exceeds their design specifications. Trucks are modified to have very tall sides to their rear beds, allowing them to be loaded higher than is typically seen in developed countries. A 1995 study concluded that 43 percent of two-axle trucks (like the Bedford Rocket) are seriously overloaded with some carrying 2.8 times the weight approved for their design specifications, and the rate of overloading is increasing by 2.6 percent a year. According to a study conducted by the Pakistani National Highway Authority, the average Pakistani truck causes wear on the roads equivalent to twenty-two American trucks.[18] Two-axle trucks in Pakistan are remanufactured using wider and more elevated bodies, reinforced frames, and use over-inflated

tires in order to increase the load per trip and therefore increase profits. Others are converted from two-axle designs to three-axle ones to carry three times their original design weight without any accompanying modifications being made to the engine or braking system. Weigh-stations are common across the country, but a combination of police corruption and low penalties makes it more profitable for transporters to pay bribes and fines for grossly overloaded trucks than to obey legal weight limits.

As such, truckers – be they owners or drivers – live in a world where they must constantly negotiate between the economic pressures of maintaining a profitable business and the sometimes arbitrary systems of taxation and extortion to which they are subjected by instruments of the state. The end result is that, in the eyes of many members of bourgeois society, they exist in a twilight of legality in which they not only are held fully accountable for the corruption endemic to the transportation industry, but also for a host of moral flaws, both real and imagined. Truck decoration may be romanticized in Pakistan, but truckers themselves seldom are.

5

Trucks, Truckers, and Society

Turn around and look, my tormentor – I too desire:
You might be a college girl, but I am a truck driver!
Truck verse

Pakistan's highly stratified society is differentiated not just on the basis of educational access and type of education but, as in virtually all societies, on economic grounds as well. As discussed in Chapter 3, to a large extent education serves as a strong indicator of economic class as well as of status, such that differences in social and aesthetic values frequently correlate to material class in Pakistani society. One of the major indicators of the enormous disparity in wealth in Pakistan is the low car ownership rate, which is at roughly 8 per 1000.[1] Given an average household size of 6.8 persons,[2] this means that less than 5.5 percent of Pakistani households possess cars. In actual fact, the number has to be even lower since an undetermined but important percentage of car owning households have more than one car.

With car ownership limited to the 96th percentile of families, owning a car functions as a substantial class marker, such that to be a member of the social upper-classes – anglophone or otherwise – requires you to possess a car.[3] With cars a rare commodity, driving skills are limited to a very small population that is almost entirely male, and carries with it substantial prestige and mystique. Being employed as a car driver is one of the highest-status service professions, and drivers (chauffeurs) in domestic households neither consider themselves servants, nor are they treated like them. The prestige of driving in the eyes of the wider population extends to bus and truck drivers, who maintain high status within their social circles. As a rule, however, they are non-car owners themselves, and therefore represent a separate class beneath the small car-owning population. In the eyes of the car-owning class, truck drivers and owners belong to a world apart

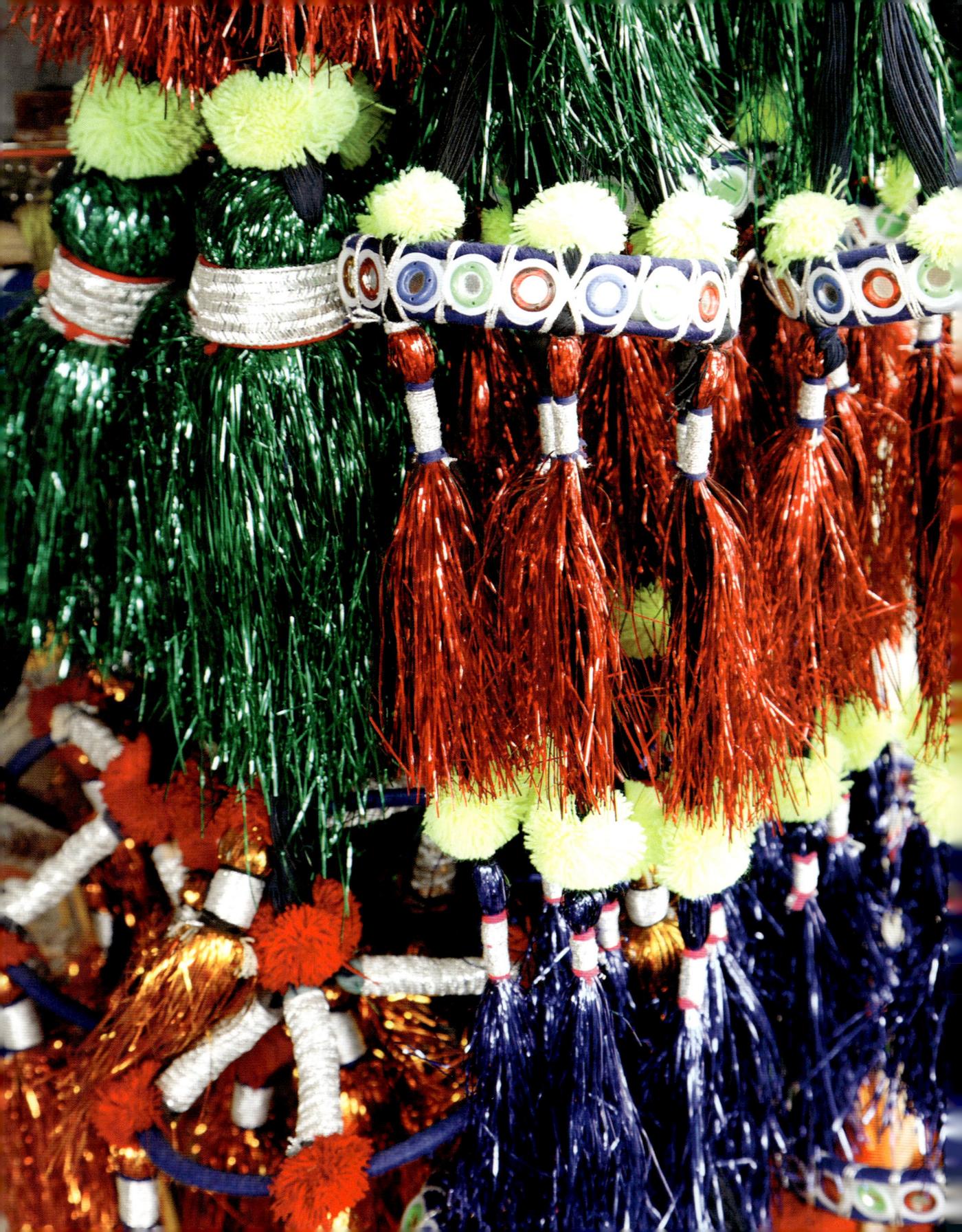

from and below their own, to which they are only tenuously connected through their own drivers, who often come from similar backgrounds as truck drivers.

Truck Owners and Drivers

Truck culture is thus almost completely distinct from the car-owning circles of the anglophone urban bourgeoisie; nevertheless, it possesses its own class structure which is arranged economically and ethnically. Ethnic divisions in the trucking industry parallel those in most other aspects of Pakistani society, with what is probably a greater degree of social and commercial interaction between ethnic groups due to the very nature of the transportation industry, the high incidence of temporary as well as permanent relocation among truckers, and the lack of a strong familial guild system in the truck decoration trades. Economic distinctions are very strong among truckers, with class differences based on wealth separating workers and trades people from owners and drivers along a spectrum of wealth. At the very top are the owners of fleets of large trucks who have very little to do with the social world of smaller truck owners, and instead operate within regional bourgeois circles and the related mercantile world of the larger bazaar businessmen. Fleet owners, as businessmen, are not normally involved in the day-to-day operation of trucks or overseeing their decoration and maintenance, which is normally handled on a contractual (rather than cash on the spot) basis with reputable workshops.

At the very top of this category are the owners of large truck fleets, holding lucrative contracts with the government or with multinationals, who see themselves as completely separate from the world of truck drivers. An example of such an individual is Mr M. Naseer Ud Din, Director of Kohistan Goods Forwarding Agency based in Taxila, with a branch office in Karachi. Kohistan Goods has a multi-million dollar annual turnover, carrying large freight, including heavy equipment for oil companies and large construction projects. The main office in Taxila has approximately fifteen full-time employees, with the office in the same location as the garage where the vehicles are parked and most of the maintenance work is done. At the time of this research, Mr Naseer Ud Din was also the president of the truck transporters' union for the Islamabad and Potohar area, making him one of the more influential figures in the trucking business at a national level.

In my interviews with Mr Nasir Ud Din, he made a clear distinction between himself (and his company) and the ordinary truck owner, as well as the world of drivers. In his representation of the trucking industry, decorating trucks is a characteristic of small truck owners and a sign of vulgarity, in addition to reflecting poor business sense.[4] He made it clear that none of his trucks were decorated because not only was it an unnecessary expense, but plain trucks were a visual characteristic (*nishānī*) of his company, which

helped distinguish them from all the brightly colored (*rang baranga*) trucks in the market. When I pointed out that there were religious stickers and small decorative pieces of hammered metal on his trucks, Nasir Ud Din confessed that he was obligated to authorize a small amount of decorating to keep the drivers happy.

Mr Nasir Ud Din's status as a businessman and trade union boss rather than a simple trucker is obvious when one mentions his name in the many truck workshops and rest areas in and around Taxila, and introductions to truck workshops provided by him and Haji Shahzada, his assistant manager and cousin, colored subsequent relations with artists and mechanics in those shops. In the highly stratified class structure of Pakistan, the driver of a car belonging to Kohistan Goods who accompanied me to ordinary truck workshops clearly occupied a higher status than the owner of an old truck, not to mention his status relative to a truck driver.

A long step below the handful of individuals who are not truckers so much as businessmen involved in the transportation industry are owners of small fleets of modern Japanese trucks. It is such individuals who represent the highest stratum of trucker society itself, in that they are intimately involved in the maintenance and decoration of their vehicles, interact socially with their drivers, and regularly visit small workshops and truck stops. Examples of such owners are Malik George Zaman of Taxila, the owner of a fleet of five Hinos and Bedfords carrying the name 'Lahore Goods', and Mazhar Ali Khan of Turnol, the owner of three Hinos.

Zaman makes a distinction between his own aesthetics and attitudes toward decoration and those of his drivers, saying that owners couldn't care less about truck decoration but their drivers get annoyed (*narāz*) if one doesn't let them decorate the trucks. As such, he is intent on conveying the message that decoration is done at the request of the drivers.[5] He claims to leave all the major decision making to the master painter he works with, Malik Shafique, a second-generation truck painter based in Taxila. Shafique confirms that he is the one to design the overall layout as well as the specific decorative details of the truck. He also claims that this is the norm, and that drivers only make vague requests regarding the colors, or else express wishes to see specific small decorative elements. Shafique did acknowledge a higher degree of agency on the part of drivers in the epigraphic program of the poetry and the ephemera of pithy sayings on the back of the truck, and was bemused by the grammatical and spelling errors drivers insist are the way they want the writing to read. By drawing attention to the poor education of the drivers (as well as their poor taste), he was distancing himself from them and reinforcing the role literacy and education play in the construction of class in Pakistani society.

In contrast to Malik George Zaman, Mazhar Ali Khan is visibly proud of his trucks and intimately involved in their initial preparation as well as their ongoing decoration.

He repeatedly boasted in a good-humored way that the like of his three trucks was not to be found anywhere. Mazhar Ali Khan maintained that the three were identical, the only way to tell them apart being from their license plates. In actual fact, the trucks were not identical but very similar, there being small decorative variations between them. Mazhar Ali Khan saw himself as a fleet owner and was proud of his decorative choices, although he did think that his selections of poetry as well as the names of the trucks (Princess of Beauty [*husn kī shahzādī*], Empress of Egypt [*Misr kī rānī*], etc.) contained an element of humor.

Mazhar Ali Khan acknowledged that the religious elements of the decorative program were there to guard against the evil eye (*nazar*) and only had what he considered the minimum amount necessary on his vehicles. At some level, he believed that even that amount should not exist because it is disrespectful to step above religious decorative elements, as one invariably has to do on a truck.[6] In regarding the religious signifiers as necessary elements of the truck, he is echoing an opinion expressed by many other truckers who feel that they either guard against the evil eye or else provide *barkat*, a complex concept of divinely provided good fortune that is (among other things) the antithesis of the negative impact of *nazar*.

Plate 15: Hino tractor trucks belonging to the Kohistan Goods Forwarding Agency. Note the almost complete absence of decoration (Taxila 2003)
▽

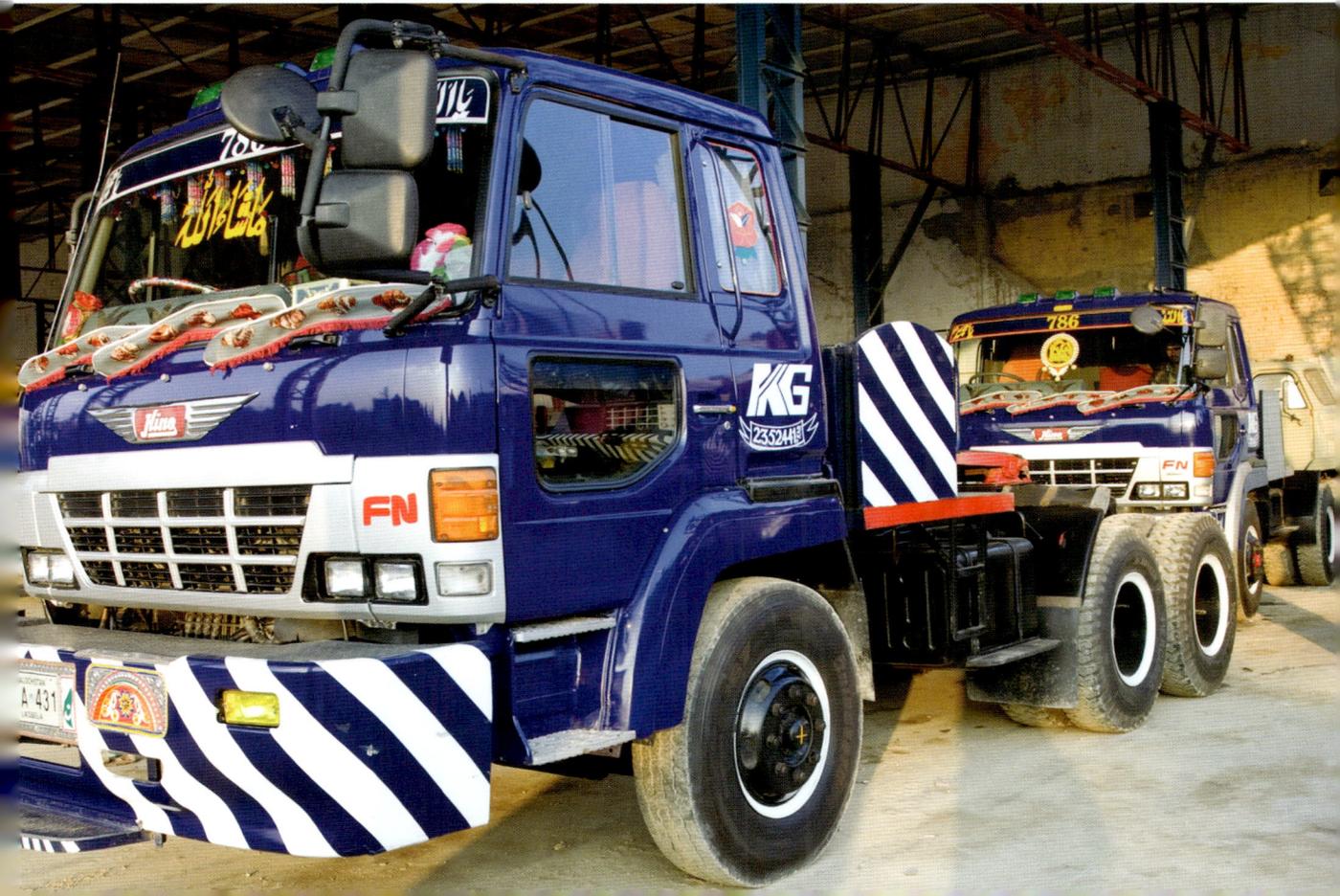

Truck owners such as Mazhar Ali Khan and Malik George Zaman do not drive trucks themselves, which puts them in a different class from owner-operators, who constitute a significant minority of truck drivers (20 percent in 1989).[7] Owner-operators – who are best represented among the drivers of Bedfords and smaller Japanese trucks – are more likely to claim their own agency in making choices in truck decoration (and thus to limit the agency of the artists), and to accord significance to specific elements of decoration. Mujahid Khan, an owner-operator from Muzaffarabad in Azad Kashmir, insisted that the religious elements of his truck (see Plate 37) are not purely decorative (*ḍekrēshan*) but are necessary expressions of religious faith (*īmān*).[8] Similarly, Abdullah Khan Achakzai Alizai of Quetta in Baluchistan, who was particularly eloquent in describing the feminine qualities of a truck (discussed in Chapter 7), insisted that all elements of truck decoration are essential, not only the religious ones, because the truck is both home and means of livelihood (*hum kor de hum rizq de*).[9]

The class differences between the owners of different kinds of trucks are due to more than simply the difference in the prices of trucks, although capital costs certainly are an

Plate 16: Two Bedford Rockets belonging to the same owner in the final stages of preparation at a workshop (Turnol 2003) ▽

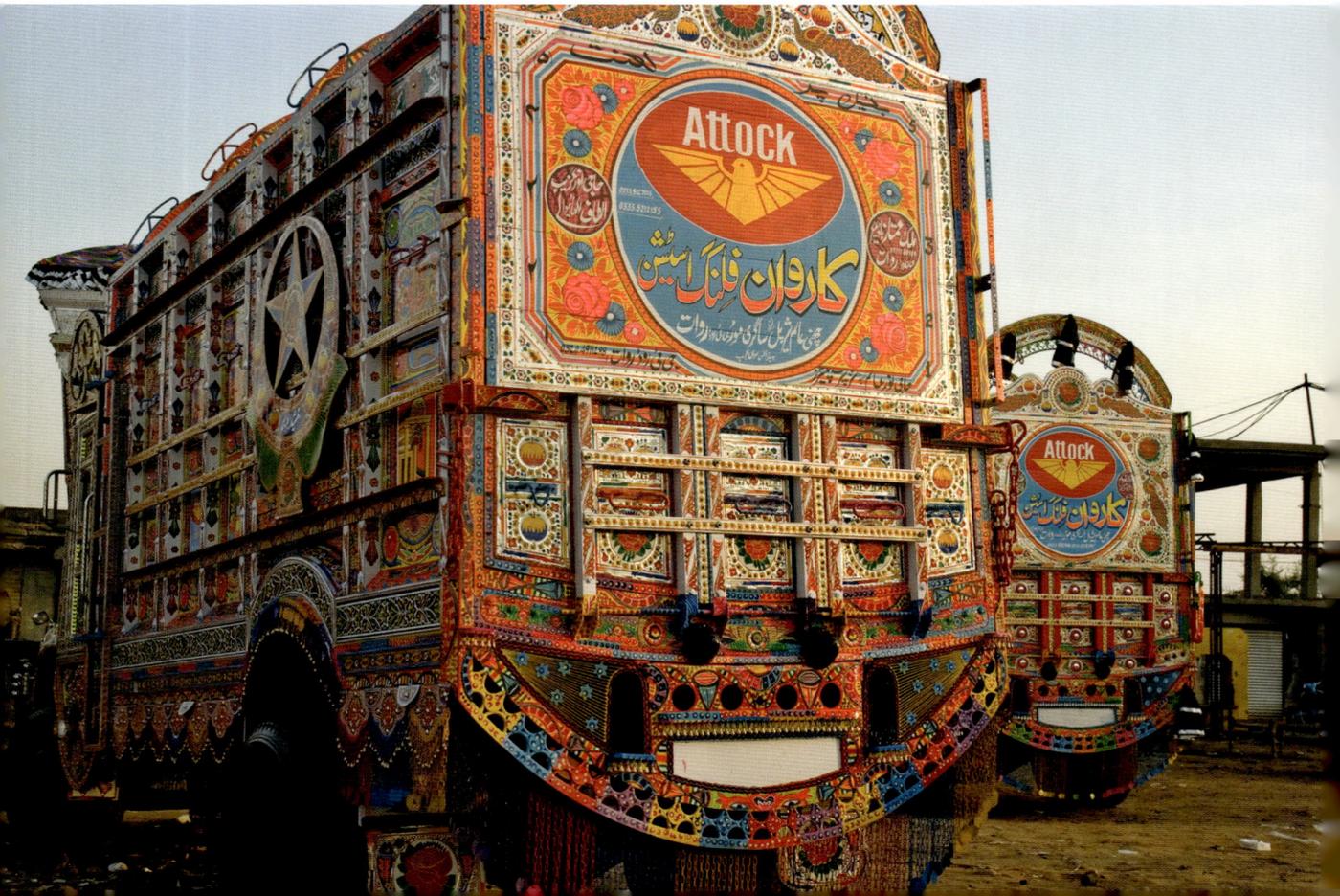

important factor in the construction of class difference.[10] Cheaper trucks such as Bedfords and reconditioned Japanese two-axle vehicles are purchased either by cash transactions or else through informal loan arrangements with the seller or with a third-party money lender. Such trucks are bought by individuals who do not possess the collateral to secure bank loans, nor the wherewithal to buy the comprehensive insurance required to secure such a loan. All of the trucking industry is dominated by small businessmen, with private individuals (rather than partnerships or transportation companies) owning the majority of vehicles in all size and price categories. Even so, large trucks – especially tractor-trailers, but also triple-axle unibody trucks – are more likely to be owned by individuals with access to bank loans and financing options.[11] These are not necessarily used as ways to purchase the truck itself (which is often acquired in a cash transaction) but to leverage other aspects of the buyers' finances so that they keep their business expenses to an absolute minimum, thereby furthering the profitability of their choices in truck purchasing.

At the same time, the markedly lower operating costs of the larger, newer vehicles give their owners a significant advantage in the marketplace and are a major reason why Bedfords are going out of service in many parts of the country. The failure of many individuals to shift to newer vehicles is due to a combination of factors: in addition to the financial inability to afford the larger initial outlay for a Japanese truck, knowledge of the economic advantages of owning a truck with lower long-term operating costs or of the financing options available has not penetrated all segments of the truck-owning population. The distinction between those with access to such informational resources naturally parallels access to education, such that even within the community of truckers education is somewhat of an indicator of class. There are no formal surveys of educational rates among truck owners and drivers, not to mention such information broken down by region and ethnicity as well as type of truck owned, but my own inquiries about education (admittedly not a focus of my field research on trucks) suggest that there is a correlation between the sort of vehicle owned and the educational level of the drivers, with larger vehicles belonging to better-educated individuals, if only because of the direct link between education and socioeconomic status.

This phenomenon appears to have a major impact on truckers from Baluchistan in particular, where literacy rates continue to be substantially lower than they are in the more developed parts of the Punjab, Khyber Pakhtunkhwa or southern Sindh. With the advent of large Japanese trucks, which have almost completely replaced Bedfords in the long-haul trucking – the mainstay of Baluchistan's transportation economy – the distinction between owners and drivers is growing as a manifestation of class difference, with drivers likely to be illiterate (or marginally literate) and far less likely to be owner-operators than they are in other parts of Pakistan. What remains to be seen is whether the inevitable move in the direction of larger and more expensive trucks, as well as more

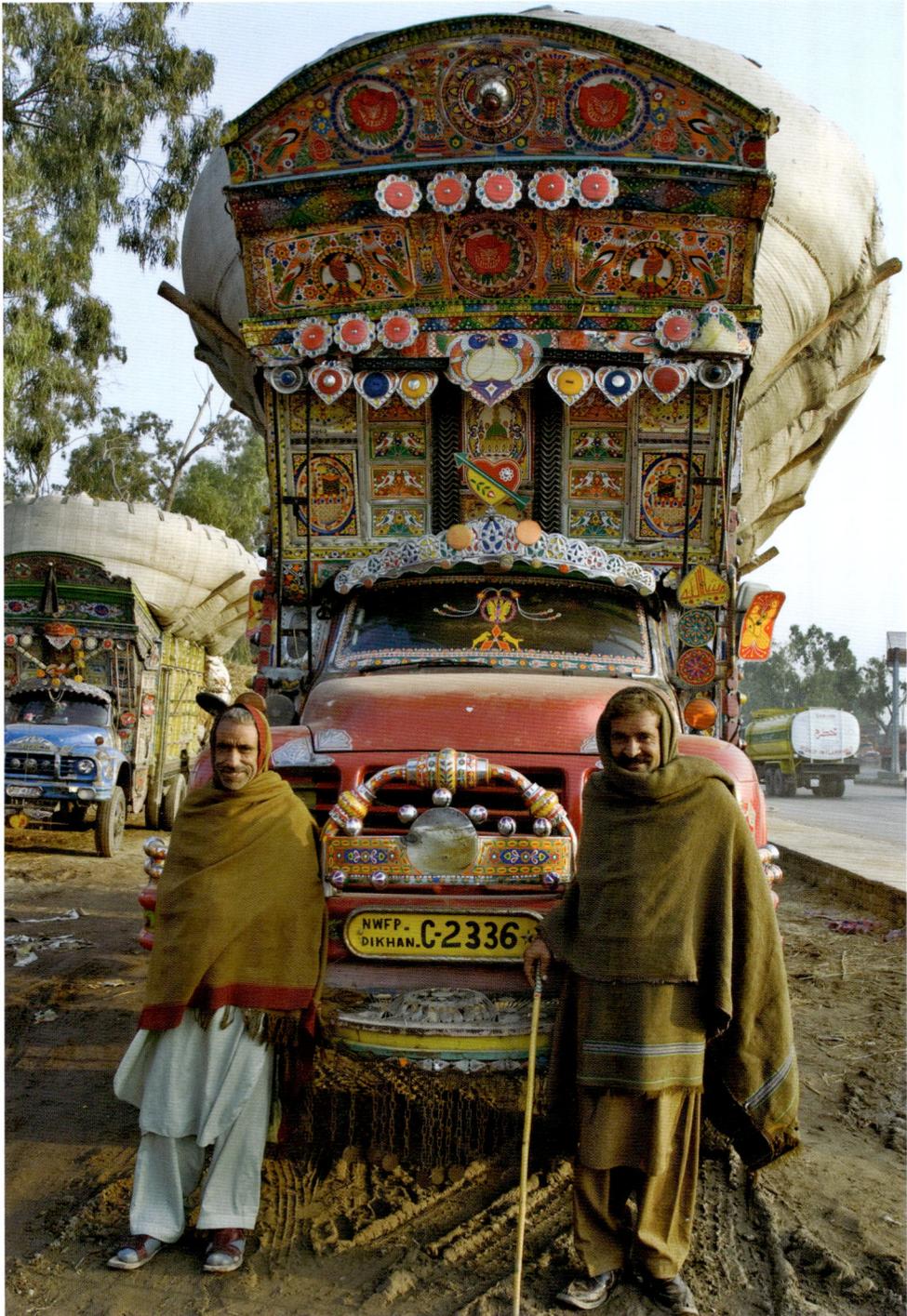

standardized systems of financing, insurance and regulation, will turn Pakistani trucking into more of a formal industry in which owner-operators and small-scale entrepreneurs will be replaced by larger freight companies, thereby changing Pakistan's trucking culture.

Truck Stops and Rest Areas

The very culture of trucks and trucking exists in two related, and frequently overlapping, social spaces: the truck stop and the workshop, which serve as the major loci of interaction between the various individuals and professional specializations associated with trucking. Writing in 1994, Schmid lists what she claims are fairly typical truck journeys in the northern half of the country, highlighting how truck stops and rest areas fit prominently in the scheduling of journeys. Perhaps the most striking aspect of these itineraries is the amount of time it takes to travel relatively short distances: ten hours for the 275 km between Lahore and Rawalpindi, and six hours for the 160 km from there to Peshawar.[12] Although the roads have improved significantly in the years since Schmid's experiences in Pakistan, particularly between Rawalpindi and Lahore, travel times described to me by drivers are not substantially different for these routes. As Schmid outlines, a typical short-haul journey (such as those between Lahore, Rawalpindi and Peshawar) entails a rest stop after two hours of travel, with subsequent stops approximately three hours apart, which makes for a somewhat unhurried drive for such one-day itineraries. However, from my interviews with drivers bringing fruit and construction materials from Baluchistan to the Islamabad area, it is clear that their drives are anything but leisurely. The journey from Quetta or Zhob to Rawalpindi – approximately 1500 km – takes thirty hours including stops, translating to an average speed of 50 kph without any breaks to sleep and with only one official driver. This is in contrast to an average speed of 27.5 kph and 25 kph for the trips between Rawalpindi, Lahore and Peshawar described by Schmid. Among long-haul truckers from Baluchistan, it is not uncommon to drive the thirty hours to the main fruit and vegetable market in Rawalpindi, unload one's cargo before dawn, and then rest for only eight to ten hours before the truck is loaded and ready to make the return journey to Baluchistan.

All planned stops occur at rest areas with which the driver has an established relationship, and the quality of food and tea – provided to regular visitors at a discounted rate – plays a large part in determining the choice of stops. Truck stop restaurants are renowned among the middle classes for their excellent food; in actual fact, members of the bourgeoisie almost never visit *real* truck stops and their restaurants, but instead frequent road-side establishments called <u>khō</u>kas or dhābas that cater to non-commercial travelers rather than to the trucking industry, and which are themselves almost never

visited by truckers. The virtual segregation of truckers' restaurants from the roadside eating establishments visited by the bourgeoisie as part of the adventure of travelling is due in part to the rigid segregation of Pakistani society along class lines as well as to the specialized needs of truckers.

Truck stops and rest areas vary in size from large complexes to modest roadside pull-ins and are normally referred to as *aḍḍas* – the term *saray*, mentioned by Dutreux as the normal term for a truck stop in the Afghanistan of the 1970s,[13] is not used even by Pushtuns. The larger stops are comprised of restaurants, modest hostels, prayer facilities, workshops for engine and chassis repair as well as bodywork and ornamentation, and a variety of small shops selling ornamental objects, music and other items of interest to truckers. In most cases, such complexes are either arranged around a courtyard or in a plaza extending for some length along the road; in both cases, the street-facing façade of workshops and teahouses hides the more private facilities, which sometimes include – besides the aforementioned hostels and baths – small brothels and spaces to indulge in illicit drugs. Smaller pull-ins frequently comprise nothing more than a teashop-cum-restaurant with room for three or four trucks, and very rudimentary facilities for tire repair and topping off engine and transmission fluids. Most truck stops – and small rest areas to a lesser degree – cater to truckers from a particular linguistic group, although this appears to be the result of patterns of association and patronage rather than animus. During my research in Turnol, where the Islamabad–Peshawar motorway intersects with the road to Kohat and points south, there was a clear segregation between truck stops frequented by Pushtuns from Zhob and Quetta, Pushtuns from Swat and Peshawar, and Punjabi- and Hindko-speakers from the Potohar Plateau, Hazara and Azad Kashmir. The patterns of association were reflected in the ethnicity of the hostel manager and, to a greater extent, that of the manager of the goods-forwarding company, if the rest area possessed one, but not at all in the trades people and craftsmen employed in the local workshops. A likely conclusion to be drawn from this phenomenon is that, as argued in Chapter 6, the skilled professions involved in truck maintenance and decoration do not follow familial patterns of apprenticeship associated with older, more traditional crafts, so that learning and becoming established in them follows meritocratic models of professional development. At the same time, the transportation industry itself remains dominated by small businessmen who employ individuals from their own locality and, in many cases, their own extended kin group.

In all cases, the individual businesses at truck stops are modest and provide only rudimentary facilities, representing the bottom end in the hierarchy of small businesses in Pakistan. None of the chain restaurants popular in the country has a franchise at even the largest truck stops, the restaurants do not have separate 'family' sections (whose existence would indicate that they expect female customers), nor do they have the sort of

general purpose convenience stores familiar at rest areas in North America and other more developed parts of the world (and now even on the short stretches of motorway in Pakistan). The most striking marker of socioeconomic segregation between trucking and middle-class passenger transportation is the absolute separation of gas (petrol) stations from truck stops. The consumer-end face of massive (and lucrative) multinational corporations, petrol stations represent a different order of small business than the modest shops that populate truck stops and are never found next to them, although they are routinely found at the rest areas designed for middle class bus and passenger car traffic. The only normal connection between the realm of truck stop businesses and the much more flashy petrol stations is the frequent presence of a scruffy stall providing tire repair services at the periphery of the petrol station, which does not normally offer any automobile maintenance or emergency repair services of its own.

Regardless of size, trucks pull in and park cabin forward at the overwhelming majority of truck stops, with seating – normally in the form of cots (*chārpāi, manjī* or *kaṭ*) – provided in front of the trucks by the local teahouse and, in the case of larger stops, by the operator of the hostel or of the goods-forwarding company office. After the driver's assistant, or *klīnar,* has finished his chores, consisting of making sure the windshield is

Plate 18: Bedford Rockets parked at a truck stop (Turnol 2007)
▽

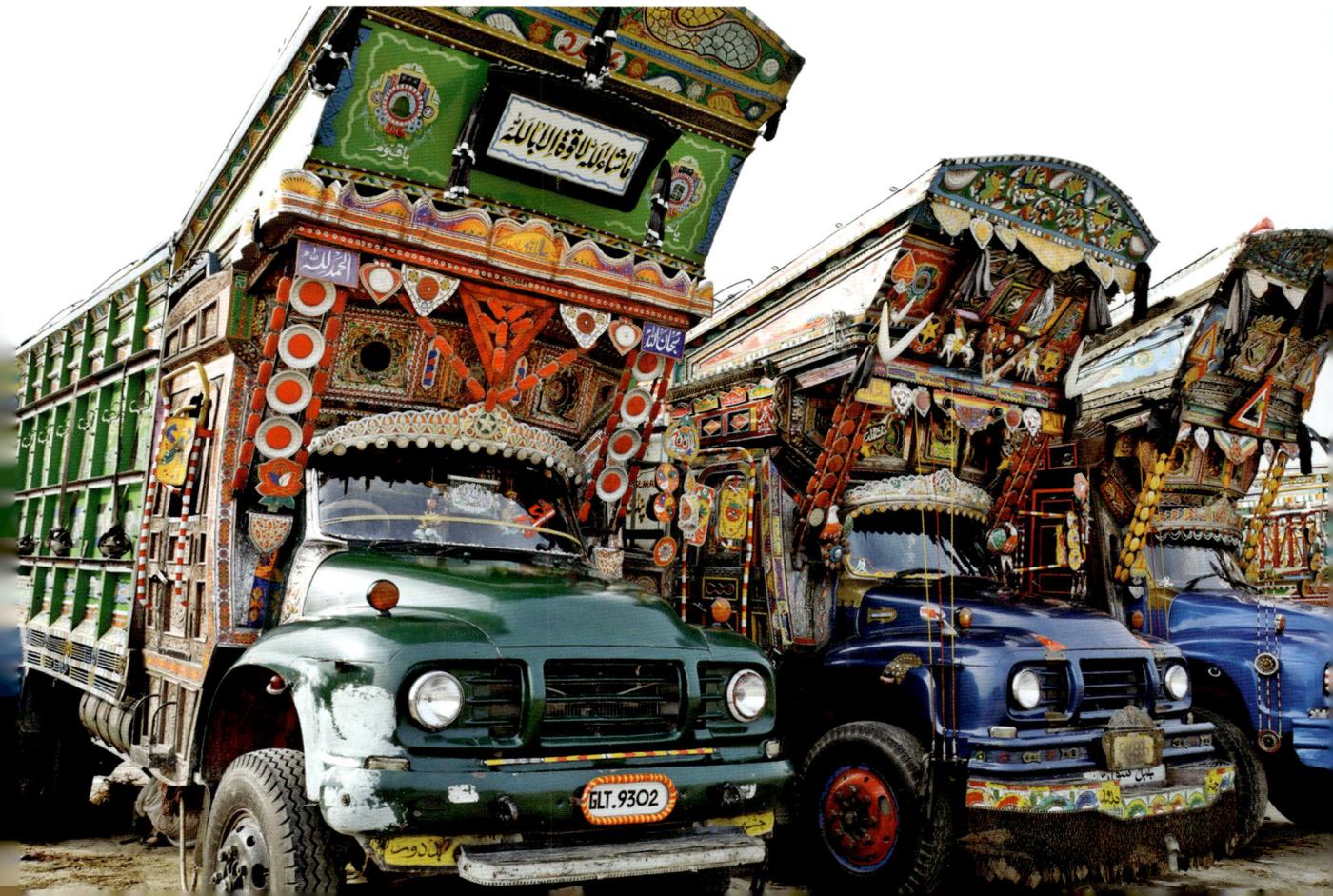

Plate 19: Hino trucks in the Balochi style at a truck stop near Taxila with a Bedford Rocket driving by (Taxila 2007)
▽

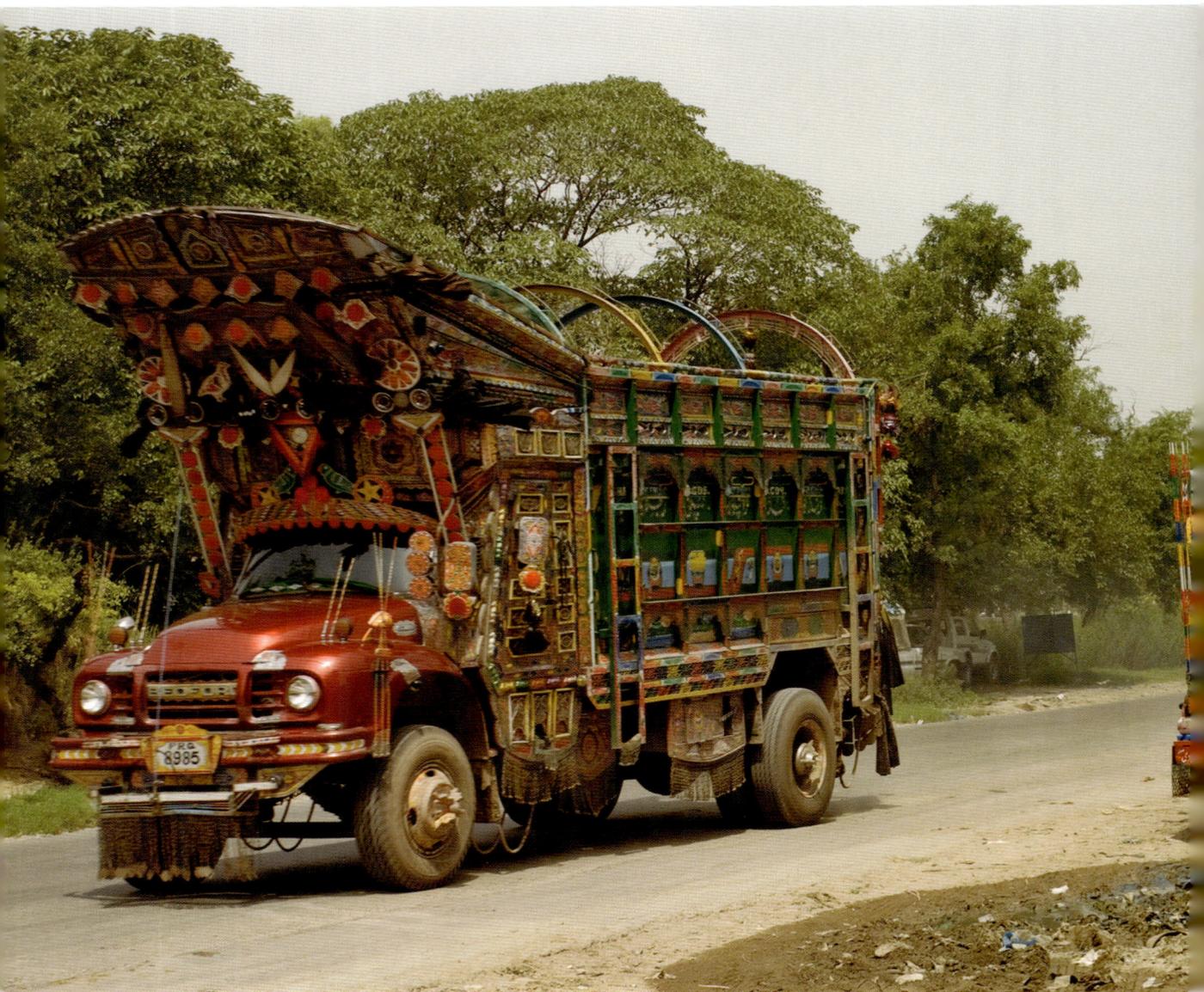

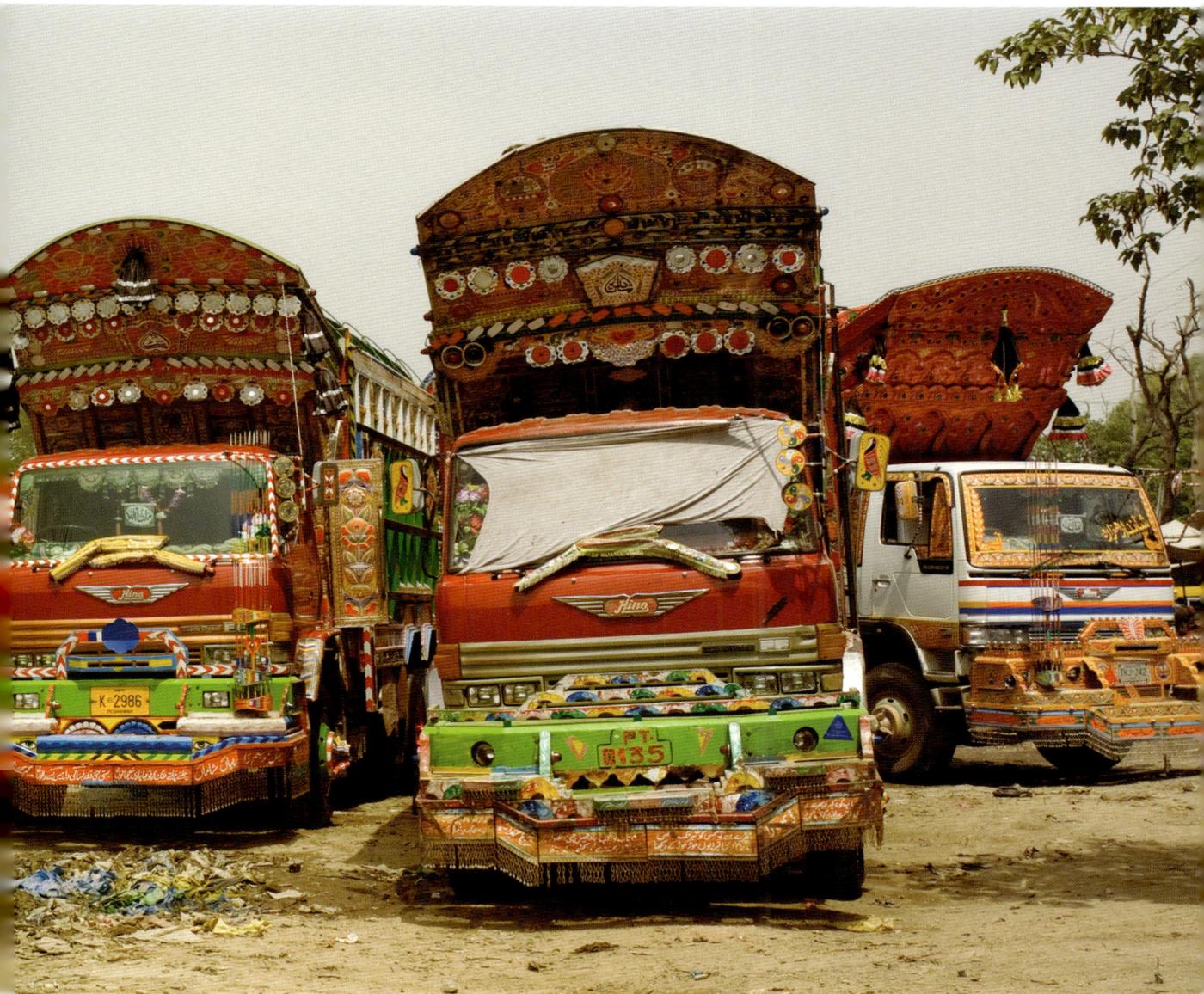

clean and the fluids topped off, the driver, *klīnar* and anyone else accompanying them congregate on these cots to socialize with the operators of other trucks and with the owners of local businesses. As such, it is the front of the truck, rather than its back or sides, that is readily visible when it is parked at a truck stop, one of the few occasions when a truck is stationary and therefore can be contemplated at leisure. Parked in this way, the sides of the truck can only be seen sectionally, since the vehicles are too close to each other to allow a panoramic view of the sides. The back is visible, but on no occasion have I observed individuals congregating at the back of a truck. The norm of face-first parallel parking applies to Bedford Rockets as well as the newer Japanese trucks; the only exceptions to this pattern are tractor-trailers, which park parallel to the road, and tankers, which tend to use their own truck stops and, when parked at a terminal (such as an oil refinery), are close together in no standard pattern.

The way in which trucks are parked at truck stops is significant for the discussion of their decorative programs, since truck stops and rest areas represent the few places where trucks are stationary long enough for their visual details to be admired. Furthermore, other truckers and workers at stops represent a significant portion of the primary audience for truck decoration. In the absence of truck shows or other venues for showing and appreciating truck decoration, the truck stop holds an important place as a venue for their display.

Truckers and Social Marginality

Truckers, especially truck drivers, are frequently characterized as a class unto themselves in Pakistan, just as they are in many other societies. The attitude of the urban bourgeoisie toward them is reflected in the stereotypes of truckers found in some of the scholarship on Pakistani trucks, in which they are characterized as brash and reckless, prone to drug use, pederasty, as well as being frequent patrons of prostitutes. Lefebvre's article explicitly describes the average Pakistani trucker as a Pushtun from an alpine village who smokes hashish, has sex with young boys, and drives his truck too fast.[14] In all likelihood the author's information is derived not from actual fieldwork but from a Pakistani informant with no real knowledge of the trucking industry or its culture, since this description is false on several counts.

There are no reliable statistics, and frequently no statistics at all, on the percentage of long-haul truckers among the wider population of truck drivers, the difference in sexual practices between long-haul and short-haul truckers, or the ease or frequency with which drivers move between long-haul and short-haul trucking. Nor is there reliable data on differences in sexual mores and practices across ethnic communities in Pakistan, although strong stereotypes prevail about the greater propensity of Pushtuns, and par-

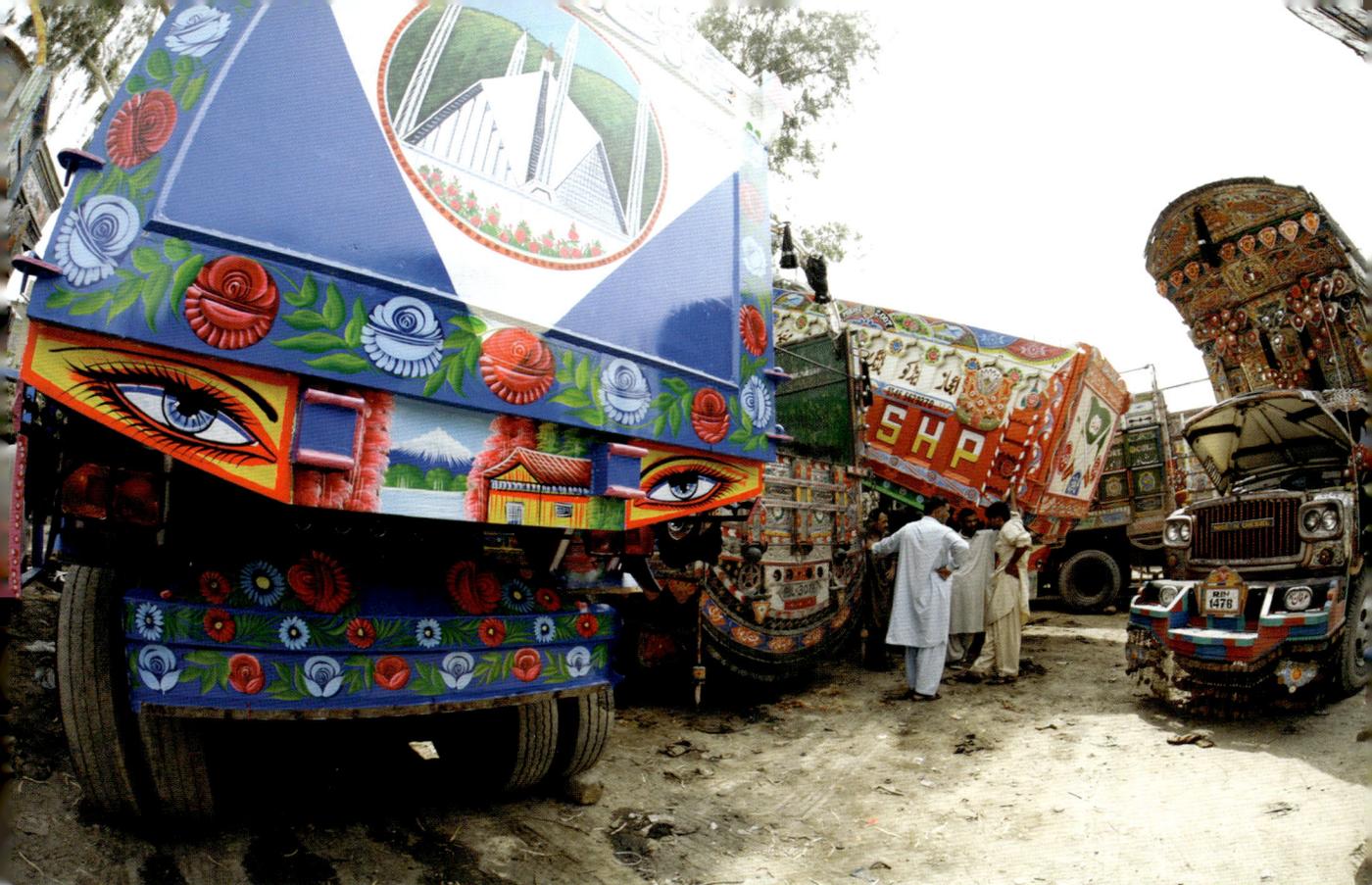

Plate 20:
A large truck stop in
Turnol (2007)

ticularly those from Quetta, Zhob and Kandahar, to engage in same-sex practices. However, truck drivers are identified as a group particularly at risk of HIV and other sexually transmitted diseases. The most comprehensive study on AIDS awareness among truck drivers was conducted in Lahore in 1998, and surveyed 303 truckers of whom 300 participated willingly. Of this population, 34 percent admitted to having had sex with a female commercial sex worker and 11 percent with a male sex worker; 49 percent of the drivers surveyed admitted to having engaged in same-sex practices, and the overall data showed a rate for condom usage in non-marital sex of only 3–7 percent.[15]

The lack of awareness surrounding sexually transmitted diseases among truckers matches the situation with the general population in Pakistan; it is only the perception that they (together with intravenous drug users and commercial sex workers) constitute a community at greater risk of contracting diseases that has made truckers a focus of particular attention on the part of the Pakistani National Aids Control Programme and various NGOs. Some health clinics, such as the Hamrahi Markaz, which has centers in Taxila and Karachi, send health workers to truck stops in order to educate drivers

about sexual health and to offer free comprehensive (as distinct for specifically sexual) health services. As of the summer of 2007, the Hamrahi Markaz center in Taxila had not seen a single HIV case among the truckers who had visited the clinic, although this does not necessarily reflect the true infection rates since going to the clinic is entirely voluntary, as is getting tested (the clinic in Karachi has seen a handful of HIV positive patients).

Concerns about the actual rates of sexually transmitted disease and especially of HIV transmission among truck drivers are, of course, very real ones. But the ambiguity of the data concerning the actual sexual practices of truckers or their infection rates should not obscure the important fact that all studies *assume* that truckers are at much greater risk of contracting HIV and other sexually transmitted diseases than the general population, and that they are in this position because of their propensity to engage in unsafe sexual practices with other men, women and transgendered (*hijra*) partners. Similarly, the hypothesis that their increased use of intravenous drugs increases their risk of contract–ing such diseases rests on assumptions rather than empirical data concerning drug use among truckers. In short, real health concerns notwithstanding, discussions of truckers'

Plate 21: Seller of decorative trinkets at a truck stop (Taxila 2007)
▽

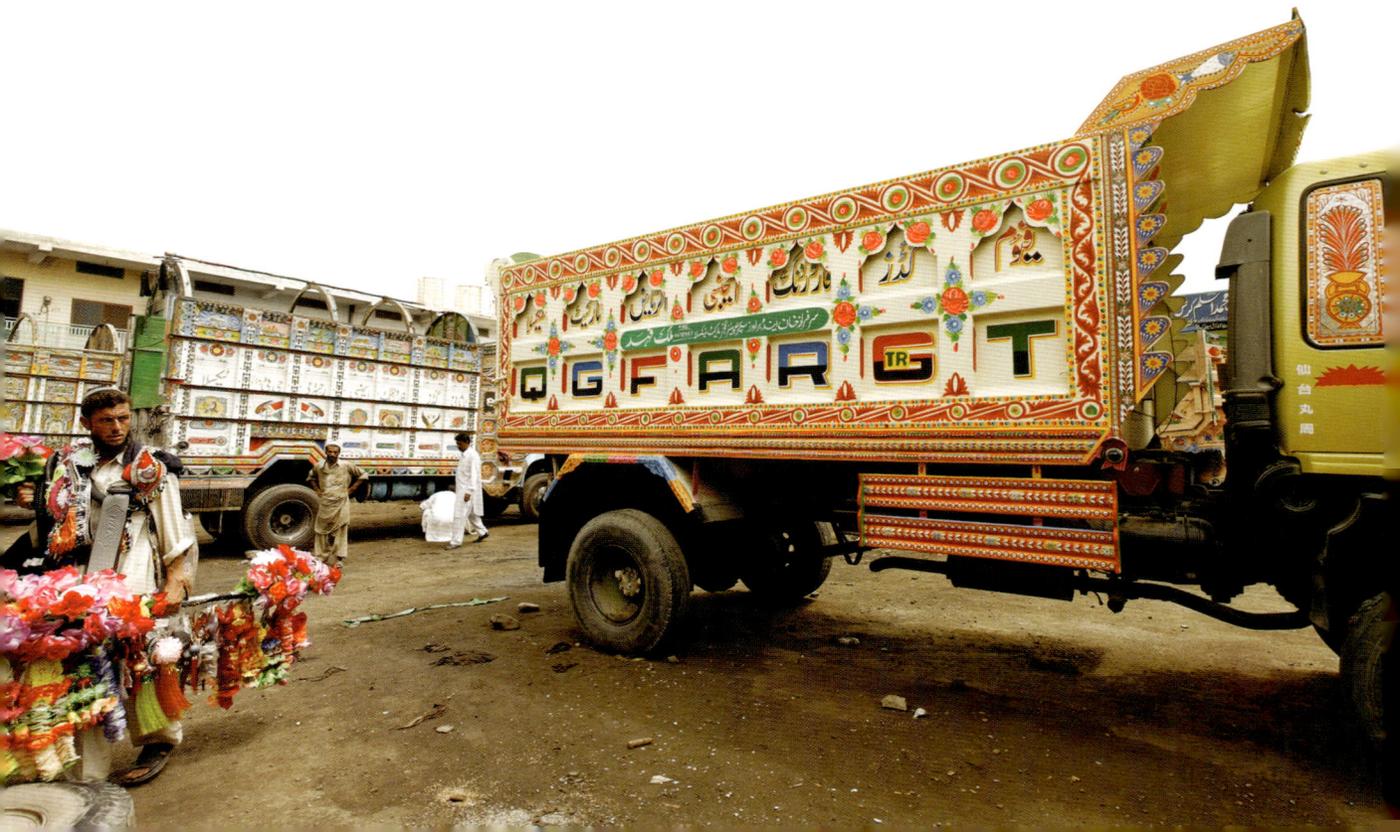

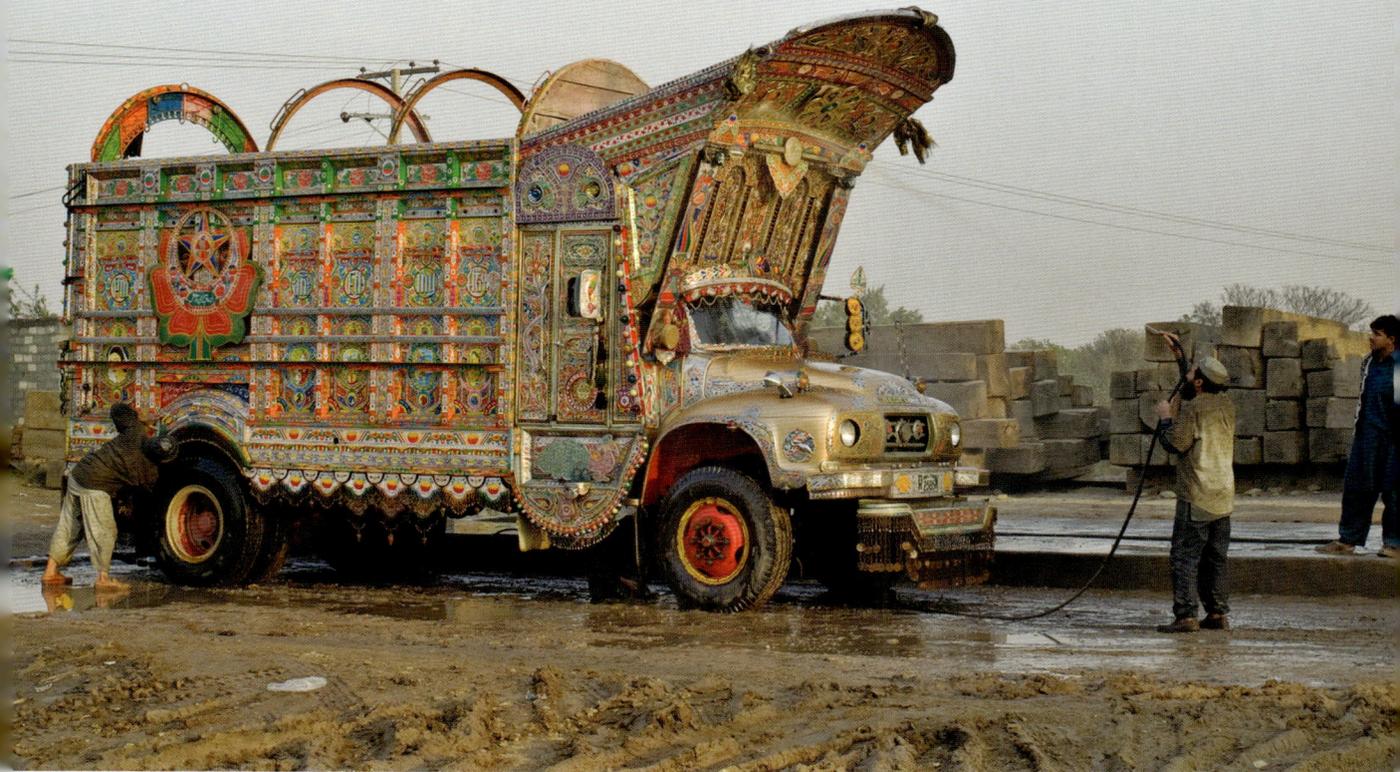

health reflect attitudes concerning the behavior of truckers that are shared by the wider population. Pakistani society is deeply conservative, with negative attitudes toward drug use and an intolerance of all forms of non-marital sexual activity. For truckers, as a class, to be identified so strongly with behaviors judged by society at large to be reprehensible is an indication of the ways in which truckers are viewed as socially marginal with a propensity toward criminality and moral turpitude.

Police

In point of fact, the legally suspect nature of truckers carries over into their relationship with the police, although not for the same reasons as they are marginalized by Pakistani bourgeois society. As an industry, Pakistani trucking exists in flagrant violation of the law. Juxtaposed against a police force which is viewed by truck drivers (as it is by the majority of Pakistanis) as a menace rather than any positive force in society, it is not surprising that truckers and the police have an adversarial, if also symbiotic, relationship.

The majority of Pakistani trucks, and especially the Bedford Rockets, fail to meet official safety standards. The trucks are built too tall, with precariously high centers of

gravity; hanging decorations in the cabin and stickers on the windshield restrict forward visibility, while the fashion of having tiny windows in the doors restricts vision of the rear-view mirrors and out of the sides. Trucks are overloaded on a routine basis, and although the frame of the vehicle is reinforced to cope with the load, no improvements are made to the brakes to allow for the need for greater stopping power. In addition, an undetermined but significant percentage of truck drivers do not possess the appropriate driver's license or are not licensed at all, with underage assistants (*klīnars*) routinely taking the wheel when the driver is tired. Finally, none of the loosely attached ornamental items (such as large banners, pin-wheels and so on) is permitted by police regulations, implying that the decorated truck is, by definition, outside the law.

Plate 23: 'The Story of Three Friends'. Cover of an informational pamphlet published by Hamrahi Markaz, a health center in Taxila targeting truckers and sponsored by a number of NGOs in Pakistan as well as the National AIDS Control Programme
▽

تین دوستوں کی کہانی

شائع کردہ : ہمراہی مرکز ٹیکسلا

Certain violations are so systemic that owners and operators consider paying those fines to be part of their operational costs. Extortions and bribes are also treated by the notoriously corrupt police as a system of informal taxation of trucks. The police seldom formally charge truck drivers with violations but prefer to extract a blanket bribery 'fee' from the drivers. Such extortion, which is applied to all commercial traffic in Pakistan including buses and *suzūkī* minivans, is a crucial means through which policemen supplement their salaries, each local precinct functioning as an enterprise that collects these fees, pools the money and then divides it among its members based on rank and seniority. Trucks are furnished with stamps in their logbooks or sometimes stickers (frequently of a religious nature) in the cabin to show that they have paid their dues for the month for a specific location. The police also extort extra money as major holidays approach because they feel the need to supplement their salaries even more to offset higher expenses at those times. Truck drivers and owners may not be happy with systematic police extortion but they are resigned to it as a necessary factor in conducting business, and one which allows them to operate with very limited concern for the much stricter letter of the law. It is only when the police break the tacit socioeconomic contract of protection and extortion that the trucking industry responds more forcefully than simply by griping about it in an anecdotal and informal way.

The dialogical relationship of truckers to the police is obvious from the way in which they react to the police's role in transportation. The standard system of extortion as informal taxation elicits no greater resentment than state regulation and taxation. Departures from the informal system, such as the demand for bribes that break the contractual understanding represented by a system of regulated payments, results in a higher degree of objection on the part of truckers, normally expressed through complaints to the print media. Civil disobedience in the form of strikes and road blockages takes place when there is the perception of a serious breakdown in the informal contractual relationship. Ironically, this occurs most frequently during periods when the police are pressured by the government to crack down for short periods on trucks and buses and to issue formal citations for all violations. It also occurs when lack of security interrupts the free movement of trucks.

Organized complaints and agitation on the part of truckers depend on the involvement of owners' associations and trucking unions, and it is no surprise, therefore, that such mobilization occurs when the interests of owners are threatened, rather than when the police are extorting money from drivers. Unlike these bribes, official fines are levied against the vehicle, and therefore against its owner; similarly, the impounding of vehicles impacts the owner directly through the loss of revenue while the truck is out of service as well as in the cost of recovering the vehicle from police custody.[16] At the same time, massive disruptions in the road network also affect the owners, who respond through

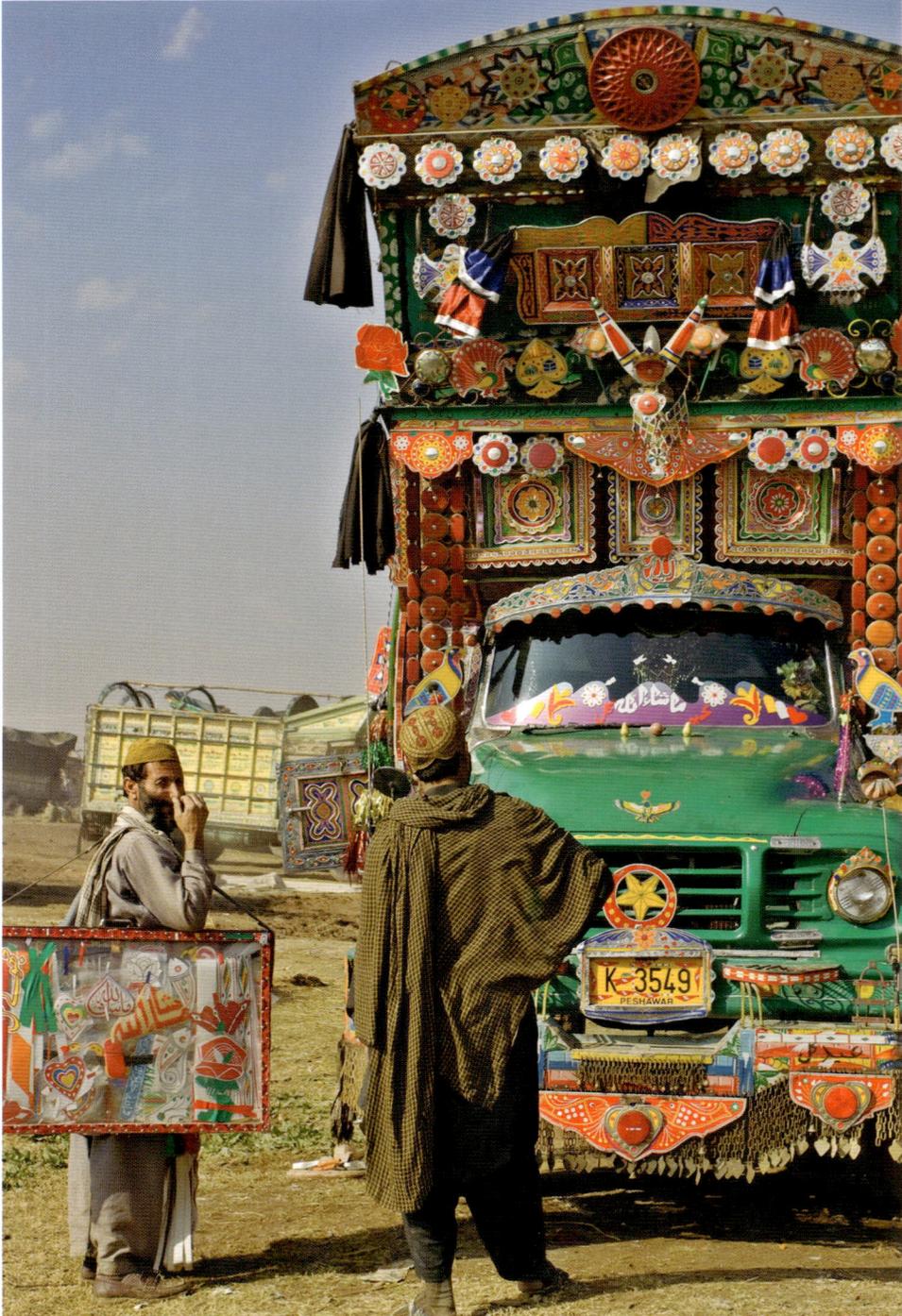

◁

Plate 24: Driver contemplating purchase of stickers for his Bedford Rocket (Rawalpindi 2003)

their unions, such as the Karachi Goods Carriers Association (KGCA), All Karachi Goods Transport Ittehad, and the Muttahida Transport Federation (Rawalpindi). It was such groups that organized successful demonstrations against the rapid rise in fuel prices during the global economic crisis in the autumn of 2008[17] and which have agitated for greater security for truck convoys travelling to Afghanistan.

The National Logistic Cell (NLC), a governmental corporation created in 1978 ostensibly to help reduce freight congestion in Karachi's port, was deployed in the 1980s to break the power of the transportation unions, which threatened the smooth convey- ance of vital supplies to the border with Afghanistan during the decade-long war against the Soviet Union. And in an almost complete corollary of the development of govern- mental trucking as an insurance against the vicissitudes of private enterprise, there is strong evidence to suggest that the Pakistani government's initial support of the Taliban – at a time when they were nothing more than a regional vigilante group in the area of Kandahar – was a direct consequence of pressure put on the government by the Pakistani transport unions, which found the lack of security in Afghanistan unacceptable and threatened a nationwide Pakistani strike.[18]

In all cases where there is a conflict between the transportation industry and other elements of society, be it the police, other organs of the state, or the urban bourgeoisie, a presumption of guilt invariably applies to the truck drivers. This is even the case when the industry as a whole is being criticized, since owners – as possessors of greater mate- rial and social resources – shift the burden of blame onto labor. Viewed by other members of bourgeois society as a class rather than a subgroup within the labor force, there is little sympathy for drivers in such situations of conflict or in other circumstances where the inequitable allocation of resources has negative consequences for drivers and other workers involved in the trucking industry. In the absence of any meaningful interaction between truckers and privileged urban classes, the latter's knowledge of trucks and truck culture relies heavily on the most striking aspects of trucking, their visual decoration, and the bourgeois viewers' perceptions of what this phenomenon implies about truck drivers.

6

Truck Design and an Artisanal Trade

The world is filled with decorated objects because decoration is often essential to the psychological functionality of artefacts, which cannot be dissociated from the other types of functionality they possess, notably their practical, or social functionality ... In other words, the distinction we make between 'mere' decoration and function is unwarranted; decoration is intrinsically functional, or else its presence would be inexplicable.[1]

In the assertion quoted above, Alfred Gell elegantly skirts the long history of discussions over the relationship between aesthetics and utility in art and material culture. To argue that decoration is, *sui generis*, functional, is to maintain that it has meaning, though not in a strictly semiological sense. All aspects of decoration do not necessarily function as signs of attitudes, beliefs or other messages, but they certainly speak of or to these attitudes, beliefs and signs. In the case of Pakistani trucks, decoration covers the entire exterior of the truck as well as the cabin. Much of this decoration – especially the epigraphy and some representational art – is readily understood as functional, if not utilitarian, but the majority of decoration has no such obvious value.

It is worth repeating that vehicle decoration is an expensive undertaking. In 2007 it generally cost up to Rs. 400,000 (US $7000 at the time) to have the coachwork done on a Bedford truck; the lowest figure mentioned by any truck painter was Rs. 125,000 (US $2000). In the case of Nissan and Hino unibody vehicles decorated in the Baluchistan style, the expenditures on finishing a truck are much higher, normally between US $12,000 and US $16,000 (2007 figures). These sums are several times the annual per capita income of Pakistan, so that such large expenditures raise the question of whether or not there is any direct economic gain from getting a vehicle decorated.

Arguably, the gain from expenditures on decoration is more direct in the case of decorated buses, since if two buses are departing on the same route at the same time (as they often do), passengers are likely to choose the more attractive (i.e. more decorated) one.

This observation holds true to a greater degree for buses on major or metropolitan routes, although routes connecting smaller towns are frequently traveled by buses belonging to the same company, thus negating any economic advantage to the fleet owner (although an incentive to decorate still applies to the bus operator). Similarly, passengers travelling on fixed urban routes are likely to get on the first bus that comes along provided the bus in question meets some basic standards of appearance, including decoration, which serve as reasonable barometers of its reliability and general comfort. One complicating factor is that inter-city (and metropolitan, to a lesser degree) bus types and designs display clear class distinctions in Pakistan. Inter-city buses catering to the middle classes are completely distinct from the traditionally decorated buses, a difference reflected both in the fares they charge as well as in their appearance. Inter-city buses catering to middle-class customers are closer in their level of amenities to those in Europe or more developed countries in Asia, and also resemble them in the simplicity of their graphic decoration and lack of other forms of adornment. The striking differences between buses catering to the middle and lower classes reinforces the Pakistani bourgeoisie's notions of kitsch, aesthetic taste and their relationship to class. As far as the buses catering to lower classes are concerned, as well as in the case of minibuses and *suzūkīs*, bright and ornate decoration is a clear indication of newness, which is related in most people's minds not just to reliability and quality, but also to purchasing power, enjoyment, and general vague ideas of a good quality of life. It is to this end that Pakistani buses and trucks proudly display 'model years' as part of their decorative program, the model year not reflecting when the vehicle was built (since that could be half a century ago) but when it last visited a workshop for a refit of its upholstery, its paint job, or both.

Compared to buses, in the case of truck decoration, direct economic advantage does not seem to be as strong a motivation and cannot provide a satisfactory explanation even at a speculative level. Most Pakistani trucks are not owner-operated but belong to small fleets. Furthermore, many trucks are contracted sight unseen through a goods-forwarding company, as a result of which the appearance of the truck would seem to be of little consequence to the person who hires it, certainly as compared to the reliability of the engine or the reputation of the driver. Despite this lack of obvious economic benefit, however, it is the norm for truck owners to authorize the driver to take the vehicle to a coachwork shop at the owner's expense and have it decorated within the overall parameters of the fleet's design and the owner's preferences, or for the owners of a small number of trucks to go to the coachwork shop and oversee the decoration themselves. And even after the initial decoration of the truck is complete, it continues to be worked on for its entire life, with the ongoing addition of ornamentation, adding to and changing the epigraphic elements, and so on.

Some of the factors influencing the decoration of buses do apply to the case of trucks, particularly the twinning of newness with quality and reliability, but it is still difficult to see strong and pervasive connections between truck decoration and economic benefit. In the absence of such a connection, and the absolute pervasiveness of this form of art (it is safe to say that, with the exception of trucks belonging to multinationals such as Federal Express, every inter-city privately owned truck in Pakistan is decorated), it becomes obvious that the motivation to decorate lies somewhere else. The specific motifs and elements of truck decoration do not display purely aesthetic considerations but, viewed collectively, are rich (if non-specific) sources of information on aspects of the religious, sociopolitical and emotional world views of those involved in the trucking industry.

Plate 25: Reinforcing the frame on a Hino truck (Taxila 2003)
▽

Chassis and Craftsmen

A small percentage of trucks are new when they enter service in Pakistan, the majority being reconditioned local vehicles, some decades old, or recent second-hand imports

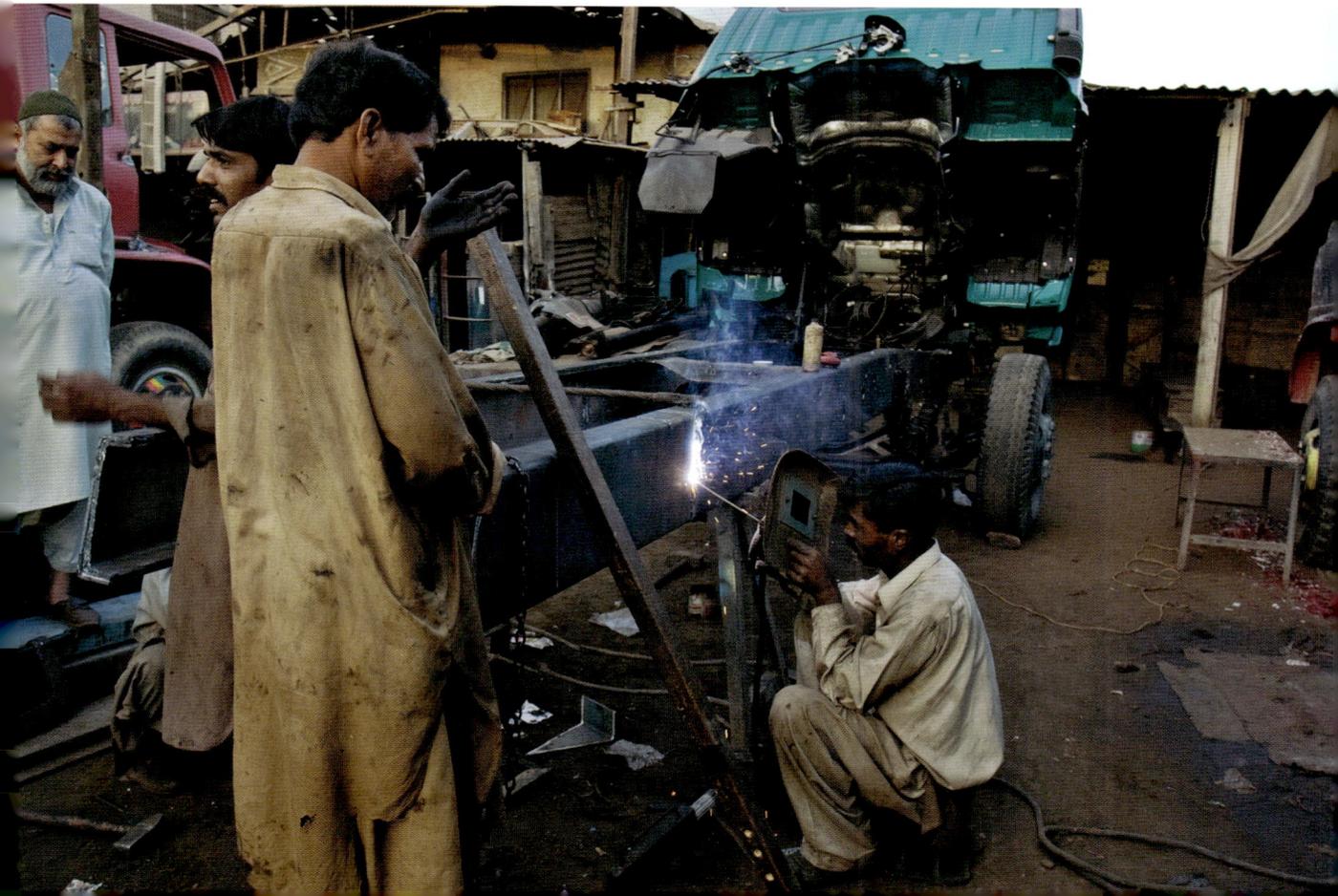

from more industrialized countries in Asia. The venerable Bedford Rocket, which started being imported in the early 1950s, has not been manufactured in over two decades. Every Bedford is therefore in a constant process of being overhauled using parts produced by local companies in Pakistan. The majority of Nissan and Hino trucks are used vehicles which have completed their service lives in more developed countries such as Japan or Korea and are imported and distributed by truck brokers who are not formally sanctioned as distributors by the official dealer networks inside the country.

Trucks are typically purchased as a bare chassis comprised of a cabin, engine, sub-frame and running gear; the bodywork and all decoration is added subsequently and can cost up to one-third of the total price of the vehicle. Minor decorative changes – adding new calligraphy, stickers and bolt-on ornaments – are conducted on an ongoing basis. Typically, the bodywork and decoration needs a complete redoing every five years. The large number of trucks, the level of their decoration, the constant renovation of it, and the substantial expense associated with the practice all go to indicate that this tradition represents a large and pervasive economy.

Whether as a 'new' chassis, or a vehicle being reworked after service in Pakistan or after a major accident, the truck is brought to a workshop (*verkshāp* or *kārkhāna*) where it is built up from the chassis and frame to the final tasks of decoration. Truck workshops are normally somewhat ramshackle affairs, a series of concrete or brick storefront rooms facing a packed-earth courtyard, heavily stained with engine and transmission oil, as well as paint, that turns into a sticky toxic soup when it rains. The arrangement allows the different specialists who work on a vehicle to have easy access to the truck without it needing to be moved. In those instances (typically along major roads) where the individual shops are in a row rather than facing a courtyard, the truck is first taken to the metal workshop and then moved to the area where body workers and decorators are located. Full-service workshops are common throughout Pakistan, but the majority of locations where trucks are worked on are more specialized. In particular, chassis work, engine and upholstery shops are often located at some distance from the shops than specialize in sheet metal fabrication, painting and decoration.

A complete overhaul or new build from chassis to completion is a lengthy process that takes an average of three weeks of full-time labor. In most cases, the owner of the vehicle remains intimately involved in the process for the entire period, watching the progress and making sure that he is not being cheated. When smaller projects are involved, such as repainting a section of the carriage, owners are frequently not as directly involved and leave the driver responsible for getting the work done. In the case of especially experienced and trusted drivers, owners will entrust them with supervising all aspects of work on the truck.

▷

Plate 26: Workshop manufacturing material for truck upholstery and interior decoration (Turnol 2003)

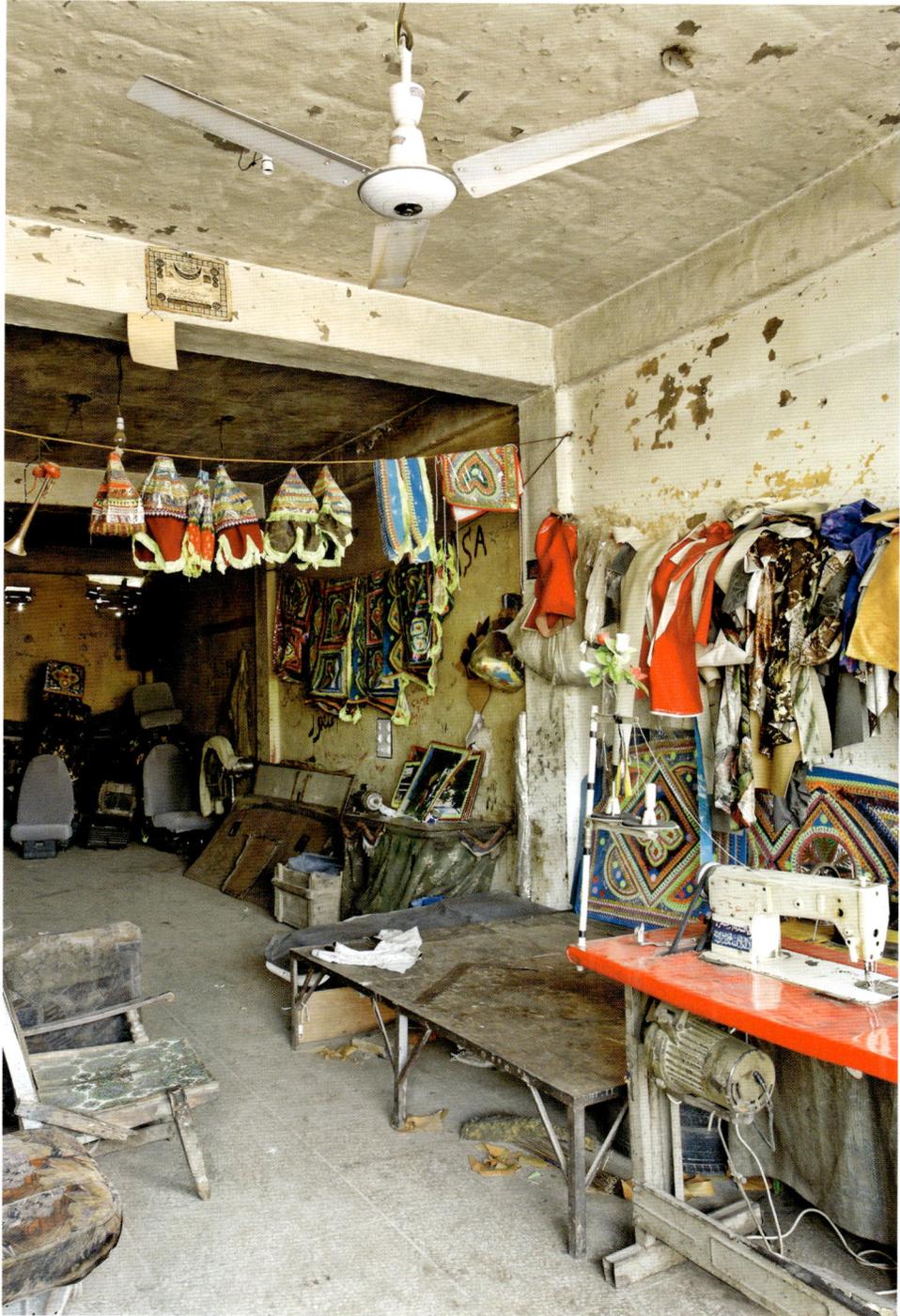

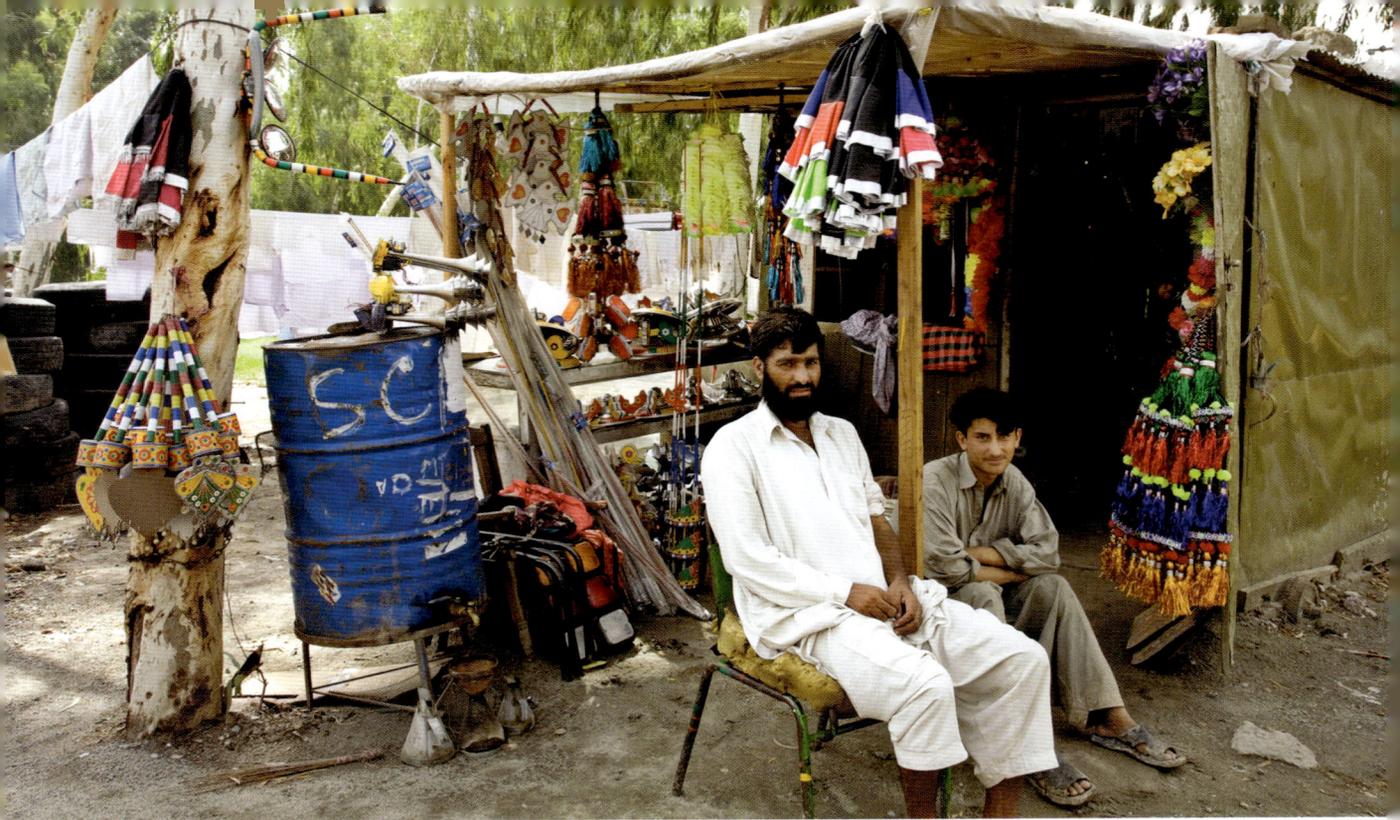

The completion of the truck consists of three phases, some subsections of which can be carried out simultaneously. Separate aspects of each phase involve thirteen kinds of specialized craftsmen:

Plate 27: Stall selling decorative items at a truck stop in Turnol (2007)

Initial frame reinforcement and repair
Welder (*velḍar*, sometimes *lohār*)
Metalworker and denter (*shō vālā* or *ḍenṭar*)

Engine work
Mechanic (*mistrī* or *makēnik*)
Electrician (*ilekṭrishan*, sometimes *bijlī vālā*)

Bodywork and decoration
Carriage maker (*bāḍī vālā* or *bāḍī mēkar*)
Spray painter (*rang sāz* or *isprē/saprē penṭar*)
Artist responsible for painted ornament and calligraphy (*likhāi vālā*, but sometimes *rang sāz* or *isprē/saprē penṭar*)
Glasswork specialist (*shīshē vālā*)
Metalwork specialist (*lapē vālā* or *lapē sāz*)
Woodwork specialist (*lakṛī vālā*)
Reflective tape mosaic specialist (*chamak paṭṭi vālā*)
Plastic-work specialist (*plāsṭik vāla*)
Upholsterer (*ladiān vālā* or *poshish mēkar*)
Makers of beadwork, embroidered edges, hanging chains, etc.

There is considerable variation in the use of terms for specific crafts.[2] In particular, the master artist responsible for the painted decorative program of the carriage and cabin is traditionally referred to as a *likhāi vālā* (calligrapher) in recognition of the professional genealogy of the craft, while terms for 'painter' (*rang sāz* and *isprē/saprē peṇṭar*) are used for the person who applies the undercoat and automotive enamel paint. However, the decorative painter is also occasionally referred to as a *peṇṭar* or *rang sāz*. Similarly, all the craftsmen who are responsible for appliqué work in glass, metal or reflective tape are sometimes individually referred to as *shō vālā* because they are responsible for making the vehicle 'showy', although the term more correctly refers to the individual responsible for giving the truck a smooth and glossy cabin and hood (bonnet), the only part of the vehicle where unadorned automotive paint shows clearly.

All the specialists involved in the production of a Pakistani truck acquire their skills through a system of apprenticeship that normally begins in late childhood. In fact, much of the less demanding work on the vehicle – such as the hammered metal and glasswork or less detailed painting – is carried out by juveniles. Although each decorative craft has a hierarchy with a master craftsman (*ustād*) and a number of apprentices (sing. *shāgird*)

Plate 28: Glassworker and apprentice in a shop (Garden East, Karachi 1999)
▽

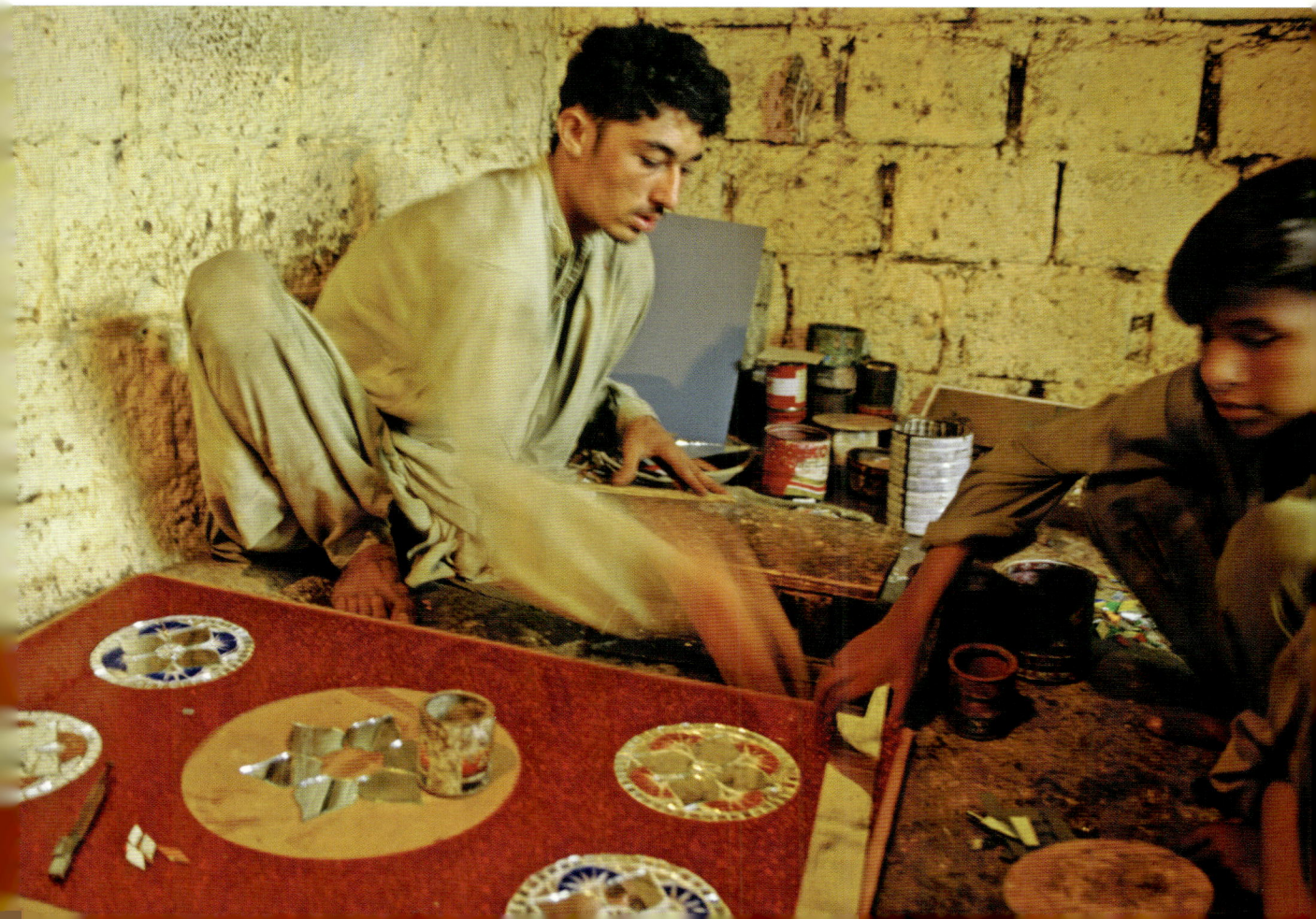

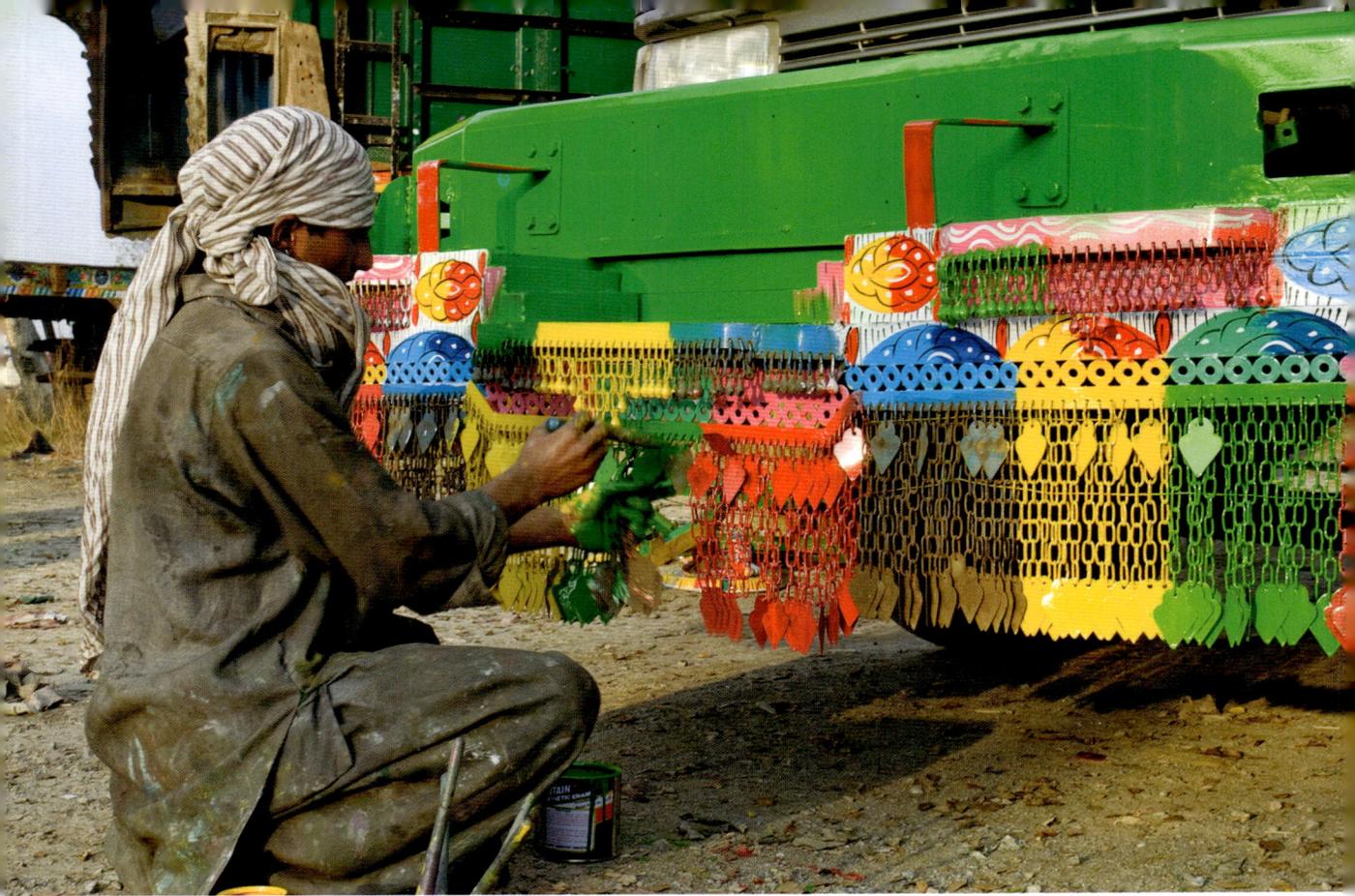

△
Plate 29: Painting the metal fringe on the front bumper of a Hino (Turnol 2007)

working under him, the highest status is accorded to the individuals responsible for the painted decorative program, which is valued differently from other forms of ornamentation, including ones, such as intricately carved wood or fine mosaic work in reflective tape, that demonstrate enormous skill. None of the crafts appear to be handed down in familial lineages, and the system of apprenticeship is no longer dependent on kinship but has been opened up to reflect patterns of migration and relocation in modern Pakistan.[3] It is perfectly normal to find a mixture of Punjabis, Pushtuns and Kashmiris bound together in relationship patterns of master and apprentice in the majority of shops in the northern Punjab and Hazara as well as in Karachi. Inasmuch as there is ethnic homogeneity among the workers in a particular shop and lineage, it reflects patterns of migration, settlement and the associated spheres of patronage rather than patterns specific to truck decoration trades as such. Truck decoration, it appears, is an entirely modern constellation of professions in which market forces are the major determinants of its development.[4]

A wide variety of objects, patterns and themes are incorporated in truck decoration and there are substantial differences between various regional styles (and even within regions).

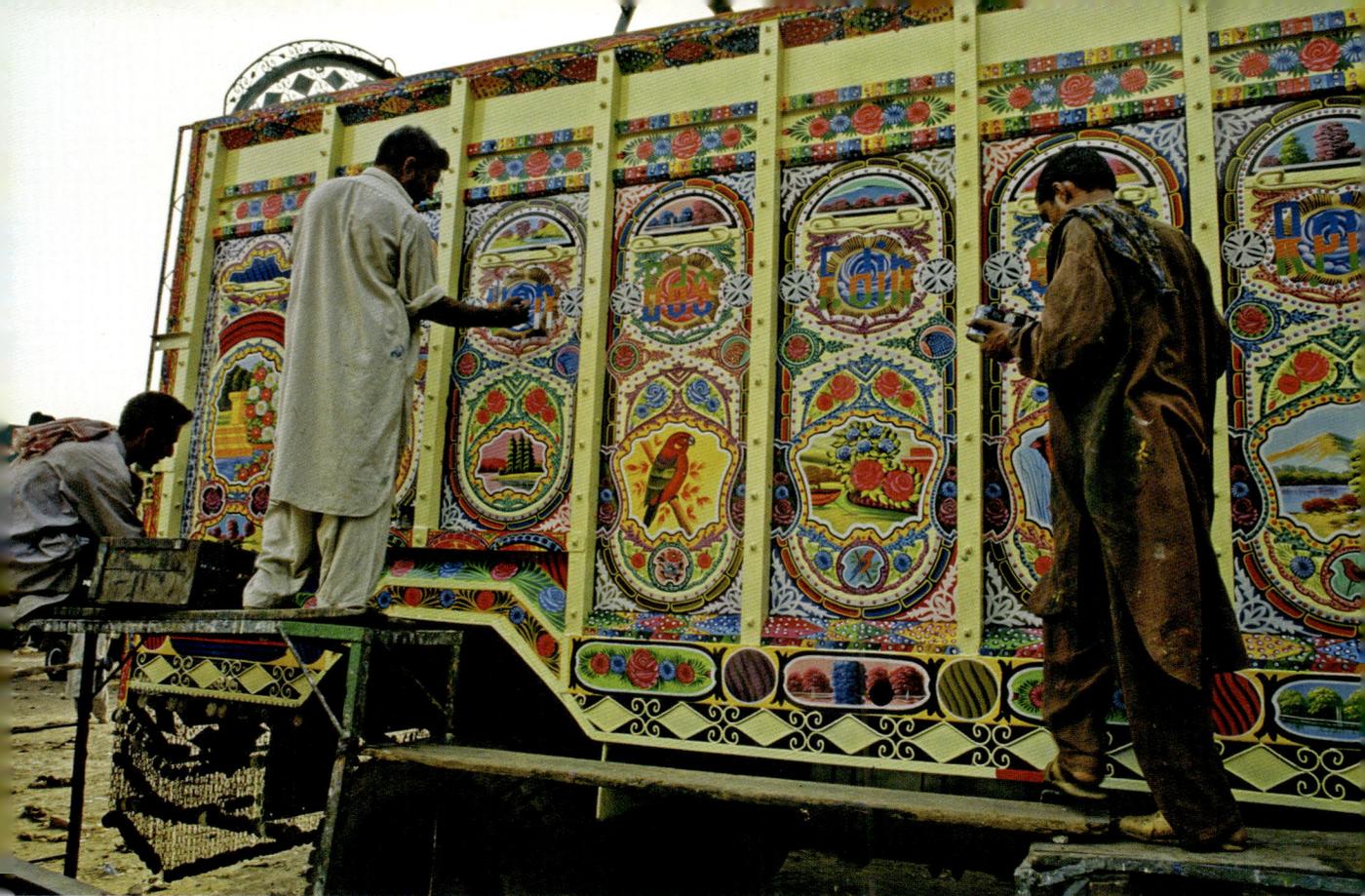

△
Plate 30: Painters in a Carriage Factory Road workshop, Rawalpindi (Rawalpindi, 2001)

All trucks are ornamented with some combination of epigraphic formulas, poetry, repetitive patterns and figural images. Both the images and epigraphic formulas may or may not be religious in nature. Much of the decoration with explicit religious significance is apotropaic or talismanic, in that it protects the truck, its contents and the individuals dependent on the truck from misfortune and – sometimes simultaneously – brings good fortune on them.[5] Apotropaic art is directed at the supernatural; even though human beings are held at fault for the misfortune of others through their envy or jealousy, they actually function as agents by which the evil eye (*nazar*) is transmitted, not as its authors.

Some decorative elements are explicitly religious but serve no obvious apotropaic function. They also appear to be directed unambiguously at other human beings. As I will argue further on, the purpose of these elements is to serve as a social marker or identifier that marks the individuals associated with the truck and situates them within their society.

Formalistic Descriptions

From a decorative perspective, a truck has three separate sides (or aspects) that are used to signify different things, these being the front, the back and the (two) sides. The sides

91

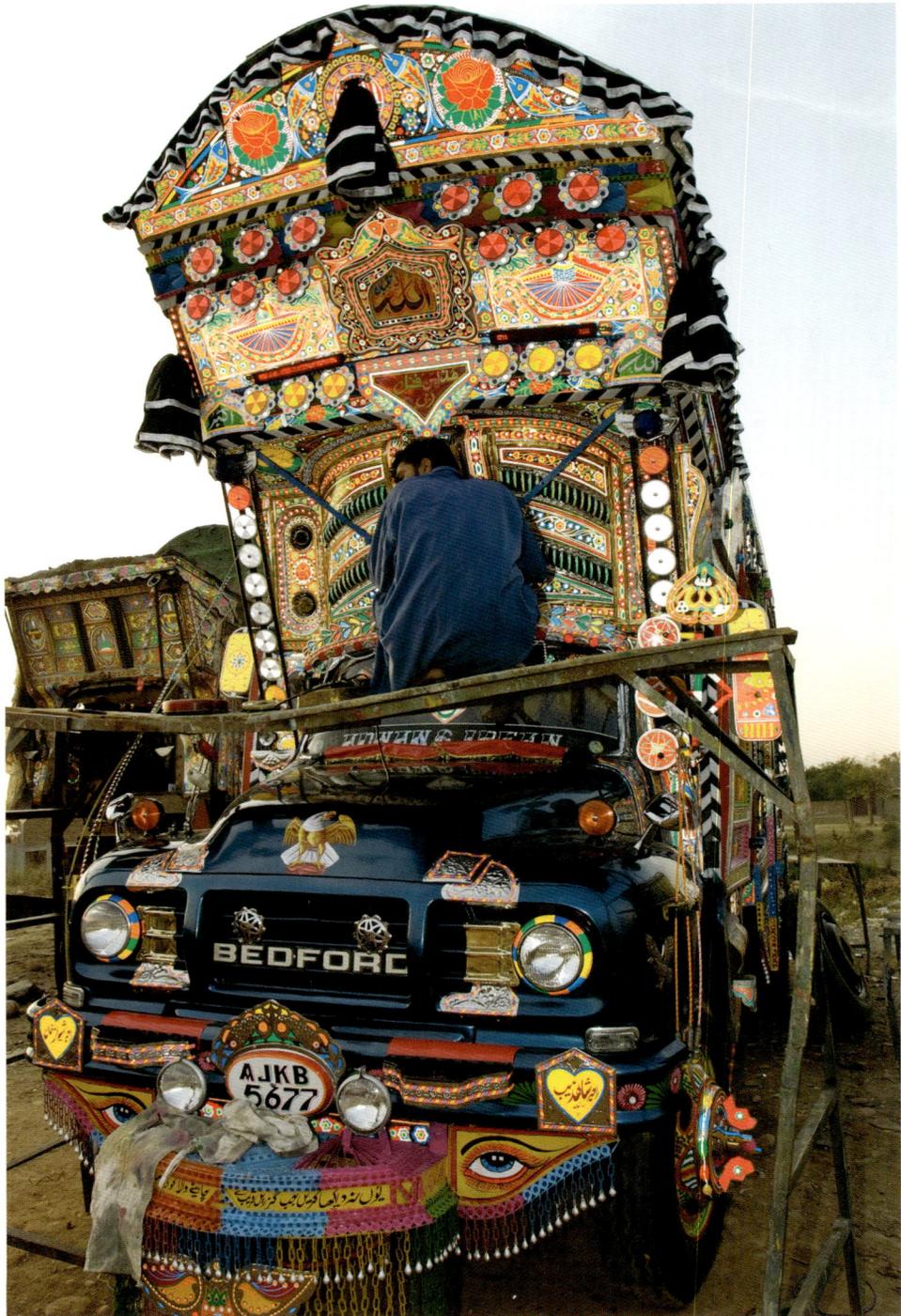

◁

Plate 31: Putting finishing touches on a Bedford Rocket (Rawat 2003)

of the truck are typically used to situate the vehicle (and consequently the owner and driver) within a wider world in a geographic or societal sense. It is here that the name of the transportation company goes, as do the more prominently displayed credits of the painter and other individuals involved in the bodywork and decoration of the truck. Even though they would naturally lend themselves to large-scale paintings, the sides are never used for mural or panoramic art but rather for small tableaus, most commonly of landscapes and famous buildings, imagined individuals (e.g. beautiful women), animals, or of animals and people in idealized landscapes. All of these are themes of emplacement, either in the literal sense (e.g. the name of the transportation company) or in a signified sense (e.g. images of idealized inhabited or uninhabited spaces).[6] Traditionally (if such a word can be applied to a phenomenon of such recent vintage) there are no overtly religious messages on the sides of the vehicle. Buildings depicted on the sides might include famous mosques, but these do not function in a formally religious way in this context; rather, they are examples of locational decoration as outlined above. No apparent distinction is made between 'landmark' mosques (e.g. the Badshahi or Faisal Mosques) and other famous buildings of no formal religious value in this context (e.g. the Taj Mahal or Jinnah's mausoleum).

Plate 32:
The owner, Raja Muneer Hussain (right) and driver Mohammed Ayub (far left) taking delivery of a Bedford Rocket (Rawat 2003)
▽

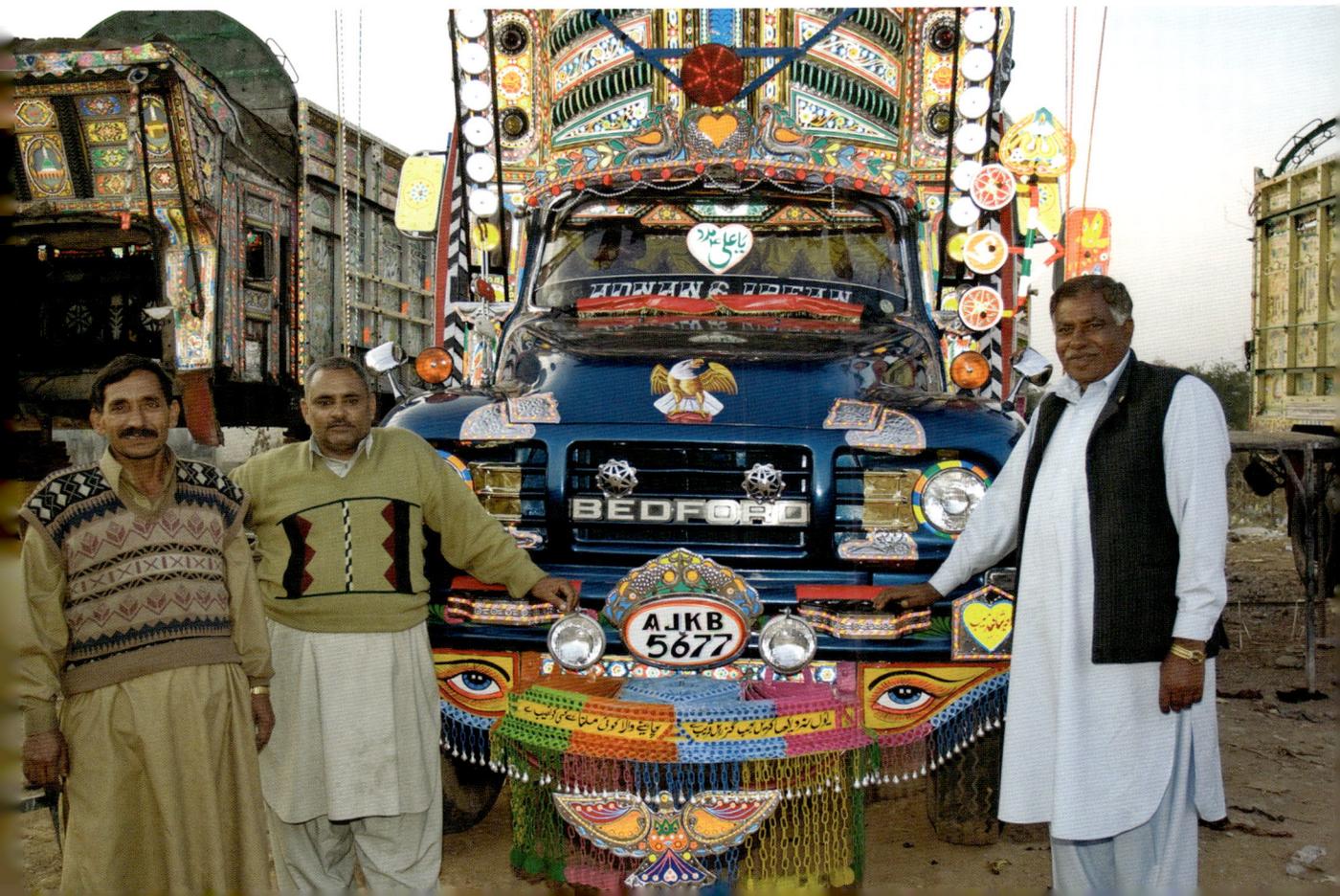

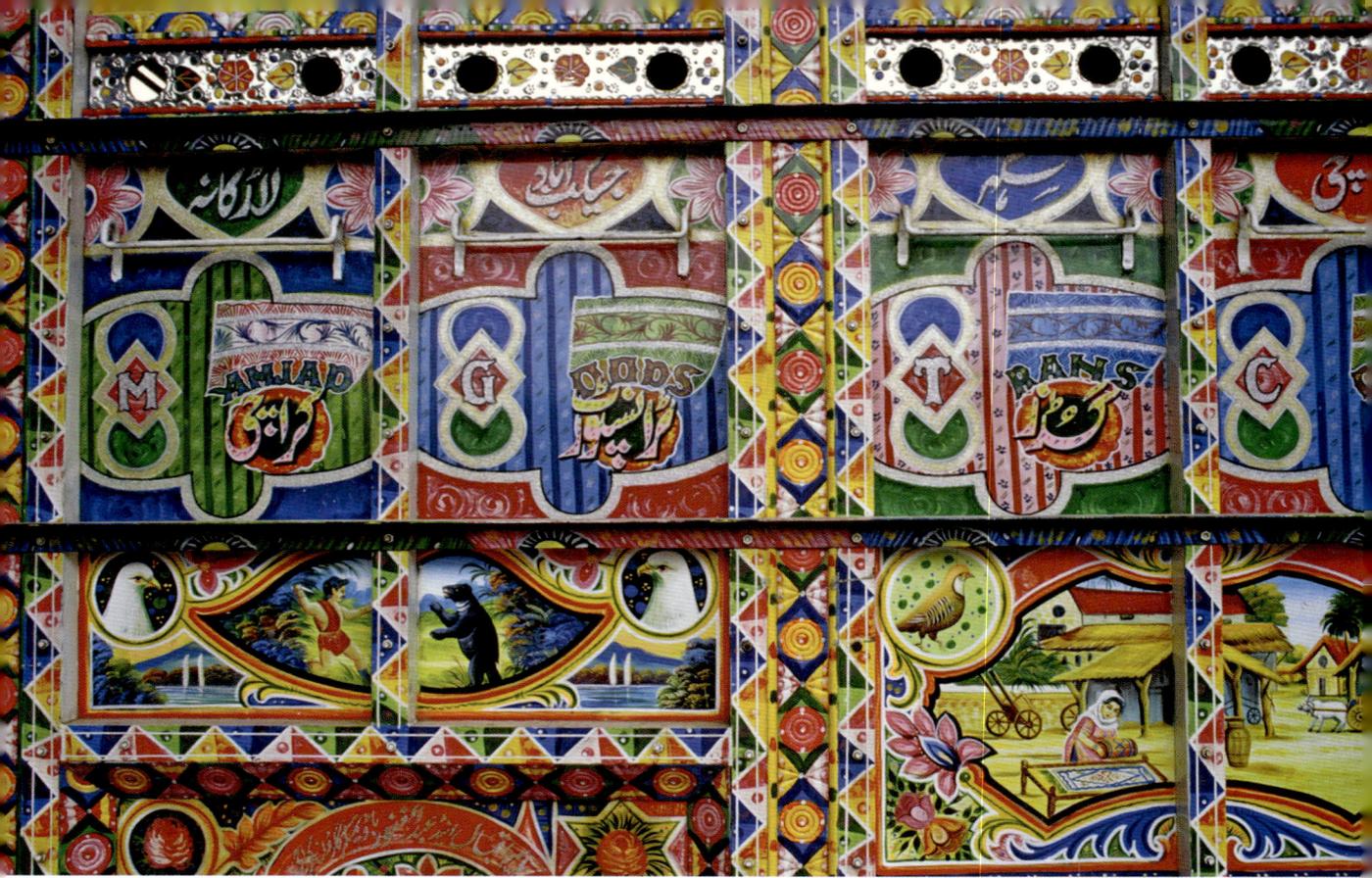

The front and back of the vehicle can each be divided into two vertical sections. In the case of the front, the upper section extends from the top of the vehicle to either the top or bottom of the windshield, the windshield itself functioning as something of a liminal space. In the case of the back, it goes as far as the tailgate, which, like the windshield, may or may not be included in the upper section.

The upper section of the back is the only place on the truck where there are large paintings, these being located on the four or five slats that slide in above the tailgate of most trucks in order to secure tall loads. This section of the truck is the least determined as a formal signifier, even though it is one of the most artistically defined parts since it is almost always the location of a large painting, very often a portrait.[7] Paintings on the back are very occasionally religious, in the form of representations of Buraq, the celestial horse that carried Muhammad on his ascension to heaven (mi'rāj), although this is itself a subject worthy of some discussion and is taken up in Chapter 9. More frequently, they are popular images drawn from both the world of entertainment (popular singers and actors) and national or sub-national culture (war heroes, politicians or tribal leaders).

94

△
Plate 33: Detail of side of a truck (Garden East, Karachi, 1999)

▷
Plate 34: A Bedford truck of the Rawalpindi style showing extensive hammered metalwork (Rawalpindi 2003)

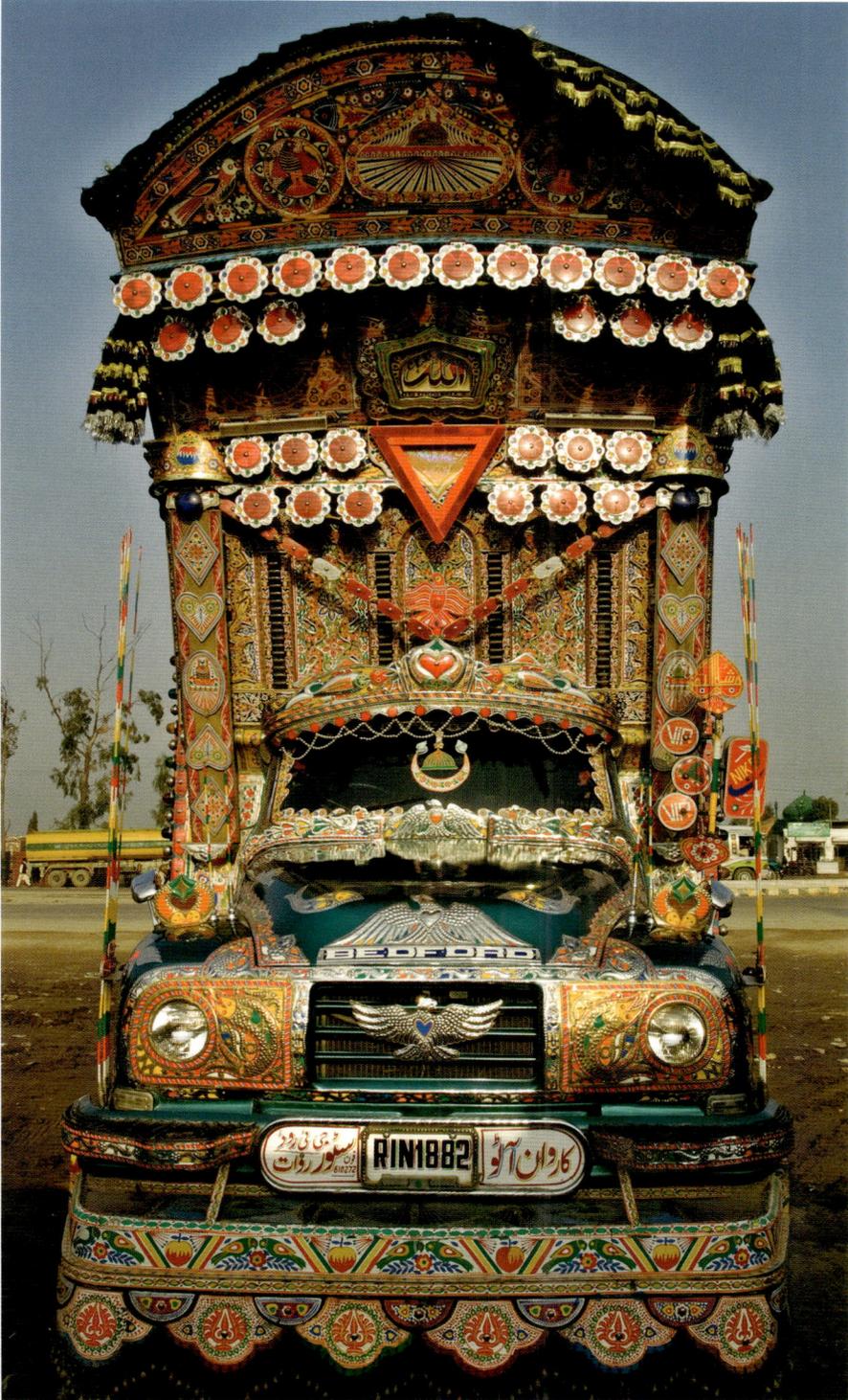

The lower section of the back typically displays writing, particularly humorous verses, pithy sayings, and popular moral and ethical exhortations (e.g. 'A mother's prayers are a breeze from heaven'). It is also common to have declarative statements referring to the hometown of the truck (e.g. 'Mianwali is my home', 'The pride of Fatehjang') or route information (e.g. 'From Kohat to Gujrat').

In contrast to the back of the truck, where the bottom section is humorous (or at least light-hearted) and the top section is either panoramic or reflects icons of popular culture, the front of the truck has a much more formal, studied layout. The bottom half of the front of a truck parallels the back in its use of poetry and aphorisms. However, the epigraphy displayed on the front lower section, though almost never religious, represents what the owner or driver would consider to be high literature. In actual fact, few of the verses placed there are drawn from recognized collections of Urdu, Punjabi or Pashto verse (the three languages most commonly used by Pakistani truckers). They are more likely to come from popular romantic songs, or else are couplets by lesser-known poets who have currency (often anonymously) in transportation culture.

The upper section of the front is the most semiotically charged part of the truck, where (largely unstated) strictures govern the placement and content of decoration more so than anywhere else on the vehicle. This section is where the overwhelming majority of religious signs are placed; in fact, based on extensive research, I would argue that – for the overwhelming majority of Pakistani trucks – overt religious symbols, such as pictures of the Ka'ba as well as invocations of God, Muhammad and saints, carry their intended spiritual charge only when they are placed in this section.

The contrast between the front and the back of the truck derives in part from important semiotic differences between the front and the behind, where the front is one's face to the world and the behind the butt of jokes. At a level specific to trucks in this context, there are several concrete reasons why these two spaces should be clearly defined. The back of the vehicle sees much more wear and tear because of the loading and unloading of cargo. As has been confirmed in several interviews, drivers, owners and artists frequently feel that such treatment, the questionable ritual purity of cargo and the fact that people clamber all over the back of the truck make it an inappropriate location for religious ornaments, images or epigraphy. In addition, the decoration of a truck, and especially the epigraphy, can only be appreciated in its full complexity when the vehicle is stationary. Such appreciation comes from individuals closely involved in truck culture and not from the urban bourgeoisie. As has already been mentioned, truck drivers routinely gather at rest areas, truck stops and cargo terminals at the *front* of the vehicles and therefore spend more time looking at the vehicle's face which, in this context, becomes the face of the driver and owner to the world. As such, more care is lavished on keeping it

▷
Plate 35: Truck of the Swati style. Note unpainted doors and the yak tails attached to the top of the truck, probably for talismanic purposes (Jaglot 1998)

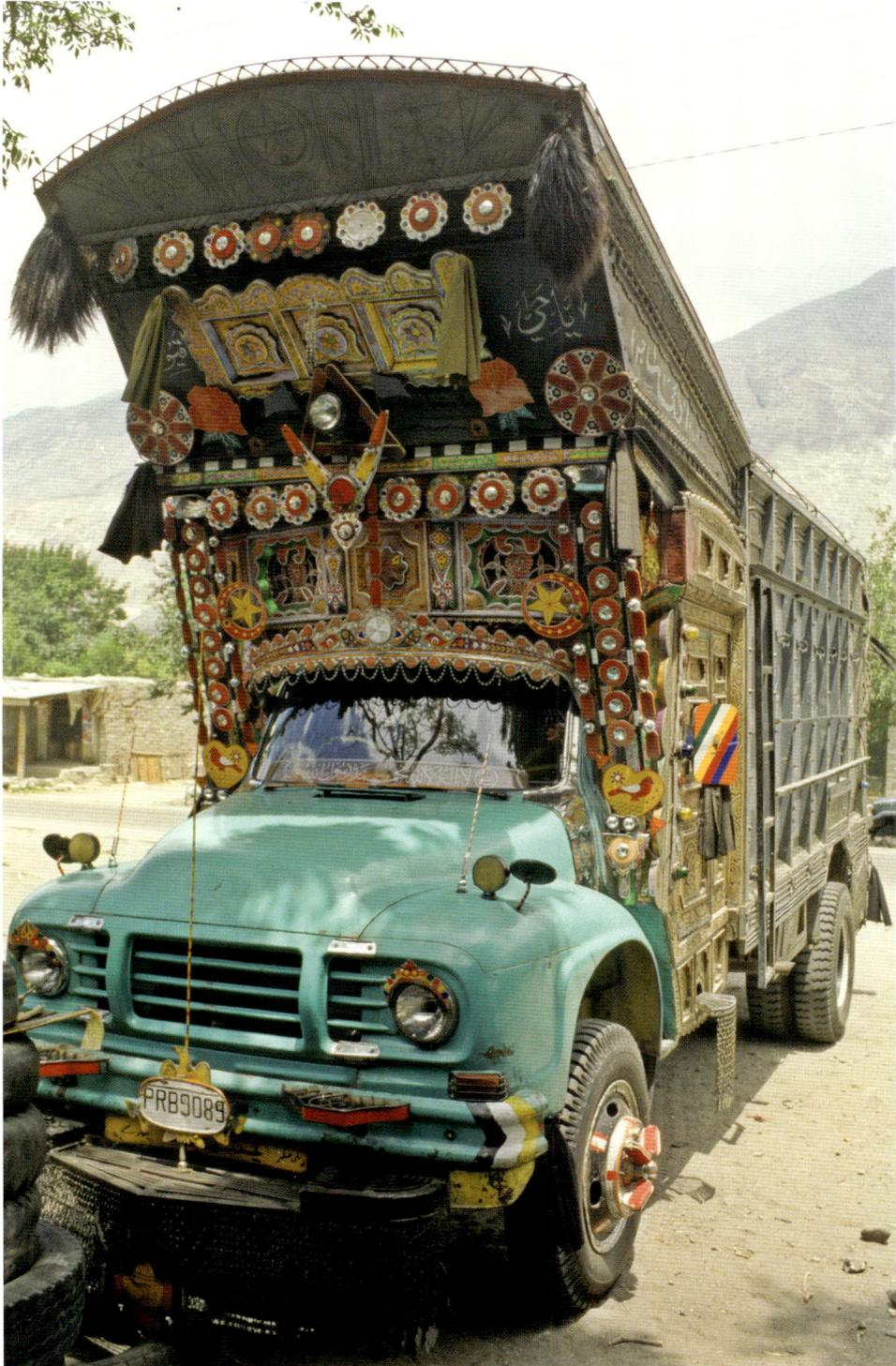

spotless, and public displays of religiosity and sophistication are made through this aspect of the truck.

Regional Styles

There are a number of different regional styles in truck design, although they tend to be extremely dynamic in modifying content, motifs, media and other elements of decoration, as well as unselfconscious, so that motifs, media and techniques are added and removed from the repertoire with great rapidity. Nevertheless, most truck drivers and designers assert that there are at least four basic regional styles of truck design. On the basis of my own research, I have identified five primary regional styles, most of which have secondary design categories; there is also a difference within each regional style between the way the Bedford Rockets – the iconic truck of Afghanistan and Pakistan – are decorated versus the more modern unibody and tractor-trailer trucks. Specific styles are identified with particular regions, which is hardly surprising given Pakistan's large geographic area and population, as well as its substantial cultural and linguistic diversity. However, a stylistic pedigree from a particular region does not necessarily imply that the truck was decorated there, since the mobility of truck artists and decorators and the lack of a kinship-based system of apprenticeship ensures that experts in particular regional styles relocate to other parts of the country.

The commonest variety of truck design is the Punjabi style, which accounts for most of the trucks built in the northern and central Punjab, Pakistan's most populous and prosperous province, as well as the area of Hazara in Khyber Pakhtunkhwa and Azad Kashmir (Pakistani-administered Kashmir). Truck design workshops are dotted all across the province of Punjab, but they are concentrated around Rawalpindi, Sargodha and Dera Ghazi Khan (although the last of these is a center of Balochi-style design). Rawalpindi, twin city to the capital of Islamabad, is located at the intersection of the two main traffic arteries in Pakistan: the north–south route connecting the sea and the major industrial and agricultural areas in the northern part of the country and on to China, and the east–west route connecting the center of the Punjab to the western city of Peshawar and on to Afghanistan. Sargodha (together with towns like Gujranwala and Gujrat) is a major center of agriculture and small industry and, perhaps as a consequence, has many design workshops (this area has the highest concentration of workshops doing coachwork for buses). Trucks of the Rawalpindi style are the most elaborate subcategory of the Punjabi style, particularly on the Bedford body: they have ornate metal cowlings (called a *tāj*, or tiara) above the windshield, and rely heavily on hammered metalwork and plastic appliqué in their decoration. These are then decorated with patterns made out of colored reflective tape (*chamak paṭṭī*). They are also the most likely of all trucks to

▷

Plate 36: Bedford truck decorated in the Peshawari style. Note the geometric ornamentation above the metal tiara over the windshield (Rawalpindi 2007)

Plate 37: Bedford truck in a variant of the Rawalpindi style. Note the extensive use of plastic, and the figural motifs (primarily fish) in the decorative program (Rawalpindi 2003)

▷

Plate 38: Hino truck in the Peshawari style. Note the exaggerated front bumper and the extensive use of colored plastic mirrors on the panels above the cabin (Turnol 2007)

Plate 39: Front of a truck decorated in the Balochi style. Note the degree of decoration, large bumper extension and extensive use of fine mosaic work in reflective tape (Turnol 2007)

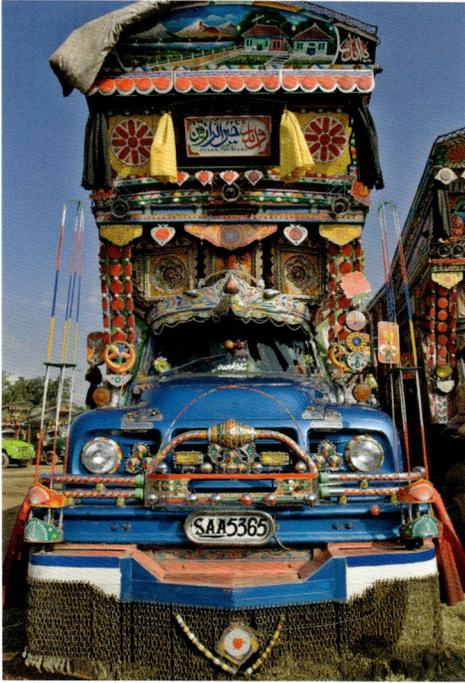
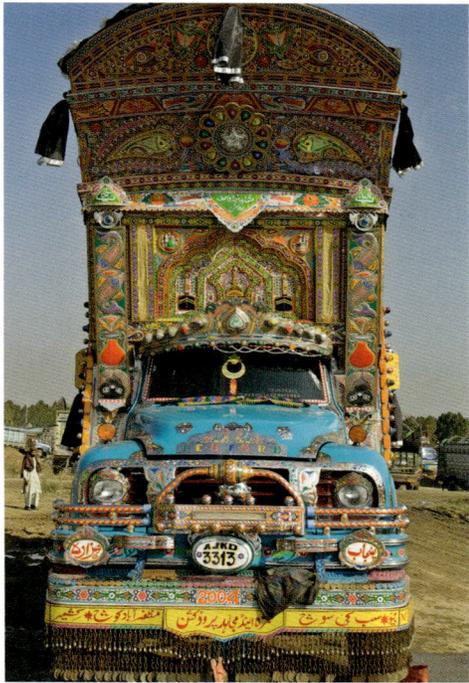
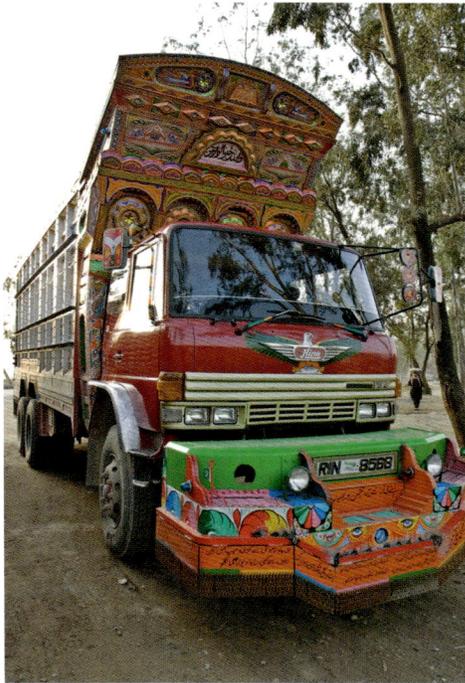
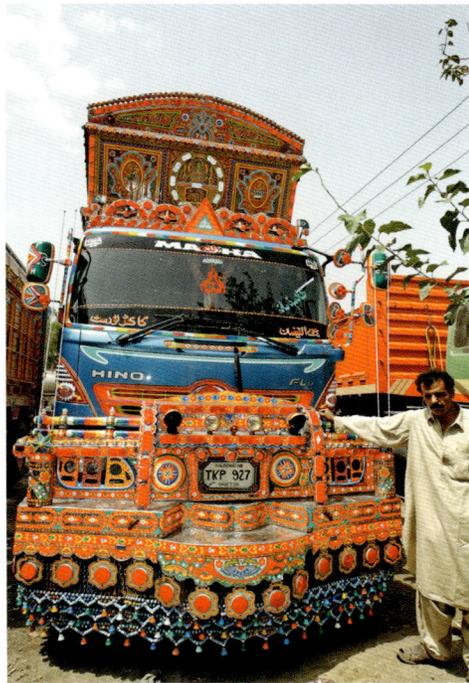

have smaller ornamental pieces attached to the front of the truck after the main decoration is done (see Plate 34).

The trucks of the Peshawari style are distinctive for their carved wooden doors, which are sometimes left unpainted, and for their very limited use of plastic and hammered metalwork. A variant of the Peshawari style is that of Swat, a valley in northwestern Pakistan that has a long tradition of wood carving. Many of the artists designing trucks in the Swati style have relocated to other places, particularly to Rawalpindi and its environs, because of better employment opportunities there. Peshawari style trucks fall somewhere in between the Rawalpindi and Swati styles: their doors are more likely to be painted than those of Swati style trucks and they use a metal cowling, only it tends to be simpler than that of a Rawalpindi truck. The major identifier of a truck in the Peshawari style is the use of a geometric pattern in the decoration above the windshield (see Plate 36).

There is a great deal of hybridization between various styles, in particular those of the Punjab (with the Rawalpindi style being the most distinctive but by no means the exclusive subcategory of Punjabi truck design), and the Peshawari style. Furthermore, there are fads to truck decoration that last for a very brief period before being replaced by something else. Plates 32, 59 and 60 show an older, more characteristic, Rawalpindi style, with very prominent metal grillwork extending diagonally above the windshield. The area between the slatted grills is frequently used as a canvas for writing verses of poetry or prayers. In contrast, Plate 37 represents a newer variant to the style, with an extensive use of plastic mosaic work replacing the metal. Both are identifiably of the Rawalpindi or Punjabi style, however, because of the absence of Peshawari style geometric boxes above the windshield, and the preference for figural and vegetative designs over geometric ones.

The differences in size, shape and underlying construction between the venerable Bedford Rockets and the more recent Hinos and Nissans have also given rise to new variants in the regional styles. The argument can be made that Rocket and Hino/Nissan design are entirely distinct from each other, particularly in the case of the Rawalpindi/Punjabi and Peshawari styles (see Plate 38), such that there are seven rather than five major stylistic categories to Pakistani truck decoration.

As is obvious from the example in Plate 38, the unibody construction of the cabin on the newer Japanese trucks effectively eliminates the characteristic ornamental elements of the doors, and since the windshield extends forward from the cargo bay further than it does on a Bedford Rocket, the vertical elements above the cabin do not flow upward from the windshield in the same way and therefore do not allow for the transitional ornamental features that characterize Bedford design in the Rawalpindi and Peshawari styles, as well as in others. Instead, the front of the cargo bay is decorated independently

▷
Plate 40 : Detail of mosaic work in reflective tape on a truck in the Balochi style (Karachi 2003)

▷
Plate 41: Fuel tankers near Karachi Port (2003)

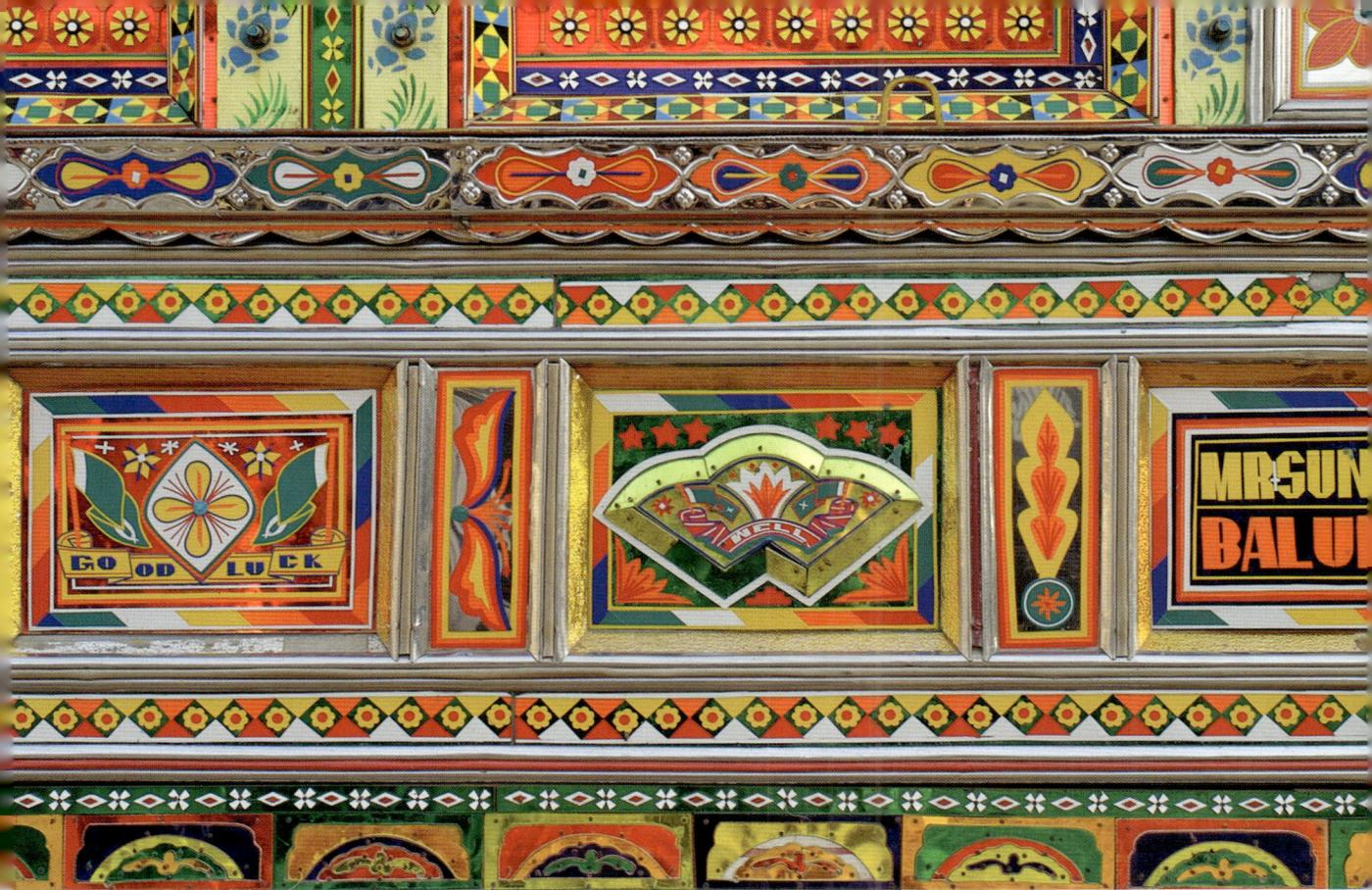

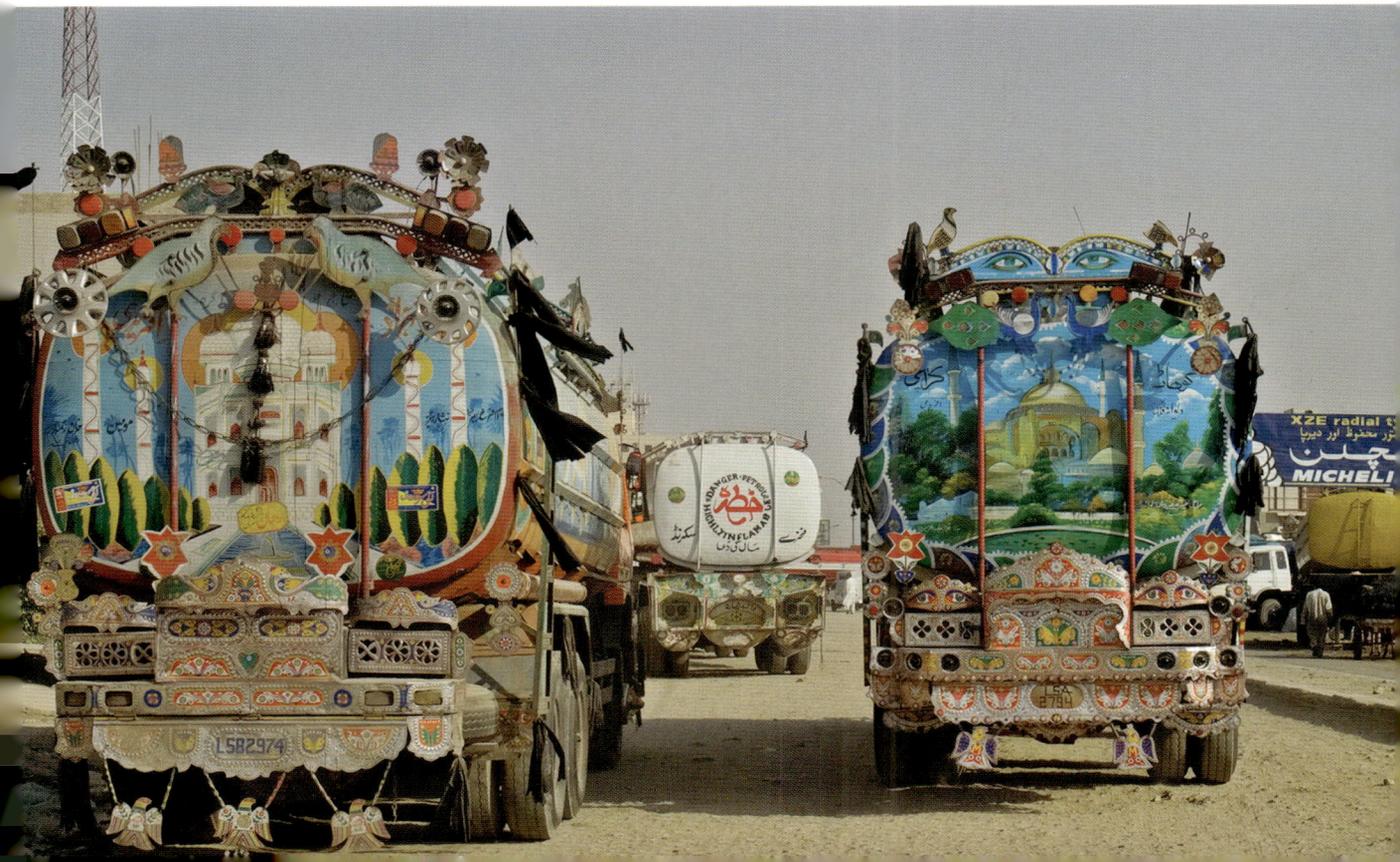

of the theme of the windshield area of the cabin and retains only a vestigial connection with the design of a Bedford Rocket: the geometric boxes visible in Plate 38 are reminiscent of the Peshawari-style Bedford; such geometric designs are now found on modern diesels decorated in the Punjab as far south as Dera Ghazi Khan, home to most of the shops designing in the Balochi style.

The Balochi style accounts for the majority of trucks from Baluchistan where workshops are centered around the towns of Quetta and Zhob, although there are also Balochi

▷

Plate 43: Interior of a 'disco' truck in the process of preparation by Muhammad Altaf 'Tafu' (Deh Movach, Karachi 2003)

Plate 42: 'Disco' truck in process of preparation by Muhammad Altaf 'Tafu', a renowned specialist in the style. Note the mirror work around the windshield, the two circular red lights, and the circular hole awaiting the installation of a larger light on the brightly painted, carved wooden panel at the top of the truck (Deh Movach, Karachi 2003)
▽

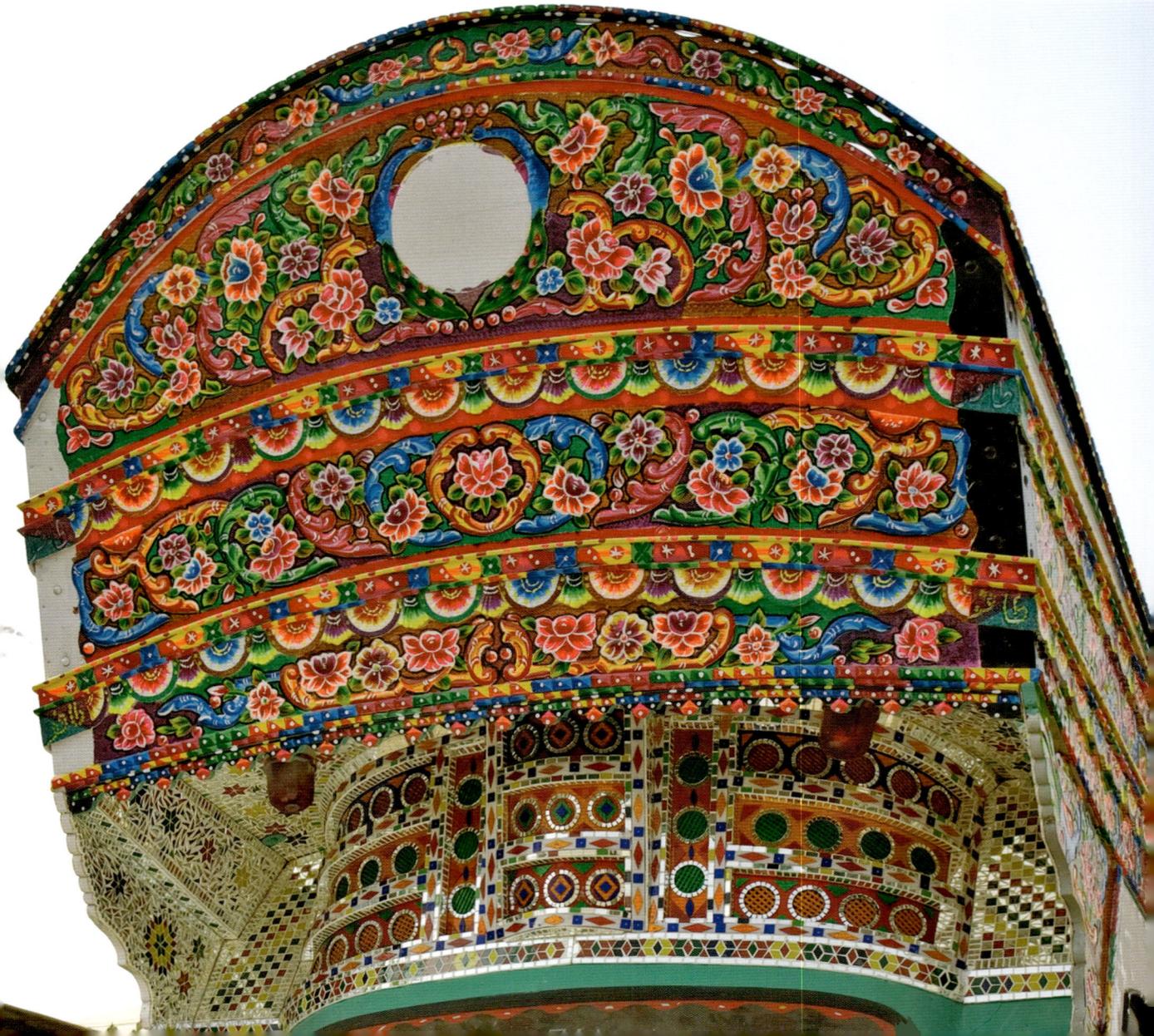

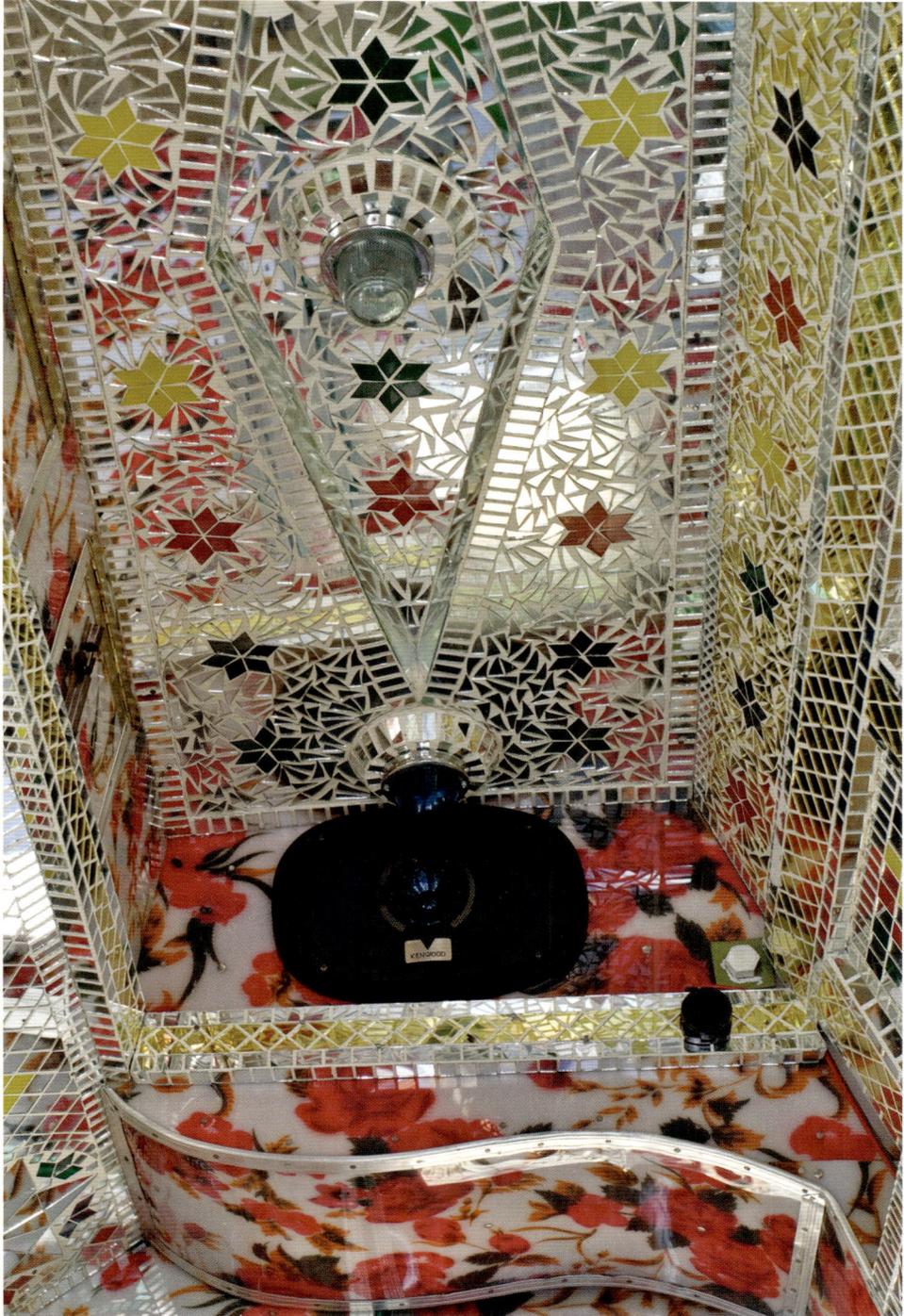

workshops in and around Karachi, and many trucks in this style are made in Dera Ghazi Khan in the Seraiki region of southern Punjab. The Balochi style is easily identifiable because the trucks themselves are distinctive: while Bedford Rockets still constitute a significant portion of trucks in Pakistan, Balochi-style trucks are now almost exclusively the larger and more powerful imported diesels that can be used for longer hauls as well as for business that relates to the seaports of Karachi and the Baluchistan coast. In terms of design, these trucks use more geometric patterns on side panels than others, and frequently have chrome modifications made to their bumpers in the form of extensions and grill guards (see Plate 39). They are also the most expensive, with between Rs. 1 million and Rs. 1.6 million ($16,000 to $26,000) being spent on top of the roughly Rs. 2 million ($35,000) cost of a bare chassis in order to build up and decorate the truck (2007 figures).

Karachi does not have an easily identifiable style of its own, but is characterized by an amalgam of several sub-variants. As Pakistan's major sea and land port, as well as its primary metropolitan area, Karachi has more trucks than any other place in the country. It also has truckers from every other region, many of whom choose to decorate their trucks in the styles of the area to which they belong. The only distinctive Karachi designs I have been able to identify are variants characterized by a flat panel above the windshield. The first variant has the wooden panel above the windshield carved in relief with vegetative and floral motifs and colored with iridescent paints. This design is most common in water tankers, a kind of truck ubiquitous in Karachi because the municipal water supply is hopelessly inadequate, and entire neighborhoods get their water from independent suppliers who deliver it in tankers (see Plate 41). A variant of this style of truck comes from the eastern desert of Thar, and is similar except that the carved front wooden panel is not painted.

The other subcategory of the Karachi style is one ordinarily referred to as the 'disco' truck. The name derives from the extensive mirror-work on the underside of a ledge shading the windshield (and normally also inside the cabin), which is combined with a flashing light to give what is characterized as a 'disco' effect (see Plate 42).

The final category of trucks is not a style per se, but the distinct genre of tractor-trailer truck decoration. Tractor-trailer trucks still constitute a minority among Pakistani trucks and, due to their greater length and poorer maneuverability, are not normally seen in the same truck stops as the rigid-body Bedfords, Hinos, and Nissans. Trailers are used to transport larger and more expensive goods than other trucks, such as automobiles and shipping containers, including those destined for Afghanistan. In many cases, not only the tractor but also the flatbed trailer belong to the same owner, in which case the sides and back of the trailer are also decorated (see Plate 44). Styles of trailer decoration are not as clearly identifiable as they are for other trucks as yet, although the decoration of

▷
Plate 44: Tractor-trailer truck. Note the decoration covering all of the flatbed trailer (Turnol 2007)

▷
Plate 45: Tractor-trailer truck. Note the hammered metalwork normally characteristic of the Rawalpindi style (Taxila 2007)

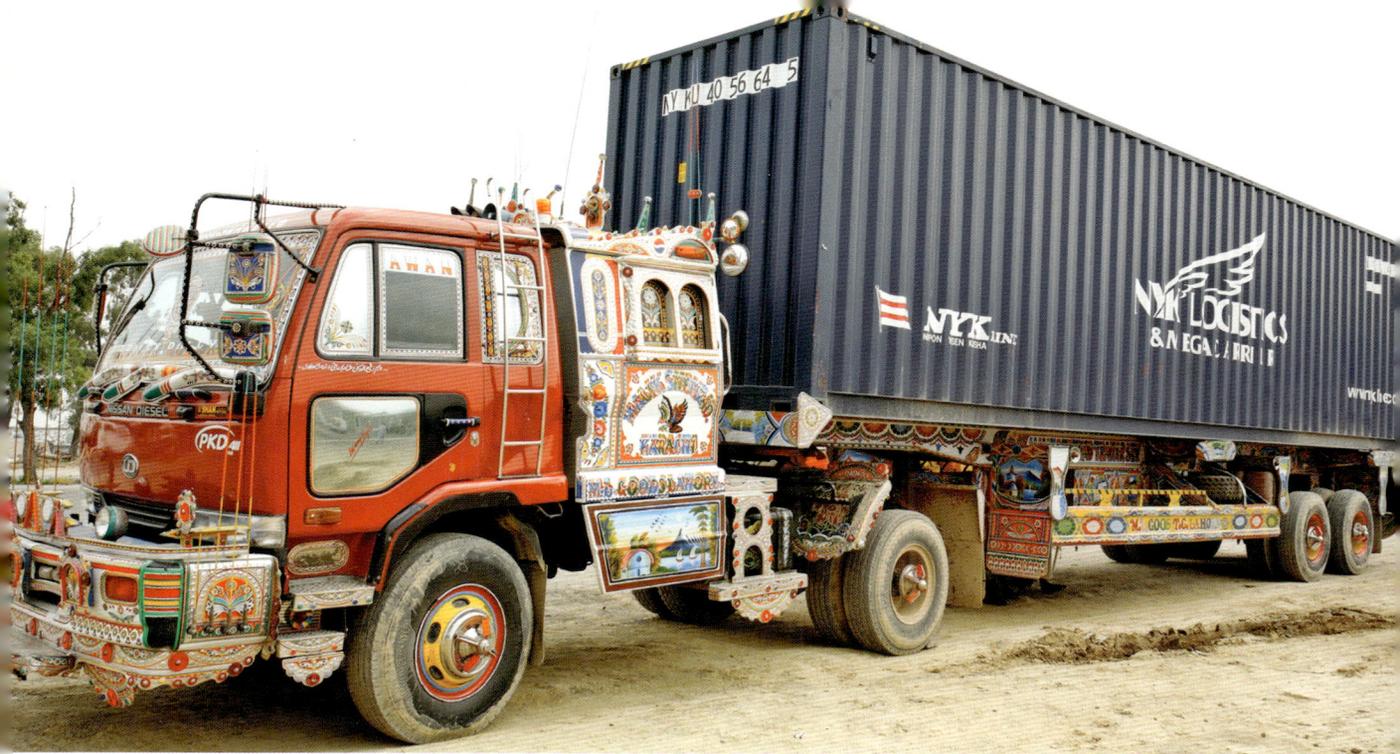

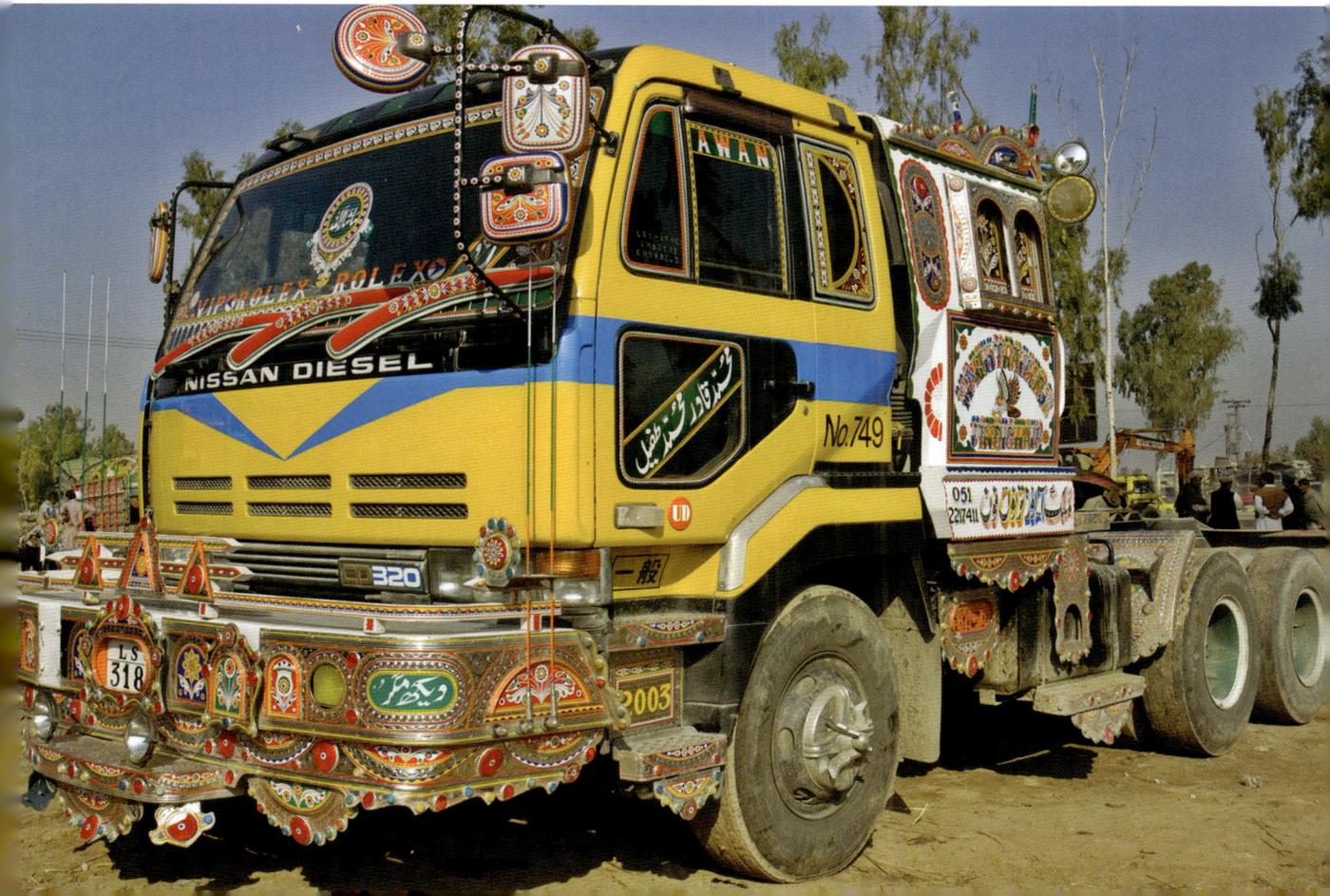

trailers shows elements of regional styles (such as the use of metalwork characteristic of Rawalpindi and the northern Punjab, or small figural decoration along the lower frame often seen in 'disco' trucks from Karachi).

Thus, in addition to amounting to a massive economy in terms of the sheer numbers of trucks being decorated and the pervasiveness of the industry across the country, truck decoration comprises a scopic regime unto itself with clear differences between various styles, reflecting ethnic and regional differences as well as the aspirations and aesthetics of individual owners, drivers, and truck decorators. The decoration itself is determined to some degree by the physical limitations of various kinds of trucks, and they cover a range of purposes and significations which are explored in the next chapter.

7

Structure, Motif, and Meaning

I don't care about my burden,
I only care about the dollars,
I've come from England, Bedford is my name,
If the driver feels up to it, passing is my game!
Truck verse

The Bedford Rocket may well be seeing the end of its days, having been all but replaced for long-haul trucking by the more modern and ultimately more economical Japanese diesels and tractor-trailer trucks, but the Rocket remains the quintessential Pakistani truck for all styles except that of Baluchistan. Writing in the 1970s, Dutreux described two basic styles of truck, the 'Raket' (rocket) and 'Chakla' bodies.[1] *Chaklā* literally means 'open' or 'flat' and refers to a flatbed truck with low side rails or none at all. 'Chakla' trucks with low sides have all but vanished from the roads, and the majority of such trucks are true flatbeds, which are not at all common and are seldom referred to as *chaklā*. What Dutreux described as the 'Raket' body is the high-sided, enclosable truck ubiquitous to modern Pakistan and adapted, with very little variation in construction (as distinct from style) from the Bedford Rocket to modern diesels with unibody cabins.

The typical Bedford Rocket has a modular front with separate fenders, hood (bonnet), grillwork, windshield and supporting pillars attached to a subframe. The console immediately above the windshield, normally referred to as a *tāj* (tiara) and already mentioned as a distinctive characteristic of trucks in the Punjabi style, serves no structural purpose except for the bolsters toward its outsides which support an open compartment above the cabin providing space for the storage of lashing materials, a canvas cover for the back of the truck, and other supplies. The doors are normally made of wood or composites of wood with a metal frame (see Plates 46 and 47).

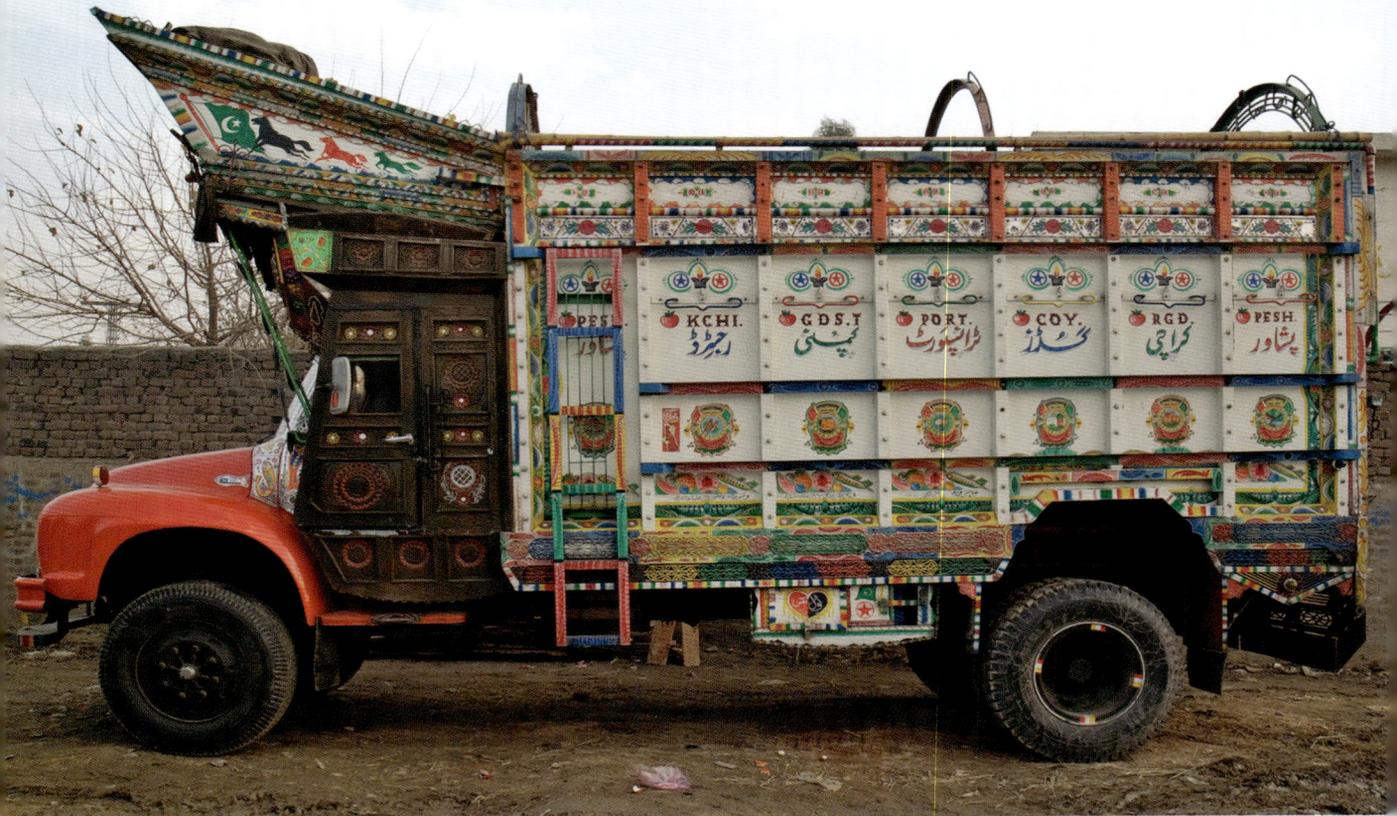

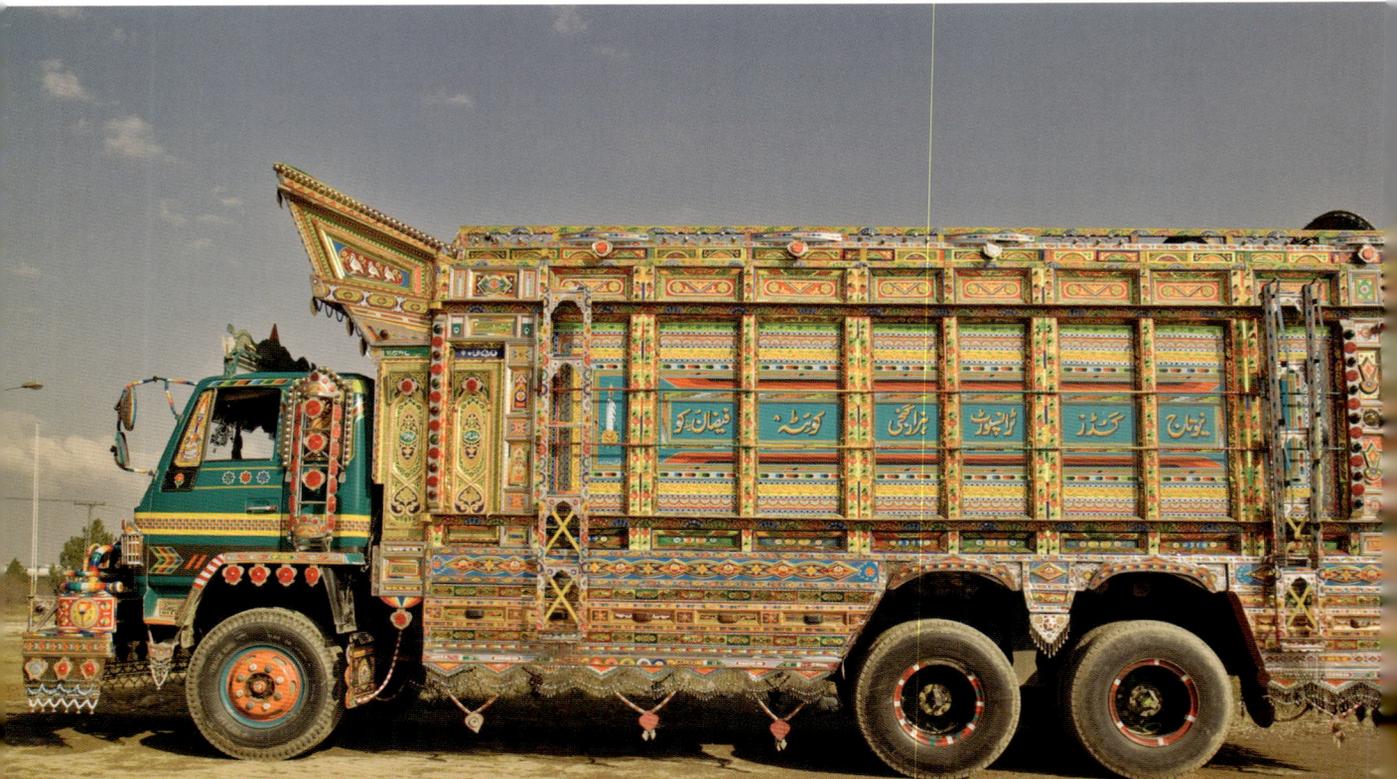

The cargo-bearing section of the truck is constructed by welding a series of vertical metal bars (normally eight to ten per side on a Bedford Rocket, more on larger trucks) between larger horizontal bars along the top of the sides and along the bottom, all of which are welded to metal beams across the bottom, which are then covered with metal (or occasionally wood) flooring. Additional metal bars (at least three per side on a Bedford) run horizontally along the outside of each flank of the truck, and three or four metal arches connect the two flanks to each other. The tailgate of the truck is made of metal and above it is a series of vertical metal slots for horizontal wood planks that effectively close off the back of the truck and secure large loads. The metal frame of the truck body is filled in with slats of wood such that the entire back of the truck constitutes a rigid container that can be bolted or welded onto the chassis. In fact, Bedford Rocket chassis can (and do) have the truck body unbolted and lifted off and replaced with a bus body as needed, and then have the truck body replaced again, allowing the vehicle to be converted from cargo to passenger use as needed (see Plate 48). Admittedly, this is not done very often, but it is not even an option on newer trucks with unibody construction.

Two different kinds of wood are normally used in the construction of the truck body: varieties of pine (such as *nishtar* [Blue Pine or *Pinus wallichiana*]) for the boards in the back and the sides, and a more expensive hardwood, *shisham* (also called *ṭālī*, a rosewood [*Dalbergia sissoo*]), for the panels on the façade and the doors, which can also sometimes be of walnut. The pine is chosen for low cost, while the *shisham* is often of the highest furniture grades and is chosen for its durability.[2] The pine on the rear of the truck is always painted while the hardwood around the cabin, and including the doors, may be carved or covered with a combination of metalwork and plastic appliqué, as has already been mentioned (plastics having been introduced into Pakistani truck decoration in the 1970s).

The body of the truck is supplemented with a number of parts that, though functional, also provide an opportunity for ornamentation. These include the bumpers, gravel guards below the front and rear bumpers, the (very vulnerable) gasoline tanks placed toward the outside, mirrors, a variety of handles and lashing points, and steps and footholds to climb into the high cabin.

The wooden doors of the Bedford Rocket have traditionally been a heavily decorated element of the truck and constitute one of the most important stylistic differences between the older Rockets and the newer Japanese trucks, the doors of which are part of the unibody construction and are not decorated except in very modest ways. The amount of exposed carved wood versus the use of plastic appliqué on doors is one of the distinguishing characteristics of regional styles. Such doors, however, do not offer any measure of protection in the event of a crash, and their tiny windows are difficult to see out.

109

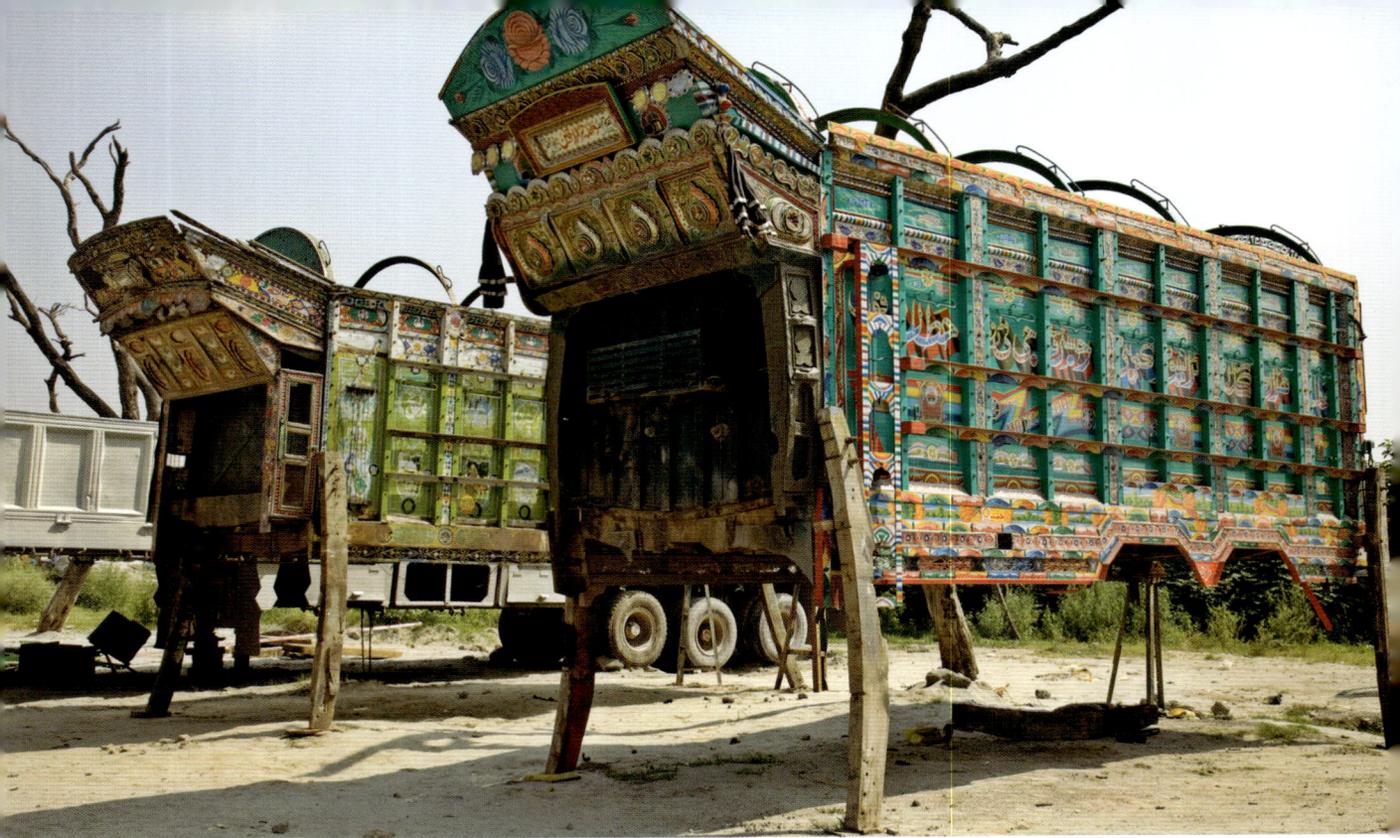
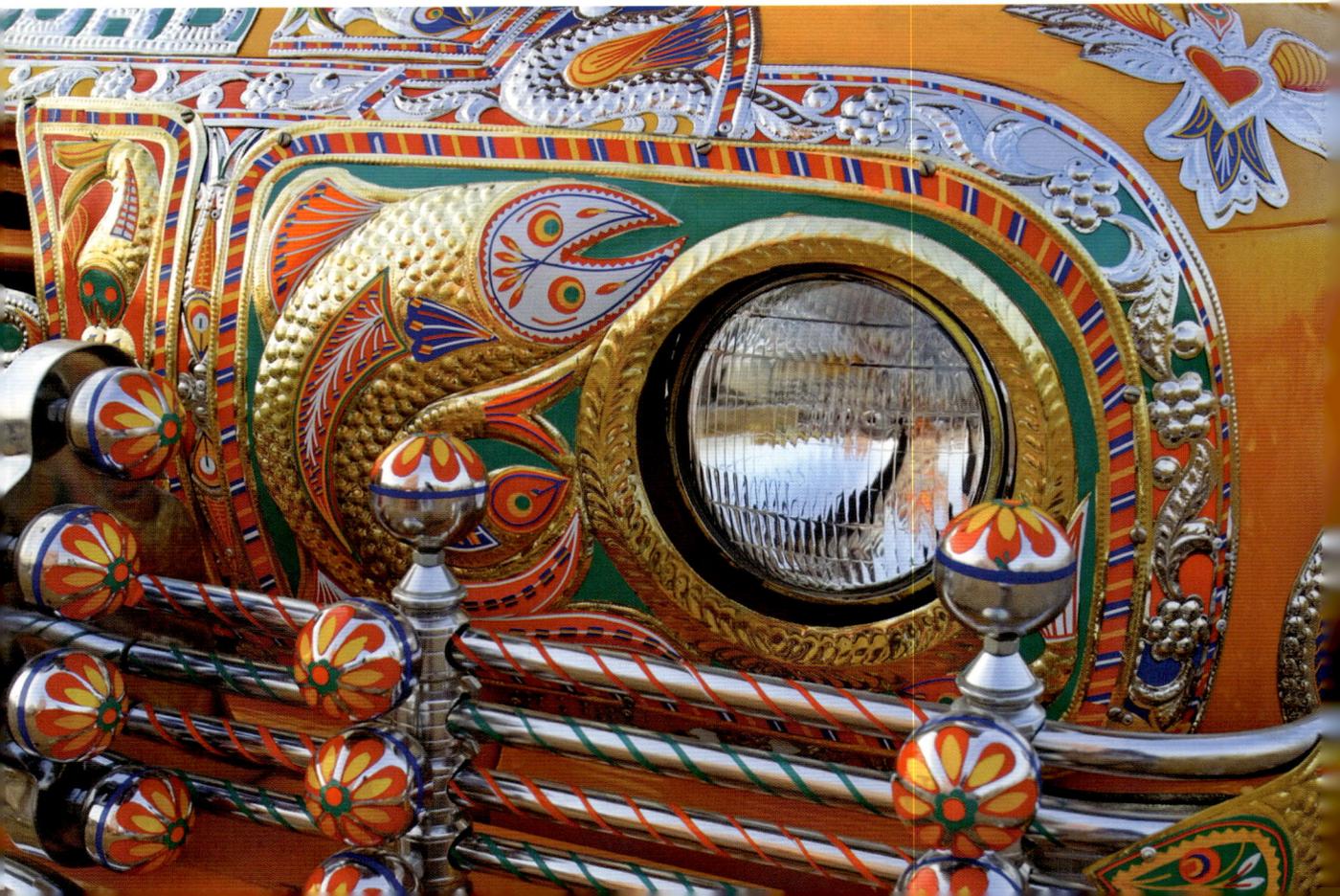

◁

Plate 48: Truck bodies
ready to be attached to
Bedford Rocket chassis
(Turnol 2007)

Interior

The interior of the cabin is ornate in all trucks except those in a very poor state of repair. There are far fewer upholstery shops than there are workshops specializing in truck painting and the various aspects of exterior ornamentation, and the majority of the good upholsterers are in the Punjab.[3] This is due to truck upholstery being, for the most part, a small addendum to the much larger business of upholstering buses, which is an almost entirely Punjabi industry.

Truck interiors are extremely ornate, but they appear to lack the semiotically loaded nature of the exteriors, with some very limited exceptions, such as the use of religious stickers or talismanic objects attached to the windshield or hung from the rear view mirror just as they are in a broad spectrum of vehicles around the world. The ornate interiors are there because of the aesthetic need to have a pleasing work environment, but they also have an ergonomic function in addition to their larger semiotic one. According to most drivers, the lush colors of the interior complement the red light that bathes the cabin at night, and together they not only prevent the drivers from falling asleep, but also keep them relaxed. At the same time, the ornateness and heavy upholstery imitates truckers' aesthetics both in room decoration as well in the use of bead and lace trimming on women's clothes. Understood from this perspective, the interior is part of the overall feminization of the truck by evoking domesticity as well as femininity, a subject discussed in some detail later in this chapter.

Motif and Meaning

Earlier scholarship on truck decoration in Pakistan, especially the work of Dutreux, has made much of the formal analysis of motifs. Although I certainly agree that motifs within the decorative programs of individual trucks are important – as they are for truck decoration as a genre – I cannot help concluding that such writers have overstated the formal significance of decorative motifs. Firstly, few of the commonly used symbols have nationally agreed upon meanings of the kind that would exist in some sort of dictionary of iconography.[4] Additionally, and this is a key point in my analysis, trucks exist as semiotic devices as well as artistic objects in their *composite* form. They are greater than the sum of their individual parts or decorative motifs – corporate creations based on the collaboration of designers, owners and drivers. As such, focusing on the formal nature of individual motifs is misleading, doubly so since, as I explain later in this chapter, text rather than image forms the most vital element in giving the truck meaning.

◁

Plate 49: Chrome detail
and bumper, Bedford
Rocket (Rawat 2003)

The pitfalls of an overly formal analysis of motif and meaning notwithstanding, I would identify seven categories of motifs within the general scheme of decoration on

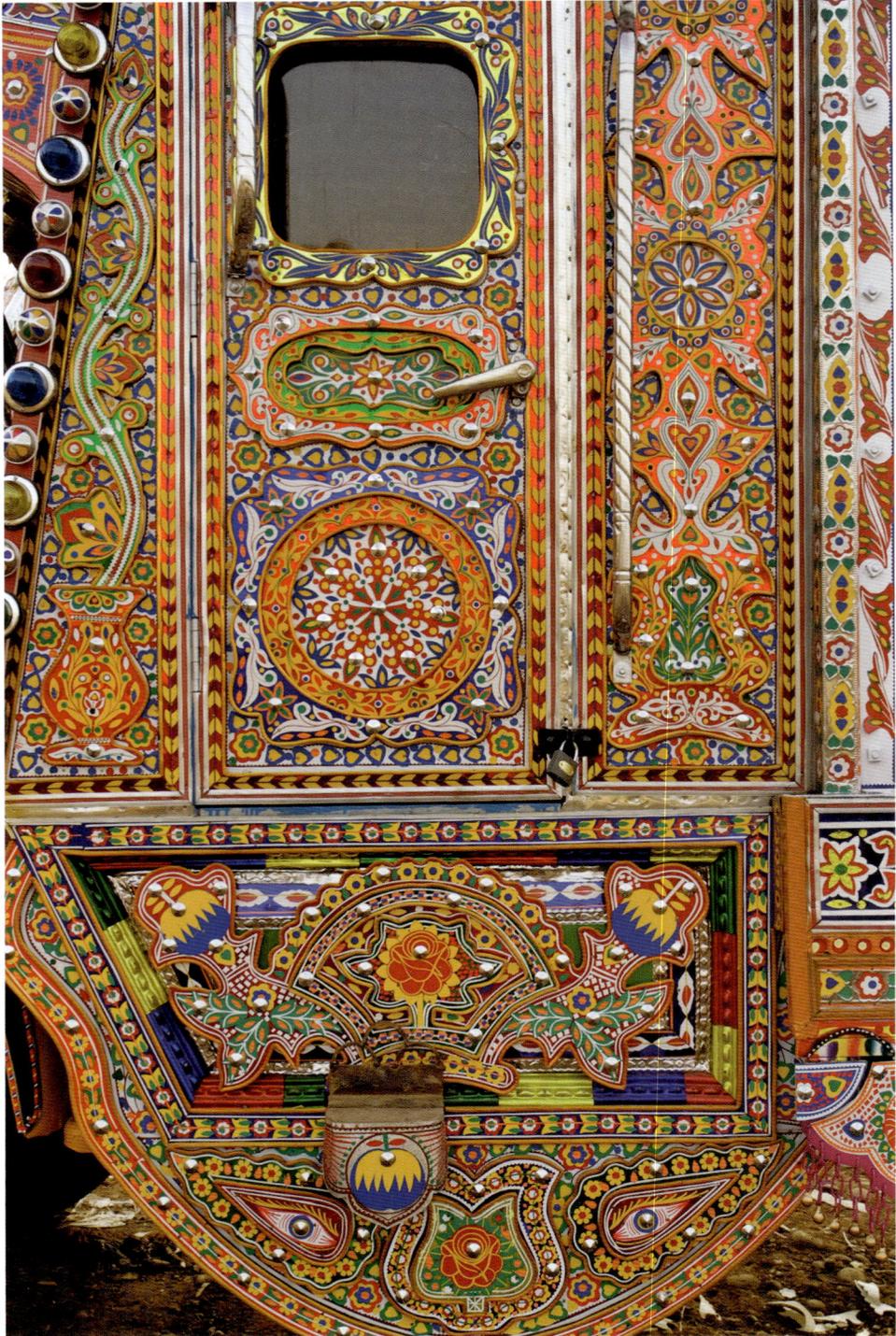

◁

Plate 50: Door of Bedford Rocket in the Rawalpindi style. Note the extensive use of reflective plastic tape over plastic appliqué cutouts (Rawalpindi 1999)

Plate 51: Cabin interior of a Bedford Rocket. Note the photographs of the truck displayed on the dashboard as a sign of the driver's pride in the vehicle (Turnol 2007)
▽

a Pakistani truck. In my classification, I am departing from established analyses that are sign-based, distinguishing between the figural and the calligraphic (for example). Instead, I am attempting to focus on the signification of all the visual symbols on the truck, and undertaking an analysis of visual decoration that suspends, for the moment, my reservations concerning the efficacy of visual images as a linguistic system and the treatment of the picture like the pattern or like the text.[5]

I am, however, distinguishing between the decorative and the ornamental, where the ornamental is the stylistic flourish of an essential constitutive element of the truck (the shape of the step up to the cabin, for example, or the paintwork on a wheel), whereas the decorative is all the work done to the truck that is not essential to its function (such as color choices, or the geometric and floral patterns that cover most of the truck). Decorative elements with obvious symbolic value – such as the images of the Ka'ba, or textual references – present a problem of categorization: they could easily be considered ornamental; however, since no individual decorative element of the truck is constitutive of its primary function as a vehicle, nor of its secondary function as a semiotic device (since it functions as such corporately,

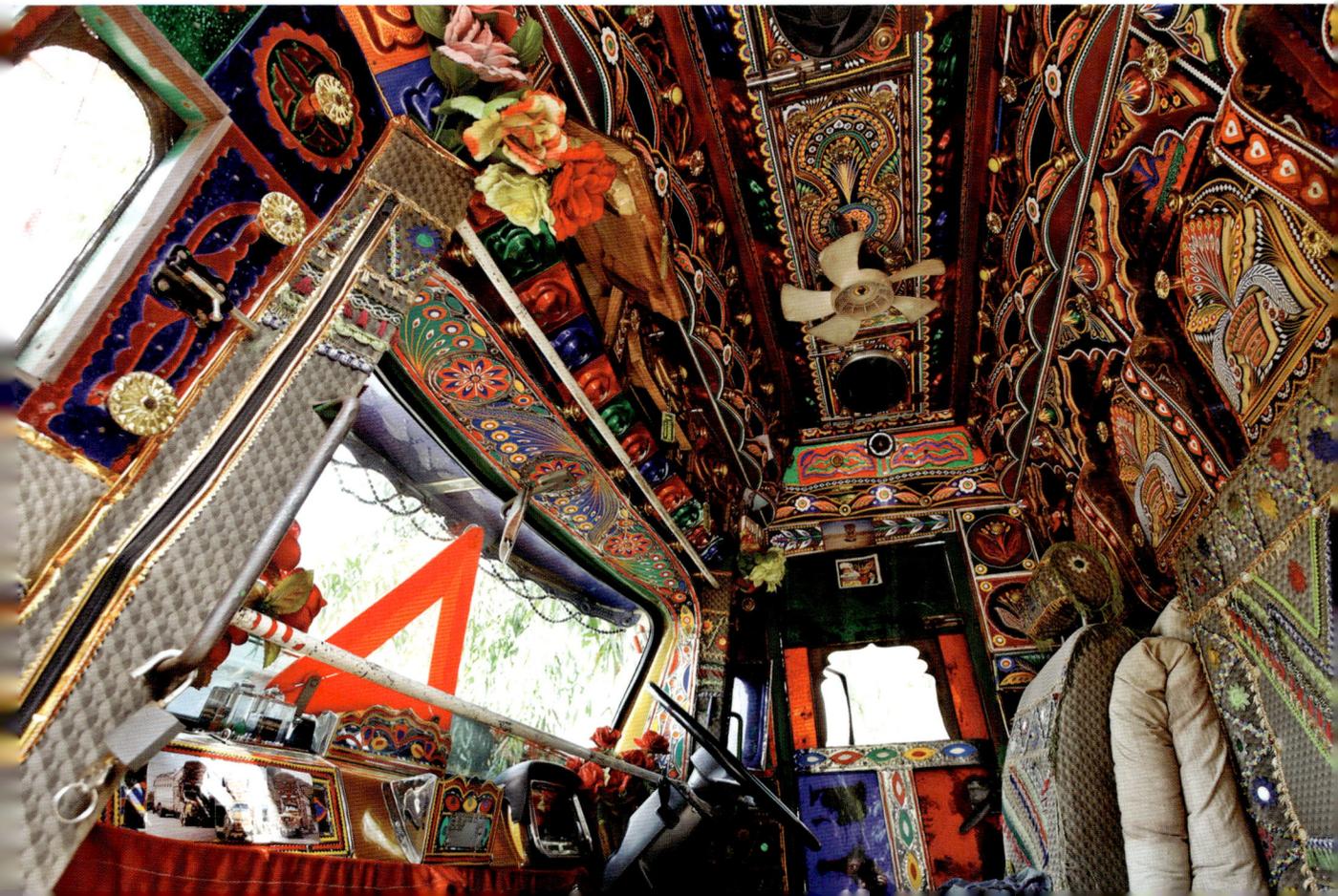

not atomistically), I feel more comfortable referring to all motifs as decorative elements.[6]

The seven categories of signifiers in the decorative motifs on the Pakistani truck are as follows:

(1) *Explicit religious symbols and images.* These include the majority of the calligraphic program of the truck as well as explicit religious symbols such as the Ka'ba. Some of these religious symbols are mixed in their signification, such as the star and crescent that simultaneously represent Islam and Pakistan. Furthermore, as I discuss at some length in the next chapter, visual religious images such as Buraq, the celestial horse that carried Muhammad on his journey to heaven (*mi'rāj*), function ambivalently (or perhaps multi-valently) as signifiers, and are not understood to be religious by all audiences. In this category also fall the names of prominent or regional Sufi saints who are invoked for protection, although arguably these could be seen as part of the religious calligraphic program of decoration.

By far the most common religious symbols appearing on trucks are pictures of the Ka'ba in Mecca and the Prophet's Mosque in Medina. These images almost invariably appear on the front of the truck (almost never on the sides or the back), somewhere toward the top. With very few exceptions, the image of the Ka'ba appears on the left side of the truck and that of the Prophet's Mosque on the right. The purpose of this arrangement is almost certainly for them to be representational of what they symbolize – Allah and Muhammad – and to mimic the way in which their names would be written or, more accurately, read: the name of God always precedes the name of His Prophet, and an individual reading in the Arabic script would read from right to left while facing the truck.

(2) *Talismanic and fetish objects.* These include a variety of amulets and other objects believed to possess powers that are talismanic, most often in the prophylactic sense of protecting the truck, the driver and his and the owner's livelihood from evil. These include animal horns, tails, flags of various kinds acquired from the shrines of Sufi saints, as well as other objects of personal significance.

(3) *Talismanically or religiously loaded symbols.* This category is distinct from the preceding one in that it is not the decorative object itself that possesses talismanic or prophylactic power, but the thing that it represents. Such symbols account for the majority of decorative motifs on the truck, and are both painted on during the initial design as well as added later in the form of stickers and smaller objects attached to the body of the truck. Common symbols are fish, which represent good fortune, and eyes, though the latter are very ambiguous in their symbolism because they appear to serve multiple purposes. Eyes often represent protection from the evil eye (*nazar*), but the eyes on the

▷

Plate 52: Cabin interior of a Bedford Rocket with extensive mosaic work in reflective tape (Rawalpindi 2003)

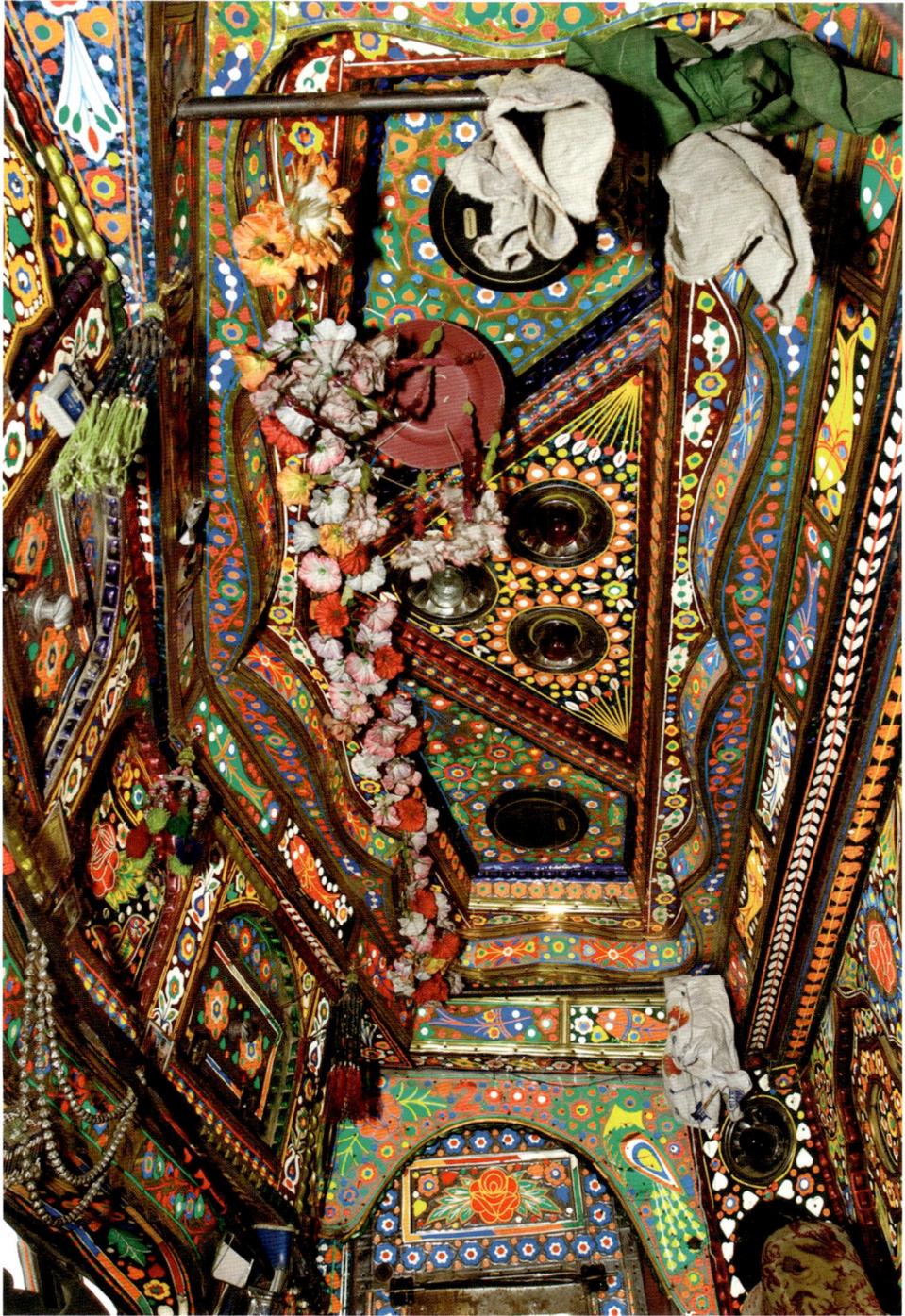

truck are exaggeratedly feminine, thereby serving not only as symbols of beauty but also as active elements in attributing a feminine personality to the truck.

(4) *Idealized elements of life.* These include naturalistic paintings of landscapes, women, and pleasing animals, particularly birds. Idealized alpine landscapes and romanticized villages that the driver never gets to visit figure prominently in this category of motifs, existing as utopias that are no less fictive than the dystopias of real life that they serve to evoke.

(5) *Elements from modern life.* A wide spectrum of motifs comes together in this category and, at first glance, it may seem that they do not share very much by way of signification. There are relatively common images of modern vehicles such as ships and aircraft, pictures of celebrities from the entertainment industry (e.g the late popular Punjabi singer Noor Jahan), as well as politically significant representations such as the Pakistani flag or portraits of military and tribal heroes. What all these images share is an overall representation of understandings of modernity and the place of the individual (be it the artist, truck owner, or driver) relative to society, religion and time. Viewed in this way, popular ex-presidents, the flag, revered singers and representatives of high technology (the aircraft are invariably those of the Pakistan Air Force or the national airlines) all belong together in defining senses of national social identity.

(6) *The non-religious epigraphic program of the truck.* This category includes the romantic poetry, pithy aphorisms and humorous quips written on the truck, as well as primarily utilitarian lettering, such as the writing of the name of the transportation company to which the truck belongs. In actual fact, epigraphy is multivalent and does not necessarily constitute one category. As I discuss in the next chapter, religious epigraphy can transform into spatial signifiers, undermining formal categorical distinctions. It is also possible to see the spatial lettering related to the truck and its routes as elements of life and therefore belonging to the previous category, while the romantic and philosophical poetry – what the driver and his comrades would view as high literature – belong in one category and the humorous anecdotes in another, thus dividing the non-religious epigraphic program into the serious and the whimsical.

(7) *Design as ornamental device.* The remaining decorative elements of the truck do not function as signifiers in the manner of the six categories outlined briefly above, not even in multivalent or ambivalent ways. The function of the remaining elements is to cover the expanse of the truck for the purpose of making it beautiful, which is meaningful in and of itself. As is brought up again and again in interviews with truckers – artists, owners, and drivers alike – beauty is not accidental to Pakistani trucks but is an essential element, without which a truck cannot be complete, where completeness does not imply solely the mechanical ability and structural integrity necessary for transporting goods, but the additional aesthetic qualities that transform this particular means of

▷
Plate 53: Detail of the side of a truck in the Balochi style showing a fine example of the style of painting called gulkārī *(Turnol 2007)*

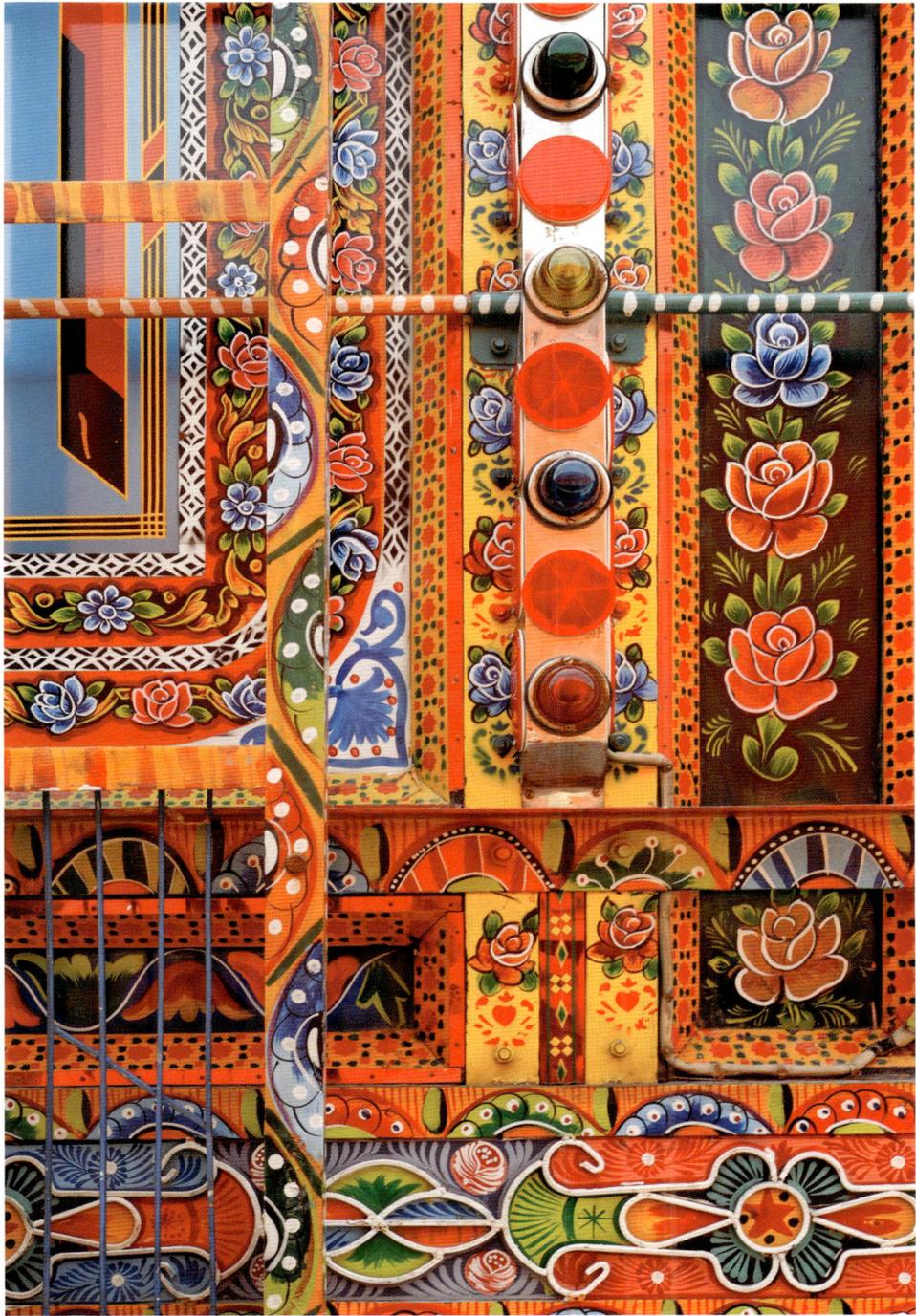

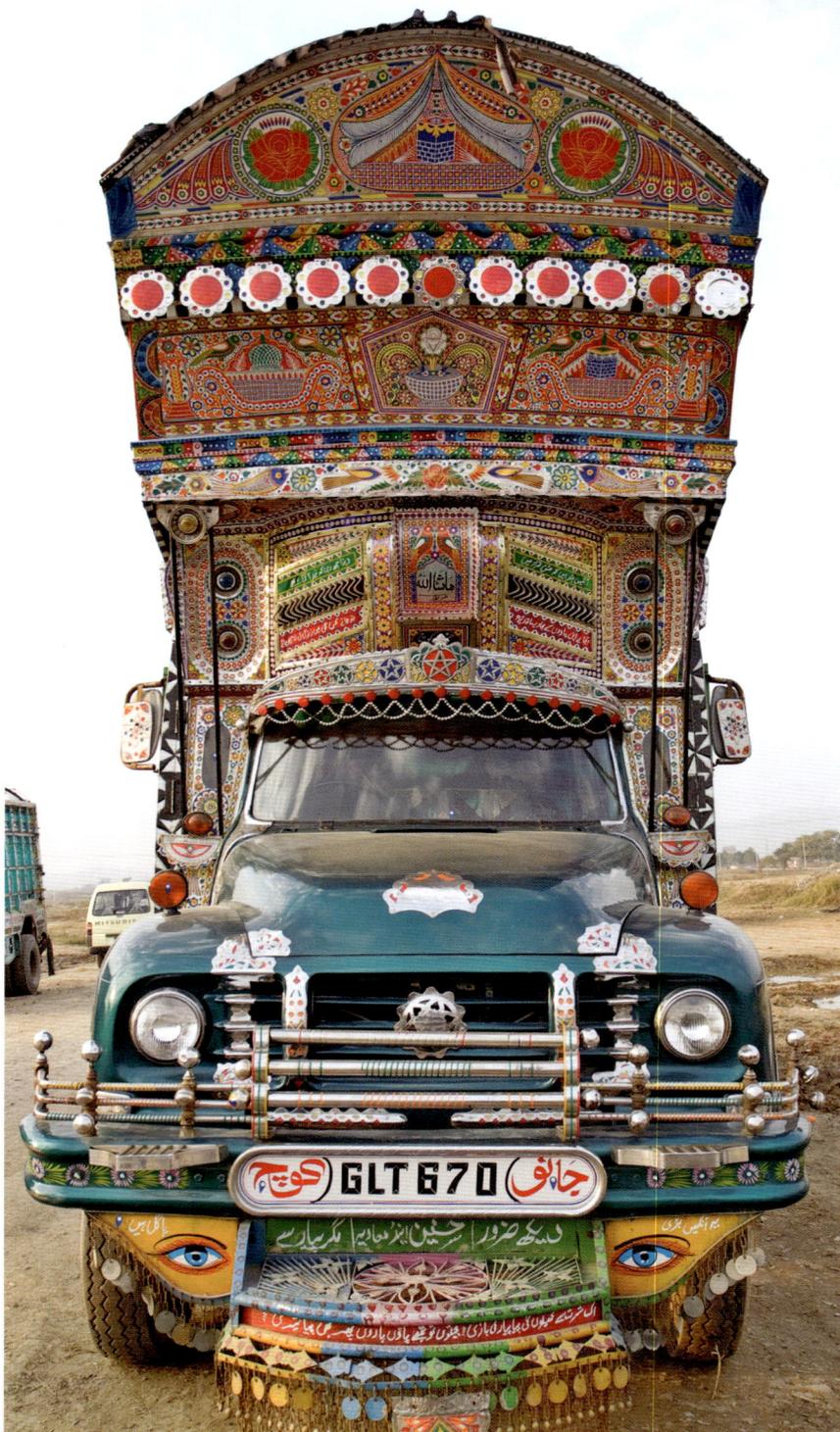

conveyance into a 'truck', with all the implications that the word carries in most sections of Pakistani society. Decorative elements that do not fall into the above categories are, nevertheless, necessary for the truck; they fill the empty frame because the rules of truck design in Pakistan abhor emptiness. As such, these elements can appropriately be referred to as ornament.

Physical Aspects of the Truck

Many of the motifs categorized above occupy predictable places on the truck, such that one can comfortably speak of a visual grammar governing the Pakistani truck's design. Explicit religious symbols and images are almost always located on the front of the truck; talismanic objects and symbols may be found on the back and occasionally on the sides, but the preponderance of such signs is also on the front of the truck. Motifs from an idealized or imagined life as well as from modern life appear mostly on the sides and the back – they are very rarely seen on the front. The name of the truck company and other spatial and locational signifiers normally appear on the sides, which is also where most naturalistic pictures are likely to be (the name of the truck typically appears on the front, and might include the company's name, but here it functions as an identity marker rather than a spatial one). Humorous statements are almost invariably on the back of the truck and serious ones (particularly poetry) on the front, although witticisms and examples of folk wisdom do appear on the rear, but very rarely on the sides.

Front

To illustrate the above discussion, I am providing a detailed description of the primary decorative program of the front and the back of two trucks in Plates 54 and 55. The first truck (Plate 54) was photographed at the truck terminal for the main produce market serving Islamabad and its twin city of Rawalpindi and is done in a Punjabi style. The decorative materials above the windshield combine carved and painted wood, plastic mosaic appliqué, reflective tape (*chamak paṭṭī*) mosaic, hammered and stamped metal, polished chrome, painted metal, and calligraphy. This example is unusual among operational trucks of its style for its lack of decorative or talismanic objects added after the vehicle's primary decorative program has been completed.

The truck is distinctive because of the extensive nature of the explicit religious signs on it, both textual and representational. The Ka'ba appears in a central medallion on the top panel on which all remaining patterns and images are ornamental, significant because they fill the vacuum of an empty space. The Ka'ba appears again together with the Prophet's Mosque on the second panel which is separated from the top panel by a

◁

Plate 54: Example of a Bedford Rocket decorated in the Punjabi style (Rawalpindi 2001)

119

band of carved and painted wood and a row of metal and plastic rosettes. No text accompanies these images, so that God and His Prophet are evoked entirely iconically. The central medallion on the second panel contains an image of a fountain that could represent the fountain of life, although any such reference would be ambiguous, as is the significance of the birds and fish that appear on this panel and the narrow one below it.

The metal cowling directly above the windshield is decorated using paint and reflective tape, and hosts two medallions. The lower one (partially obscured by the metal tiara above the windshield) bears a name for the truck, 'Hasanayn Coach'. The upper one contains the popular formula *Ma'shallah* ('As God wishes'), used talismanically in Pakistan and all across the Muslim world to ward off the evil eye. The formula also functions as an expression of amazement or admiration (on the logic that the object or person for which it is being invoked is deserving of jealous attention), and therefore serves to underline the fact that the truck is beautiful.

The diagonal metal grillwork on either side of this medallion bears two verses of poetry written in a poor calligraphic hand. Both verses are romantic in nature, and at the same time reflect the aesthetics of truckers in their reference to the beauty of this blue truck in the first verse and to the lonely life of a trucker in the second:

Eyes closed, beauty in repose –
All behold – Fairy Blue[7] has come!
(*āṇkhayṇ band hēṇ ke husn qarār mēṇ*
dunyā samajh rahī hē ke nīlam ā gaī hē)

The second couplet is very popular and encountered frequently on trucks:

Leave some light of your memory with me
Who knows in which alley night will fall on my life.
(*ujālē apnī yādōṇ kē hamārē pās rehne dō*
na jānē kis galī mēṇ zindagī kī shām hōgī)

The curvaceous hood (bonnet) of the Bedford is unadorned except for decorative pieces of hammered metal which complement the large extension to the front bumper. The bumper itself has flowers painted on it and the large registration plate displays another name for the truck, 'Janu Coach'. The ornamental extension of the section below the bumper very clearly is intended to evoke the face of a veiled woman. The epigraphy above the eyes says: 'These eyes are crazy' (*ye āṇkhēṇ baṛī pāgal hēṇ*). The extension directly below the registration plate bears a variation on a popular aphorism, 'Sure! Look, but with love!' (*dēkh zurūr magar piyār sē*) and the names of the owners, Hasanayn and Mu'awiya (a highly unusual pairing given their diametrically opposed

sectarian implications). The red band toward the bottom of this section has a slightly off-color couplet with several spelling errors:

> I'll play the game of love on one condition:
> If I win, you are mine, if I lose, you take me.
> (*ik shart sē khēlūṇ gī piyā pyār kī bāzī*
> *jītūṇ tō tujhē pāūṇ hārūṇ phir bhī piyā tērī*)

Side

The detail of a side panel represented in Plate 33 (p. 116) is from a truck in the finishing stages of design at a workshop in Karachi. The style is a hybrid one, typical of Karachi, with elements of the Balochi and Punjabi styles predominating. The center of the image has the name of the trucking company in both English and Urdu (M. Amjad Goods Transport Company), above which is a list of city names from southern Pakistan where the company operates (Karachi, Sukkur, Hyderabad, Larkana). There are two naturalistic paintings at the bottom, each flanked by pictures of birds. The painting on the left, of a caveman fighting a bear, is part of a group of images appearing on both sides of the truck that are inspired by pictures from a children's story book and have little specific significance beyond being purely ornamental. The painting on the right depicts a romanticized village: the architecture is foreign to Pakistan, though the woman sitting in the foreground is clearly Pakistani, as is the design of the empty cot beside her. The major signification of the woman by the side of the cot is apparent when one looks at the painting closely: she is very well-dressed, is heavily made up and wearing jewelry. At the same time, she is sitting on the ground beside at empty cot, waiting for the arrival (or return) of someone who is absent, undoubtedly a man.

Back

Plate 55 is of the back of a new Hino truck decorated in the Peshawari style, with the dominant use of shades of red and orange covering the wood and metalwork of the vehicle and the liberal use of red reflectors. The prominent portrait on the back is painted on slats that secure the rear of the cargo bay. The subject in this instance is the owner's young son, Malik Hasan, who is described in the epigraphy as what is best translated as the 'Blossom of my garden' (lit. 'garden of my courtyard', *gulshan mērē āngan kā*). In addition, the slats bear numbers and letters to aid in their correct placement as well as the name and phone number of the painter (Javed Arts).

The metal tailgate has a number of ornamental handles and lashing points and is decorated with paint and reflective tape over metal. Three similarly decorated metal

panels hanging below the tailgate declare: 'Mad with love, I am, mad!' (*dīvānī mēṇ dīvānī*)'. The bottom panel displays the registration plate twice, symmetrically placed toward the outside. The outermost ends of this panel also display the name of the owner (Amir Malik) and a medallion in the center declares 'The heart is king' (*dil bādshāh*).

▷

Plate 55: Back of truck displaying a portrait of the owner's son (Taxila 2007)

Religious Objects, Context and Activation

The example of the front of a truck discussed above and other façades of trucks reproduced in illustrations scattered throughout this book show the mixture of epigraphy, image, and attached objects that provides a range of religious signification to the truck. The images themselves are commonplace and the text familiar. In addition, the religious medallions and other objects of decoration that are attached to the truck are readily available in shops that supply truck accessories. Objects with religious subject matter are not treated any differently than those with flowers, birds or geometric patterns, and when attached to the truck, there is no system by which the patterns or attached talismans are consecrated or activated – the rituals of consecration at shrines that I outlined above apply to the vehicle as a whole and not to its constitutive parts. There are numerous examples around the world of objects assuming their religious function only when they appear or are used in an appropriate way, a phenomenon that constitutes informal consecration through use. Gregory Starrett has drawn attention to the way an object with religious inscriptions, such as a keychain, can be kept in a pocket or bag with other objects of ambiguous ritual purity where the keychain's inscription remains religiously inactive. Once hanging from the ignition, however, the keychain serves to protect the vehicle, its passengers and contents from misfortune.[8] In the case of the religious epigraphy, images and objects on the Pakistani truck, they are only activated through their collective placement on the vehicle and, vitally, through the truck being put into service, since it is the truck – with all that it represents as a means of conveyance, of livelihood and of danger – that necessitates the particular forms of protection that are provided by religious objects. It is also the truck, as a product of a specific set of societal and political contexts, that is instrumental in providing meaning to other visual signifiers present on it.

Text versus Image

Representational images and patterns typify the more visually striking aspects of the trucks' decorative program but – in almost all cases – they lack the power as signifiers to be readily understood or to provide any explicit or systematic message comprehensible to the majority of onlookers. Epigraphic material, it might be argued, is very clearly

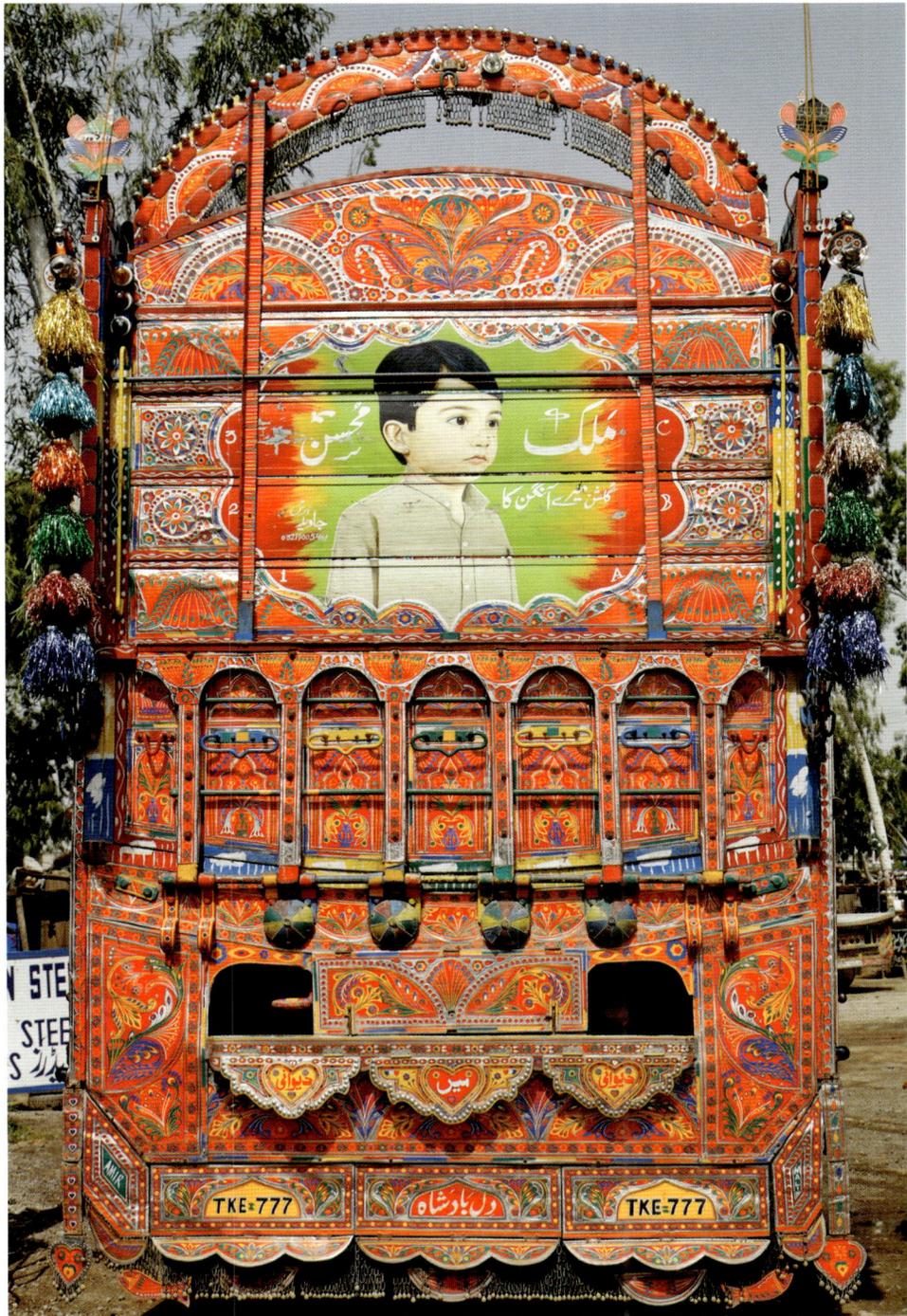

selected to be seen as well as read, and to provide explicit messages concerning the iden-
tity and concerns of the individuals associated with the truck. This applies to the more
skilled calligraphy that forms part of the decorative program when the truck is first
completed in a workshop, as well as other, less formal and frequently less skillful, exam-
ples that are added later on. Unsurprisingly, text is used to impart mundane information,
such as the name of the owner and transportation company, as well as to advertise the
services of painters and body makers involved in the trucks' completion, since their
telephone numbers very frequently appear next to their names. But it is also text, rather
than image, that is used to actively engage viewers in the most direct manner and to
communicate a variety of messages to them.

Images intended for interpretation, or understood to possess power as signifiers, are
almost invariably captioned on a truck. Thus portraits of national heroes even of the
stature of the father of Pakistan's nuclear program, Abdul Qadeer Khan, or the war hero
celebrated in textbooks, Major Aziz Bhatti, are accompanied by epigraphy with their
name (see Plates 88 and 93 in the next chapter). Where the names do not appear, other
epigraphic details make the significance of the image clear, as in the example of the
painting of a little boy in Plate 55, which is only properly understood as a picture of the
owner's beloved son by reading the captions. On a wider scale, the epigraphic program
ties the truck itself together as an artistic as well as a semiotic device, such that focusing
attention on one part of the truck (a pattern, a decorative medium, or a category of
images) misses the nature of the truck, its function within the *habitus* of the truckers
where it properly belongs, and its place in the visual regime of Pakistan. This fact seems
to be universally ignored by those among the Pakistan elite with an interest in so-called
'truck art' as well as by international folk art and craft markets, with important conse-
quences for their (incomplete) understandings of Pakistani truck decoration and its
importance in comprehending several aspects of Pakistani society, a subject I take up in
more detail in Chapter 10.

In the profusion of their numbers and the lavishness of their adornment, Pakistani
trucks transform the landscape into a checkerboard of moving religious and cultural
tableaus, mobile talismans through which the truckers protect themselves and their live-
lihood, and itinerant homes which bear visual testimony to the truckers' sense of place
and belonging, and their aspirations of a better (or utopian) life.

It is not fully established that either the truckers or the truck designers are entirely
clear on what the significations of the motifs used in truck decoration and ornamenta-
tion actually are. In fact, many owners, drivers, and artists with whom I spoke pleaded
ignorance of the signification of all the symbols and claimed that they are purely aesthetic
choices. In other instances, owners and artists competed to receive credit for choosing
motifs and epigraphy, and attributed meanings to motifs that were contradicted by the

other contesting party involved in the decoration of the truck. For their part, truck designers assert that, even though owners normally express preferences for what motifs should appear on the vehicle, the overall aesthetic planning is the designer's own domain. However, when faced with the possibility of giving what they perceive to be an unsatisfactory answer to questions concerning the choice and significance of motifs, artists will attribute that particular motif to the owner or driver's preference, just as the latter will do to the artist. Despite the fact that truckers (artists as well as owners) do not admit to any intentional messaging through the choice and placement of words and images on the truck, I would argue that images, even at their least denotative, or most abstract, are images nonetheless. They are perceived and – as David Chidester has so succinctly paraphrased a central idea of Paul Ricoeur – perception gives rise to symbols, and symbols give rise to thought.[9]

Margaret Miles has argued that religious images, at their most denotative, are iconic, in that they are organized in a traditional way and are responded to by the individual in terms of very specific religious and historical significances. Images can also be representational, encouraging the viewers to relate the image to an element of their own experience or of their belief. At the other end of the spectrum from iconic imaging and response is impressionistic or highly ambiguous representation, which Miles terms 'antirepresentational', which only minimally designates its sacred and experiential content.[10]

The question of whether or not the religious symbolism – or the entire decorative program for that matter – on Pakistani trucks elicits a standard, predictable response is related to a second assertion, namely that responses might be dulled as a result of familiarity through overexposure, but that this dulling does not empty the symbolic value of its meaning or truth. Though this dulling of response is indeed true, I believe that the symbol elicits a response nonetheless. In fact, with progressive loss of a symbol's status as an active figure of speech, a piece of language or a metaphor, it becomes not *less* but *more* like literal truth. To quote Nelson Goodman's *Languages of Art*, 'what vanishes is not its veracity but its vivacity'.[11] Viewed in terms of the response, the truck – both at a composite level and in the specific individual decorative elements present on it – becomes the locus of meaning for the *habitus* of a significant segment of Pakistani society.

Thus, I would argue, one can make visual sense of the Pakistan truck which, at first glance, appears to be an explosive expression of popular or folk art. The side panels are used to depict the imagined home, thereby situating the driver, who by definition is never at home, in a social geography. The role played by the writing of the trucking company's name and routes is self-apparent in situating the driver, but other images, particularly romanticized or idealized naturalistic paintings, are equally significant. The nomadic nature of the driver is critical to his self-conception, consciously articulated by

him in conversation as well as in the music to which he listens. He pines for an imagined home from which he is absent by definition, an imagined home perfectly captured by the beautiful woman sitting beside the empty cot in the bucolic village in Plate 33. In his perpetual absence from a physical, geographically grounded home, the truck functions not only as his home away from home, but also his means of livelihood as well as his partner. The last concern explains the general motivation to decorate the truck as well as to feminize it and endow it with bridal symbols.

Power and the Feminine

Trucks frequently carry traditional masculine symbols, such as weaponry or other forms of technological prowess, but they are invariably viewed as feminine. The word 'truck' is masculine in Punjabi, Pashto and Urdu, but formal gender notwithstanding, trucks are notionally assigned feminine gender, even if they carry masculine-sounding names such as Prince Coach or Malik Express. In actual fact, trucks are frequently completely feminized, both in appearance and the way they are thought of by truckers. Numerous drivers mentioned in interviews how a truck is like a woman; they explained the motivation behind decorating the truck through posing the rhetorical question of who would want to have sex with an unattractive woman – driving the truck and living with it being a comparable experience in their thinking. Trucks are seen not just as female sexual or romantic objects, but as partners or wives. One driver from Quetta, Abdullah Khan Achakzai Alizai, explained that a truck was just like 'the woman at home' (*pa kor kakhe khaza*), and just as one took small gifts of jewelry and clothing to keep the woman happy, so too did one have to buy small ornamental 'gifts' for the truck. Abdullah Khan Achakzai claimed that one quarter of the earnings from each job were spent on the truck, an explicit parallel to the custom among Pakistani men of handing over a portion of their earnings to their wives.[12]

The precise figure of a quarter of all earnings might represent an exaggeration, although it could be reasonably accurate if, as I was informed, it includes all operating expenses of the vehicle (its care and 'feeding') and not just its beautification (*khūbsūrtī*). Implicit in the comparison of expenses on a man's truck to those on his wife is the belief that a 'happy' truck is better for a harmonious working life than an unhappy one. And although no trucker has ever seriously suggested to me that trucks think or feel, this concept of making offerings or gift-giving as a man's duty in his relationship with his truck fits in with culturally pervasive notions concerning the best means of maintaining marital harmony, wherein women are fulfilled (and hence less troublesome) when they receive small, pretty gifts and are told they are beautiful.

Conceivably, the romantic verses that appear on the front and back of trucks can be viewed as part of the feminization and romanticization of the vehicle. However, not only are such verses seldom separated from the larger body of epigraphy, but there is also a long-standing poetic tradition in Pakistan – inherited from classical Persian poetics – wherein no distinction is made between profane erotic verse, erotic references to divine love, and allegorical moralistic poetry. As such, romantic verses are no more explicit signifiers of the feminization of the truck than are the common paintings and stickers of beautiful women found on them.

The truck is feminine – and specifically bridal – in its totality, a message that is explicitly conveyed in some of them, especially Bedford Rockets, which combine the decorative use of prominent, very feminine, eyes with hanging chains that give the combined effect of a woman's face partially covered by a *niqāb*-style veil. The effect is apparent in Plate 56. The prominence of the eyes is reinforced by the choice of poetry placed on the yellow panel between them:

Plate 56: Truck with feminine eyes and a veil motif (Karachi 1999)
▽

You turned your eyes away and became lost in your pleasures,
I embraced sadness as my lot in life.
(*tum to nigāhēṇ phēr kē khushiyōṇ mēṇ <u>kh</u>ō gaē
ham nē udāsiyōṇ kō muqaddar banā liyā*)[13]

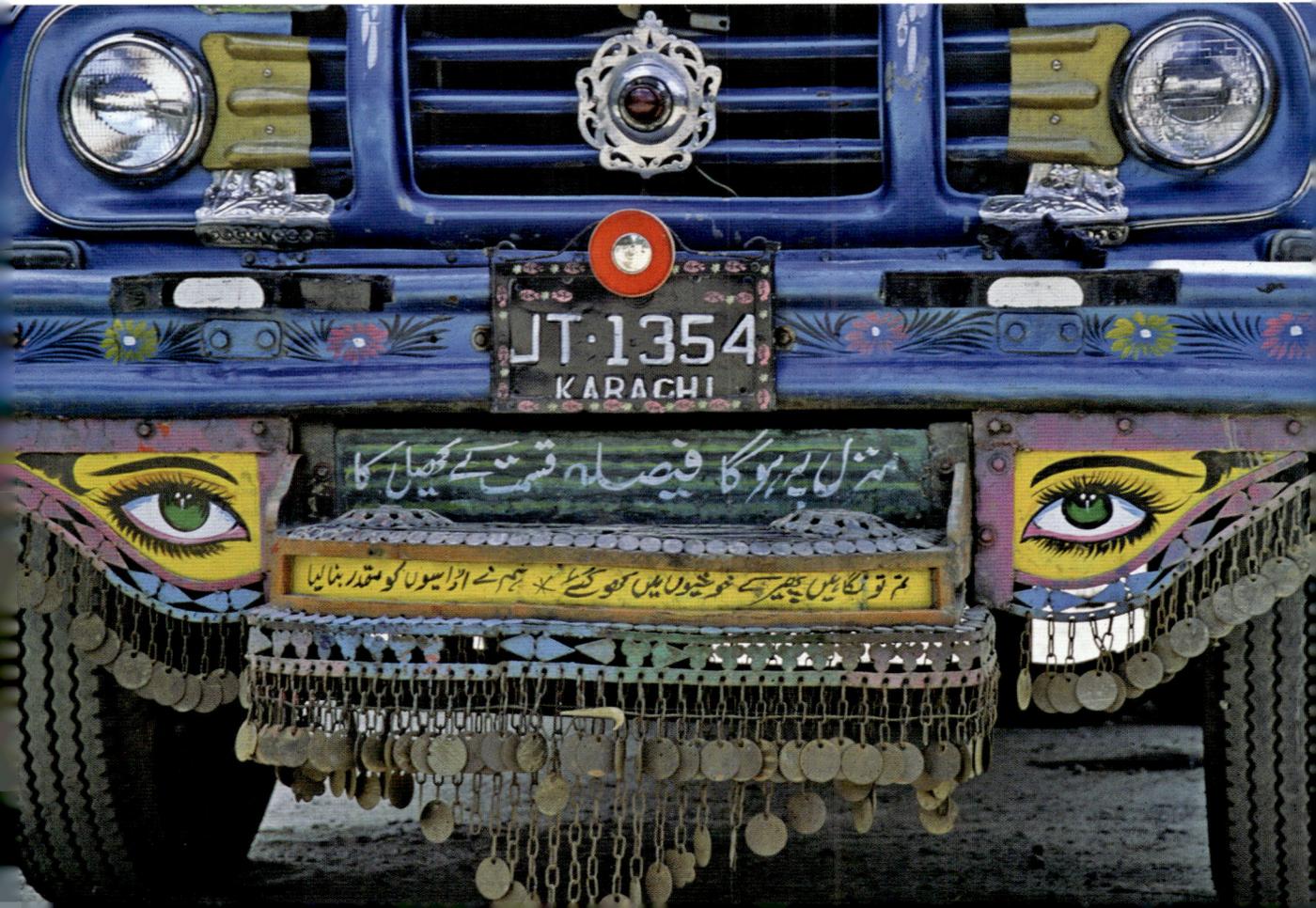

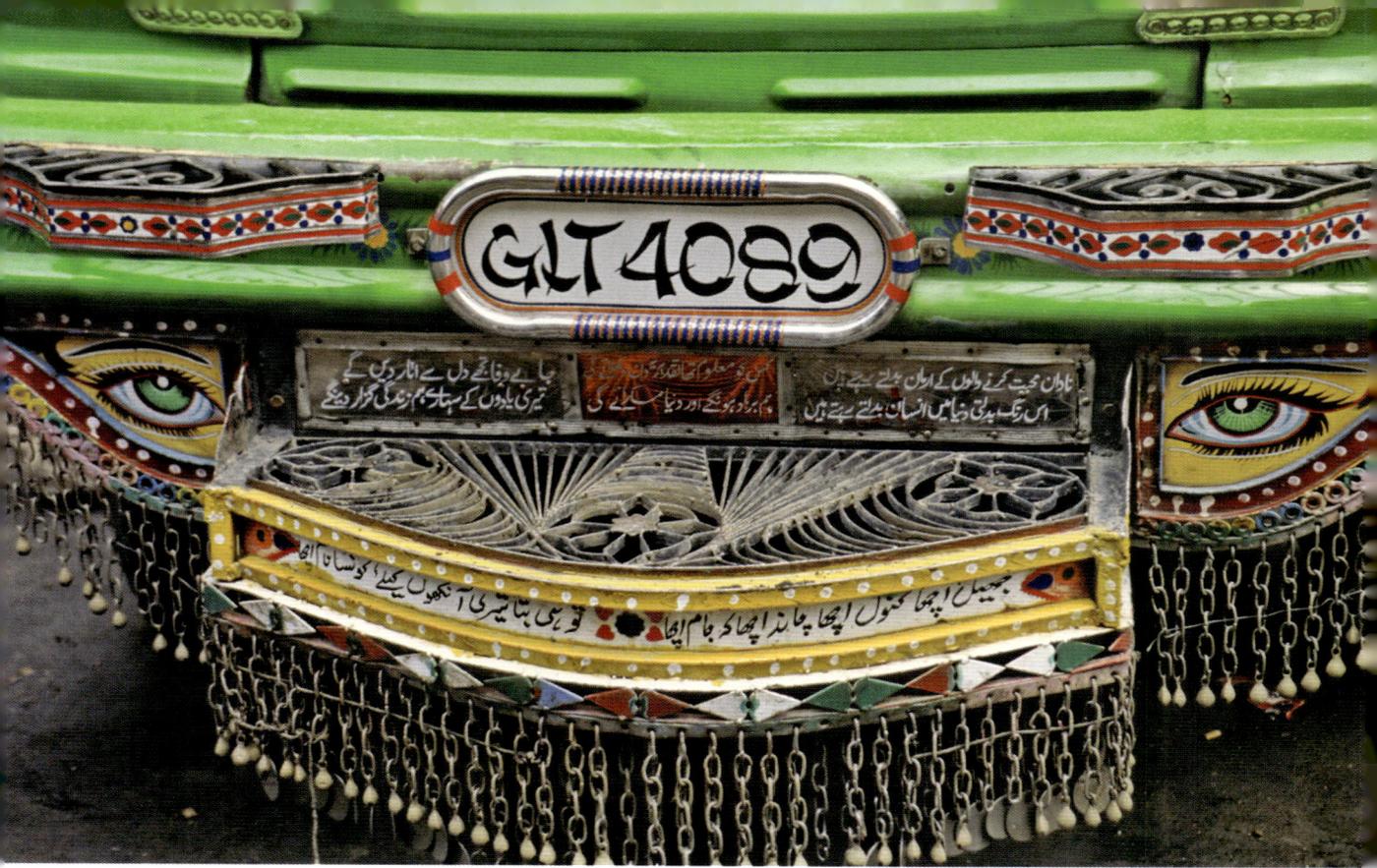

The significance of the eyes is emphasized even more on the truck in Plate 57. The poetry on the white background at the bottom reads:

△
Plate 57: Another example of a truck with a feminine 'face' (Gilgit 1998)

Is 'lake' good, or 'lotus' good, or 'moon' good, or 'glass of wine' –
You tell me what name is good for your eyes!
(*jhīl achchā kaṇval achchā chānd achchā ke jām achchā*
tū hī batā tērī āṇkhōṇ kē līye kōnsā nām achchā)

The three couplets on the panel above this verse are also explicitly romantic in content:

Those who love easily are fickle in their passions –
In this ever-changing world, people keep changing.
(*nādān muhabbat karnē vālōṇ kē armān badaltē rehtē hēṇ*
is rang badaltī dunyā mēṇ insān badaltē rehtē hēṇ)

Who would have known that fate would show this day?
I would be ruined and the world would smile …
(*kis kō ma'lūm thā taqdīr ye din dikhāy gī*
ham barbād hōṇgē awr dunyā muskurāy gī)

128

Go, unfaithful one! I'll wipe you from my heart,
I'll live out my life with nothing but thoughts of you.
(*jā bē vafā tujhē dil sē utār dēŋgē*
tērī yādōŋ kē sahārē ham zindagī guzār dēŋgē)

Poetry of this nature is the stock of popular romantic imaginings in Pakistani culture; its presence on the truck in proximity to the bridal face is therefore a strong reinforcement of the message that the truck is feminine, attractive and an object of desire. The face does not resemble a female human face in a strictly mimetic sense, nor does it come attached to a body that visually resembles a human body at all. In fact, the feminization of the truck does not rely entirely on somatic or mimetic visual cues such as the bridal eyes, but is attitudinal, based in cultural, frequently unspoken, attitudes toward vehicles, and in specific, smaller visual and primarily textual cues which reinforce a gendered relationship between the truck as female and the owner and driver as suitor or husband, in the literal sense of the latter term. The truck in Plate 58 is one of three belonging to Mazhar Ali Khan from Turnol, and was described to me as a woman by its owner (albeit in a tongue in cheek manner). The very ornate front bumper has a different eponym on either side: 'Empress of Egypt' (*Misr kī rānī*) and 'Queen of Beauty' (*husn kī malka*). In addition, the large star and crescent visible halfway down on its right side (which has a twin

Plate 58: Mazhar Ali Khan with one of his three trucks (Turnol 2007)
▽

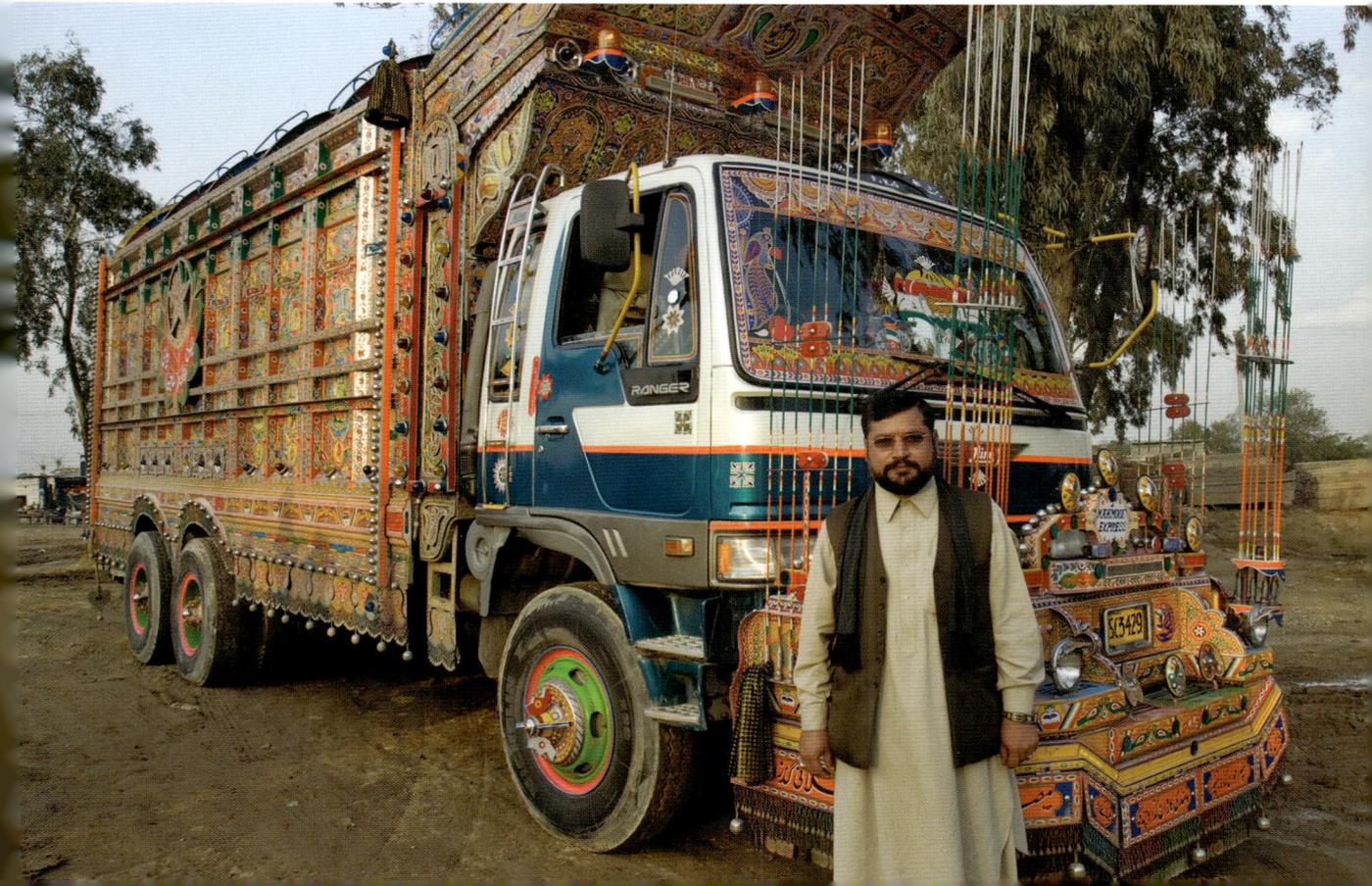



on the left) refers to the truck as 'Phoolan Devi, the darling of her lover' (*lāḍlī sājan kī*). According to the owner, all three names belong to the truck, and, although I did not discuss the implications with him, it is clear that, though the truck does not possess an individual identity or personality, it is endowed with a decided femininity displayed through the set of feminine names. That another name 'Mahmood Express' is written prominently on the front does not change this fact, nor does the front bumper's display of the popular phrase 'Let Prince pass!' (*prins kō jānē dō*). 'Mahmood' in this instance (and the pattern repeats itself on other trucks) refers to the owner, whose 'Express' can easily be, and *is*, feminine. And although 'Prince' is certainly a truck's name in this case, it is best seen as part of a grammatical construct, an aphorism, which is written on many trucks. 'Let Prince pass!' is not a reference to any specific truck, but rather belongs in the category of widely copied phrases that circulate in the popular vocabulary of truckers and are well known beyond their circles, such as 'Sonny, don't bug me!' (*pappū yār tang na kar*) or 'Look, but with love' (*dēkh magar pyār sē*).

Feminization and female notional gender are therefore characteristics of the truck as a whole, and not readily deducible from the explicit message of any one signifier. On the contrary, it is an awareness of the truck's feminization that allows one to adduce a gendered, sexualized or romantic reading of individual signifiers on the truck. The context of being on a truck renders otherwise ambiguous love poetry as exclusively profane in its reference. Conversely, it is this same context that contributes to the ambiguity of signs that hold clear messages in other contexts.

Together with such feminine or feminizing signifiers, the symbolism connected with safety of person and livelihood dominates the truck as well as the trucker's behavior. The interior of the truck is heavily adorned with religious stickers, and the majority of truck drivers build visits to important shrines into their regular itineraries. The need to avoid misfortune and gain good fortune provides a simple explanation for the talismanic objects, symbols and explicit religious motifs on the truck. However, their specific nature and placement signify more messages about the worldview of those involved in decorating the vehicle, and provide additional evidence for my assertion that truck decoration functions as a symbol system which, to a large extent, can be understood linguistically, and that the choice of motifs and their location are the syntax through which varying messages can be conveyed.

As I have discussed briefly, one important piece of evidence in this regard is the difference between how the front and the back of the truck are decorated, in that, unlike the front, the back is whimsical (often humorous), and predominantly has motifs from modern life. I find three main factors to explain this. First, there is the practical consideration that the back of the truck suffers much wear and tear from the constant loading and unloading of goods. This not only makes it impractical to have too much detailed

(and expensive) ornamentation on the back, but would also potentially imply a disrespectful attitude if one was to have explicit religious ornamentation which was then subjected to abuse. Second, there are important semiotic differences between the front and the behind in general, in that one's face to the world is one's serious expression, and one's behind is the butt of jokes.[14] Third, the back of the truck is normally seen by those stuck behind it on the road. Keeping them entertained is therefore a viable use of the back of the truck (bumper stickers normally go on the back of the vehicle in the US as well). More importantly, the only category of people apart from other truckers to be stuck behind a truck are those travelling in cars who, in Pakistan, definitionally belong to a class of people with whom the trucker has little contact and therefore do not represent the social context in which he draws status.

The driver's sense of personal standing in his own social circle derives from presenting his best *face* to the world, that being the front of the truck. As has been mentioned already, when parked at truck stops, the vehicles are pulled into parking spaces face first, and truckers gather in front of the vehicles to eat, drink tea and chat. Given that the detailed decoration of the front of the truck can only be seen fully when the truck is stationary, and when it is stopped the human beings around it are normally only truckers (or laborers and mechanics), it is to them that the trucker presents his serious face. This face is one that he partly creates and partly acquires or inherits – inasmuch as he has only partial control of the ornamental program of the truck – but at the moment of display it is *his* face since *he*, the truck driver, is inseparably identified with the truck, not the truck's owner or the dozen or so people who have a hand in its design.

The truck driver may not even be aware of the specific messages given off by his vehicular face, nor that the design of the truck functions as a language system, but the truth of this is clear from the comparison of the religious content of trucks made in the next chapter. The general layout of the trucks is the same but their messages are entirely distinct; in other words, they have the same syntactical structure as communicative devices but crucial differences lie in the specific decorative motifs and the meanings they impart.

8

Religion, Identity, and Trucks

It is indeed on this level of organization and realization that language has a reference and a subject: since the system is anonymous or, rather, has no subject – not even 'one' – because the question 'Who is speaking?' has no sense at the level of language, it is with the sentence that the question of the subject of language arises. This subject might not be me or who I think I am; in any case, the question 'Who is speaking?' has a sense at this level, even if it must remain a question without an answer.

Paul Ricoeur[1]

The decorative program of a truck signifies a great deal about the identities (at religious, social, national and other levels) of the individuals involved in truck culture, and the changes in the content and nature of the decoration mirror changes in the role of religion in Pakistani society. To illustrate this assertion, I will compare the decorative programs of four trucks, three countenancing forms of religious expression that have long histories among the people of Pakistan and in South Asia in general, and a fourth, associated with the movement commonly called Tablighi Jama'at, which has only recently seen expression in the visual regime that is the Pakistani truck.

As I have stated already, there is a great deal of freedom in what colors, materials, motifs and subjects are actually used on the truck. As such, truck decoration has not taken on a formal arrangement to the point where decorative content and syntactic arrangement would consciously serve to project conscious and elaborate messages about the vehicle's owner and driver. Nevertheless, a careful analysis of the decoration reveals a great deal about precisely these messages, as becomes clear through a careful analysis of these four examples.

The Sufi Truck

Plate 59 shows the front of a truck decorated in a style common in northern and central Pakistan and in Pakistani-administered Kashmir ('Azad Kashmir'), similar to the Rawalpindi or Peshawari style. The use of religious imagery and epigraphy is extensive in this example. The Ka'ba and the Prophet's Mosque in Medina appear twice in pictorial form (on panels one and two). Accompanying their pictorial representations, God and Muhammad are invoked four times in writing as 'O Allah! O Muhammad!', in each case from right to left as one faces the truck: on the extreme ends of panel one (the 'O Muhammad!' is damaged); on panel two just to the outside of the medallions with the Ka'ba and Prophet's Mosque; toward the outside of panel three; and in very small writing on the central medallion of panel two. To either side of this medallion is the phrase 'In God's Protection' (*sapurd-e khudā*). Both central medallions invoke the names of saints, the top one that of Shah Bilawal Nurani, 'luminescent light, all afflictions stay away' (*nūrānī nūr har balā dūr*), and the lower one of Lal Shahbaz Qalandar, perhaps the most popular Sufi saint in all of Pakistan.

There is extensive religious epigraphy on the upper section of the truck. Across the very top is a couplet describing Muhammad's status as the primordial human being:

In all God's creation Muhammad was made first,
There was no Adam, there were no angels, God was not apparent.
(*banē sārī khudāī mēṇ Muhammad Mustafā pehlē*
na Ādam thā na farishtē thē na zāhir thā khudā pehlē)

An inscription at the bottom of the top panel reads 'Crown-bearer of the Sanctuary, he is, vision of grace' (*tājdār-e haram hū nigāh-e karam*), an honorific title given to Muhammad by the classical Persian poet Sa'di, but popularized in modern Pakistan in a *qawwālī* song by the Sabri Brothers.

The metal medallions attached at the bottom of the second panel have the names of the owners on either end (Anjum Khan and Nadim Khan) and the name of the truck in the middle (*Lāhūtī Kārvān* [Divine Caravan]).[2] The word '*fayzān*' appears right above the windshield, and is most likely another name for the truck.

The red and yellow grillwork on either side of the central medallion on the main cowling right below the metal medallions has two couplets, the first asserting that Muhammad, his daughter Fatima, her husband Ali, and their sons Hasan and Husayn are the best of human beings. The lower couplet is popular and encountered on trucks in various parts of the country, including on the truck in Plate 60:

If you are faithful to Muhammad, then I am yours;
What is this world after all, the pen and the tablet are yours.[3]
(*kī Muhammad sē vafā tū nē tō ham tērē hēṇ*
ye jahāṇ chīz hē kyā lūh-o qalam tērē hēṇ)

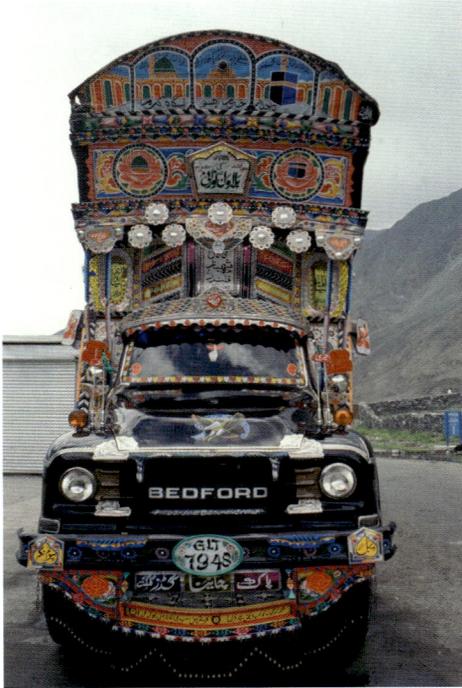

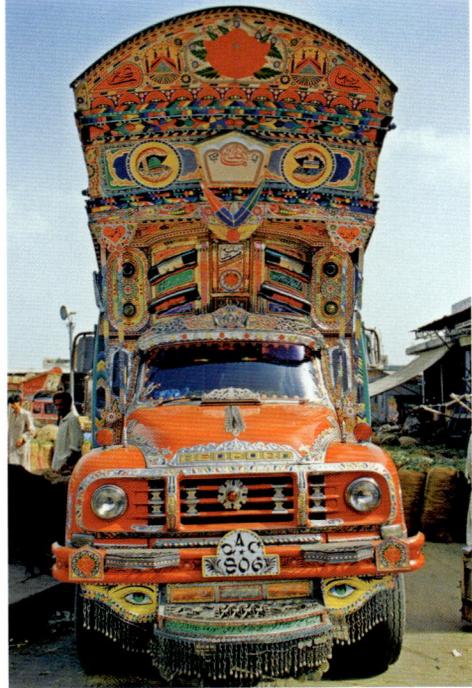

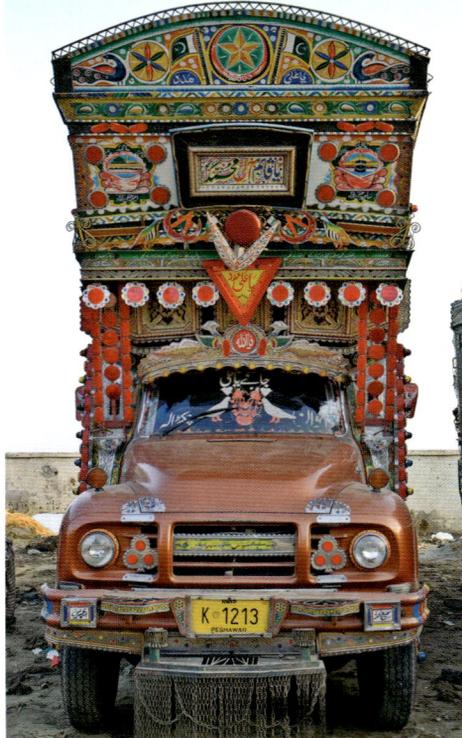

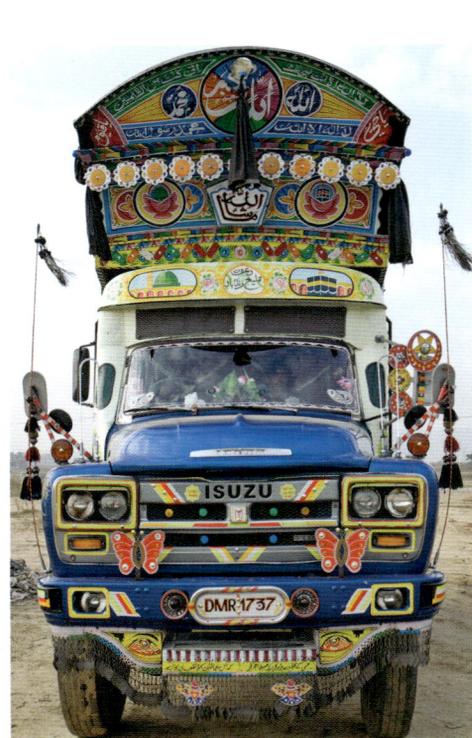

This marks the end of the top section of the truck's front. At the bottom of the radiator, under the name 'Bedford', there is a non-religious couplet, extremely common on Pakistani trucks, in very small white paint:

> Burn away in silence under the blazing sun, but
> Never ask your relatives for the shade of a simple wall.
> (*jal jāo khāmushī sē kaṟī dhūp mēṇ lēkin*
> *apnōṇ sē kabhī sāya-e dīvār na māngō*)

Below that is the registration number and two small panels on the ends of the bumper advertising the route. Directly under the oval registration plate is the name of the truck company (Pak China Goods, Gilgit). At the bottom is another non-religious couplet:

> Who ever notices the tears of the morning dew?
> Everyone is busy looking at the smiling rosebud.
> (*shabnam kē ānsū kō kab dēkhtī hē dunyā*
> *kartē hēṇ sab hī nazzāra haṇstī hui kalī kā*)

The Unmediated Truck

The truck in Plate 60 is different in its specific signs, although the arrangement of decorative elements is very much the same as in the vehicle just described. The Ka'ba and the Prophet's Mosque appear only once, nestled in clamshells on the second panel from the top. On the top panel they have been replaced by twin images of the King Faisal Mosque in Islamabad, iconically conveying an increased emphasis on God relative to Muhammad. This message is repeated in the epigraphy: the written pair '*Yā Allah! Yā Muhammad!*' appears only once, on the orange ornamental medallions hanging from the ends of the second panel. In other places it has been replaced by references solely to God, mostly by epithets from the list of God's ninety-nine names: '*Yā Rahīm! Yā Karīm!*' (O Merciful One! O Generous One!) appears on the ends of panel one. The formula '*Yā hayy! Yā qayyūm!*' (O Living One! O Eternal One!) appears in small lettering on the central medallion of the second panel and again on the lowest pair of blue panels on either side of the central medallion on the panel right above the windshield.

No saints are invoked in the central medallions of these panels, the way they are in the previous example. In both cases, the space is occupied by the exclamation '*Ma'shallah!*' (As God wishes), the commonest apotropaic formula used by Muslims to guard against the evil eye and misfortune in general.

Below the large medallion in the center of the main cowling there is a smaller medallion – almost invisible in this illustration – with the name of the truck company (Muhammad Farid Transport). The middle pair of panels on either side of these medallions bears the religious couplet appearing in the same location of the truck in Plate 59.

The bottom of the truck has an exaggeratedly feminine pair of eyes above a hanging gravel guard which is more ornamental than functional, and the significance of which together with the eyes has already been discussed. Fish, which possess talismanic value in South Asia as symbols of plenty and are therefore related in some way to notions of *barkat*, appear on the hammered metal panel separating the two panels above the windshield. The boomerang-shaped object in the middle – often a nonfunctional limousine antenna – is a popular decorative element. When interviewed, truck drivers attach no special significance to it; however, it might be a representation of ibex horns which have talismanic properties as bringers of good fortune, but are expensive and hard to come by.

At the bottom of the truck, there is a non-religious romantic couplet reminiscent of the one in the same location on the truck in Plate 59, which draws attention to the mimetic qualities of the front of the truck as a woman's face:

> Lips that cannot smile – what do they know of blooming flowers?
> Eyes that cannot cry – what do they know of keeping secrets?
> (*jis lab pe haṇsī ā na sakē vo gul <u>kh</u>ilānā kyā jānē*
> *jis āṇ<u>kh</u> mēṇ āṇsū reh na sakē vo rāz <u>ch</u>upānā kyā jānē*)

The Shi'a Truck

The truck in Plate 61 shares the same decorative syntax as the previous two examples but has a third set of signifiers. In this example, as in the previous ones, God and Muhammad are represented iconically by the Ka'ba and Prophet's Mosque on the second panel from the top. However, the primary emphasis in this truck is on the section of Muhammad's family referred to by Shi'as (and frequently also by Sunnis) as the *ahl-e bayt* ('people of the household'). Across the top of the vehicle, beneath Pakistani flags, is the formula '*Yā 'Ali madad!*' (O Ali, aid us!), referring to Muhammad's cousin and son-in-law, Ali ibn Abi Talib. Ali is the first Imam of Shi'i Islam but is also deeply revered by much of Pakistan's large Sunni majority. As such, this declaration carries little specific signification. 'O Ali, aid us!' is also an official battle cry of the Pakistani army, and therefore represents a formula with wide nationalistic appeal and little sectarian specificity.

The names of Allah and Muhammad are written directly above the images of the Ka'ba and Prophet's Mosque in the second panel. On either side of them are the invocations 'O Ali! O Fatima!' and 'O Hasan! O Husayn!' respectively, Hasan and Husayn being Muhammad's grandsons by his daughter Fatima who succeeded their father Ali as the second and third Imams. Below the two images are the names of the truck's owners (Sajid Husayn Shah and Amir Husayn Shah). The central medallion says 'O Eternal One of the Household of Muhammad' (*Yā qā'im āl-e Muhammad*), a reference to the last Imam

who lives in occultation awaiting the end of the world when he will play a decisive role in Shiʻa versions of eschatology.

Below the medallion is another example of the boomerang-cum-ibex horns flanked by two crescents with stars, an important Islamic and Pakistani nationalistic symbol. On either side of these are images of a chukor partridge, the prophylactic functions of which will be discussed shortly. Below the partridges on the horizontal narrow green band is a couplet in honor of Muhammad's daughter, Fatima, referred to here by her honorific title 'Zahra':

> Bow down and salute the threshold of Zahra
> Who nurtured Husayn and gave him to the world.
> *(jhuk kar salām karō Zahrā kē āstānē kō*
> *pāl kē Husayn diyā jis nē zamānē kō)*

The red triangle in the middle of the fourth panel repeats the formula 'O Ali, aid us!' and there is an invocation of God directly below it. The windshield has 'Only Ali knows' written in the middle and the name of the owner at the bottom. The two white doves do not carry any specific symbolism in Pakistan, especially with heart-shaped stickers directly above them. However, the dove or pigeon very commonly symbolizes Qurʼanic revelation in the Islamic world, sometimes clearly signifying either the Holy Spirit (*rūh al-quds*) or the Archangel Gabriel who is considered the agent of revelation.[4] The panels below the headlights announce the name of the truck (Samiullah Express).

Functionality as Social Identifier

The arrangement of decoration on the fronts of these three trucks is very similar: invocations of highest religious authorities go toward the sides on the top, Allah and Muhammad being represented in writing as well as iconically. References to saints go in the middle. Religious verse goes above the windshield, not below it and, with few exceptions, romantic verse never goes above it. The arrangement notwithstanding, the specific choices of decoration provide very different messages about the owners and drivers of these vehicles. The truck in Plate 59 shows a deep veneration for Muhammad who gets more prominence than Allah. There are also references to at least two saints, as well as verses in honor of Muhammad's family. Devotion to Muhammad, Sufi saints, as well as to Ali, Fatima, and their children is a common characteristic of Islam as it has been practiced in present-day Pakistan for several centuries. As such, this truck countenances a form of vernacular Islam that relies on holy people as intercessors before God. The tension between intercessory and non-intercessory models of religion is arguably one of the major divisions within Islam, although this distinction has never organized itself to fall neatly along sectarian lines. The truck in Plate 60 represents the other side

of this divide, with the total absence of saints' names and the conscious elevation of references to God at the expense of references to Muhammad (who functions for most Muslims as the ultimate intercessor).

Plate 61 shows a truck which is easily identified to be of Shi'a ownership or design. Its signifiers are unambiguous in this regard: individually, some of the statements in honor of Muhammad's family might appear on other vehicles, but no non-Shi'a would ever display this combination of statements, nor are certain ones, especially the reference to the hidden last Imam, used by non-Shi'as.

These three expressions of Islam – Shi'ism, a vernacular Sunni Islam which venerates saints and petitions intercessors, and another vernacular Sunnism which opposes the notion of intercession – represent most of the spectrum of Islam as it has traditionally been practiced in Pakistan (albeit a spectrum painted with a broad brush). That at least two forms of Sunnism exist in this society attests to the fiction of a singular 'orthodox' religious tradition practiced by the majority of Muslims. In actual fact, Sunni Islam in Pakistan (and all across South Asia) has been fractured to a much greater degree for several decades, and strongly self-identified and externally recognizable groups visibly contest social religious spaces in Pakistani society and of which the Tablighi Jama'at, Deobandis, Barelvis and Ahl-e Hadis mentioned in Chapter 2 are only the largest and most visible. The dramatic growth and influence of such self-identified 'Islamist' Muslim groups can be seen on the truck in Plate 62.

The Tablighi Truck

This vehicle is of a make and model not commonly encountered in Pakistan. Nevertheless, the bodywork and decoration are done in a style common in the northern Punjab and employ the same use of surface space as a Bedford Rocket. The top panel of the truck has a large medallion in the center with the words '*Allāhu akbar*' ('God is Great!' a very important formula repeated several times in the Islamic call to prayer) written in it; this is flanked by the names 'Allah' and 'Muhammad'. The top and bottom edges of the top panel display Qur'anic phrases used in prayer ('There is no god but You, glory be to You!' (*lā ilāha illā anta subhānaka*), 'Indeed I am one of the sinners!' (*innī kuntu min az-zālimīn*), and the Muslim credal formula 'There is no god but Allah and Muhammad is the messenger of Allah'). The ends of the panel invoke God using two epithets that appeared in Plate 60: '*Yā Hayy*' (O Living One!) and '*Ya Qayyūm*' (O Eternal One!).

The second panel and the cowling just above the windshield display the familiar iconic representations of God and Muhammad through the Ka'ba and the Prophet's Mosque. The medallion in the center of the second panel has the formula '*Ma'shallah*' (As God wishes), familiar from the vehicle in Plate 60. Directly below this is another

medallion declaring 'Long live the call of Tabligh!' (*Daʻvat-e tablīgh zindabād!*), a reference to the important modern Muslim movement of the Tablighi Jamaʻat, which has been outlined earlier and will be discussed more in the next section.

The bottom of the truck has a pair of exaggeratedly feminine eyes with a verse written between them:

Never vow more in love than someone can bear,
For undeserved kindness can cause great harm.
(*kisī kē zarf sē baṛh kar na ra<u>kh</u> mehr-e vafā hargiz
ke is bējā sharāfat kā baṛā nuqsān hōtā hē*)

So far, I have limited the comparison of these four trucks to the front of the vehicle because in truck decoration, as normally practiced throughout Pakistan and in Afghanistan going back to the mid-1970s, it is the front that serves almost exclusively as the locus of religious signifiers. In the case of the three trucks in Plates 59, 60 and 61, the sides and back follow the same generic visual syntax described in Chapter 7. At first glance, the truck under review here appears to function identically to the previous ones. The tailgate of the truck (Plate 63) displays the name of a transportation company. There are two poems at the bottom, the one to the right of the license plate being the same as appears at the bottom of the radiator on the truck in Plate 59.

This relatively serious verse is offset by a more humorous one on the left:

The one I had held by the hand to show the way –
On reaching his destination showed me the finger.
(*unglī pakaṛ kē jis kō di<u>kh</u>āyā thā rāsta
manzil milī tō ham kō anguṭhā di<u>kh</u>ā gyā*)

To the extreme left and right is the phrase 'From Raiwind to everywhere', a declaration that echoes a common practice of writing the names of two towns by way of mentioning a route. What makes this particular example noteworthy is that Raiwind is the center of the Tablighi Jamaʻat movement in Pakistan. The annual Tablighi gathering at Raiwind draws approximately 2 million members and sympathizers. It is rivaled only by the Vishwa Ijtema, the annual gathering at Tongi in Bangladesh, but draws a much more international crowd, thus making Raiwind the global center of the Tablighi Jamaʻat, eclipsing Mewat in India where the movement was founded. In light of its status as the geographical center of a large Muslim missionary movement, the phrase 'From Raiwind to everywhere' delivers a message that is completely different from all other spatial signifiers of the category to which it ostensibly belongs. The reference is no longer to the spatial orientation of the transportation of capital goods but, rather, to the concept of missionary activity as a commodity which is carried universally outward from its geographic center.

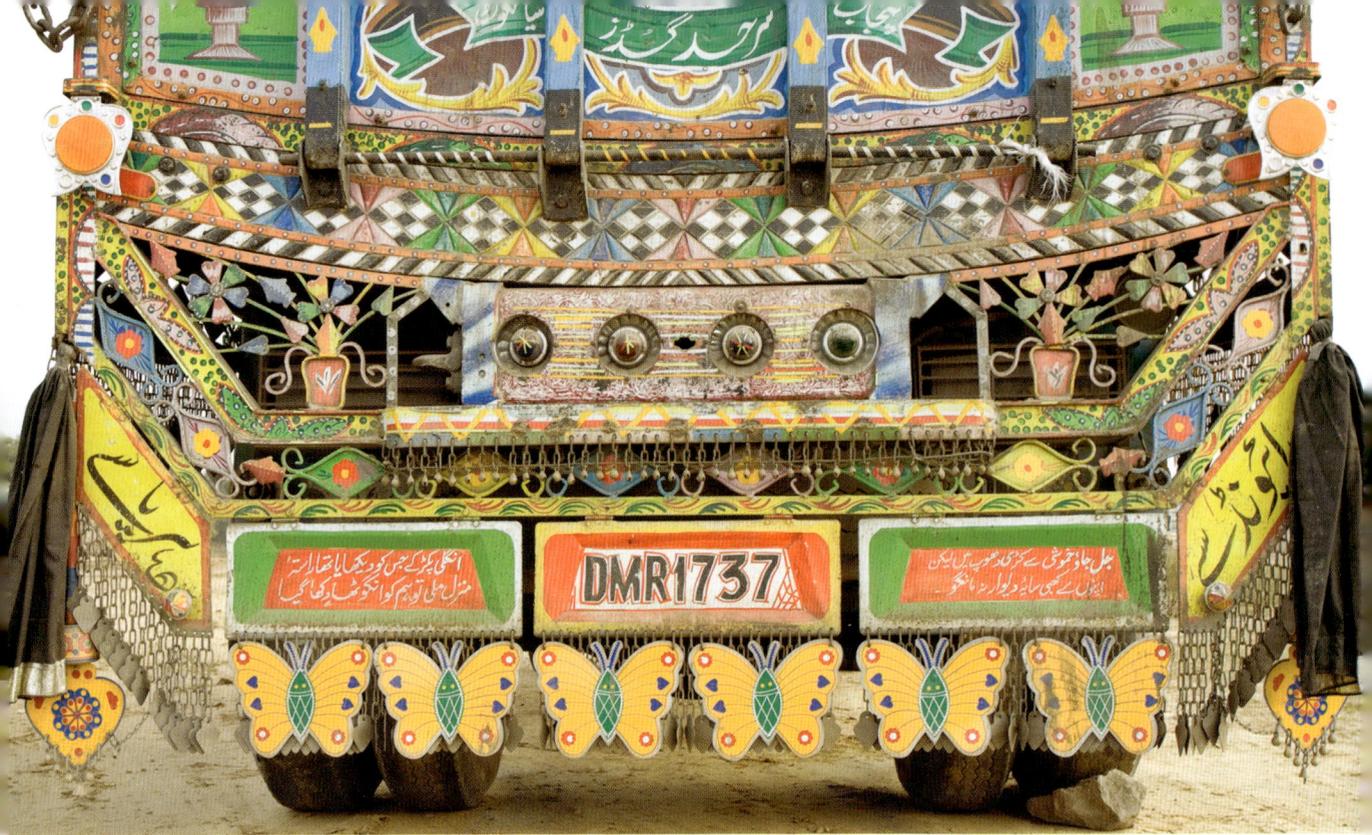

DMR1737

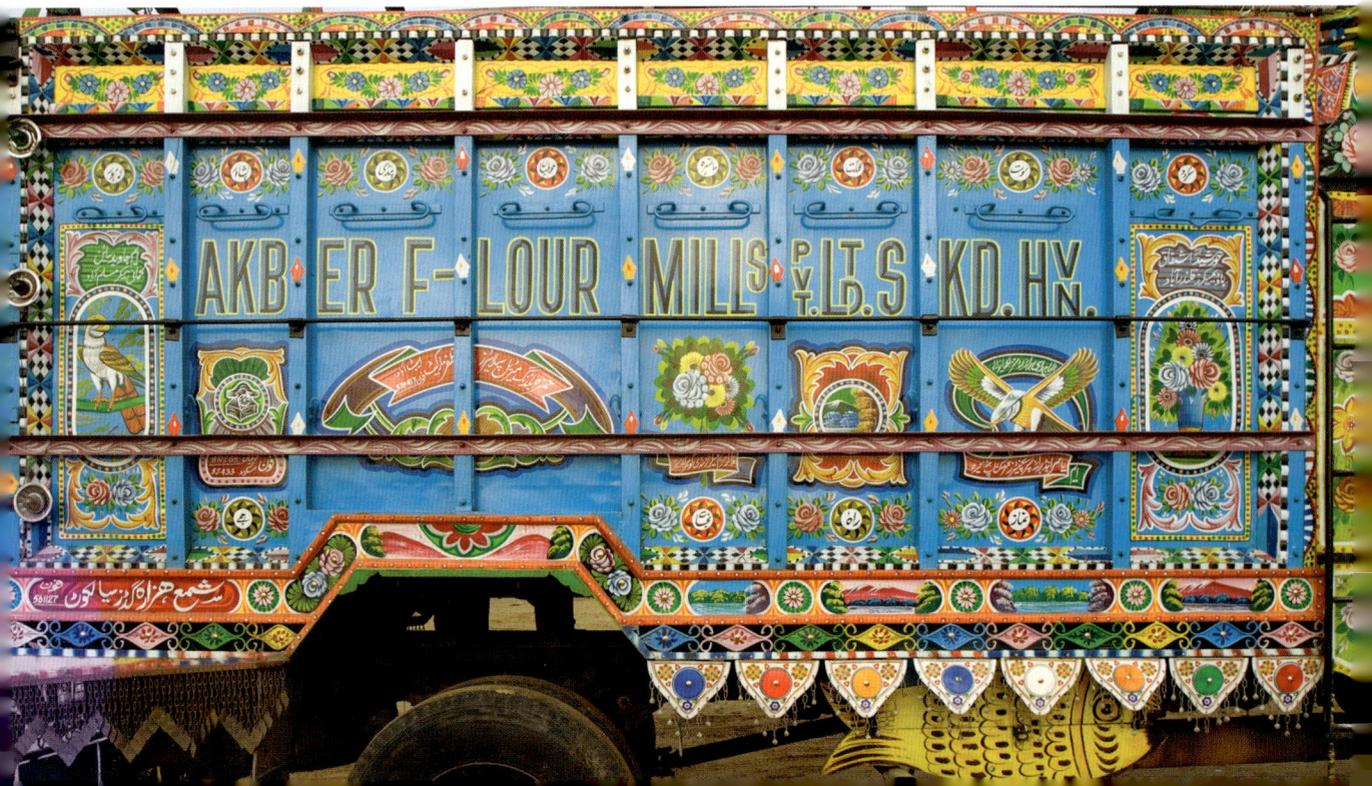

AKB ER F-LOUR MILLS PVT. LD.S KD. HN.

The sides of this truck are also qualitatively different from the preceding three examples. Typically, with the occasional exception of an owner or artist's name, there is no epigraphy whatsoever on the doors of a truck. However, this example has the owner's name below the window (Abdulwahid Awan), and a verse of obvious religious significance written above the door:

Stone idols carved by my own hands
Are today resting in the temple as gods.
(*mērē hāthōṇ kē tarāshē hūē paththar kē sanam*
āj but-khānē mēṇ bhagvān banē bēṭhē hēyṇ)

At first glance, the sides of the truck bed look ordinary and not at all worthy of note (Plate 64). Across the very top are small medallions with names of Pakistani towns written in them, referring to the route the vehicle normally travels; below these, in large letters, is the name of the flour mill to which the truck belongs. In smaller panels scattered across the sides are the names and addresses of the frame and body maker as well as advertisements (Hamza Building Material Suppliers and Shama' Hazara Goods) of a building materials supplier in the town of Abbottabad and a goods trader in Sialkot. However, medallions across the bottom of the right side of the truck, which visually mimic the ones with names of towns across the top, contain the statement 'Prayer is the path to salvation' (*namāz rāh-e najāt hē*). Similar medallions on the left side of the truck declare 'Prayer is the Mi'raj of the believer' (*namāz mu'min kī m'rāj hē*).

The presence of explicitly religious writing on the side of the truck is a very recent development that I observed for the first time in 2003, after four years of fieldwork on Pakistani truck decoration. Furthermore, until even more recently, the content and placement of this material was limited to trucks identified with the Tablighi Jama'at movement. This phenomenon is not an aberration, but one that is linked to the nature of Tablighi Jama'at beliefs and identity.

As outlined in Chapter 2, personal reform through prayer is one of the most identifiable features of the Tablighi Jama'at movement. At the same time, travel has become an essential characteristic of the movement through which followers not only call others to the 'true faith' (i.e. engage in *da'wa*), but which also offers a means for self-improvement. Loose organization, the absence of a firm geographical focus, and the importance of travel and of prayer combine to give explicitly religious writing on the truck in Plates 62, 63 and 64 a new significance and explain the important departure in religious outlook that these changes in decoration represent.

The content of the messages themselves does not constitute the most significant feature of the Tablighi Jama'at's representation in truck decoration. As is clear from the detailed analysis of all four trucks, the front of a Tablighi vehicle presents a 'face' just like that presented by the other trucks, except that certain markers identify it as a

Tablighi 'face'. The remarkable aspect of this vehicle, and the aspect that requires explanation, is the transfer of religious epigraphy to the sides, a syntactical shift that appears to be the consequence of two distinct phenomena: first, the need for vitality in a visual message and, second, the qualitative departure from traditional (or long-standing) vernacular understandings of Islam in Pakistan.

Overexposure to an image, pattern or written message undoubtedly dulls our conscious response to perceiving it. A dulled response does not necessarily mean that the 'truth' of the message is no longer perceived or accepted by the viewer. On the contrary, repetitive exposure to the point where the viewer no longer pays attention to the specific message of the image or epigraphy can mean that the message has become accepted as literal truth and is no longer subject to analysis or scrutiny.

This point of theory seems patently obvious in the commercial world of advertising, where fortunes are spent on making brands a household name. Under such circumstances, a new message requires not just a difference in image but also in approach. The Tablighi truck represents just such a shift; despite the substantial differences in the content of the decoration of the truck's front (Plate 62), including explicit references to the Tablighi Jama'at in the epigraphy, it resembles all the other examples in its visual syntax – both in terms of the arrangement and the degree of decoration. The 'literal' religious truths accepted by the dulled sensitivities of a viewer concern references to God, the Qur'an, Muhammad, and other beliefs universally shared by Muslims. The written reference to the Tablighi Jama'at (on the cowelling above the windshield) is unambiguous, but requires a level of careful scrutiny to which a standard truck 'face' is not likely to be subjected. It is through breaking convention by moving religious messages to the sides of the vehicle that the painter or owner has a greater assurance that the religious message will be noticed. Through relocation, it regains its vivacity; as such, it becomes perceived by the viewer consciously, a phenomenon highly desirable for anyone associated with an actively missionary movement that relies on getting its message out.

It is not insignificant that religious messages on trucks affiliated with the Tablighi Jama'at are relocated to the sides of the vehicle rather than the back. As I have made clear earlier, the side of the truck serves as a signifier of emplacement, locating the individuals associated with it in a place or geography. The emplacement in question is not necessarily to a specific geographic location, as in the name of the transportation company or names of specific towns.[5] Rather, emplacement refers to locating the truck and its associated individuals in a national and global geography, both at a singular point or locus (the name of the transport company) as well as motion outward from one point or between two points (place names mentioned individually or connected by a transitive grammatical construction).

Plate 65: Another example of the side of a truck displaying religious references specific to the Tablighi Jama'at. The top of the illustration has the names of Pakistani towns and a transportation company. Above the scenic tableaux at the bottom are two epigraphic panels declaring 'Prayer is the path to salvation' (namāz rāh-e najāt hē) and 'Long live the call of Tabligh' (da'vat-e tablīgh zindabād). The right panel is partially obscured by a sticker advertising a petrol filling station (Taxila 2003)

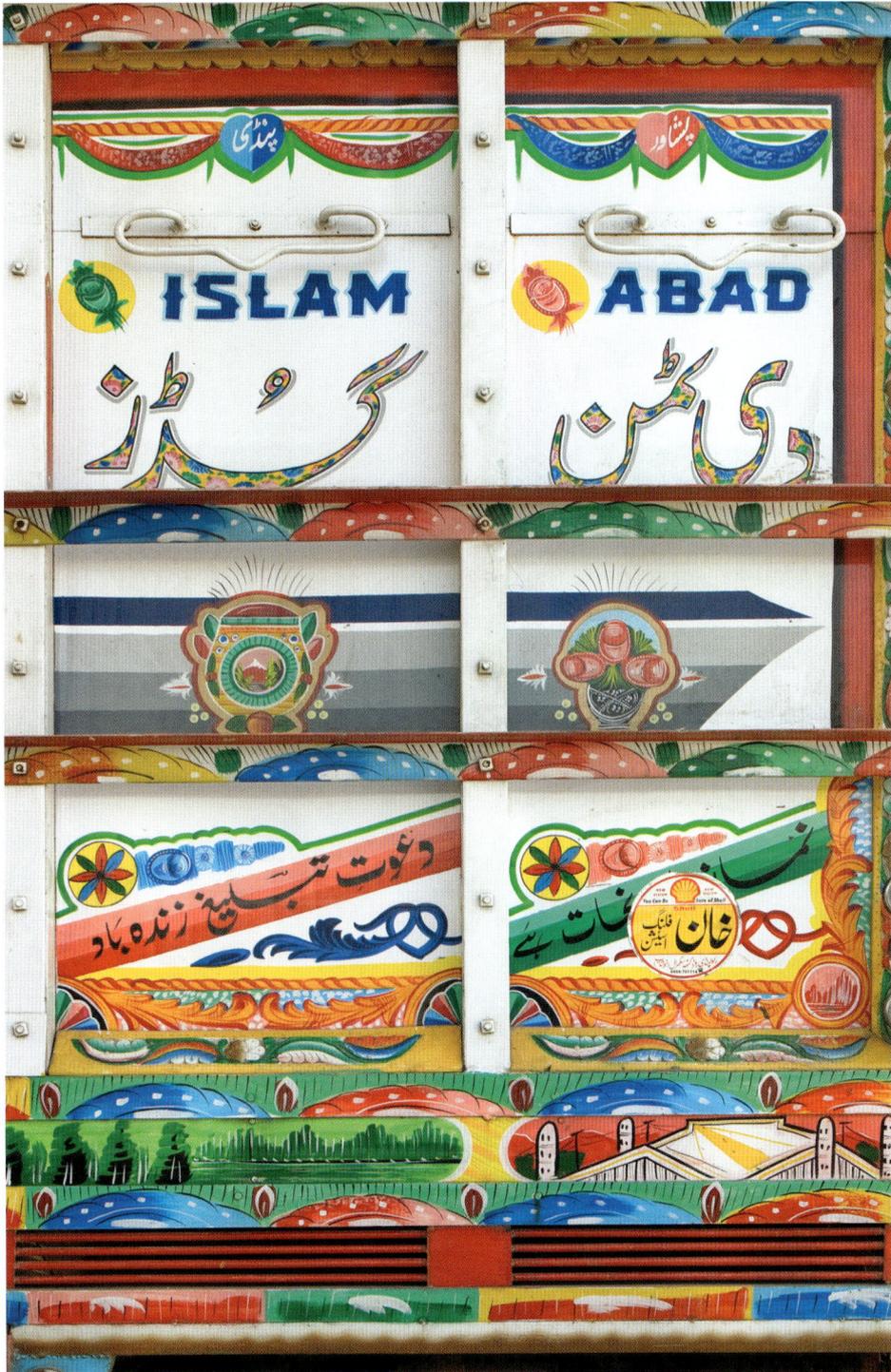

The modern Tablighi Jama'at represents a significant departure from other popular forms of vernacular Islam in Pakistan. It would be an exaggeration and oversimplification to say that religiosity has been an individual concern rather than a social or a communal one in Pakistani society until the arrival of modern movements such as the Tablighi Jama'at; however, there is little doubt that active proselytizing and formal association in sectarian societies underneath the Sunni umbrella historically have been unfamiliar phenomena in most forms of vernacular Sunnism. In contrast, the Tablighi Jama'at's elevation of missionary activity, travel, and belonging in a transnational religious community necessitates a qualitative shift, not just in the content of a truck's decoration but also in its syntax.

▷

Plate 66: Front of a truck displaying religious messages on all sides (Gujrat 2003)

The New Religious Syntax

The shift in syntax initiated by members of the Tablighi Jama'at has two larger interrelated consequences. First, the syntactical shift that restores the vivacity of the Tablighi message immediately puts existing systems of signification at a temporary disadvantage, one that can only be reversed by adopting the new syntactical pattern. Second, the breaking apart of (albeit unspoken) rules of visual grammar opens up the possibility of new patterns of signification that depart from established norms without necessarily competing with the Tablighi truck, or with others, in a deliberate fashion. Precisely this pattern of change is apparent in the truck illustrated in Plates 66, 67, 68, 69, 70 and 71.

The front of this truck (Plate 66), completed in Faisalabad in June 2003, is decorated in an unusual Punjabi style both in terms of its extensive use of painted wood with almost no ornamental appliqué of metal, plastic or reflective tape as well as its combination of unmediated and Sufi-mediated religious signifiers. The panel directly below the unusually placed alpine scene contains the familiar medallions with the Ka'ba and the Prophet's Mosque, with all remaining religious references being textual and to God alone: He is mentioned with four epithets: *Rahīm* (Merciful), *Karīm* (Noble), *Hayy* (Living) and *Qayyūm* (Eternal). In addition, the central medallion with a picture of a ship declares 'God is King!' (*Allah bādshāh*). Three hanging plaques at the bottom of that panel evoke Allah and Muhammad in text, with the middle one displaying the Islamic creedal formula, the *Shahāda*, which is also written right above the windshield. The panel above the windshield represents God and Muhammad iconically and also has the names 'Allah and Muhammad' written toward the outside in an unusual geometric script.

References to God repeat themselves down the front of the truck: the mirrors have the formula *Ma'shallah* written on them, and the windshield has the common formula 'In the name of God, the Compassionate, the Merciful' written in its numerological

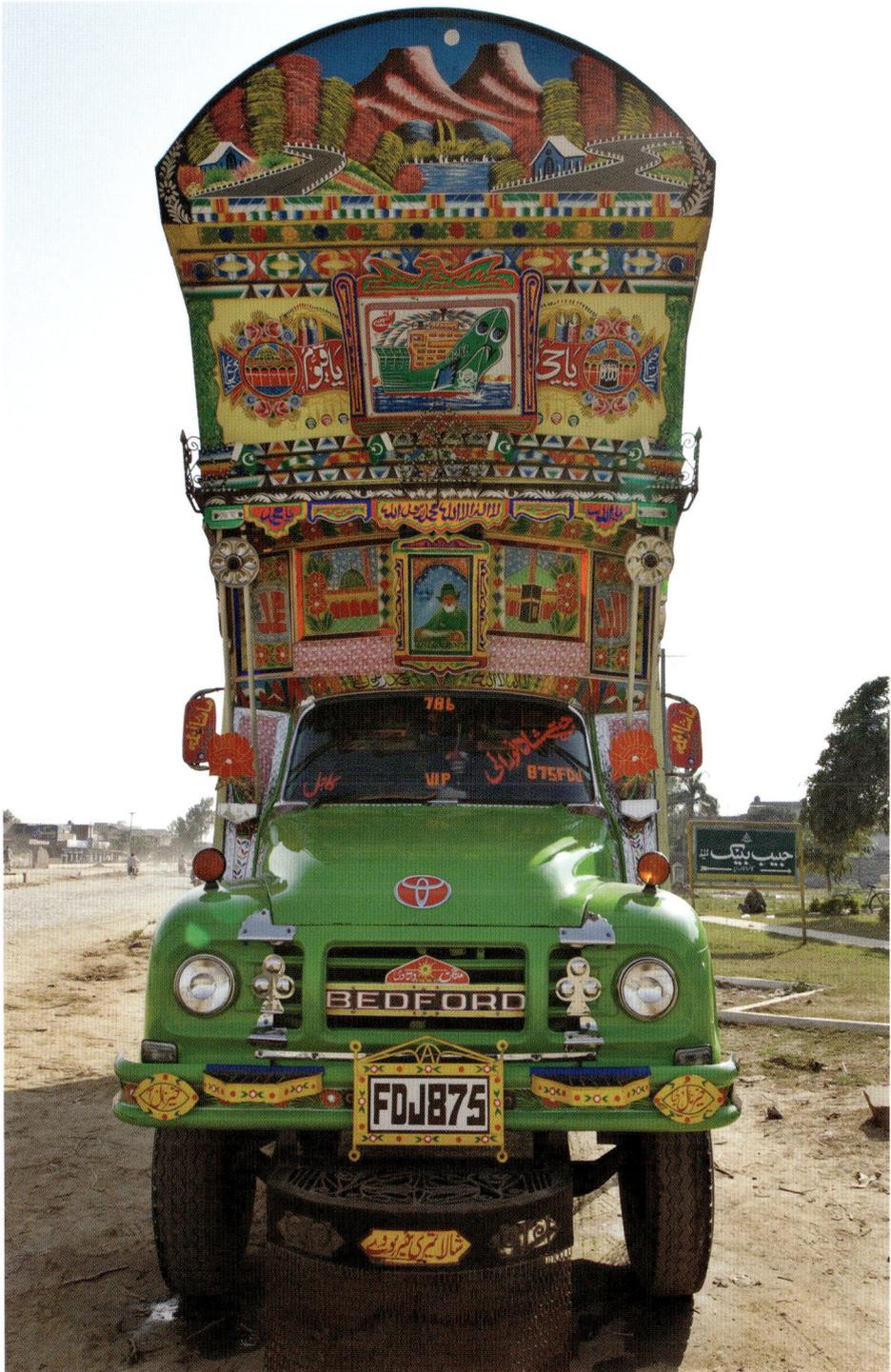

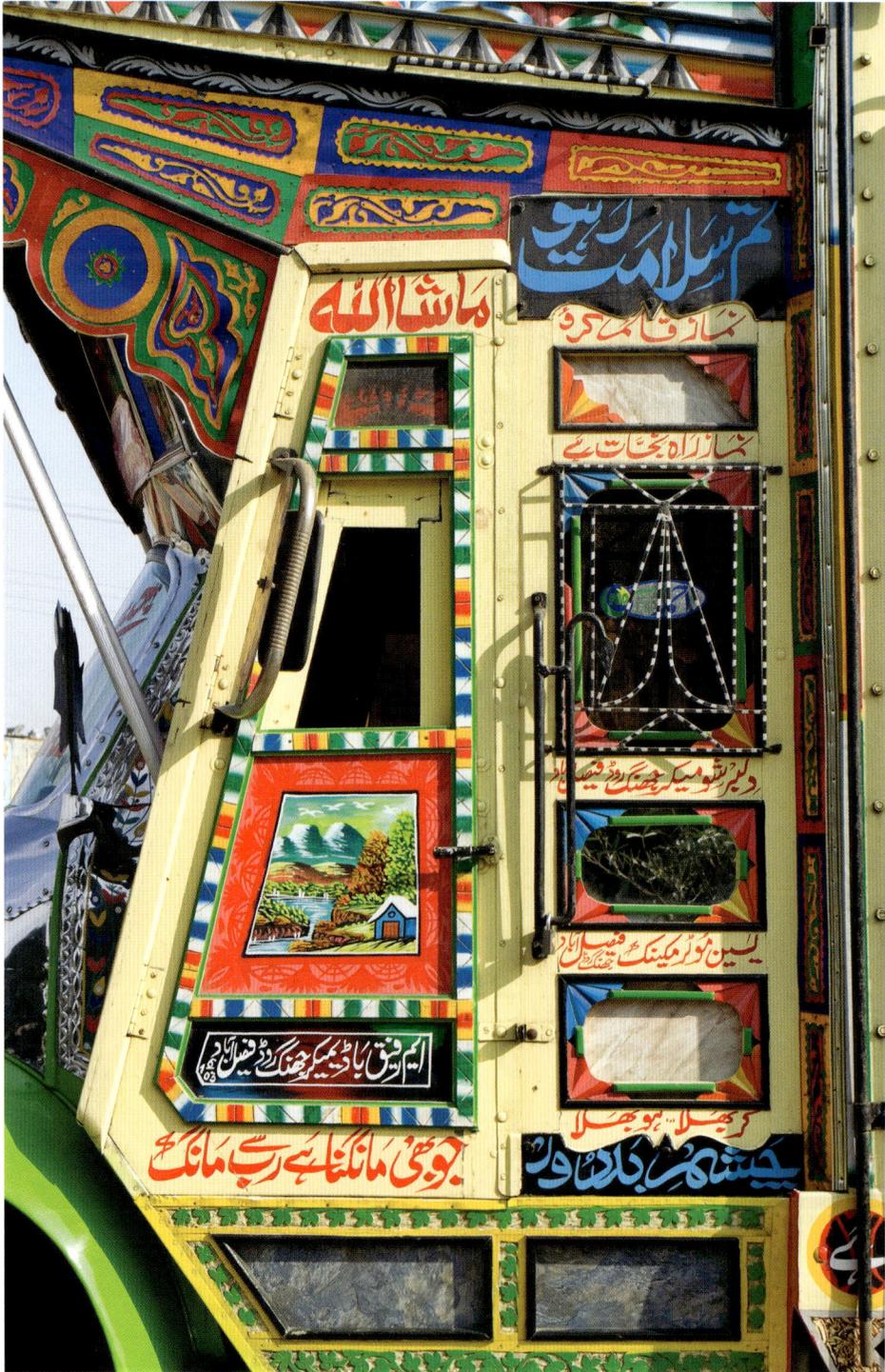

equivalent, 786 (the windshield also has the registration number of the truck and the name Kajol on it). However, in addition to these frequent invocations of God, the front of this truck also invokes Sufi figures: the name of the Sufi saint Shah Nurani is written on the windshield, and the central medallion on the panel above the windshield has a painting of the famous Seraiki Sufi poet, Khwaja Ghulam Farid (d. 1901). Furthermore, the major saint of Lahore, Ali Hujwiri – better known as Data Ganjbakhsh – is invoked on a small red plaque on the radiator grill in the phrase 'I beg from Data' (*mangan Dātā dī*).[6]

The doors on this truck carry a unusually large amount of epigraphy with a variety of subjects. In addition to advertising the individuals who worked on the truck,[7] the door has the formula *Ma'shallah* as well as a number of aphorisms: 'May you be safe' (*tum salāmat rahō*), 'Do good and good will happen' (*kar bhalā hō bhalā*), and 'Evil eye be gone!' (*chashm-e bad dūr*). These generally pious phrases are supplemented by an exhortation which explicitly mentions God, saying 'Whatever you ask for, ask it from the Lord' (*jō bhī māngnā hē rabb sē māng*). Finally, exhortations to prayer seen on the side of the truck with decorative elements associated with the Tablighi Jama'at (Plate 64) are written toward the top of the door: 'Establish prayer' (*namāz qā'im karo*) and 'Prayer is the path to salvation' (*namāz rāh-e najāt hē*).

Plate 67:
Left door of a truck displaying religious messages (Gujrat 2003)

Plate 68: Right side of a truck displaying religious messages (Gujrat 2003)

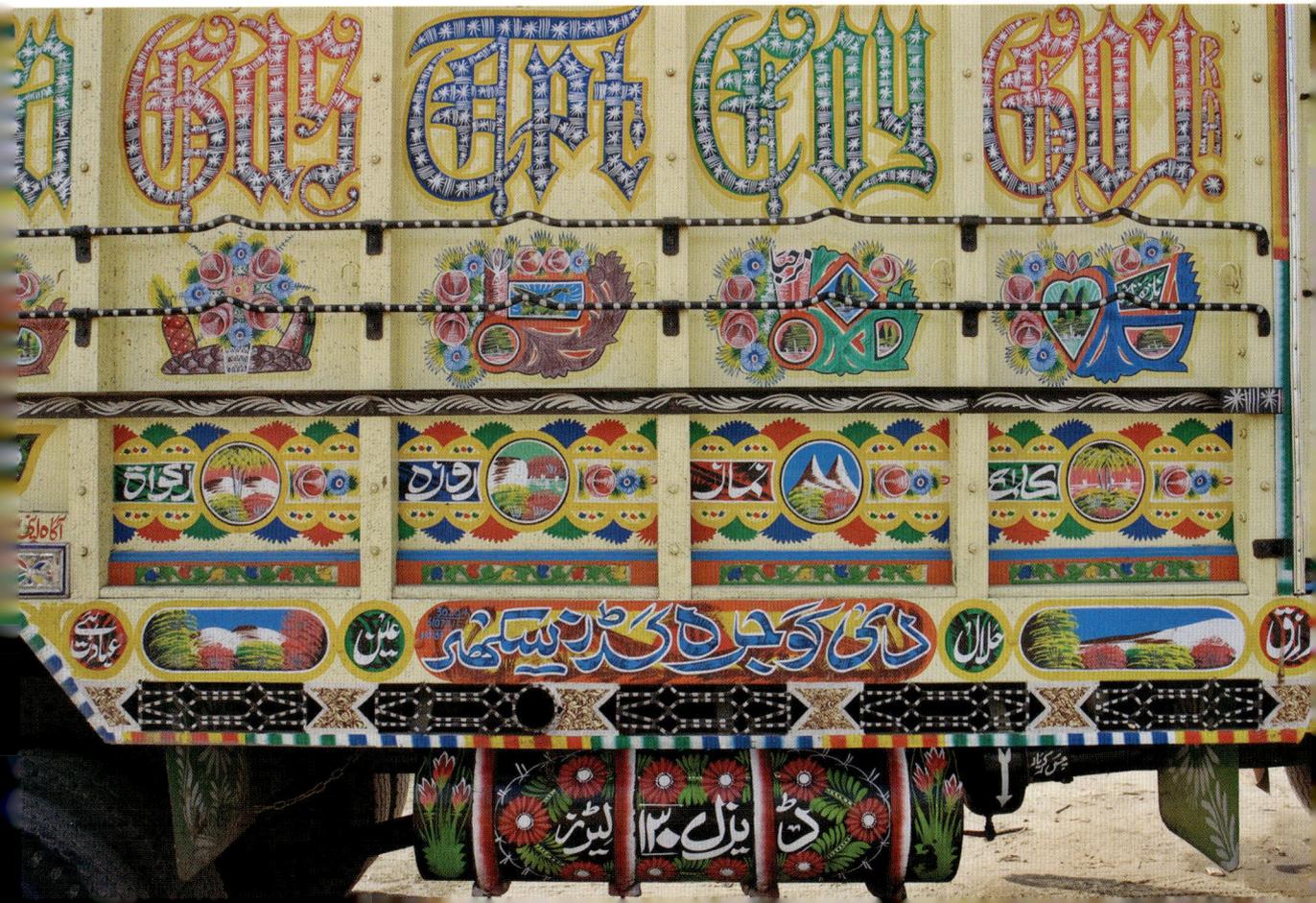

The right door is a mirror image of the left one, except that it advertises a different set of workers.[8] The sides of the truck (Plates 68, 69 and 70) carry the necessary locational references to the transportation company ('Azad Gojra Gas Transport Company, Gojra' written in Latin script, and in Arabic on the right; 'The Gojra Goods, Sukkur' on the right side and 'Super Attock Karachi Goods, Kharo' above the rear wheel on the left, both in Arabic letters). The inclusion of city names (visible toward the top in Plate 70) is a common design element, in this case advertising that the truck visits (or potentially is available to visit) every major city in the country: Peshawar, Pindi, Lahore, Faisalabad, Multan, Hyderabad, Karachi. The inclusion of artists' names (Hafiz and Nasir Naz) is also common on the sides, although in the case of this truck the majority of names appear on the doors instead. The visual framing is also familiar from the established conventions of truck design, with the space between the vertical metal bars providing the frame for small landscape paintings.

In a significant departure from the established norms of truck design, but reflecting the new syntax visible in the truck affiliated with the Tablighi Jama'at, religious messages are prominently displayed on the sides. The horizontal metal beam at the bottom on the left declares 'Prayer is the path to salvation' (*namāz rāh-e najāt hē*) and on the right 'An honest living is the essence of worship' (*rizq-e halāl 'ayn-e 'ibādat hē*). The panel above this

Plate 69: Right side of a truck displaying religious messages (Gujrat 2003)
▽

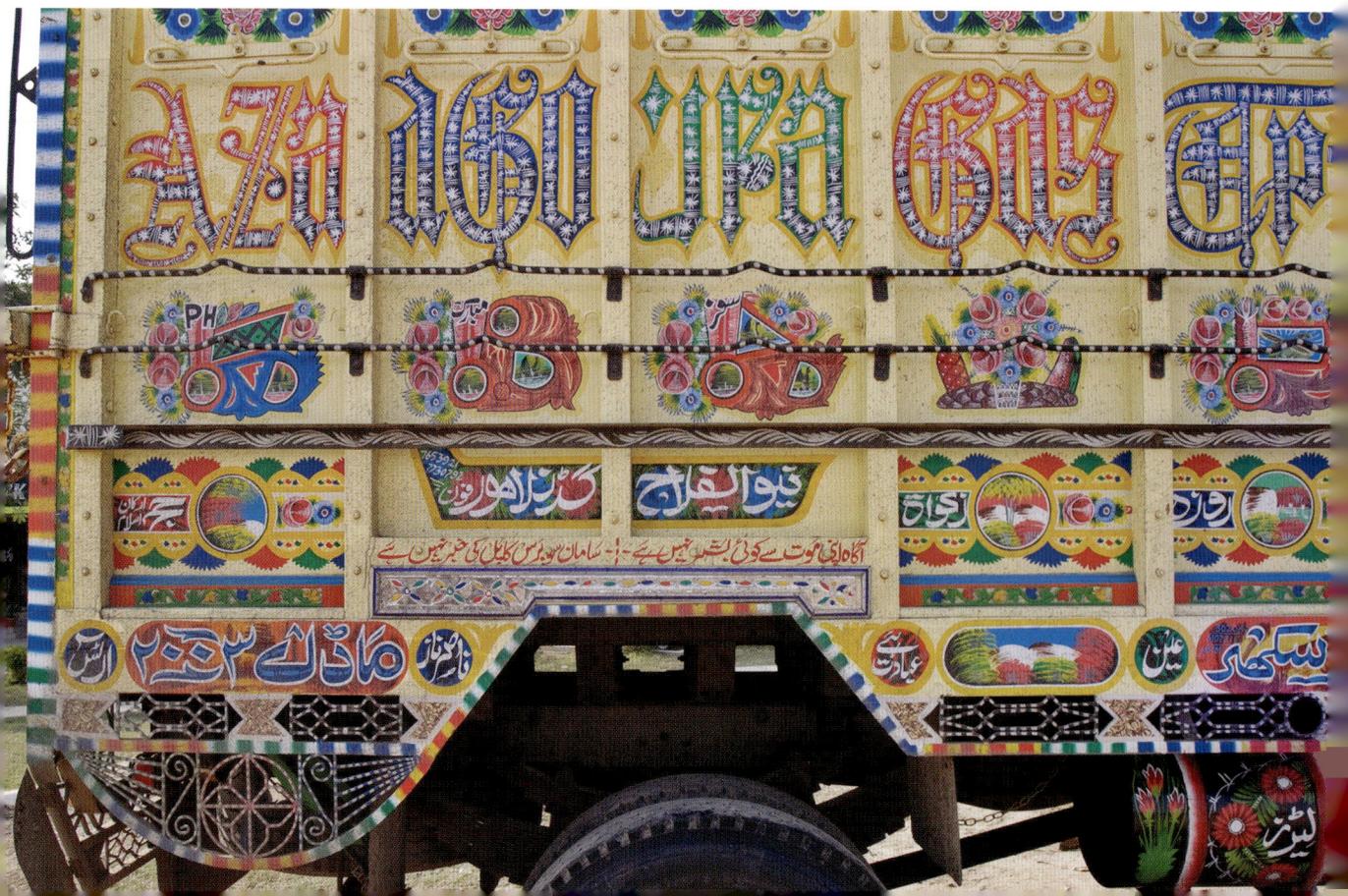

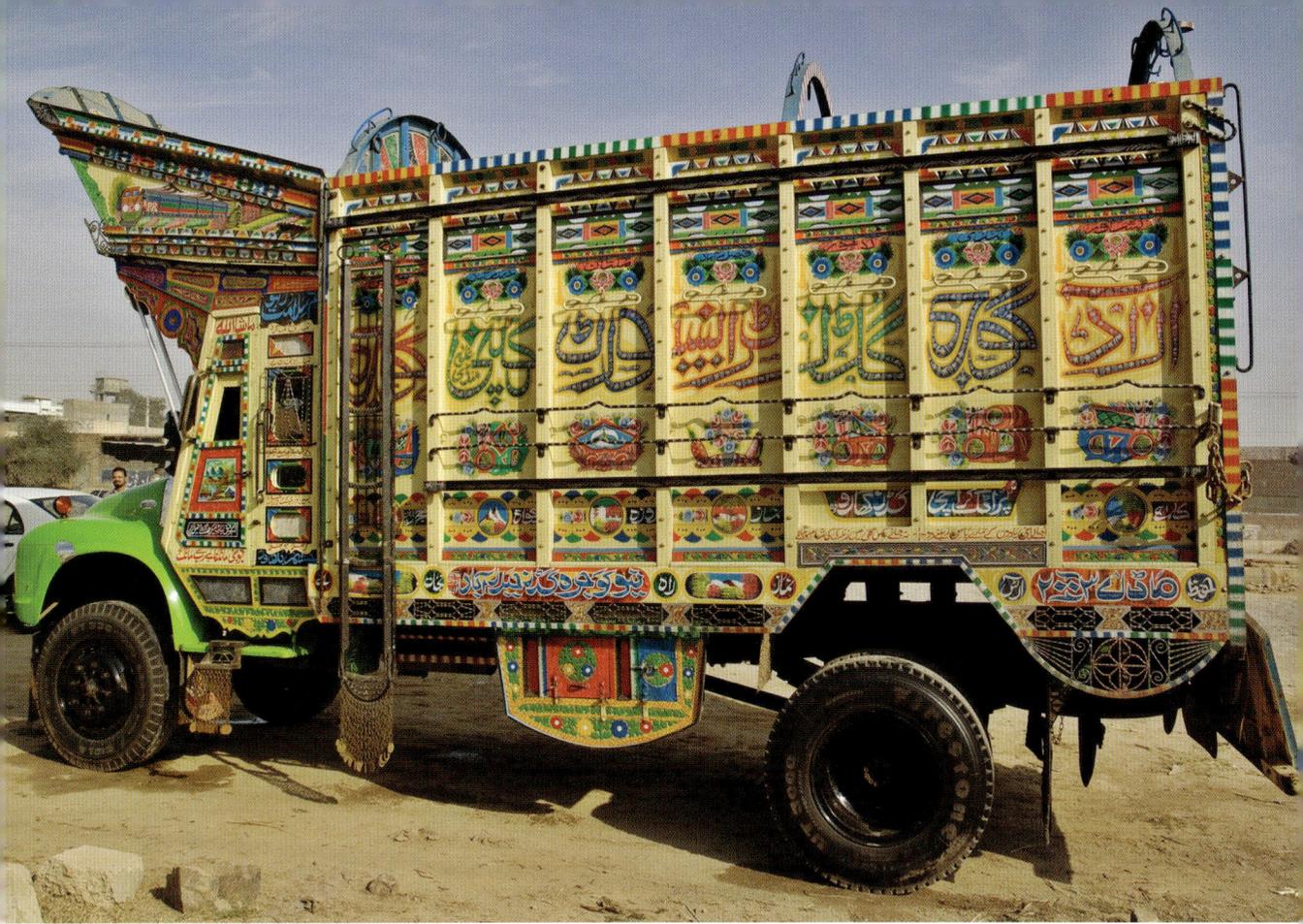

Plate 70:
Left side of a truck
displaying religious
messages (Gujrat 2003)

beam on both sides says 'The creed, prayer, fasting, alms–giving and pilgrimage – the pillars of Islam' (*kalima namāz rōza zakāt hajj arkān-e islām*).

The breaking of visual grammar represented in the decision to relocate religious material to the sides also allows for poetry and aphorisms to appear on the sides of the truck, where they were not found previously. In this example, poetry that would normally be reserved for the front appears above the wheel wells on both sides; on the left:

Leave some light of your memory with me;
Who knows in which alley night will fall on my life.
(*ujālē apnī yādōn kē hamāre pās rehnē dō*
na jānē kis galī mēn zindagī kī shām hōgī)

And on the right:

No mortal man is apprised of his death,
With supplies for a hundred years, unaware of the toll bridge.
(*āgāh apnī mōt sē kōī bashar nahīn hē*
sāmān sō bars kā pul kī khabar nahīn hē)

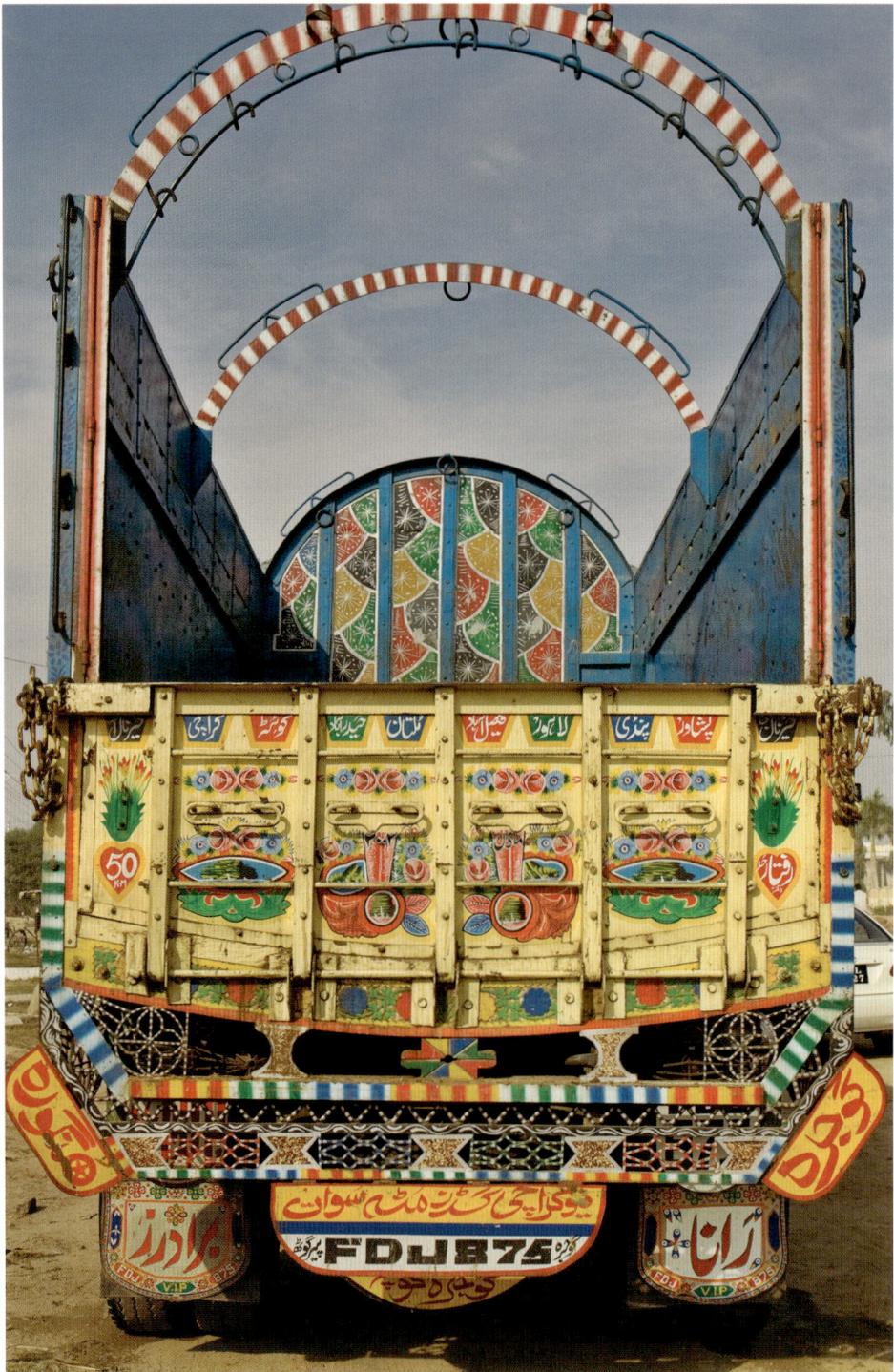

Other epigraphy that is normally reserved for the front is also found on the sides here: 'Hello!' (*marhaba*) (on the right) and 'Evil eye be gone' (*chashm-e bad dūr*) (on the left) and on both sides 'May the journey be blessed!' (*safr mubārak*). Through this migration of signifiers, the distinction between the front as the 'face' of the truck versus the sides as the aspect with spatial signifiers is obliterated, and the truck is transformed into a four-sided tableau with few obvious distinctions between its four aspects. Even the back does not conform fully to customary standards (Plate 71).

At first glace, the back of this truck follows conventions on truck design and decoration, although the epigraphy is unusual in that there is an absence of pithy verse, the only aphorism being 'Come safely, go safely' (*khayr nāl ā khayr nāl jā*) toward the outside at the top of the tailgate. There is also a high usage of spatial signifiers: Gojra-Pirghot (in small letters on either side of the registration plate), Gojra-Mingora (on yellow and red plaques to the outside), and the city names written on the side have been reproduced across the top of the tailgate.[9]

The result of these syntactical changes is a truck that presents its sides as an extension of its face. There is a continuity of information between the sides and the front, such that the two aspects do not serve distinct purposes – identificational versus spatial – but signifiers for both sorts of messages are present on both aspects. On a truck such as this, one can get a sense of the religiosity of the person responsible for the decision-making in decorative choices by looking either at the front or the sides. The significant exception is that of Sufi affiliation, which does not transfer to the sides, a fact that suggests the possibility of a layered nature to Muslim self-understanding in Pakistani society. The front of the truck remains the locus of individual expression, as a result of which personal devotion to specific Sufi saints (or other specific identities, such as being Shiʻa) are still located on the front. However, religion has become an everyday part of Pakistani social and political life to such a pervasive degree that the visual regime has come to reflect it. With religion being an explicit and dynamic part of public space, the spatial signifiers of the truck come to reflect religion, previously only found explicitly in identificational signifiers. As such, the distinction gets eroded between the spatially identificational, the spatially descriptive, the religiously descriptive, and the religiously exhortative. Visual grammar is opened up without the establishment of new rules of syntax, but the broken rules themselves shed light on changes in society and individual understandings of it.

9

Meaning, Modernity, and Shifting Signifiers

Whatever the pictorial turn is, then, it should be clear that it is not a return to naïve mimesis, copy or correspondence theories of representation, or a renewed metaphysics of pictorial 'presence': it is rather a postlinguistic, postsemiotic rediscovery of the picture as a complex interplay between visuality, apparatus, institutions, discourse, bodies, and figurality … Most important, it is the realization that while the problem of pictorial representation has always been with us, it presses inescapably now, and with unprecedented force, on every level of culture …

W. J. T. Mitchell[1]

Among the many enduring elements of Pakistani truck decoration, a winged horse with a human female's head continues to be a popular image, though not as pervasive as some writers have suggested. The image is clearly copied from pre-modern Islamic representations of Buraq, the winged horse that is supposed to have carried the prophet Muhammad on his celestial journey (*isrā'* and *mi'rāj*) from Mecca to Jerusalem and up to heaven (in some versions he went directly from Mecca to heaven). In common belief, the Dome of the Rock commemorates the point from which Buraq leaped into the air, leaving a hoof print on the bedrock. Muhammad's celestial journey has captured the imagination of many people over the course of Islamic history; it was seen as the model of the ideal spiritual quest by Sufi practitioners, poets, painters, and their patrons, and was one of the most commonly represented motifs in illustrations of the Prophet's life.[2] Buraq, the winged horse with a woman's head, is instantly recognizable by anyone familiar with Islamic visual arts and has a long history of being painted on trucks in Afghanistan and Pakistan.

But the average Pakistani does not live in a society where the rich tradition of Islamic representational miniature painting occupies a visible place in public life, and it is not clear in the least bit that the majority of truckers – owners, drivers and painters alike – know

that the image instantly recognizable as that of Buraq by the 'culturally educated' is, in fact, explicitly religious in a traditional Muslim sense. In every instance where I have let a trucker discuss the image rather than introduce my own understanding of its symbolic nature into the conversation, the winged horse with a woman's head has been called a 'fairy' (*parī* or *khaparey*). Some truckers believe that it was a fairy that carried the Prophet on the *mi'rāj* but others do not make the connection between Muhammad's vehicle and *parīs* which remain an important part of vernacular belief, especially in the mountainous north of Pakistan where they bewitch people and carry off children, their beauty contributing significantly to their seductive powers.

That the winged horse is seen as a feminine rather than an explicitly or exclusively religious figure is evident from the fact that this image frequently appears on parts of the vehicle that are not otherwise loci for religious representation. It appears on the back of the truck, although its presence as a visual subject is not especially common even in that location, and seems to be less frequent than it was in the 1970s and 1980s. As in Plate 73, there is never a caption to suggest a connection to Islam, the Prophet or his ascension; the writing next to the winged horse in this image says 'Pahāpā Khālid Tayyāra', a name for this truck, although the vehicle is also called 'Princess Coach' (*shahzādī kōch*) on either side of the license plate and 'Imperial Coach' on the bottom panel.[3]

Although there are a few exceptions, as a rule, the back of the truck is not the locus of religious painting for reasons discussed elsewhere, all of which deal with the etiquette of respecting religious objects and images, including never stepping or standing on top of them. Plate 74 shows the winged horse painted on a panel hanging below the door of a tractor-trailer truck, right next to the steps used to climb into the cabin, a location entirely inappropriate for depicting religious subjects.[4] The most probable explanation for such profane usage is that the winged horse, as 'fairy' (*parī*), has lost all Islamic significance for many truckers (if it ever possessed any in the first place) and has become part of the general palette of pictorial themes from which owners and painters choose what to represent on the truck, and more narrowly from those associated as signifiers with femininity or with flight and speed. But the religious association is not entirely lost: it is clearly there among the more educated members of trucking society, even if the association of the *parī* with Buraq is imposed upon their understanding during the formal moment of discussing the image with an interviewer who is perceived to be of a higher class and therefore needful of a more Muslim sensibility on the part of the trucker. Even tangential associations of the winged horse with explicitly religious signifiers are few and far between, and when they do exist, they are in forms that do not fit traditional patterns of religious representation. The image of the winged horse in a wood panel above the door of a truck and next to an image of the Prophet's Mosque together with the name 'Muhammad' is one of the only explicitly religious uses of this image

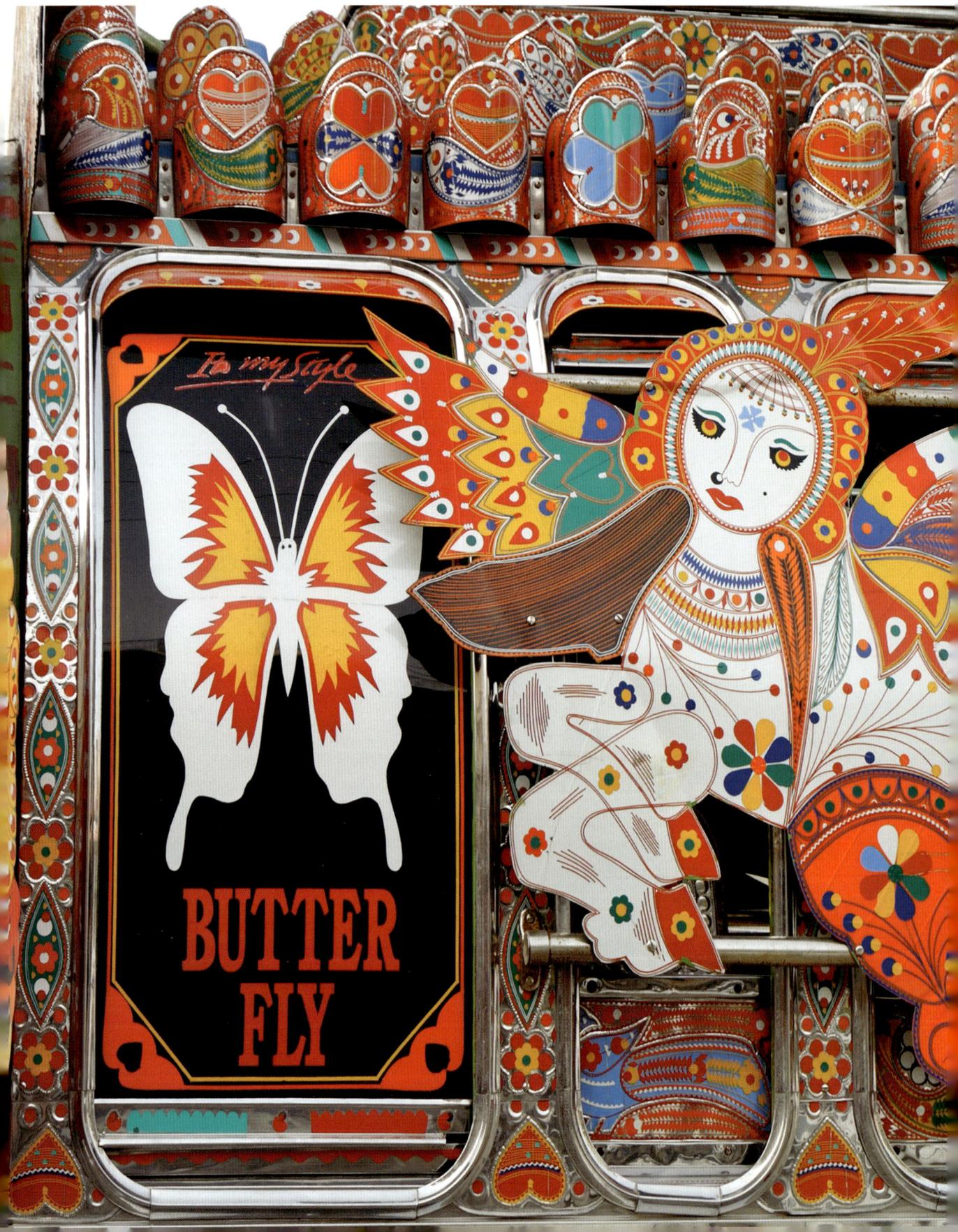

Plate 72: Image of a parī or Buraq on the side of a suzūkī (Rawalpindi 2003)

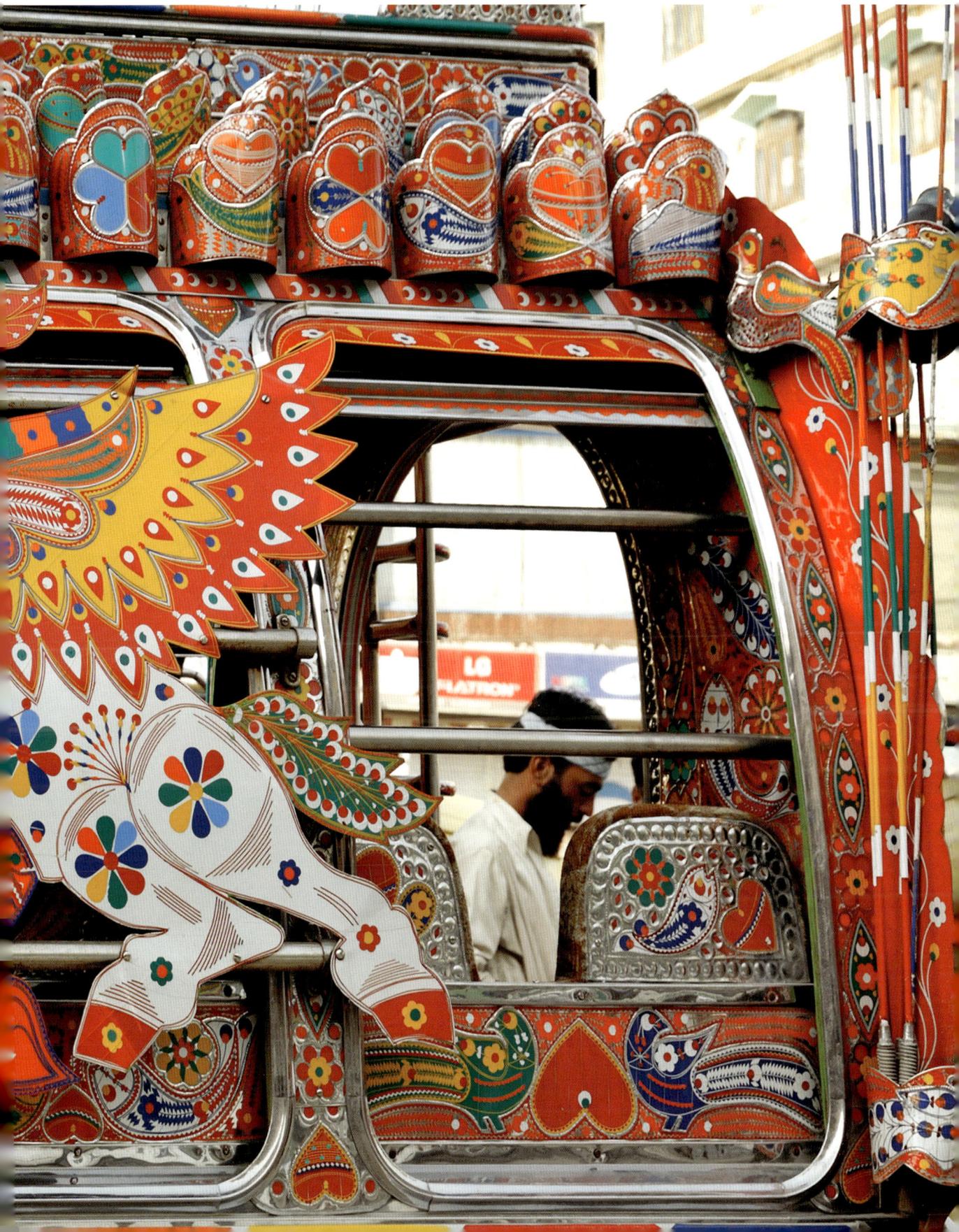

I have encountered (Plate 75). But this location is not normally used for religious imagery and, if it is any indication, the Quetta-based driver of the truck was completely unaware of the significance of the image, referring to it simply as a picture of a fairy (*khaparey*).

Images on trucks therefore possess ambivalent or multivalent significations, their messages shifting with different audiences and also across time. The latter point is not clear in the case of the winged horse because this particular image has not made any significant shifts of signification in the years of my study, although in the mid-1970s Dutreux had already noticed that Buraq did not fit comfortably into the easy categories of religious imagery on Afghan trucks.[5] The pattern of shifting signification as well as loss of vitality as a signifier is readily apparent in other images, most significantly Shi'a iconic images of Husayn's horse and Ali's familiar, the lion, and in the traditionally talismanic chukor partridge.

The front of the truck in Plate 76 provides an excellent example of a truck displaying talismanic and prophylactic signs. It combines explicit textual messages to complement the iconic ones meant to defend against the evil eye. The common formula *Ma'shallah* repeats itself six times in this image: on red spade-shaped plaques on either side of the second panel (to the outside of representations of the Ka'ba and the Prophet's Mosque); once on a rectangular panel to the left beneath the white boomerangs (the other side says '*Yā Allah khayr!*' [O God! Good Fortune!]); once on a violet panel between these yellow rectangular pieces; and twice on the chukor partridges immediately below this. In addition, the narrow panel directly above the boomerangs states 'Cursed be the evil eye!' (*bad chashm par la'nat*), 'May [my] life end, but not faith!' (*jān jāy par īmān na jāy*) and 'May you be well!' (*khayr ho āp kī*).

In light of these explicit messages guarding against misfortune – and appealing to God directly in that respect – it is not inconceivable that the images of the winged horse, which appear in the same row as the boomerangs, fulfills a prophylactic or apotropaic function in this context. After all, other images in its immediate vicinity do just that, some explicitly and others implicitly. Stars and crescents are multivalent nationalistic and religious symbols for Muslim Pakistanis, signifying the related positive characteristics of religious pride and patriotism, which represent good works and therefore deserve to be rewarded. The boomerang (as mentioned earlier) is almost certainly a cheaper substitute for ram or ibex horns, believed to bring good fortune by many people in Pakistan (although it is unclear how many truckers actually make the connection between actual horns and plastic boomerangs).

Most important of all are the two images of chukor partridges on the tiara (*tāj*) directly above the windshield. The chukor partridge is commonly kept as a pet in Pakistan and Afghanistan because of a belief that it functions as a supernatural

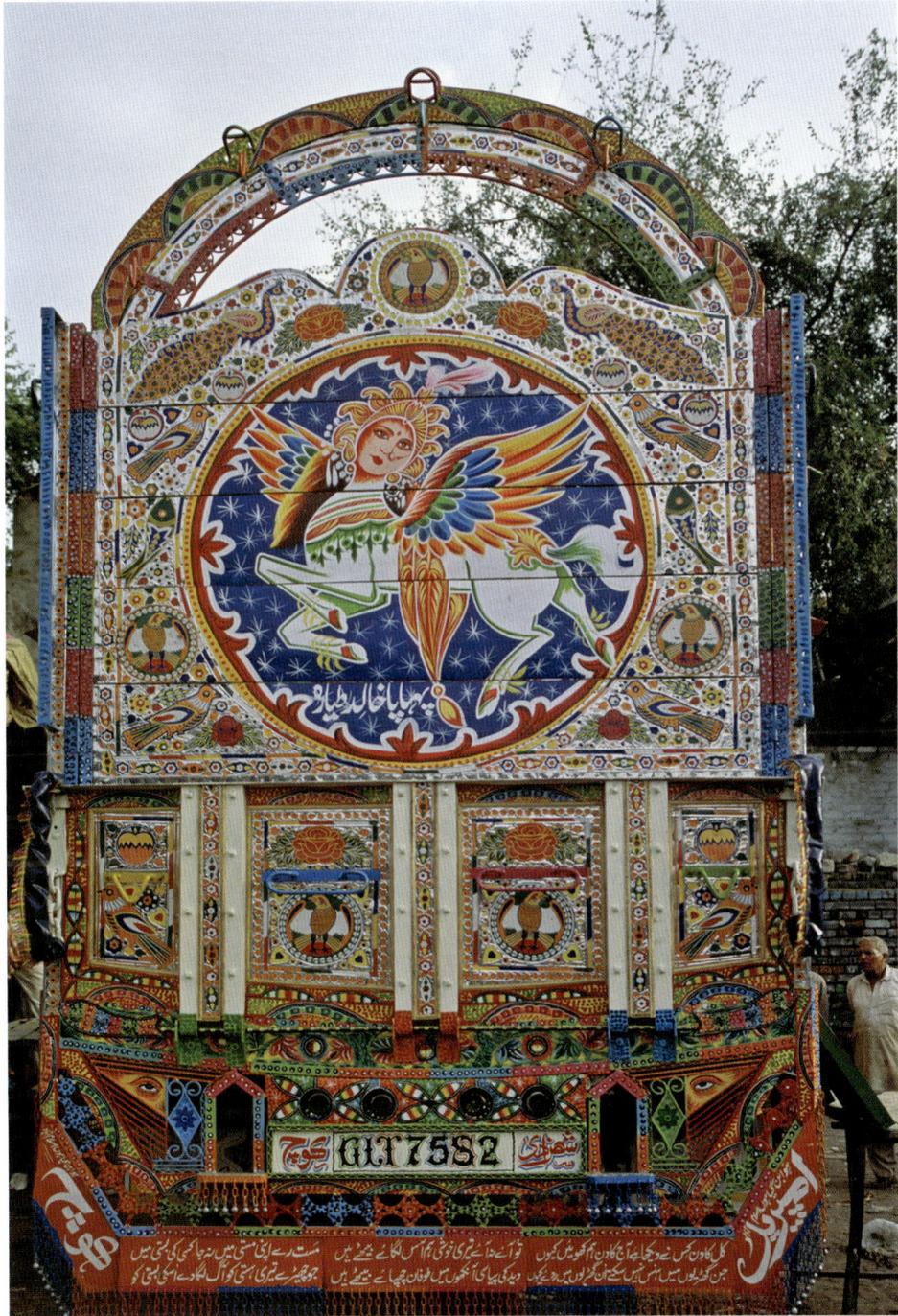

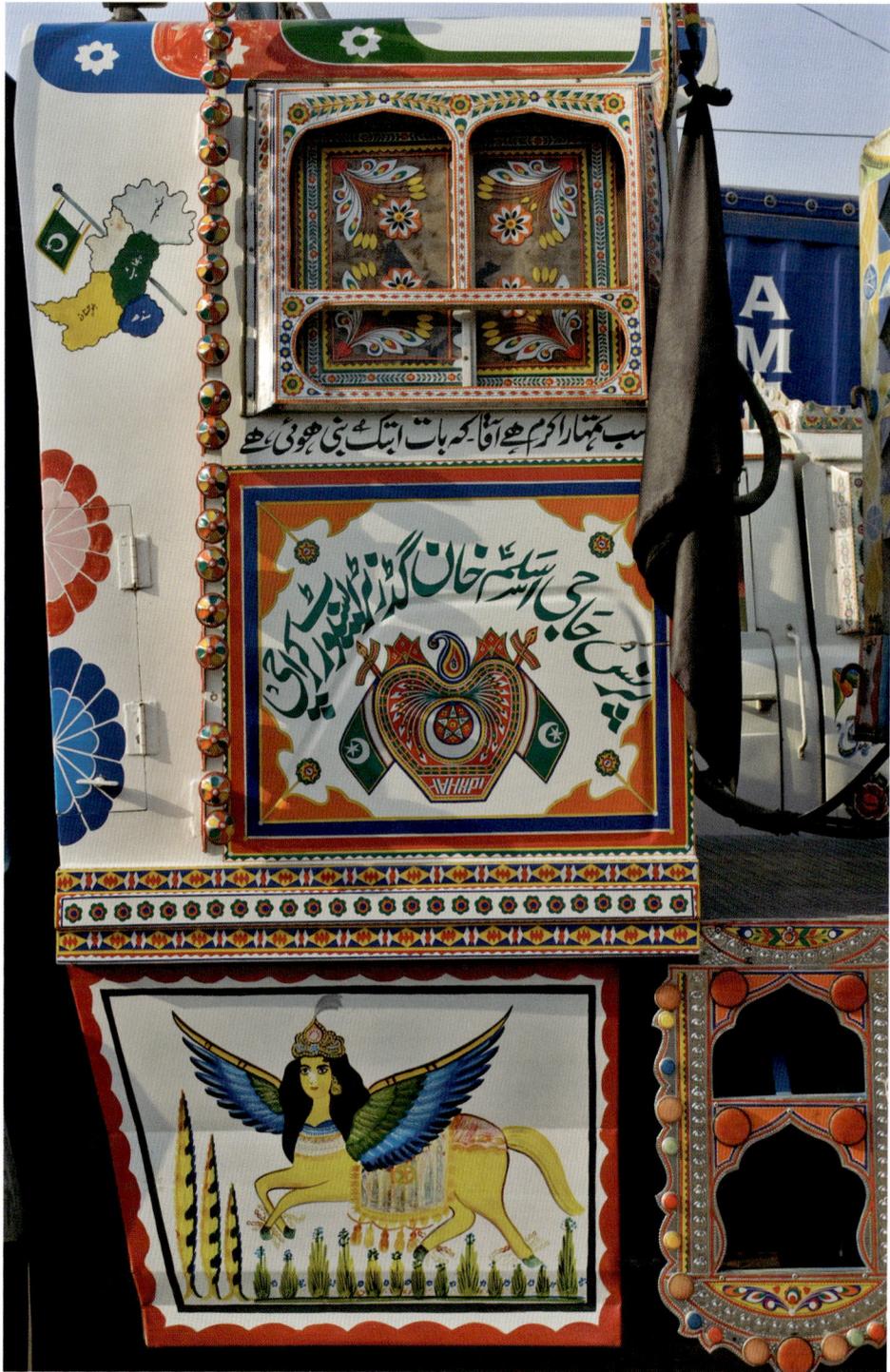

◁

*Plate 74: Image of a
parī or Buraq below the
door of a tractor-trailer
truck (Karachi 2003)*

miner's canary: if anyone casts the evil eye on a household or individual, the spell is
deflected onto the bird which then dies. The death of the bird serves as a warning to its
owner to take immediate preventative measures to avert misfortune. Visual representa-
tions of the chukor partridge, therefore, possess a clear prophylactic purpose, guarding
the truck, its cargo and those associated with it against the evil eye. That message is made
explicitly in this instance by inscribing the *Ma'shallah* on the partridges, the formula
being the commonest phrase deployed to seek protection from the evil eye in Pakistan,
as it is elsewhere in the Islamic world.

Images of chukor partridges appear very commonly on the front of trucks, especially
on vehicles that display a belief in intercessory forms of Islam, which are more likely to
incorporate belief in the evil eye and the necessity of guarding against it than are trucks
advertising other ways of being Muslim, though these symbols are by no means entirely
absent from such vehicles. The two trucks in Plates 77 and 78 both belong to the inter-
cessory type and contain references to Sufi saints in their epigraphy.

*Plate 75: Image of a
parī or Buraq with
religious imagery above
the door of a truck
(Karachi 2003)*
▽

The black plaque between the partridges on the truck in Plate 77 says *Ma'shallah*, as
does the white and red sticker on the windshield directly below it, making the explicit
connection between the partridges and prophylactic agency. Directly above the black
plaque is one declaring 'God is king!' (*Allah bādshāh*), while both white plaques on either

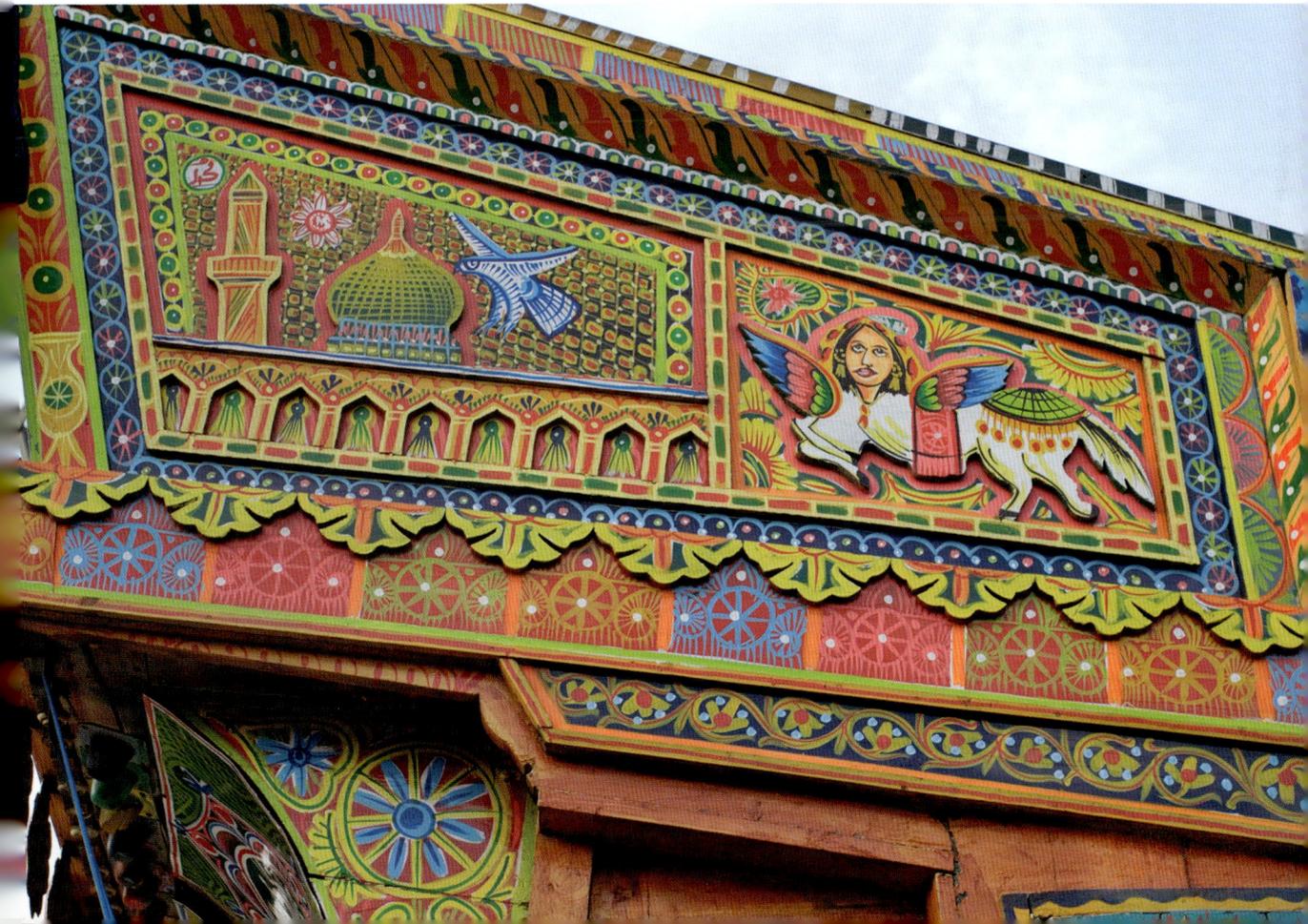

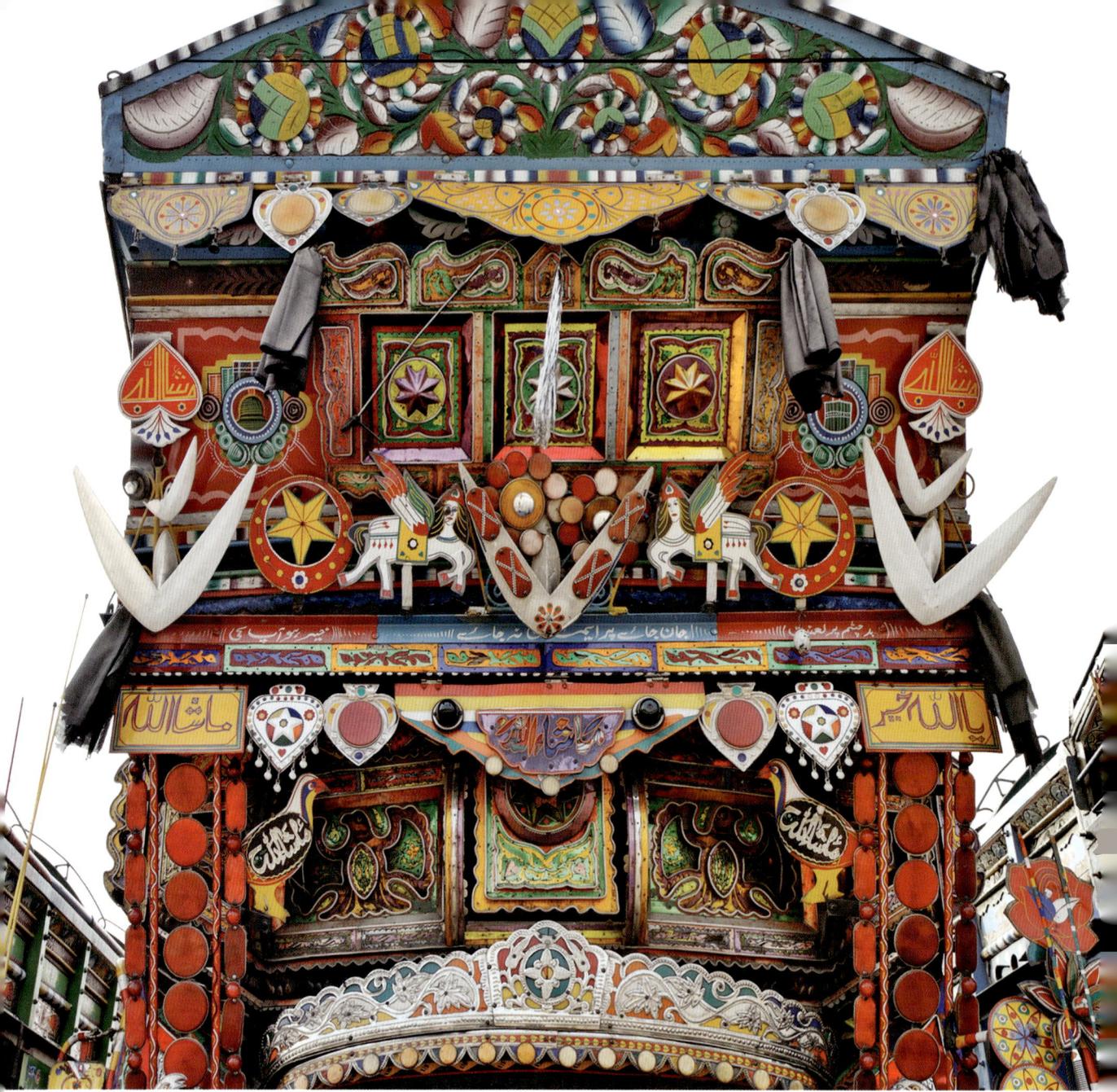

side of that one list the names of two Sufi saints of local significance, Pir Muhammad Amir Sahib Wirali and Pir Muhammad Azim Sahib Wirali.[6]

Plate 78 depicts a truck in a hybrid style with dominant features from Peshawar, and which displays a similar explicit connection between the chukor partridge and guarding against the evil eye. Here, too, the formula *Ma'shallah* appears on a red plaque in the middle between the partridges, and there are references to local Sufi figures: Baba Nuri

△

Plate 76: Detail of the front of a Bedford in the Peshawari style showing a variety of talismanic and other objects (Rawalpindi 2003)

160

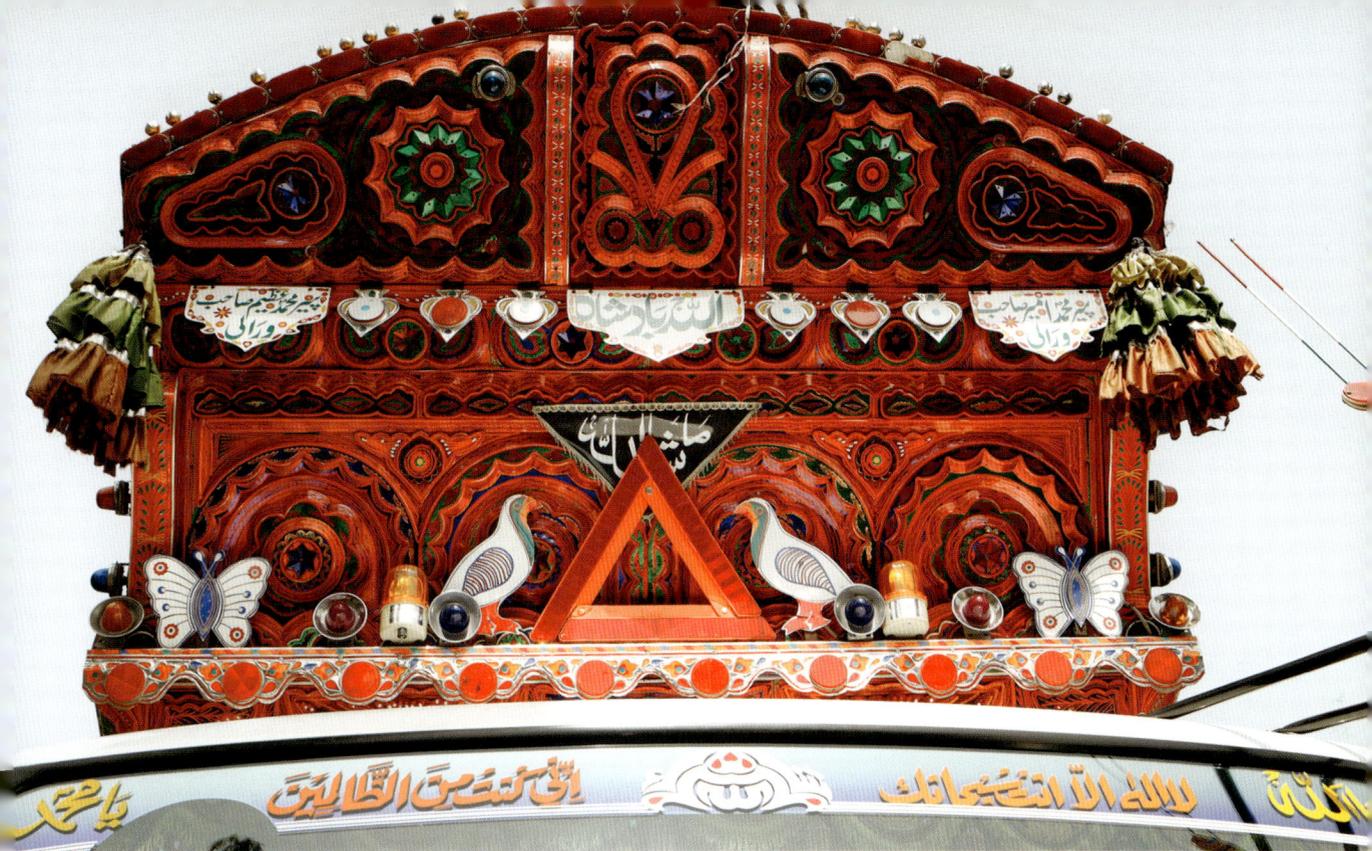

△

Plate 77: Detail of a Hino truck decorated in the Balochi style of Dera Ghazi Khan with chukor partridges (Turnol 2007)

Nag Sultan in the main medallion between the eyes, and Pir Sayyid Amir and Pir Tufayl Ahmad, both of Chakki Sharif (a small town on the Potohar Plateau), on the goblet-shaped plaques at the bottom of the image.[7]

By the mid-2000s, the image of the chukor partridge had migrated from the front of the truck – where it occupied a space within the established array of talismanic symbols, objects and phrases – to the back of the vehicle. This migration has occurred primarily, but not exclusively, on dump trucks which serve as some of the best indicators of trends in pictorial choices and their function as signifiers because such vehicles have a large expanse of unbroken metal in the back to serve as a canvas for larger paintings, a canvas that sees a great deal of wear and tear because of the nature of the vehicle, and therefore requires more frequent repainting than other kinds of trucks. The vehicle in Plate 79 is an example of just such a dump truck from near Rawalpindi. In this instance, the chukor partridges have migrated from the front of the truck to the back with their sign value almost completely intact: they appear as a pair facing each other as they normally do on the front of a vehicle, and directly above them is a reference to God: 'Glory be to Your creation!' (*subhān tērī qudrat*). The call of a partridge is widely believed by Pakistanis to sound out these words – one in a plethora of examples of how all of nature bears witness to the glory of God. Although not specifically a reference to the evil eye, as in the case when the chukors appear together with the *Ma'shallah*, the reference to God and the

161

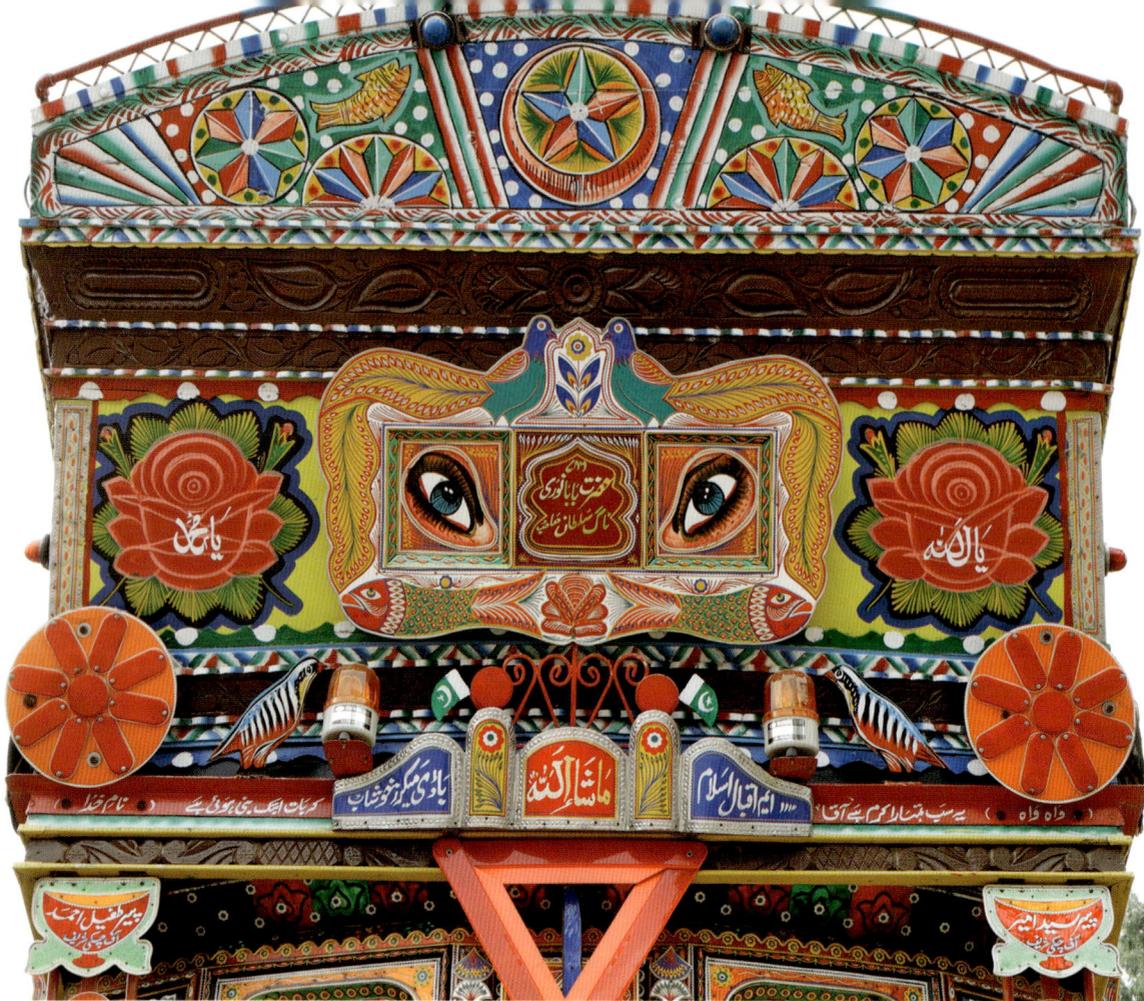

Plate 78: Detail of Bedford in the Peshawari style with a variety of talismanic images including chukor partridges (Rawalpindi 2007)

piety of partridges retain their religious significance and, arguably, keep alive the connection to their prophylactic function in society.[8]

Plate 80 shows an almost identical painting from the same workshop of Tariq Salim Brothers, well-respected painters based in the Carriage Factory neighborhood of Rawalpindi.[9] The chukor partridges appear in exactly the same pose against the background of an autumnal alpine landscape, with the slight difference that, whereas in Plate 79 there is a small gap between the birds, in this instance their beaks are touching. Despite the identical visual representation, in Plate 80 there is no reference to the partridge's call as an invocation of God, nor any other reference that would suggest a formal awareness of the popular religious significance of partridges in Pakistani culture. To anyone unfamiliar with this aspect of vernacular culture, the partridges appear as nothing other than colorful (and presumably attractive) birds in a sentimental landscape. Certainly, the overwhelming majority of members of the urban middle-classes would see them as nothing else.

162

In this regard they would be no different from the bird in Plate 81, which shows a single (and zoologically more accurate) chukor partridge on the back of a truck in the Balochi style. In this instance, the partridge appears alone against an alpine landscape and is standing in a pose substantially more naturalistic than those in the two paintings in the previous illustrations. There are no indications whatsoever of any religious significance to the bird, nor any talismanic or prophylactic images, objects or phrases that would suggest such a function to it. Detached from any other signifiers, such as appearing as a pair or with references to God or the evil eye, the chukor partridge arguably has shed its sign value and now represents one of numerous pleasing images that appear on the backs of trucks.

The same process of shifting signification is encountered in the case of an image that possesses iconic status within Shi'a circles around the Islamic world, not just in Pakistan. A white stallion is instantly recognizable by many Shi'as as Zuljanah, the horse of Imam Husayn that, according to myth, was given to him by the prophet Muhammad and served as his mount during the siege at Karbala when Husayn was martyred. In common Shi'a belief, when Husayn was so badly wounded on the battlefield that he could no

Plate 79: Chukor partridges on the back of a dump truck (Rawalpindi 2003)
▽

longer carry on, his horse kneeled on all four legs to let him down gently onto the ground and then galloped back to camp, where its rider-less arrival was taken as confirmation that Husayn, the grandson of the Prophet, had fallen. To this day, a rider-less white stallion occupies the central place in annual processions commemorating the martyrdom of Husayn on the 10th of Muharram, the first month of the Islamic calendar.[10]

There are no reliable statistics on the actual numbers of Shi'as in Pakistan, partly because of the general inaccuracy of religious demographic data, but also because the Shi'as perceive themselves as a beleaguered minority and therefore manipulate their own statistics, inflating them in some instances (such as when making demands for resource allocation) and deflating them in others (especially when hiding their identities to avoid discrimination). Nevertheless, approximately 20 percent of Pakistan's population is likely be Shi'a, of which the large majority belong to the Twelver (Imami or Isna 'ashari) sect, that is the one that is most notable for its commemoration of Husayn's martyrdom. Twelver Shi'as are present all across Pakistan, but they have higher concentrations in certain areas, including on the Potohar Plateau near Islamabad, where the accompanying series of photographs of dump trucks was taken.

The truck in Plate 82 is unambiguous in its Shi'a identification. Painted by Tariq Salim Brothers (and the body painted by Zubayr Brothers), the white horse's flank is emblazoned in blood red with the name 'Mashhadi Flyer' (*tayyāra*); Mashhad, in northeastern

Plate 80: Dump truck with painting of chukor partridges and eyes (Rawalpindi 2003)
▽

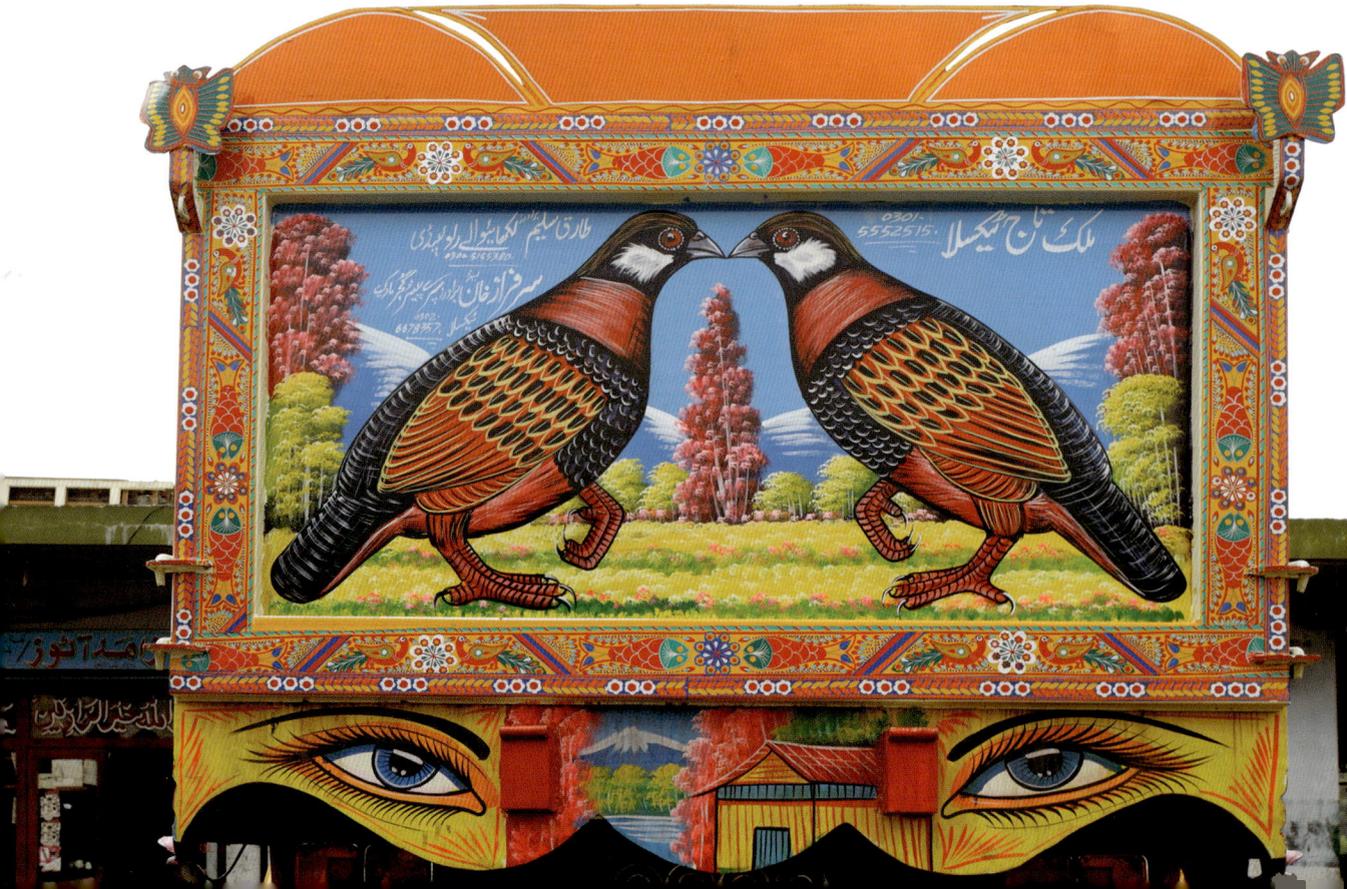

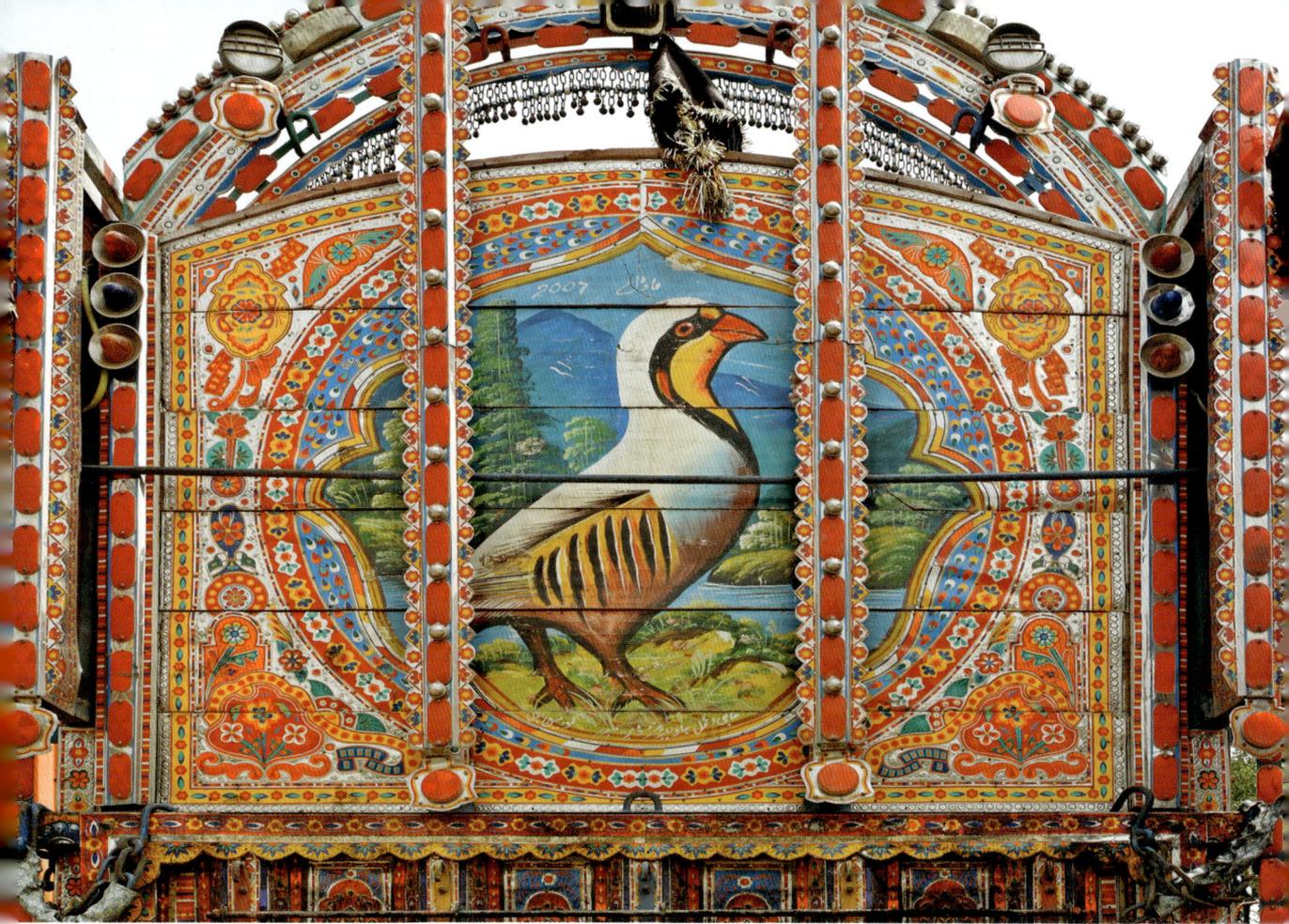

Plate 81: Back of truck in the Balochi style with a painting of a chukor partridge (Turnol 2007)

Iran, is one of the holiest Shi'a cities and a center of pilgrimage. Furthermore, the horse is peppered with silver rivets signifying wounds suffered while carrying Husayn on the battlefield. On either side of the horse are the names of the Shi'a heroes, Hamza and Ali.[11]

Reminiscent of the case of the chukor partridge above, Plate 83 shows a truck with a white horse also painted by Tariq Salim. The two paintings of a white stallion are virtually identical, with the horse in the same pose against a background of deep green foliage. In this instance, there are no indicators that this truck has any formal Shi'a affiliation. Other than the advertisements for Tariq Salim and the spray painter, Haji Abdullah of Hasanabal, the remaining epigraphy comprises generic statements, an Urdu prayer wishing 'May you always be happy, that is my prayer' (sadā khush raho, ye du'ā hē mērī), and a rhetorical Punjabi aphorism with ambiguous religious significance of a very generic Sufi sort: 'Why have you given me a cheating, thoughtless lover?' (kyūṇ dittā ay asākūṇ rōl bēparvāh ḍōlā).

165

Based on early descriptions and by historical consensus, Husayn's horse is believed to have been white, and this belief is reinforced every year by the public reenactment of his martyrdom. The annual ritual recollection of a white horse has not prevented an image of a black and white stallion gaining popularity in the truck art of the Potohar Plateau. Plates 84 and 85 show two such black and white horses painted by Tariq Salim Brothers. The painting in Plate 84 has the names of the Shiʻa heroes Hamza and Ali above the horse and the horse itself bears rivets representing wounds, but the second painting has no signifiers indicating any religious importance to the image.[12]

The rider less horse leaves the narrow confines of Shiʻa iconography and enters a wider world of images popular among truck owners and artists. Works by well-known painters such as Tariq Salim are copied by others and circulate widely in the world of truckers, as is apparent from the truck in Plate 86 which has a horse painted by Javed Brothers of Rawalpindi.[13]

Portraiture and the Modern

As the shifting signification of the images discussed above makes apparent, the back of the truck remains the most semiologically undetermined aspect, and one where personal expressions have always played a greater role than on the sides. The locus of pithy statements and jokes, it is also the part of the truck to display some of the most specific sociopolitical statements in truck decoration, and also ones that are primarily pictorial rather than textual.

The back of the truck has long been open to a variety of uses without carrying the syntactical constraints regarding signifiers apparent on the front of the vehicle and – to a somewhat lower degree – on its sides. It remains the only part of the truck utilized as a canvas for large paintings, and there are few rules concerning what can be displayed there, the only apparent one being that there should be no representations of sacred individuals and places, or ones subject to religious veneration, with the notable exception of the Shiʻa images discussed above. But even this rule is not observed equally across the country, and in recent years there are many more examples of trucks with religious themes on the back – in portraiture, landscape and architecture – as well as sloganeering.

Portraits on the backs of trucks can be of religious figures in a marginal or wider sense who arguably are more famous as celebrities of popular culture, such as the late singer Nusrat Fateh Ali Khan. Khan was a formally trained performer of *qawwālī*, the musical meditational tool of the Chishti Sufi order, and therefore can be seen as a religious figure. However, in Pakistan *qawwālī* is sufficiently pervasive that few people beyond practicing Chishti Sufis and the very well informed actually think of it as formally religious rather than just part of the wide range of love poems and songs prevalent in the

▷
Plate 82: Image of the horse of Imam Husayn on the back of a dump truck (Rawalpindi 2003)

▷
Plate 83: Painting of a white horse on a dump truck (Rawalpindi 2003)

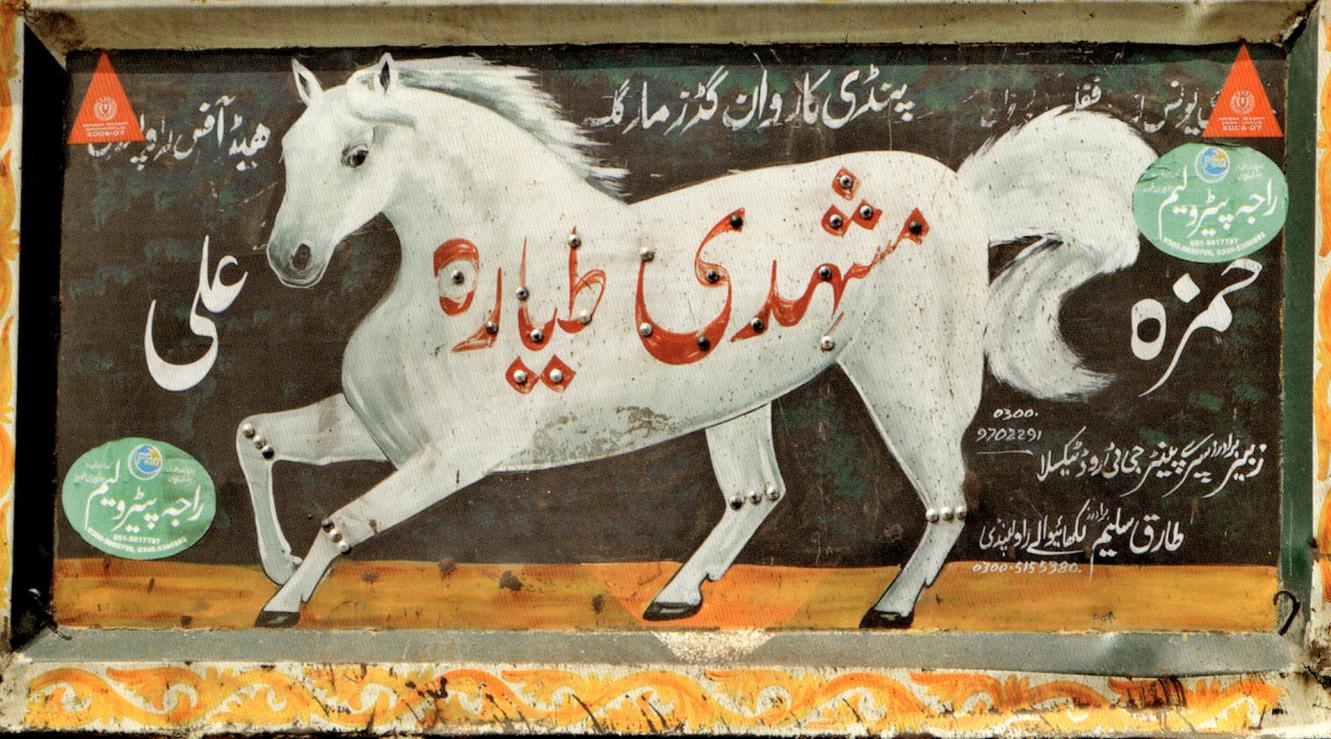

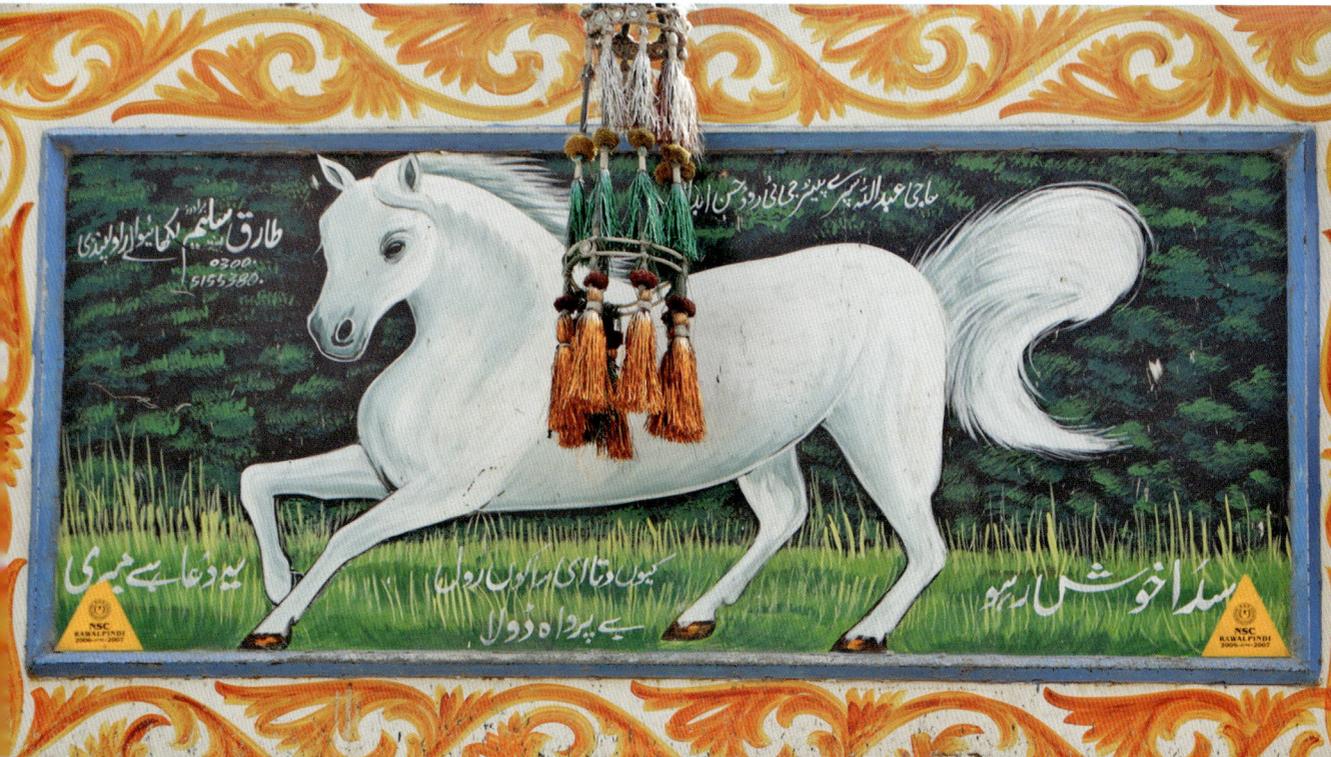

society which play on their ambiguous messages as to whether the object of desire is human or divine. One could argue, therefore, that Nusrat Fateh Ali Khan is in the same category as other respected singers who appear on the backs of trucks, such as Noor Jahan and Ataullah Khan Issakhailvi (perhaps the most popular singer among truck drivers). On very rare occasions, one encounters images of prominent Sufi figures such as Khwaja Muinnuddin Chishti, the eponymous founder of the Chishti order, although even he is more likely to appear iconically represented by his mausoleum in Ajmer. This shrine remains a pilgrimage site of great importance to South Asian Muslims, but it has been inaccessible to the vast majority of Pakistanis since the sealing of the border between India and Pakistan in 1965, and therefore is as much an imagined thing as the dead saint it represents.

The use of the back of the truck for religious slogans is much more common, particularly on the part of politicized religious groups. Plate 87 shows the back of a dump truck used for transporting gravel in the Islamabad-Rawalpindi area. It provides an excellent example of the blurring of boundaries between Sunni religious groups in modern Pakistan, with explicit references to the Tablighi Jama'at existing side by side with a clear exhortation to armed *jihad*. Such attitudes would be anathema in a strict reading of the movement's teachings; however there is evidence both from trucks and other elements of Pakistani popular culture that individuals blur the distinctions between groups and do not necessarily consider it a contradiction to express sympathies for the Tablighi Jama'at as well as overtly militant groups such as Jama'at ad-da'wa. The top of the truck declares 'O God, aid us!' (*Yā Allah, madad*), flanked on either side by affirmations of the legitimacy of the first four Sunni caliphs (*khilāfat-e rāshida* and *haqq chār yār*). The beseeching of divine help occurs here in a formula that is normally used to ask for Ali's aid (*Yā 'Ali, madad*); together with the references to the 'Rightly guided' Sunni caliphs, the top of the truck could be seen as an attempt to assert a Sunni identity against a Shi'a one.

Below this is a couplet:

Your servant is a sinner, but You are merciful, O Lord!
Showing grace to Your servant is Your glory, O Lord!
(*banda tō gunahgār hē tū rehmān hē Mawlā
bandē pe karam karnā tērī shān hē Mawlā*)

The green flag behind the crossed swords says 'Al-Jihad'; the two medallions on either side of it declare 'Long live the call of Tabligh!' (*da'vat-e tablīgh zinda bād*).[14]

Religious imagery on the back of trucks takes such different forms that to categorize it as religious in its primary significance is to misconstrue the place of the individual subjects represented on the truck, as well as that of religion and the religious in

▷
Plate 84: Dump truck with black and white stallion and Shi'a signifiers (Rawalpindi 2003)

▷
Plate 85: Dump truck with black and white stallion (Turnol 2007)

168

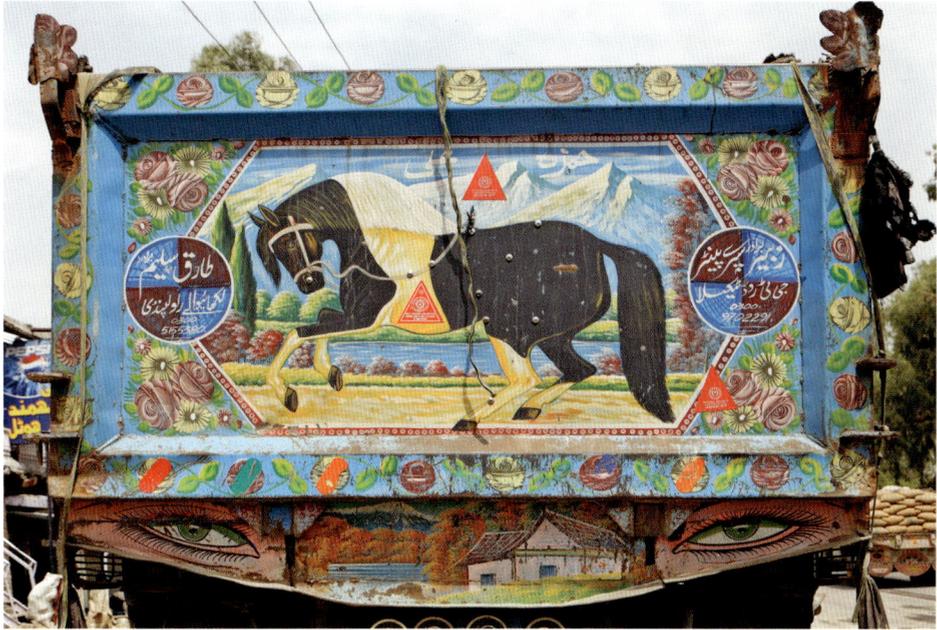
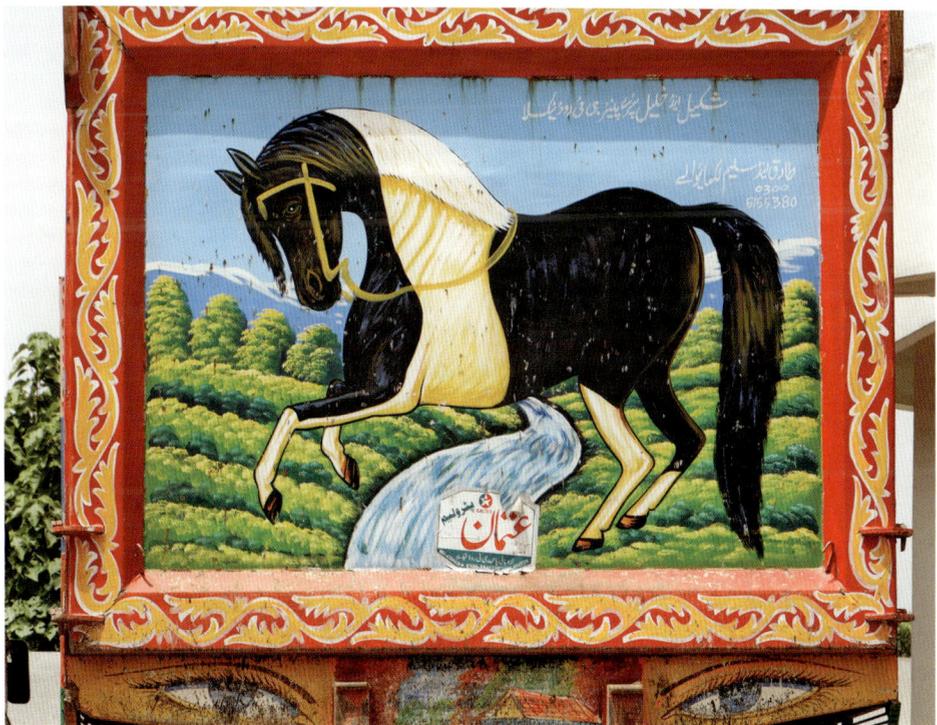

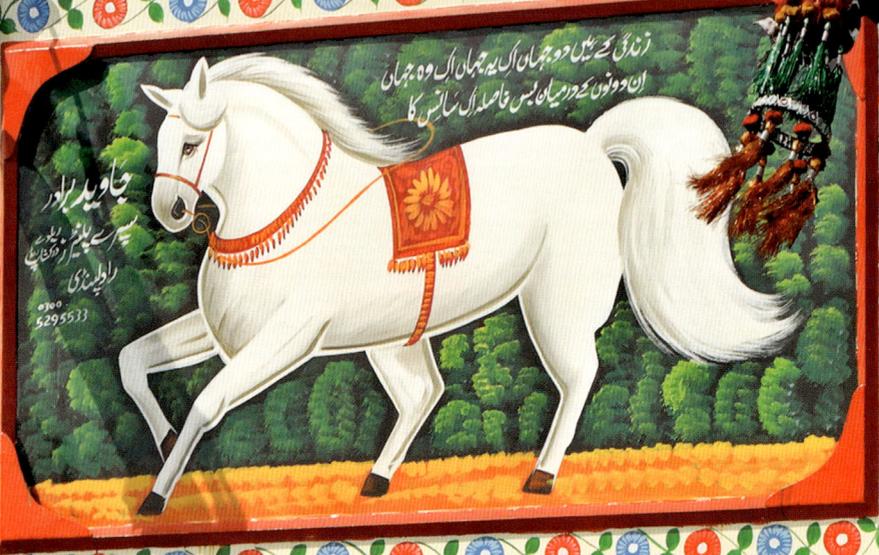

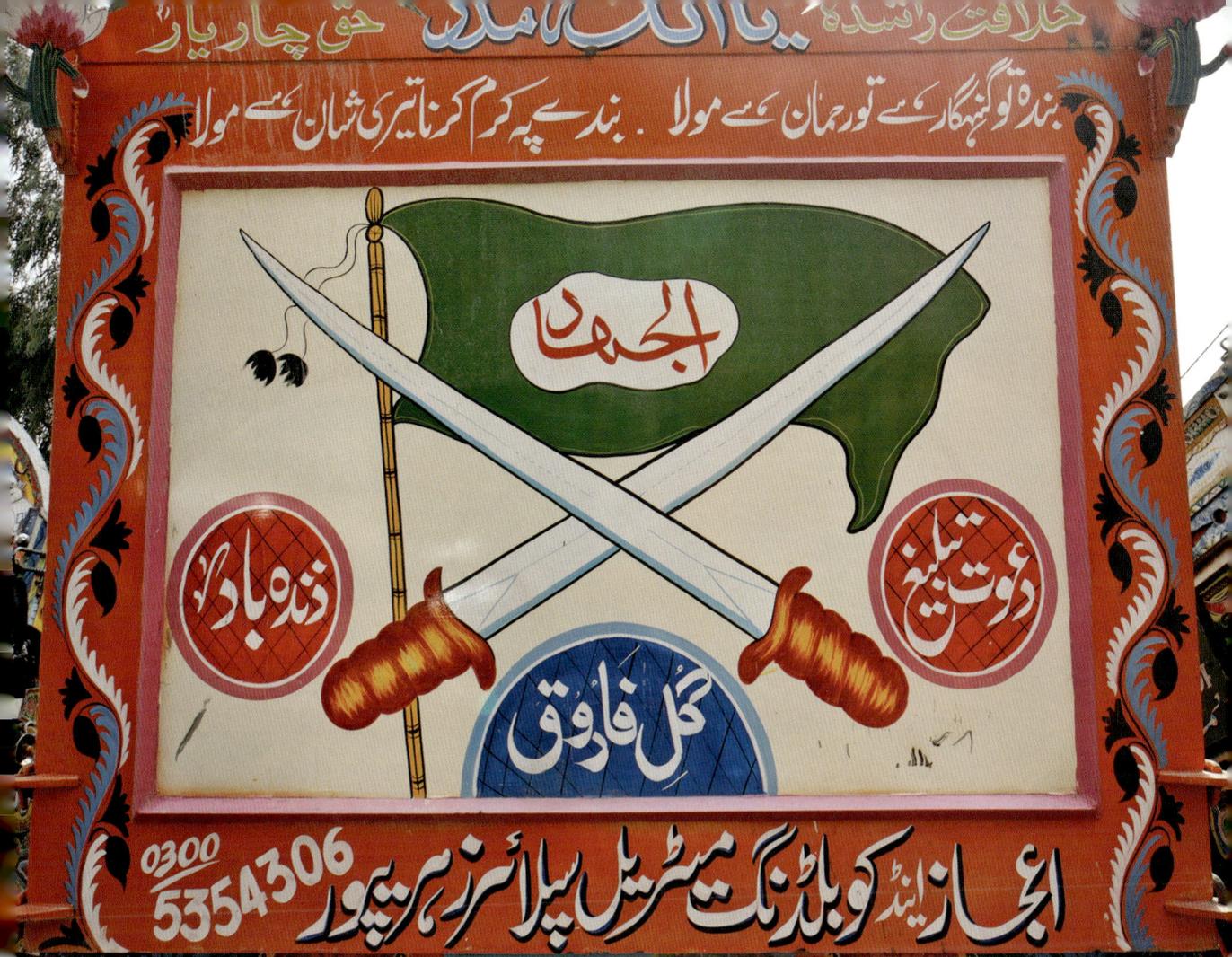

△
*Plate 87: Dump truck
extolling Jihad (Turnol
2007)*

◁
*Plate 86:
A dump truck travelling
near Taxila (2003)*

Pakistani society. The placement of religious slogans on the back definitely represents a migration of signifiers to a place where they previously did not reside, and therefore a shift in the syntax through which trucks communicate their messages. For contemporary religious groups such as the Tablighi Jama'at, to advertise themselves and their ideology on the back of a truck is likely to relate to the phenomenon, detailed earlier, of the need on the part of politicized religious groups to shift the visual syntax in order to have their messages (and maybe even their identities) noticed by the intended audience. The very modest increase in the frequency with which Sufi-themed images are seen on the backs of trucks in recent years might very well represent a response to the practices of more politicized groups and the consequent growing acceptance of new rules of syntax among a wider population of truckers.

The most frequent religious images on the backs of trucks remain those of politicized Islamist groups, a phenomenon that should be seen not as part of some formalistic thematic classification of religious images as part of the decorative program of

171

Pakistani trucks, but as one of the notable ways in which the back of the truck is used to convey sociopolitical attitudes and concerns with contemporary issues. In this regard, such images belong more appropriately to the wider category of portraits that appear on the backs of trucks.

Portraiture on trucks has many functions and is used differently among individuals from different parts of Pakistan. It is most frequent among Pushtuns and non-Pashto-speaking truckers from Hazara, although it is not entirely uncommon in the Punjab, particularly on the Potohar Plateau. Portraits can be of celebrities in popular culture, or else of members of one's family, especially young sons, as has already been seen. Most commonly, however, truck portraiture constitutes the evocation of the heroic or exemplary, either at a national or a regional level. It is seldom entirely personal (in the manifestation of personal heroes unknown to a wider audience), reflecting as it does a desire to advertise individual attitudes and to communicate with a wider (though specific) cross-section of society.

A substantial proportion of the heroic portraiture on trucks is of figures of national significance. Of the individuals associated with the formation of Pakistan, I have never seen a portrait of Jinnah on the back of a truck, although smaller images of him appear on the sides of trucks and also in the hammered metalwork (see Plate 7 on page 23). Iqbal, the ideological rather than political founder, is encountered on the back occasionally, represented in a famous pensive pose that appears in official publications and on posters throughout the country. The preference for Iqbal over Jinnah in matters of representation might partly be due to the taboo on representing truly revered individuals – Jinnah is the 'Great Leader' (*Quaid-i-Azam*) and may therefore fall within the same category as prophetic figures in the eyes of some. It is more likely, however, that the majority of truckers either do not identify with Jinnah at a personal level, as he was a very westernized citizen of Bombay, or that they belong to the section of religiously politicized modern Pakistanis that sees Jinnah as possessing values at odds with their own and their vision of Pakistan. In contrast, Iqbal is widely believed to have been an advocate of greater Islamization, of giving an avowedly Islamic character to Pakistan, and of a broader awakening of pan-Islamic pride and mobilization.

Iqbal and Jinnah do not only differ in their ideologies as imagined by sections of modern Pakistani society, but also in their relevance to Pakistani modernity. Despite his centrality to nationalistic discourse and in the Pakistan Studies curriculum in schools, for many Pakistanis Jinnah has receded into the mists of history, belonging to a time so far removed from the realities of modern Pakistan as to be virtually irrelevant. Iqbal, on the other hand, as a religious and nationalistic poet and an ardent advocate of pan-Islamism, is as relevant today as he has ever been. Truck portraiture is an arena for the socially relevant, and in this Iqbal shares space with national heroes of more recent vintage.

There is a regional and ethno-communal dimension to who is recognized as heroic. Thus Zulfiqar Ali Bhutto and his daughter, Benazir Bhutto, are popular subjects of truck portraiture in Sindh, understandably so because they belonged to the feudal aristocracy of that province, which also constitutes the heartland of their political party, the PPP (Pakistan Peoples Party). General Ayub Khan, the first military ruler of Pakistan, who was forced out of office in the period immediately preceding Bangladesh's war of liberation from its status as East Pakistan, is still relatively common on trucks from his home region of Hazara. His portrait normally appears with a caption tinged with nostalgia for a past that is seen by many across the country as better than the dystopic present: 'Thoughts of you came after you were gone' (*tērī yād āī tērē jānē kē bā'd*).

Like Zulfiqar Ali Bhutto, Ayub Khan is nostalgically recollected by the people of his home region as the best leader the country has seen and a native son of Hazara, which often feels beleaguered in the face of the ever-expanding Pushtun majority of Khyber Pakhtunkhwa (NWFP, of which Hazara is a part). There are other examples of heroic figures from the past that appear in truck portraiture, the majority of whom are military men. The most common among these is Major Aziz Bhatti, killed in the 1965 war with India and awarded the Nishan-e Haidar, Pakistan's highest medal for bravery which is, by tradition, only awarded posthumously (see Plate 88).

The majority of heroes and exemplars appearing in truck portraiture are contemporary figures rather than those from the past, although Major Aziz Bhatti arguably has greater contemporary relevance than his death half a century ago might suggest. He plays a prominent role as a hero in Pakistan's annual Defence Day celebrations (*yawm-e difā'-ye Pakistan*), is studied by all school children as part of their mandatory 'Pakistan Studies' curriculum, and is the subject of poetry and song. As such, Bhatti is very much alive in the imaginations of contemporary Pakistanis.

Military heroes like Major Bhatti remain popular subjects in truck portraiture and, in a wider sense, reflect the prestige the armed forces have historically held among the Pakistani populace. The truck in Plate 88, which is owned by someone of the same Rajput background as Major Bhatti, not only commemorates the war hero depicted pictorially, but also the armed forces themselves in the comment above Bhatti's head: 'Salutations to the Pakistan Army!' (*pāk fawj kō salām*). 'Pāk' has an intentional dual meaning, since not only is it an adjectival abbreviation for Pakistan, but it also means 'pure'; 'Pakistan' literally means 'Land of the Pure' or 'Pureland', an idea that is often not far from the surface in nationalistic self-conceptions. When used as a descriptor for the Pakistan army, it lends the armed forces and their actions a stamp of moral righteousness that, arguably, makes all Pakistani military conflicts just wars, and criticism of them an act that carries not just political but also religious ramifications.[15]

173

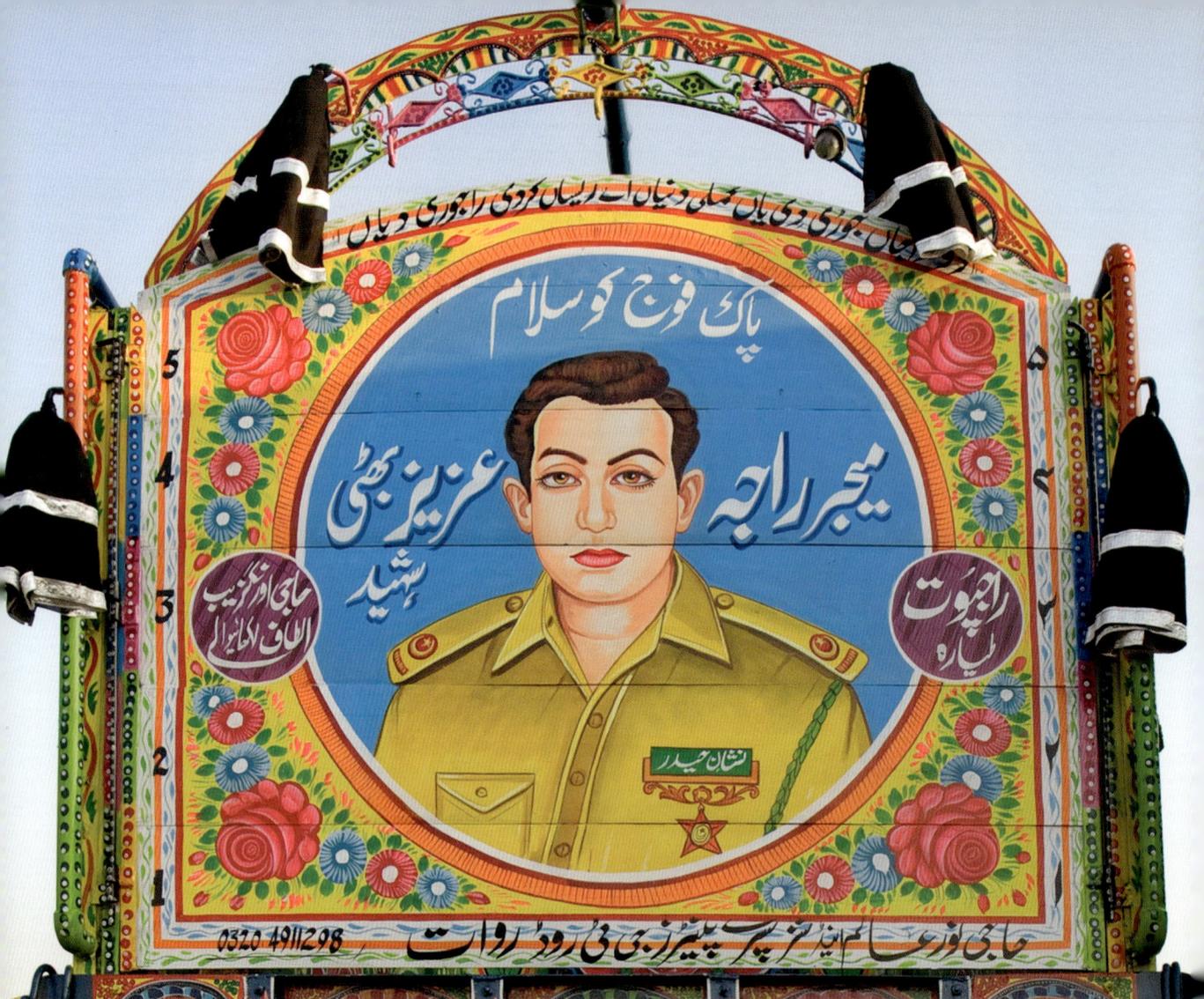

△
Plate 88:
The war hero, Major Aziz Bhatti (Rawat 2003)

Homages to fallen military heroes are an important means of advertising one's participation in a collective consciousness and of publicly positioning oneself in the spectrum of Pakistani sociopolitical ideologies. The truck in Plate 89 commemorates Captain Karnal Sher Khan, the first and (to date) only recipient of the Nishan-e Haidar to hail from Khyber Pakhtunkhwa, awarded to him during the Kargil conflict with India in 1999. In addition to textually endorsing his status as a martyr (*shahīd*), the image refers to him as the 'Pride of Swabi', his home district in which his birthplace of Nawan Kili has been renamed Karnal Sher Khan Kili in his honor. Sher Khan – whose first name of Karnal reflects his parents' wishes that their son would grow up to be a colonel in the army – was killed in a high-altitude war in which tanks and fighter aircraft, depicted in the background of his image, played no part.[16] The Kargil conflict, precipitated by a

174

violation of the Line of Control separating the Pakistani and Indian-held portions of Kashmir, was a largely unacknowledged war that was begun by the Pakistani military, ostensibly without the knowledge of the elected prime minister of the country. During and after the conflict – which ended through substantial international pressure being brought to bear on Pakistan – the military categorically denied the involvement of Pakistani regulars in the hostilities, maintaining that the incursion had been conducted by Kashmiri separatists with Pakistani logistical and moral support.

From the perspective of the liberal educated elite of Pakistan, as well as the community of international analysts, Kargil was an absolute disaster for Pakistan. Following the conflict, India made a dramatic increase to its annual military budget, which was already beyond anything with which Pakistan could hope to maintain parity. The incident undermined Pakistan's credibility internationally as well as with those Kashmiris in Indian-administered Kashmir who supported a political solution to the long-running conflict. And, perhaps most importantly, the blatant violation of the chain of command in Pakistan represented by this action undermined the democratic government of

Plate 89: Portrait of the military hero Captain Karnal Sher Khan on the back of a truck (Taxila 2007)
▽

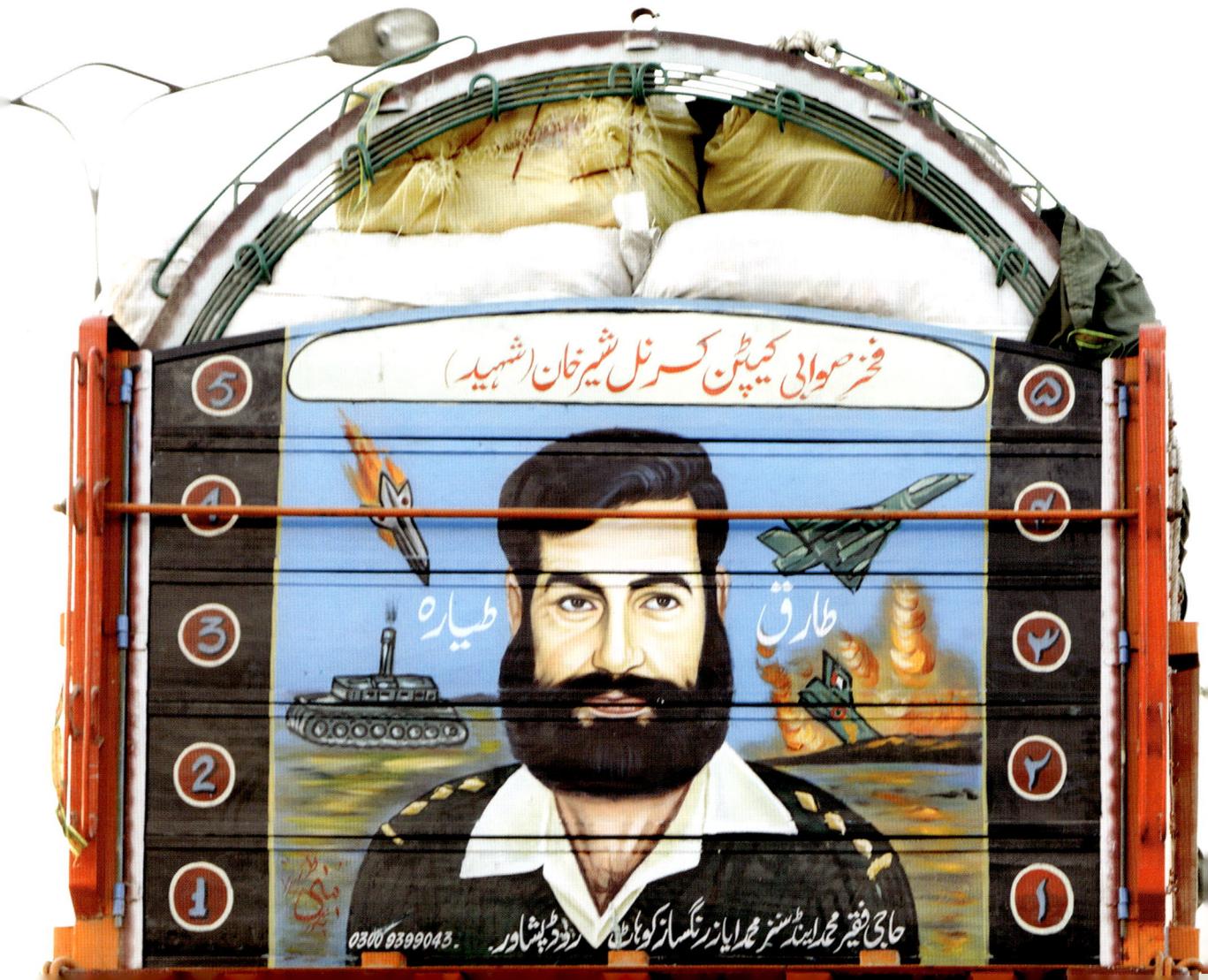

Nawaz Sharif, who tried to remove General Parvez Musharraf – widely believed to have
been the architect of the Kargil misadventure – from his post as head of the army, pre-
cipitating the coup d'état that brought about the nine-year military rule of General
Musharraf.

Seen through the lens of truck decoration, questions of democratic legitimacy, due
process, and international treaties do not carry the same significance in Pakistan's visual
regime as they do in scholarly and journalistic analyses of Pakistani politics. In the mirror
of the truck, the righteousness of Pakistan's cause in Kashmir is an implicit assumption,
and the heroism of Pakistan's soldiers and military is independent of the culpability,
competence and legitimacy of the rulers. Indeed, General Musharraf was not to be seen
on the backs of trucks even before his popularity ratings plummeted in 2007. Musharraf's
lack of popularity was a constant in interviews I conducted with truckers from different
parts of the country, the majority of whom disagreed with the governmental policy of
supporting the United States-led coalition in Afghanistan. This policy is viewed as a
misrepresentation of national interests, as is the pursuit and (to the minds of most truck-
ers) maligning of Osama bin Laden. He was referred to with open admiration and
affection by many truckers, but is not represented on the backs of trucks because of the
conviction among owners, drivers, and painters that they will fall foul of the police and
intelligence community if they do this.

The choice of subjects used in political portraiture conveys the explicit message that
contemporary rulers and generals are not suitable subjects for representation. One can
only conclude that either there is a taboo against representing sitting leaders, or that
these individuals are not seen as embodying admirable leadership qualities, or else that
they do not represent the cross-section of the Pakistani population with a hand in truck
decoration. There is certainly no taboo in truck decoration on depicting leaders with
whom one identifies. It is therefore most likely that the leadership of modern Pakistan
is not viewed by truckers as representing themselves either politically or ideologically.

This fact was made clear by a Pushtun driver from Quetta (who wished to remain
anonymous) when discussing the image from the back of his truck which appears in
Plate 90. When questioned as to the identity of the subject of this painting, he said: 'He's
our president.' When I remarked that the portrait did not resemble Musharraf very
much, he replied: 'Not Musharraf! Our president Saddam!'

Recognizing Saddam Hussein, who had been captured by US troops only a few days
before this interview, as 'our president' (*zamung sadar*) reflects a pan-Islamic notion of
Pakistani citizenship in which the US occupation of Iraq is part of a wider attack on
Muslims that includes Pakistan, Afghanistan, and other conflicts of the day. Plate 90 visu-
ally affirms this attitude: Saddam Hussein's epaulets and the microphones display the
Iraqi flag (albeit drawn incorrectly), while the two missiles behind his head are clearly

Pakistani: they bear the Pakistani flag and the names 'Ghauri' and 'Shaheen', two kinds of ballistic missiles developed by Pakistan and sources of great pride in many sections of Pakistani society.

Identification with and admiration of Saddam Hussein is not based in an established historical relationship between Iraq and Pakistan. If anything, through much of their histories as republics, the two countries have fallen on opposite sides of Cold War alliances that had a direct bearing on Pakistan's greatest defense and foreign policy concern, its relationship with India. Identification with Saddam stems from pan-Islamic sympathies held by the majority of truckers as well as by wider sections of Pakistani society. Such attitudes are deliberately engendered in the citizenry by the state, both through the formal educational system as well as all other propagandist tools aimed at strengthening national ethos. They are also very much part of Pakistan's self-vision as a state.

Plate 90: Back of a truck with the image of Saddam Hussein (Rawalpindi 2003)
▽

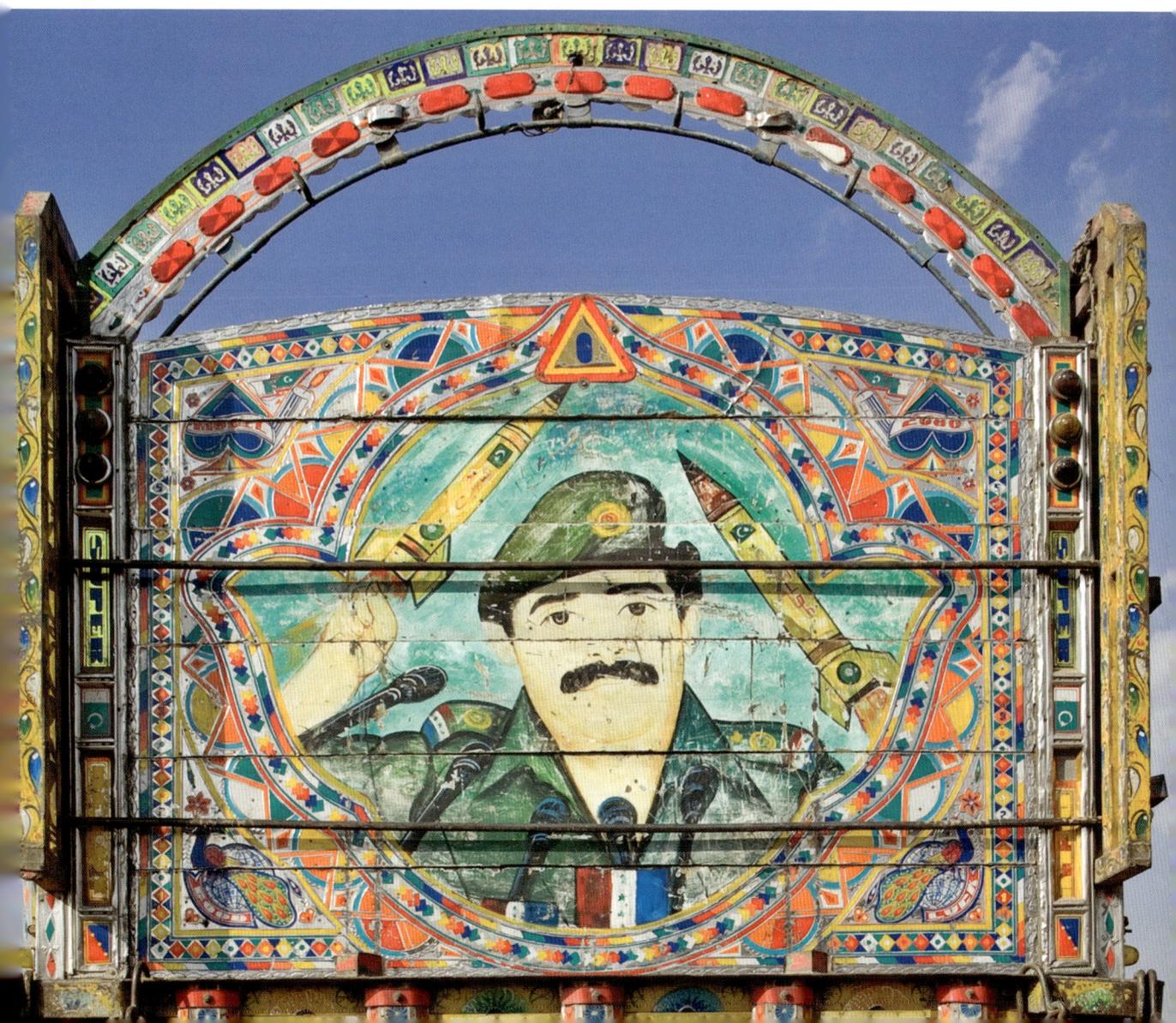

But popular feelings of pan-Islamism do not reflect those of the government, the high ranking *'ulama* or the shapers of educational policy. Popular pan-Islamic ideology is a direct consequence of Pakistan's involvement in Afghanistan following the Soviet invasion in 1979 and of its Kashmir policy. In both instances, pan-Islamic feelings have been consciously employed for the express purpose of encouraging the populace to support and participate in the Pakistani government's regional policies. However, as is clear from the lionization of Saddam Hussein at the very moment when Pakistan had taken a strong official stance in sympathy with the coalition *opposed* to the Ba'athist regime in Iraq, popular opinion in Pakistan runs counter to national policy and finds expression in the scopic regime through the truck and other venues.

Saddam Hussein was not personally religious and the Ba'ath Party that ruled Iraq from 1968 to 2003 was socialist and secular, allied with the Soviet Union which was viewed with great suspicion (and often outright hostility) by the majority of Pakistan's public. However, when Saddam Hussein's regime came under serious threat from a US-led international coalition, he consciously courted the sympathies of Muslims around the world by representing himself in a pious fashion. Images of Saddam praying were a staple of Iraqi propaganda in the years between the first and second US-led wars in Iraq, and versions of these made their way into Pakistani popular art as early as the first war in Iraq, when posters, calendars and postcards depicted Saddam as personally pious and with the signifiers of nationalistic and pan-Islamic defense that are normally associated with national military heroes.

In this poster (Plate 91), as in the majority of posters of Saddam Hussein circulating in Pakistan through this period, his religious credentials relate directly to his promise to 'liberate' Jerusalem. As Saddam Hussein kneels in prayer in front of symbols of Iraqi military prowess, the text above the image of the Dome of the Rock in the background reads 'O God! Grant us the strength to liberate the Sacred Precinct!' (*Yā Allāh! hamēṇ bayt ul-muqaddas āzād karnē kī himmat 'atā farmā*). From the potential 'liberator' of Jerusalem, Saddam Hussein becomes recast as a Muslim hero on the backs of trucks as early as the first war in Iraq, when portraits celebrate him with statements such as 'Long Live President Saddam Hussein, Warrior of Islam!' (*mujāhid-e islām sadr Saddām Husayn zinda bād*).[17]

The lionization of Saddam Hussein continued in truck decoration during the early years following the US-led invasion of Iraq in March 2003. Plate 92 shows a portrait from the back of a Balochi-owned truck that is clearly influenced by the widely distributed posters of Saddam. He is kneeling in the same position and is dressed identically (down to his watch), with the significant addition of a string of prayer beads which helps make his religiosity appear more contemplative. Although the Iraqi troops are no longer in the background, jet aircraft and tanks continue to constitute important elements of

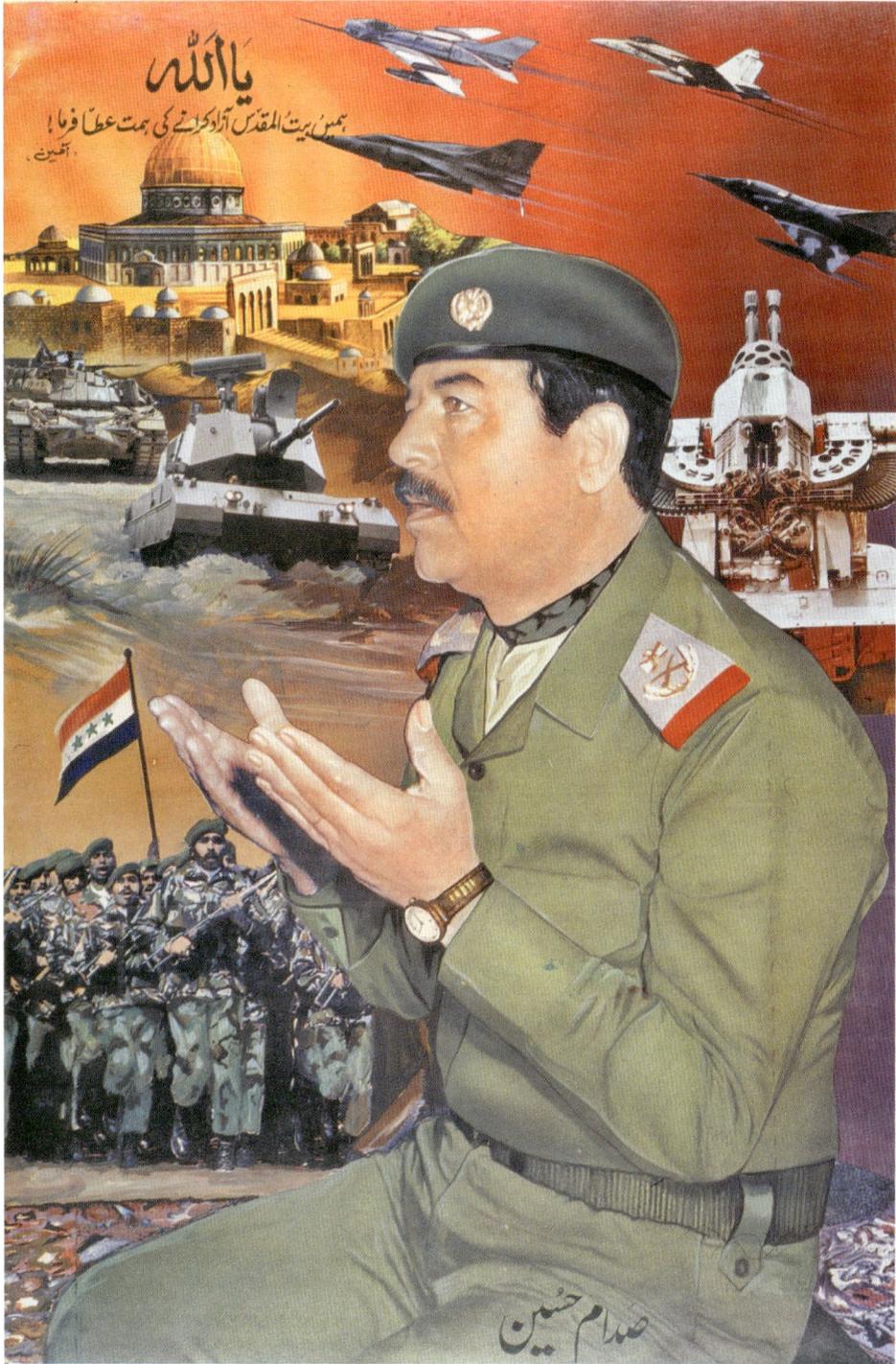

the scene. However, the Dome of the Rock has been replaced by the Ka'ba which floats beside his head at the top of the image. The Ka'ba is a much more vibrant Islamic icon in Pakistan than the Dome of the Rock, since the majority of the populace has only vague understandings of Jerusalem's religious significance or the specific nature and function of Islamic monuments in that city. Awareness of the Dome of the Rock and the symbolic value of Jerusalem is dependent upon a degree of familiarity with Islamo-Arab politics concerning Zionism and the legacy of imperialism that is not widespread among Pakistani truckers, such that being 'liberator' of Jerusalem has limited iconic value. Instead, the evocation of the Ka'ba elevates Saddam Hussein to the defender of the faith itself, since the image clearly suggests that it is the holy heart of Islam in Mecca that is at threat, and for the defense of which Muslims must rally behind this sacred warrior-president.

Plate 92: Back of a truck with the image of Saddam Hussein (Turnol 2003)
▽

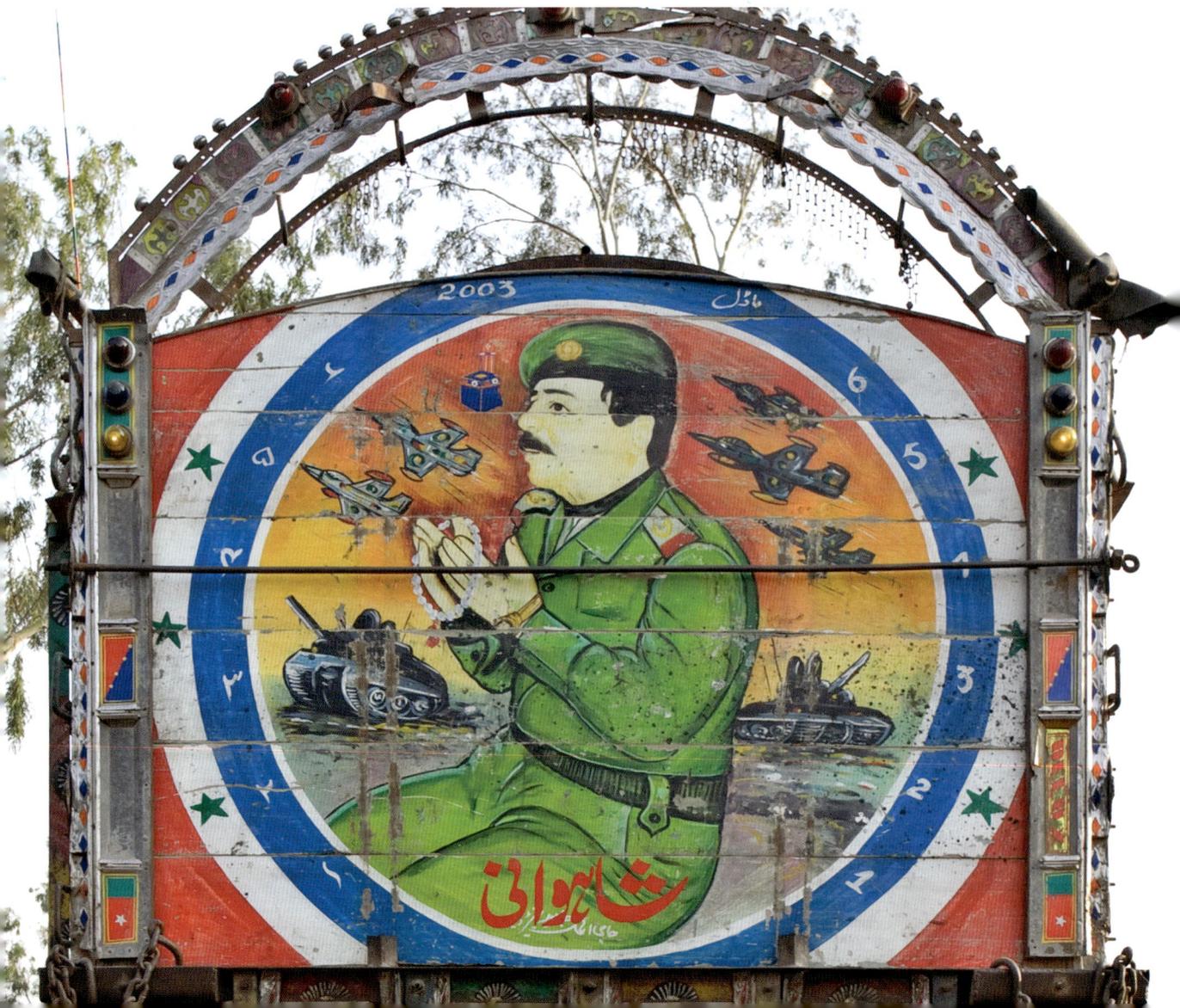

A related visual idiom is apparent in Plate 93 where Abdul Qadeer Khan, the 'father' of Pakistan's nuclear weapons program, appears on the back of a truck decorated in Dera Ghazi Khan. In January 2004, Abdul Qadeer Khan confessed to involvement in an international smuggling operation that transferred restricted uranium refining technology to Iran, Libya, and North Korea in violation of the Nuclear Non-proliferation Treaty as well as of Pakistani law. Despite the political embarrassment caused by this revelation, General Parvez Musharraf pardoned Abdul Qadeer Khan and placed him under informal house arrest. Subsequently, Khan alleged that he had been scapegoated by the government, which had itself been involved in the network's dealings and had been kept apprised of all developments, and that his televised confession and apology to the nation were made under duress and through appeals to his patriotism.

Despite international pressure, General Musharraf could not take any substantive actions to censor Abdul Qadeer Khan. Quite possibly, fear that Khan might have revealed secrets harmful to the Pakistani government, if he was backed into a corner, played a part in the decision to pardon him. But critically important to Musharraf's decision in this regard was the enormous popularity enjoyed by Abdul Qadeer Khan in Pakistani society. Colleges, schools and laboratories are named after him, as are streets and wings of hospitals, making him the single most celebrated national hero of the last two decades. That his prestige was untarnished by his ambivalent confession and subsequent pardon and house arrest is readily apparent from the image in Plate 93. He is referred to as 'the honorable' (*muhtaram*) Doctor Abdul Qadeer Khan, with a flag of Pakistan displayed prominently on his lapel. Around his head are representations of the missiles that embody nationalistic pride in Pakistan, accompanied by the titles 'The Pride of Islam' (*fakhr-e islām*) and 'Benefactor of the Nation' (*muhsin-e qawm*). Despite their placement, the titles are more likely to refer to Khan than to the missiles, rhetorically emphasizing the perception of him as a true national hero.[18]

The example of Abdul Qadeer Khan, like that of Saddam Hussein, emphasizes the lack of legitimacy of the Pakistani government but not of the concept of the state or nation. Symbols of modernity and statehood constitute important features in the visual language through which national (and transnational) heroes are represented in truck portraiture. Advanced weaponry – rather than the swords and horses of a romanticized past – are central elements in reinforcing the legitimacy of such heroes, as are nationalist symbols, in particular flags. Plate 94 shows a truck from Quetta, Baluchistan, with a portrait of Nawab Taimur Shah Jogezai, the leader of the Kakar Pushtun tribal federation toward the end of the period of British rule, revered by many Pushtuns as a wise and upstanding statesman who negotiated for the collective interests of the Pushtun people. Here he is depicted with Pakistani flags in the background, wearing formal Western dress of a sort no longer seen in Pakistan, nor ever publicly sported by Pushtun politicians

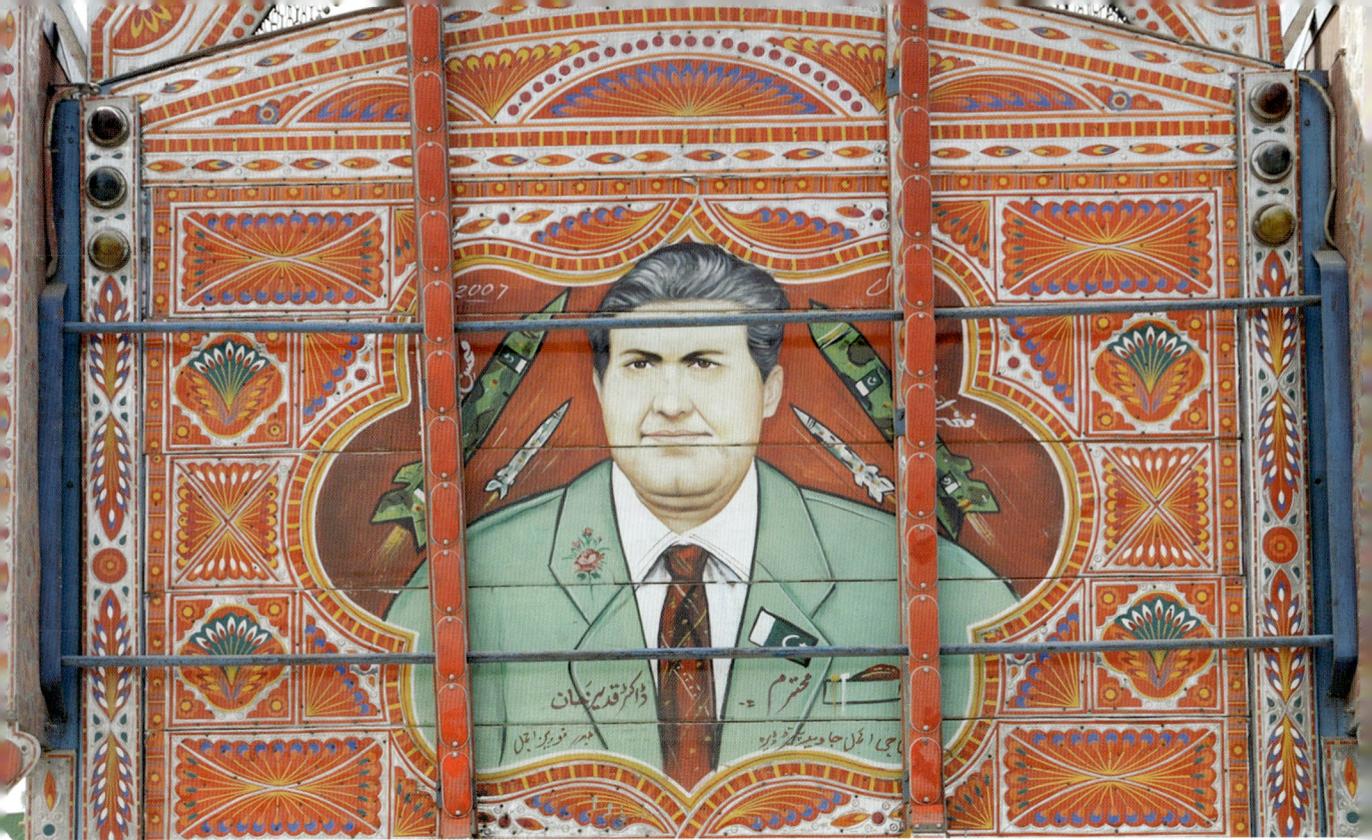
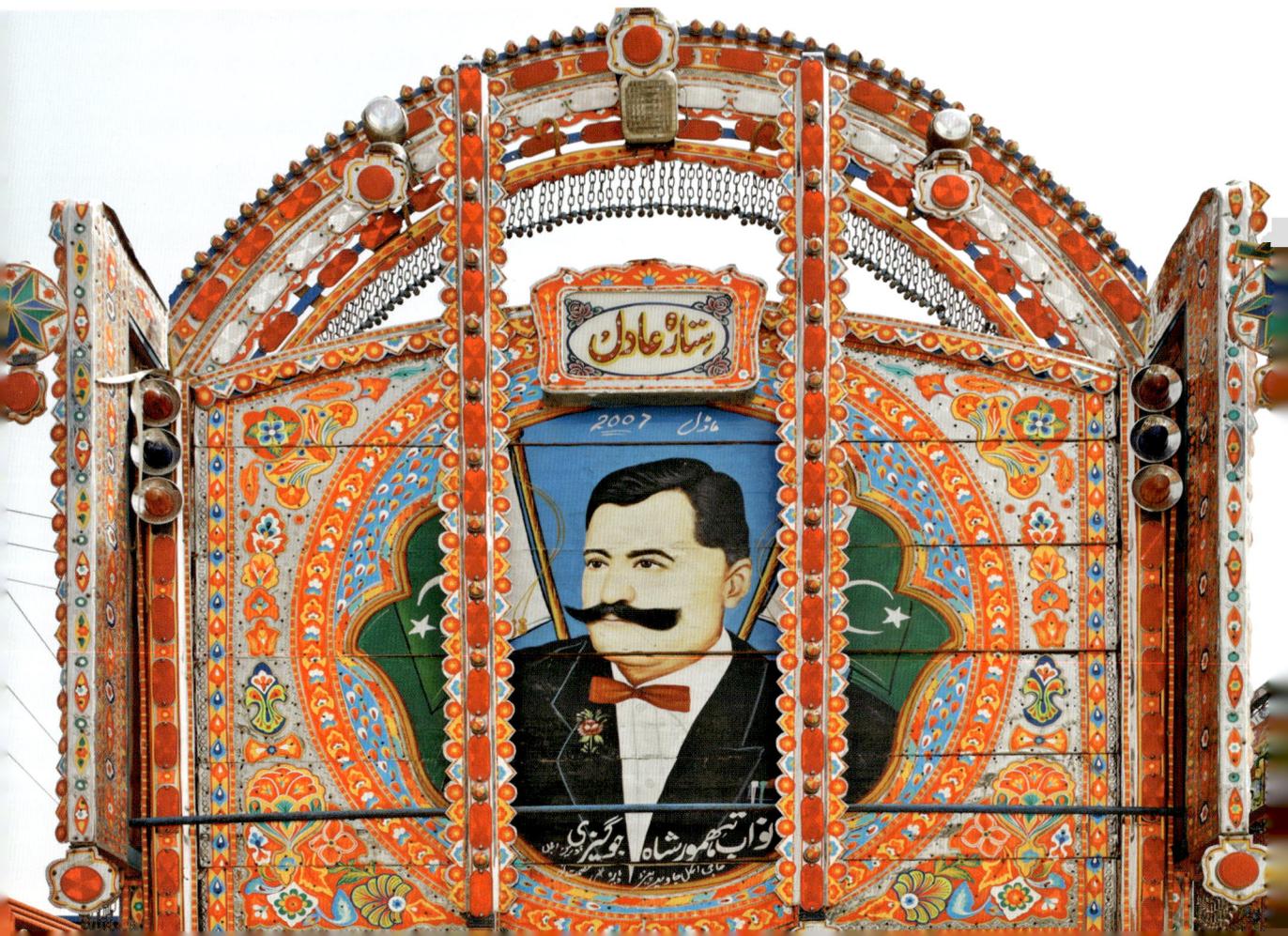

◁

Plate 93: Portrait of Abdul Qadeer Khan, founder of Pakistan's nuclear weapons program (Turnol, 2007)

who, like the majority of Pakistan's political class, take great care in their manner of dress to appear as populists and 'authentically' Pakistani.[19]

In contrast to the representation of Jogezai, Plate 95 depicts a contemporary Pushtun politician, Mahmud Khan Achakzai, president of the Pakhtunkhwa Milli Awami Party, one of the two major Pushtun nationalist parties in Pakistan. Achakzai claims for himself the political mantle of secular, populist Pushtun leadership that goes back, through the National Awami Party, to Gandhi's associate, Khan Abdul Ghaffar Khan. In contemporary Pakistan, Achakzai is one of the most important political figures fighting for minority ethnic rights against the centralizing tendencies of the federal government, as well as for secular sub-nationalist interests against Islamist forces such as the Jamīʿat-e ʿUlamāʾ-ye Islām (JUI) and various militant groups (such as the Tehrīk-e Tālibān-e Pakistan or the Tehrīk-e Nifāz-e Sharīʿat-e Muhammadī) with whom the JUI is affiliated. In this image, Mahmud Achakzai is depicted with the same set of symbols seen in previous images of national and transnational heroes: a flag (of the Pakhtunkhwa Milli Awami Party in this case) and microphones, which are also seen in Plate 90.[20]

In all cases, the leader is depicted with visual symbols that signify authority and access. High-technology weaponry, flags, microphones, and (with the exception of Achakzai, a populist politician) Western dress all signify goods and status that lie beyond the reach of truckers who, as a class, constitute a marginal group regardless of their regional or ethnic background. The heroic, in this imagining, is of two types, both of which constitute the modern leader. The first, represented by the military hero, evokes religio-social values held by the truckers in their understandings of their place in the world as Muslims as well as citizens of Pakistan. The second, represented by local political and tribal heroes, evokes their acute sense of personal marginality and lack of empowerment within the national structures of power and allocation of resources. Through his stereotypically colonial statesmanlike dress and appearance, the late Nawab Taimur Jogezai symbolizes a tribal ethnic leader who is comfortable in the halls of power of the late colonial and early Pakistani states, where he can mediate for and represent the interests of his marginal and disenfranchized tribal followers. Similarly, the microphones in Plate 95 make Achakzai, quite literally, *the spokesman* of Pushtun nationalist interests which are visually represented by the flag behind him.

Images on the backs of trucks – and on the trucks in general – become what have been called the:

◁

Plate 94: Portrait of Nawab Taimur Jogezai on a truck from Quetta (Turnol 2007)

bearer[s] of a multitude of possible meanings, both potential and actual, that vary over time and in different contexts. Potential meanings are actualized or operationalized in many ways, making a connection to the world (that is, to other bodies) through their

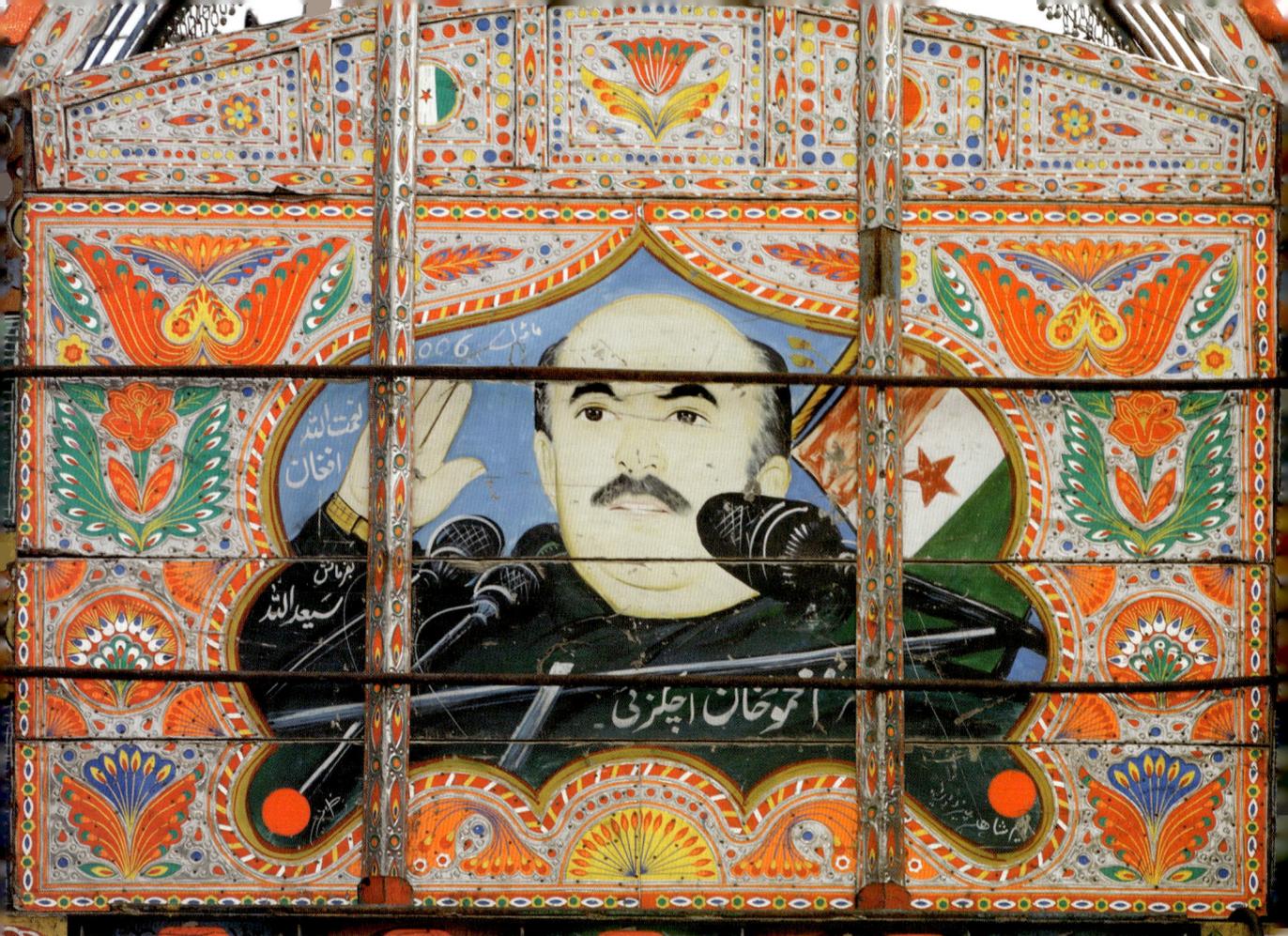

psychocorporeal impacts on practices as well as through consciously articulated interpretations, whether oral or written, whether denigratory or celebratory.[21]

Neither the reflection of an unchanging religious ideology, nor a static sociopolitical view, nor a stagnant aesthetic, the back of the truck becomes the most easily deciphered aspect of the corporate artistic enterprise that is Pakistani truck decoration, a window into the visual regime of popular culture in Pakistan.

I have, so far, mostly avoided any engagement with questions of the *popular* – the nature of 'popular culture', 'popular art' and 'popular religion'. As I stated in the first chapter of the book, this is in large part out of a dissatisfaction with the way the term carries a necessarily pejorative connotation when it is applied to people, ideas, and artifacts other than oneself. Though valuable as a term when applied to temporally defined attitudes and actions, in popular usage it is frequently paired with the word 'folk'. The latter term is widely used in the Pakistani context to evoke notions of rustic prater-authenticity and primordiality, and is routinely applied to truck decoration with significant consequences, as discussed in the next chapter.

△
Plate 95: Truck from Zhob with image of Mahmud Khan Achakzai, head of the Pakhtunkhwa Milli Awami Party (Turnol 2007)

184

10

Truck Design, Art, and Agency

It would be an analytical convenience to begin by supposing, even if false, that there exists, just as a great many philosophers of merit have believed there to exist, an aesthetic sense, or a sense of beauty, or a faculty of taste; and that it is (or those are) as widely distributed among men as the so-called external senses, such as sight and hearing, are.

Arthur Danto[1]

In the introduction to her short book on trucking in Pakistan, Anna Schmid describes the process of buying a truck to take to Germany for a museum exhibit. Her Pakistani companions who helped her negotiate the purchase were as bewildered by her priorities in a vehicle, as were potential sellers and other onlookers. Most significantly, they could not understand why the condition of the engine and running gear was not a primary concern in the purchase of a truck.[2] The gap between the priorities of Anna Schmid and those of the truckers is a synopticon of the place of the Pakistani truck in the international economies of art and design as well as those of goods and transportation. For a European museum curator such as Schmid, to buy a truck in Rawalpindi, drive it herself (there are no female truckers in Pakistan) to the port city of Karachi, and put it on a ship to Germany, where it is to become the centerpiece of an exhibit on folk art, is the stuff of experiences known to anyone familiar with the academic and folk art worlds of the West. This is ethnography as contact sport – academic research as self-enriching experience with the added benefit of providing excellent material for party conversations. For their part, the truckers got a rare visit from a European (and a woman at that) – an event that breaks the routine of regular life, endows them with status relative to their peers for having been chosen as participants in the supraordinary event and provides anecdotes for later conversations (including with future visitors, such as me, who are told about the time the 'German lady' came to buy a truck). But the two parties continue to appreciate the truck for separate reasons and to afford decoration a very different place in the

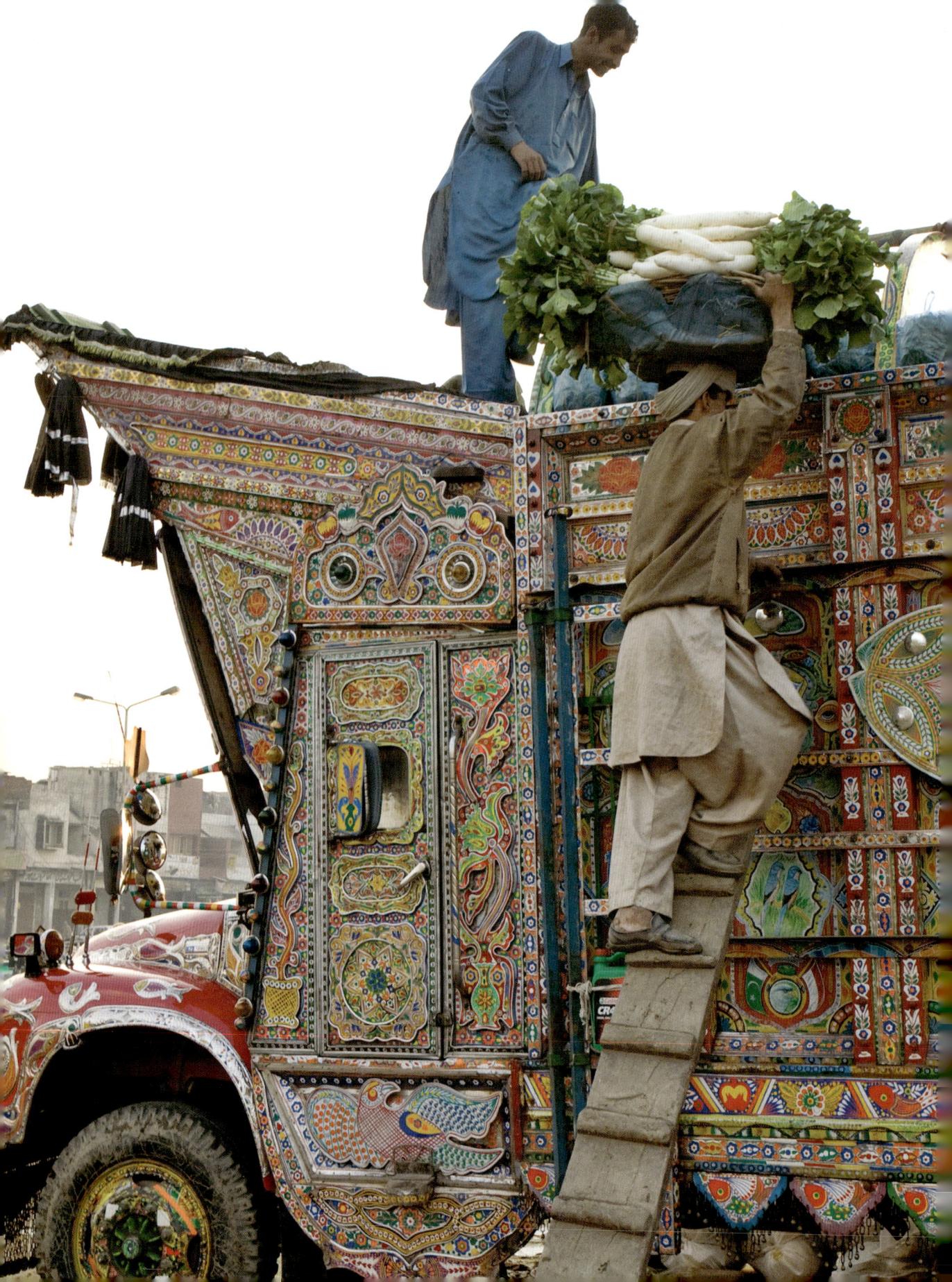

Plate 96: Loading vegetables onto a Bedford Rocket (Rawalpindi 2003)

◁

truck's valuation. For the truckers the truck remains – first and foremost – an economic means of production; as such, its decoration is seen as tied to its ability to function economically, to carry goods reliably, and these requirements remain paramount even when truckers are fully aware that the vehicle will be taken to Germany to be placed in a museum. Understanding completely that European curators and museum visitors appreciate the truck for its visual qualities, the truckers view the ornamentation as secondary and integrally related to the primary function of the truck as a means of conveyance. A truck that does not run is not a truck, regardless of how beautiful it might be.

Pakistani Society and the Truck

Plate 97: Freshly painted interior of the cargo bed of a truck (Rawat 2003)

▽

Truck decoration has become a celebrated subject among Pakistani elites as well as in the international folk arts and crafts worlds since the early 1990s. Picked up in this way, truck decoration travels in the overlapping yet contentious realms of art, craft, and design, with different constituencies reacting to it in distinct ways, hoping to incorporate truck arts into expanding spheres of expression and appreciation, yet differing in what they understand such spheres to be and what agencies truck artists themselves should have in such a development. The experience of truck art and artists in this regard is similar to

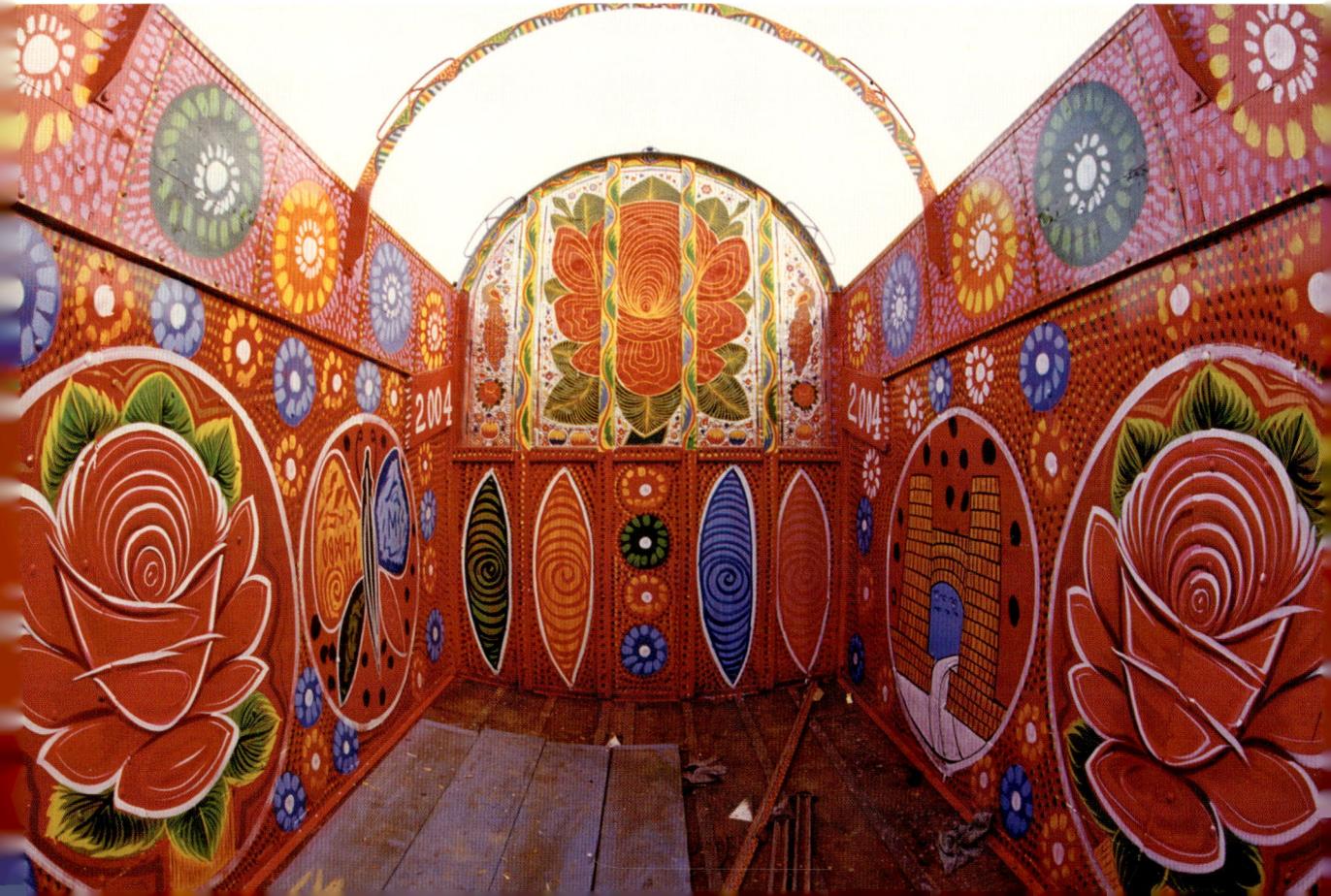

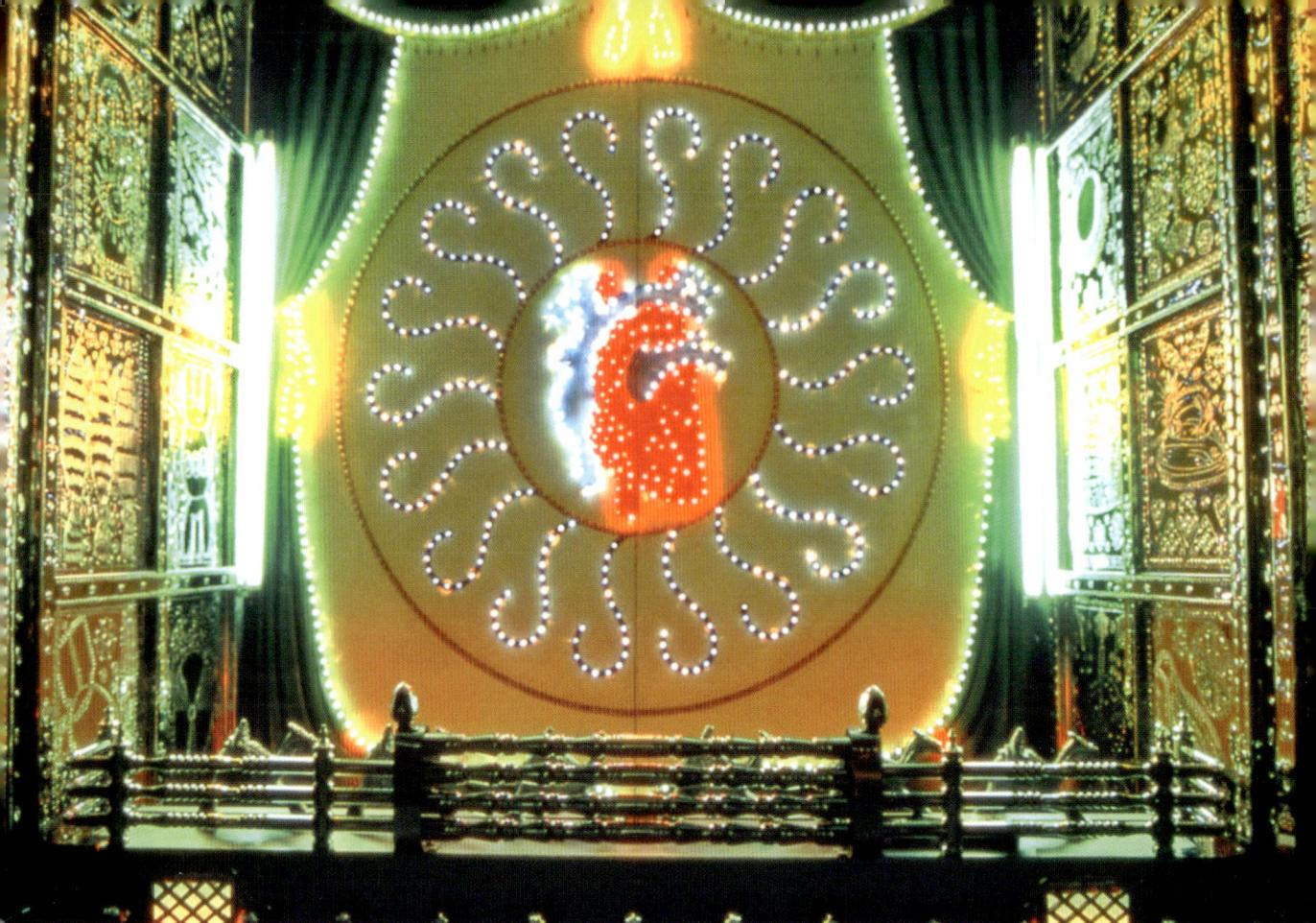

that of many other supposedly indigenous or 'folk' art forms as they become fetishized in national or international arts and crafts markets.

In the case of Pakistani trucks, the first credible attempt to treat automotive decoration as an art form – or a collection of artistic media – was made in the early 1990s by four artists living in Karachi at the time. Three of them – Durriya Kazi, David Alesworth and Elizabeth Dadi – came from a background in sculpture, and the fourth, Iftikhar Dadi, was a photographer. In a city with few museums or art galleries, and ethnic tensions making civil life and public entertainment all but impossible, they were exploring the limits of what it meant to 'make art'.[3]

Kazi, Alesworth, Dadi, and Dadi were invited to submit a piece for an art exhibition to be held in Copenhagen in 1996, the year of that city's tenure as the 'cultural capital of Europe'. Entitled 'Copenhagen 96' to celebrate the history of the city as a global center of sea trade, the exhibit comprised 96 shipping containers which were decorated by artists from different countries. The work of the collaborators from Pakistan came to the attention of Oscar Ho, the curator of the Fukuoka Art Museum at the time, and a modified version of their container was displayed in Japan as part of the first of a series of triennial exhibitions.

△
Plate 98: Interior of the collaborative art installation entitled 'Heart Mahal' (Photograph by Iftikhar Dadi)

188

'Heart Mahal', as the collaborative mixed-media installation of container art was called, is the first major example of art consciously incorporating substantial elements of Pakistani truck decoration to be exhibited on the international scene. This collaboration is also significant because it was the first instance (and to date, one of the few) in which the professional truck artists whose work was incorporated into the finished collaborative piece of art were recognized *as artists*. Recognition of professionals working in truck decoration did not come easily in this project, and there was substantial disagreement among the four collaborating artists over whether the truck artists' contribution should be recognized at all as creative input or as simply technical; in other words, should they be acknowledged at all as artists? In the end, the metalworker, painter, and electrical workers were recognized in the credits for the piece, although in being called 'Mairaj Nicklewala and Sons, Yusuf and Sons Truck Painters, Bachoo Painter, Light Gate Decorator, Shaukat Lala and Sarfaraz Electricians', their presence reflects a compromise between those of the four collaborators who insisted on their inclusion and those who viewed the truck artists simply as tradesmen without any artistic agency.[4]

In this particular project, Iftikhar Dadi and Elizabeth Dadi were concerned with the subaltern implications of representation, the recognition that it was the four collaborating artists who, as members of a cultural and social elite, possessed representational power in those circumstances, not the craftsmen whose skills were being exploited to create the collaborative work of art. Dadi and Dadi wanted to explore the artistic possibilities created by giving the truck decorators incomplete ideas and then allowing them full agency to see what would come into existence.

Iftikhar and Elizabeth Dadi ceased to be involved in making such collaborative pieces shortly after the Fukuoka exhibition, in part out of discomfort with the inability of their previous collaborative efforts to satisfactorily allow for the truck decorators to express their own creative vision. Durriya Kazi and David Alesworth continued to explore projects of installation art that incorporated elements of truck decorative crafts. These include mixed-media installation pieces such as *Very Very Sweet Medina (Home Sweet Home)*, created in 1999 and now part of the permanent collection of the Queensland Art Gallery in Australia. The installation piece consists of two parts: a circular painting with the face of a (blond) boy against the background of a garden that contains fountains and a pond with swans; and a tall cabinet with lights and sound. Both pieces reflect the color palette, designs and media of Pakistani truck decoration, though the vision reflected is not that of a truck painter but of the two artistic collaborators. The makers of the cabinet and the painters of the installation itself are acknowledged in the following manner in the descriptive materials accompanying the exhibition 'The Family in Contemporary Asian Art' for which the piece was purchased: 'YUSUF PAINTER collaborated on making

images on the cabinet – PARVEZ collaborated on the painting'. Needless to say, both Durriya and David have last names in the literature.[5]

The artists' description of *Very Very Sweet Medina (Home Sweet Home)* reads as follows:

> Durriya Kazi and David Alesworth's *Very Very Sweet Medina (Home Sweet Home)* explores the everyday dreams and desires of people in relation to their 'home'. The artists say: 'Consumer marketing strategies address our aspirations and anxieties and so reinforce the significance of the home, whether through idealised housing schemes that will change lives for the better, or through interior design products, kitchen gadgets, home comforts or the perfect washing powder'. Kazi and Alesworth worked with a range of individuals including film poster painters, truck artists, and designers to make these works. The glowing boxes comprising *Very Very Sweet Medina* are designed to resemble stands, which dispense information on buying a house, that form part of the everyday street landscape. Names of housing schemes in Pakistan, such as 'Green Gardens', 'Star Shelters' and 'Lake View', cut from *chamak patti* (glass impregnated reflective tape), adorn the dispensers which are placed at various locations around the Gallery and in the city.[6]

The artists' statement provides additional relevant information:

> Here we chose the stereotype of 'The Home'. The stereotype of the perfect home is invested with a sense of belonging, social arrival, success, the perfect family, the purpose of enduring difficult working conditions. Much of the motivation and yearning of contemporary urban life, its frustrations and anxieties are associated with negotiations of the home. Consumer marketing strategies address these aspirations and anxieties, and so reinforce the significance of the home, whether through idealised housing schemes that will change lives for the better, credit schemes, or through interior design products, kitchen gadgets, home comforts, or the perfect washing powder.[7]

The most remarkable thing about this piece of collaborative conceptual installation art is that, though it centers around notions of the home, it relies on the aesthetics of truck (and cinema hoarding) decoration even though such decorative forms never find their way into the homes of the urban classes whose notions of idealized domicility and domesticity are being evoked in the art. Truckers do not decorate their homes in 'truck art', much less the urban consumers of 'idealized housing schemes' to whom dreams of 'interior design products, kitchen gadgets, home comforts, or the perfect washing powder' are marketed. In the artists' description of the piece, truck art becomes a marker

▷

Plate 99: Detail of a truck wheel (Rawalpindi 2001)

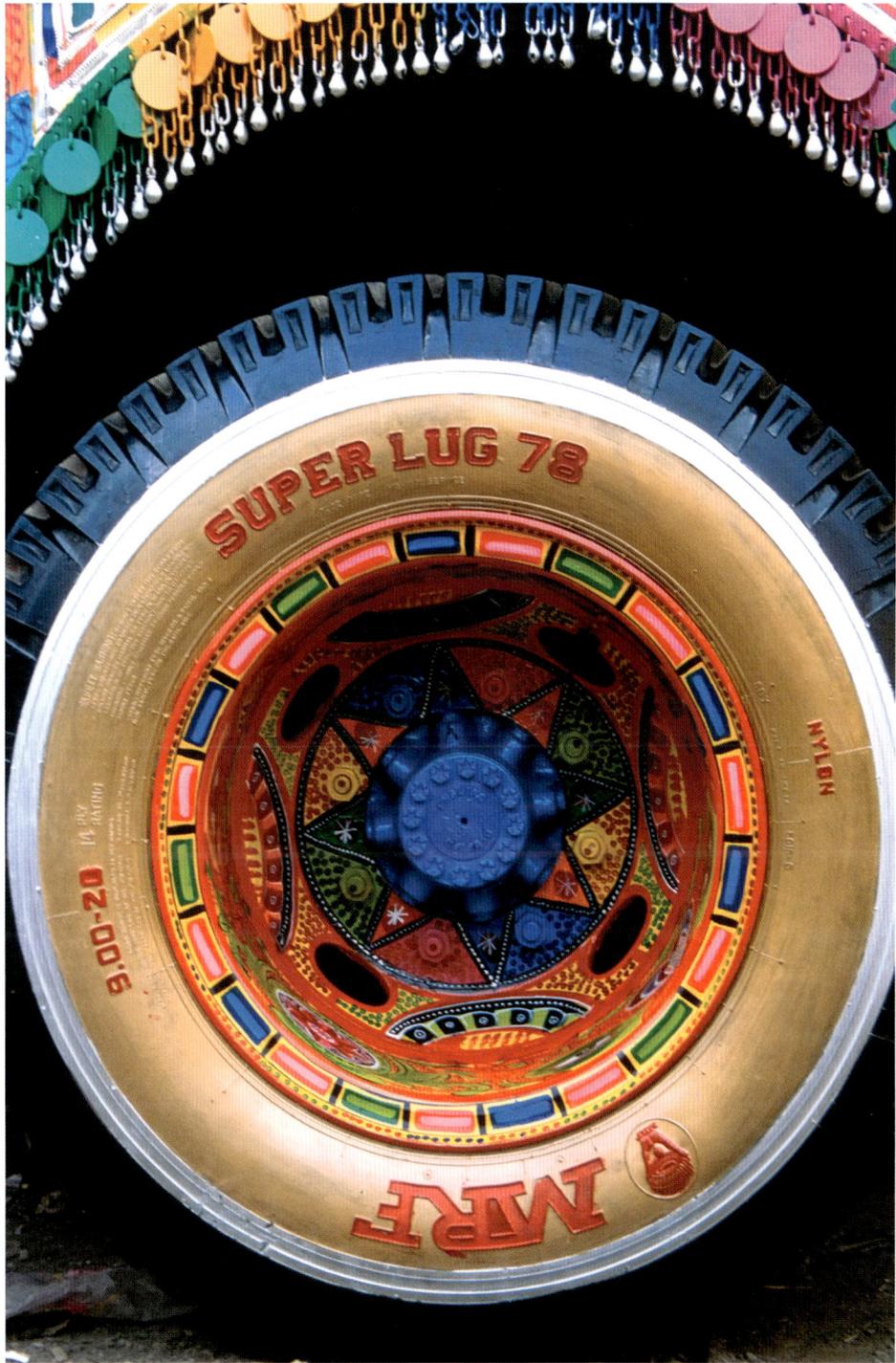

of the *popular*, as an all-pervasive aesthetic that characterizes the 'Pakistani-ness' of all who do not belong to the Anglophone bourgeoisie.

Exhibits featuring or incorporating aspects of Pakistani truck decoration remain rare, but through them so-called Pakistani 'truck art' is finding a place within the wider world of international folk arts and crafts, and in this it resembles other indigenous traditions such as those of Aboriginal art in Australia or various kinds of folk art in Latin America. Unlike the case of Aboriginal art, however, truck decorators themselves have not emerged as *artists* in the sense of creative agents who, through their work, purport to represent a marketable vision that is bought *as art* by a client base of collectors.[8] Also, unlike the case of Mexico (and many other societies), it is not truck artists themselves who have been successful at finding a commercially viable way to market versions of their traditional products or labor to a bourgeois audience in search of folk crafts representing their own so-called 'folk culture' and its peasantry in some imagined authenticity, or else to a souvenir market of tourists seeking authentically ethnic mementos to commemorate travel experiences.

Nevertheless, truck decoration has been embraced by sections of the Anglophone bourgeoisie as the single most distinct aspect of Pakistani 'folk' culture and is being marketed as such. In 2007 the former Pakistani High Commissioner (ambassador) to the United Kingdom spoke at the opening of an exhibition on Pakistani 'truck art' at a gallery-cum-Indian restaurant in London: 'These colourful trucks are known as Kings of the Road and the colour and artwork reflect the diversity of Pakistan.' Almost like a mirror reflection or corollary of *Very Very Sweet Medina (Home Sweet Home)* eight years earlier, this exhibition did not include trucks, truck parts or anything vehicular. Instead:

> [t]he exhibition includes truck art items ranging from the purely decorative to the functional — enameled utensils commonly used in dhabas or roadside restaurants frequented by truck drivers along the highways as well as wall hangings, mirrors, key chains, oil lamps, boxes and other interesting and collectable items.[9]

Presumably, in the absence of trucks, truckers, or any genuine element of their lives, their utensils painted in ways that would never be seen in the *habitus* occupied by the truckers were brought to represent not just truck culture, but the truckers themselves as they sat eating at a roadside restaurant out of dishes the bourgeoisie never use themselves.

The organizer, Anjum Rana of Karachi, had been working for several years putting together a collection of objects representing what she refers to as 'tribal truck art'. The catalog copy of another exhibition held as part of the Pakistani Film Media and Arts Festival in Glasgow the same year provides the following description of 'Tribal Truck Art' (some of it is the same as the text accompanying the exhibition in London):

Truck art items range from the purely decorative to the functional. There are items for the living areas, garden/patio, dressing table, desk, and other miscellaneous gift items. Hand-made miniature versions of trucks are not just great toys and decoration pieces – but unforgettable souvenirs from Pakistan. Tribal Truck Art has produced trucks with a high level of detail: original motifs, bad poetry and reflective tape decorations. Another inexpensive souvenir item are [sic] Postcards depicting truck art objects as well as popular motifs. The website: www.tribaltruckart.com describes truck art and the significance of truck art motifs, explaining how these magnificently decorated trucks are not just galleries on wheels exhibiting this folk art peculiar to Pakistan, but an anthropological study and essay on the hopes and aspirations of its people. Enameled utensils are commonly used in '*dhabbas*', or road-side restaurants frequented by truck drivers along the highways. Once painted, they are not to be used for wet food stuffs, but may be used for serving nuts, placing keys and other knick knacks, or just as decorative pieces. These include different sized bowls, plates, jugs, buckets, traditional milk containers, kettles and teapots. Thus, with Anjum Rana's efforts: Tribal Truck Art's simple kettles, lanterns, oil-lamps, boxes etc, become collectible home accessories, the truck painters have a new source of income and their art – a new legitimacy![10]

Rana believes that her enterprise of decorating household objects in 'tribal truck art', if successful, would provide truck decorators with much-needed income that they currently lack.[11] In this capacity, she combines the role of entrepreneur with that of the privileged arbiter of taste, as well as the individual who moves what is (by her reckoning) a traditional artisanal craft into a standardized arena of folk art production for a souvenir market. This 'tribal truck art' enterprise follows in a long tradition of appropriating and defining so-called 'traditional' crafts into commercially viable and identifiable designs, which not only delineate the parameters of what subsequently constitutes the *correct* forms of that craft, but also frequently makes the resultant design the intellectual – and consequently economic – property of members of a privileged class who determine the nature of state, the 'authenticity' of design, and control the means of production and distribution.

The text from the Glasgow Film Media and Arts Festival quoted above betrays a number of attitudes symptomatic of the relationship between vernacular culture and the bourgeosies that not only control the nature and definition of art in particular societies but also possess the disposable incomes to purchase such art:

(i) 'Truck art' is not the art of trucks, but is a design style.
(ii) 'Truck art' is 'tribal' and therefore represents a primitive aesthetic completely detached from the world of modern economies and aesthetics.

193

(iii) 'Truck art' objects are household items, both practical and decorative, not industrial arts.

(iv) These objects make excellent souvenirs.

(v) The decoration includes poetry, but the poetry is categorically 'bad', thus drawing a clear line between the belle-lettristic tastes of the potential audience of 'truck arts' and the producers of the arts themselves.

(vi) Once useful utensils ostensibly used by truckers are rendered unsafe for their original use by being transformed into 'truck art'. Yet these items would never deserve to be purchased by collectors without being transformed into decorative objects.

(vii) Truck painters' 'art' gains legitimacy *as art* through the intervention of a member of the privileged class.

(viii) Truck painters gain the possibility of a new and (presumably) better livelihood through the intervention of a member of the privileged class.

(ix) 'Truck art', as it appears on trucks, is a 'folk art'.

The principle underlying the processes through which vernacular popular arts move into the realm of collectible 'folk art' is that popular tastes are defined and devalued by the bourgeoisie whose members function as the arbiters of taste and culture. But if, as argued by García Canclini, 'being cultured in the modern sense is above all to be lettered',[12] then even to this day, roughly half of all Pakistanis have no possibility of making a claim to cultured status. In actuality, the claim to 'possessing' culture relies on much higher levels of education than the primary schooling possessed by the overwhelming majority of that relatively small number of Pakistanis who are literate, which means that only a minute percentage of the populace can even aspire to the status of being cultured. Culture, then, is the domain of the educationally privileged, and therefore of the socioeconomically privileged as well, who appropriate cultural capital for themselves. Conversely, the lower one descends on the educational and economic scale, the less the ability to appropriate cultural capital. And even when the lower classes, as 'popular' or 'folk', are included within conceptions of a wider society, a 'hierarchy of cultural capitals' continues to exist. '[A]rt is worth more than handicrafts, scientific medicine more than popular medicine, and written culture more than culture transmitted orally.'[13] In the case of Pakistan, where language itself is arranged in a hierarchy of English, Urdu, and the vernaculars, culture and control of cultural capital are that much more hierarchized.

The process of incorporating vernacular artisanal products and the culture surrounding them into a national vision of cultural aesthetics has a number of results. In the first place, the 'supermarketization' (to use García Canclini's term) of such crafts and cultures through their incorporation in handicraft and souvenir consumer markets makes them 'folkloric appendages' of the national (and even international) systems of urban and

bourgeois consumer culture.[14] This process, which results in the purchase of such 'folk' crafts by the privileged classes, enables the economically and socially advantaged to display their wealth as well as their taste in the same manner as they do through the purchase of so-called 'high' art, but with the additional benefit that the purchasers also get to display their inclusive national affinity with the 'folkloric' population. Ultimately, however, the structures through which artisanal classes such as truck decorators get incorporated into a national economy of art and 'folk' crafts serve to ensure that the ownership of the means of production and distribution, as well as the claim to cultured status, remains in the hands of existing privileged classes. Thus any growth in the popularity of truck decoration as a 'folk art' only serves to maintain the hegemony of social class structure.[15]

'Truck art' has found its way into the many handicraft and souvenir shops in Pakistan's major urban centers. There is a national network of handicraft shops that sell crafts purportedly representing Pakistani folk culture and where the vernacular and regionally specific devolves into the national, in which the ethnic becomes not a mark of difference but of variety and color. Government-owned handicraft shops are an attempt to create an official repository of Pakistani crafts, and each province also possesses its own handicraft outlets, all of this on top of the large number of souvenir and folk craft shops that

Plate 100: Detail of the interior of a tractor-trailer truck's cabin (Turnol 2007)
▽

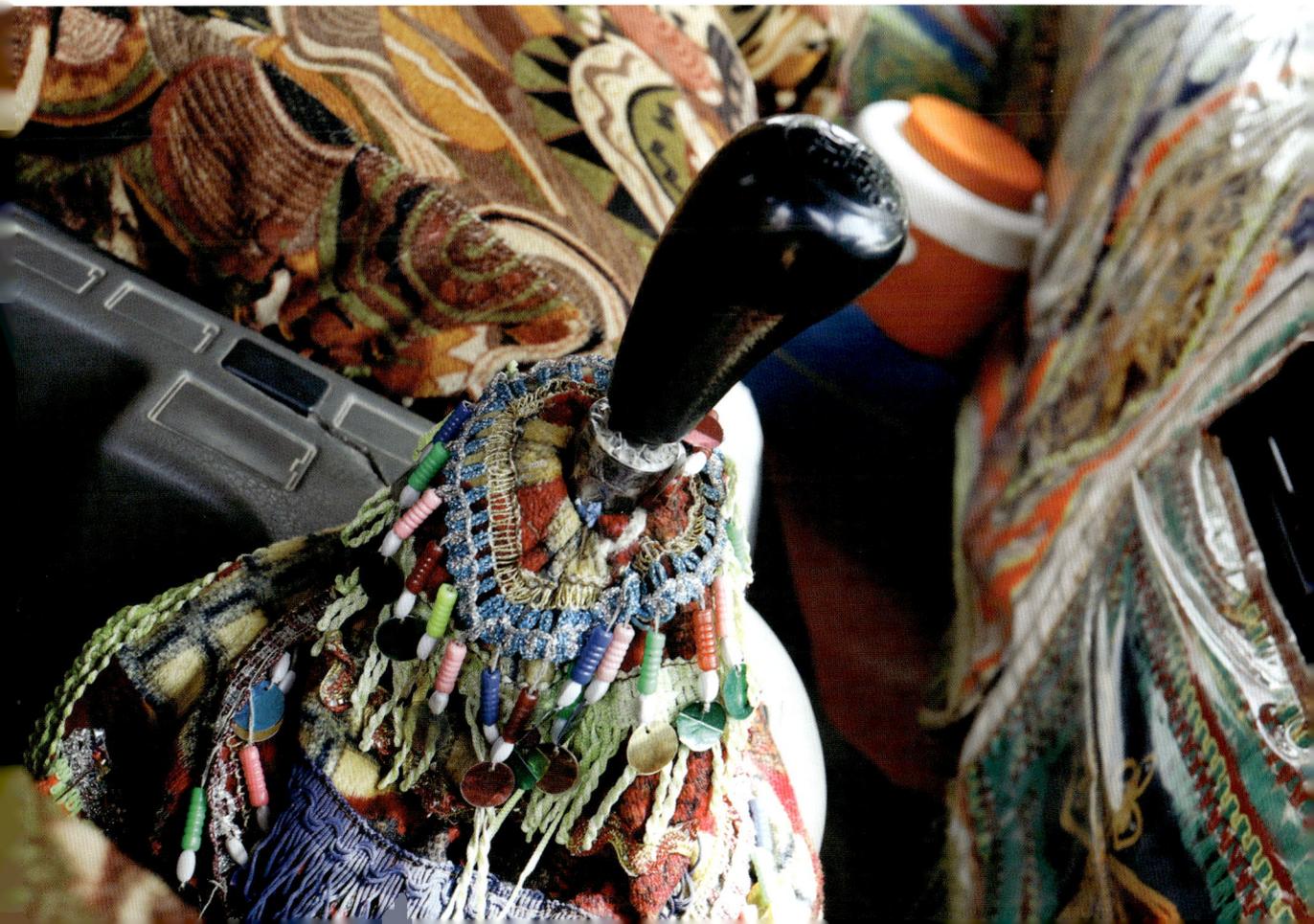

are found in fashionable shopping districts. Provincial handicraft shops are supposed to highlight crafts of their own province, but the necessity of competing with private shops and the national ones requires them to provide the same range of goods and results in a certain promiscuity of folkloric authenticity. Thus the provincial handicraft shops of Baluchistan, which once stocked mostly rugs and various knick knacks made out of marble and onyx, now also sell shawls from Sindh and Kashmir, brass lamps and trays from Khyber Pakhtunkhwa (NWFP) and inlaid furniture from Punjab. The more entrepreneurial shops that have a significant foreign clientele also sell Afghan crafts, including real blue *burqas* and tiny 'bottle *burqas*' (so called because they fit over a liquor bottle) which are made under the auspices of an NGO providing employment to Afghan refugees.

Miniature trucks have become a standard item stocked by such souvenir shops. They come in two varieties, the first, featuring less detail and selling for less, is made in small toy factories in the Punjab; the second, displaying a greater attention to detail, is manufactured in workshops run by the same sorts of NGOs as the ones that produce 'bottle *burqas*'. In neither case is the manufacture and design of these model trucks related to the economy of truck decoration; truck artists are neither consulted nor involved in any way in the manufacture of the 'folk craft' miniatures. The truck has become an iconic aspect of Pakistan's folk-cultural authenticity, and 'truck art' become a translatable system of design that can be incorporated on other objects.

These miniature trucks might be purchased by foreigners more often than not, but one must remember that 'the main ideological function of crafts is not fulfilled in relation to tourists but to the residents of the country where they are made'.[16] Truck arts serve as a design aesthetic for the Anglophone bourgeoisie, the socioeconomic class that retains the greatest claim to aesthetic taste and culture. It is members of this class, almost exclusively, who inhabit the world of art schools which are direct heirs to the institutions of art and design established by the British in South Asia with many different purposes, the most tangible of those being the standardization of 'ethnic' patterns and designs with the goal of preserving them, and transforming traditional and popular crafts into the intellectual property of the privileged classes, and the creation of a local (and later indigenous) class of art and design 'managers' who were distinct from the producers of the crafts themselves.[17]

Shortly after the Great Exhibition of 1851, the Department of Science and Art (DSA) was founded under the authority of the British Board of Trade. Its purpose, in a narrow sense:

was to introduce superior design and artisanal sensibilities in industrial workers. If workers were inculcated into better taste, it was argued, their involvement in

industrial processes would be less dispensable and alienable, thus making them more essential to production, therefore raising wages, and mitigating their widespread misery.[18]

The DSA had far-reaching influence, with individuals trained in its halls going on not only to direct the Metropolitan Museum of Art in New York, but also to occupy positions of authority in the many art schools that were opened in British India. In the South Asian context, these institutions functioned as vocational schools to refashion and modernize the local artisanal or 'traditional' labor force. 'There, the liberalism of the DSA enterprise cast itself as savior of the decaying native industries and Indian artisanry under the onslaught of cheap, mass-produced, imports from the metropole.'[19]

Whereas the goal of the DSA and the colonial art schools ostensibly might have been to preserve the crafts and thus secure the ongoing livelihoods of the local artisanal classes, in actual fact the process of constraining them within the parameters of traditional folk crafts ensured that the local crafts and artisans could not compete on equal footing with the products (and laborers) of the industrialized center, and so condemned them to a subordinate and exploited status.

Through the DSA, local artisans were instructed in what were to become the officially sanctioned versions of their own traditional crafts, and exhibitions of crafts together with industrial products went a long way toward underscoring the difference between native Indian and metropolitan British production, and the explicit superiority of the latter. As a prime example of this phenomenon, a short fifteen years after the conquest of the Punjab, the Punjab Exhibition of 1864 served to display superior industrial products and economic processes to the newly conquered Punjabi elites and force them to acknowledge British cultural superiority. 'Through the exhibition, empire descends into the vernacular.'[20]

The creation of native colonial (as distinct from traditional) elites to serve as intermediaries between the colonial authorities and the subject population is an important and recognized fact of British policies in South Asia and elsewhere, and is a project that is itself reflected in the structure of the Pakistani educational system and ongoing constructions of class, culture, and taste. Among the notable offspring spawned by the DSA was the Mayo School at Lahore, founded by John Lockwood Kipling, the father of Rudyard Kipling and the founding curator of the Lahore Museum. A vocational school on the DSA model as it was carried into British India, the Mayo School sought to define and preserve native artisanal crafts and design. After the independence of Pakistan, it was renamed the National College of Arts (NCA) and ranks as the most prestigious and influential art school in the country.[21]

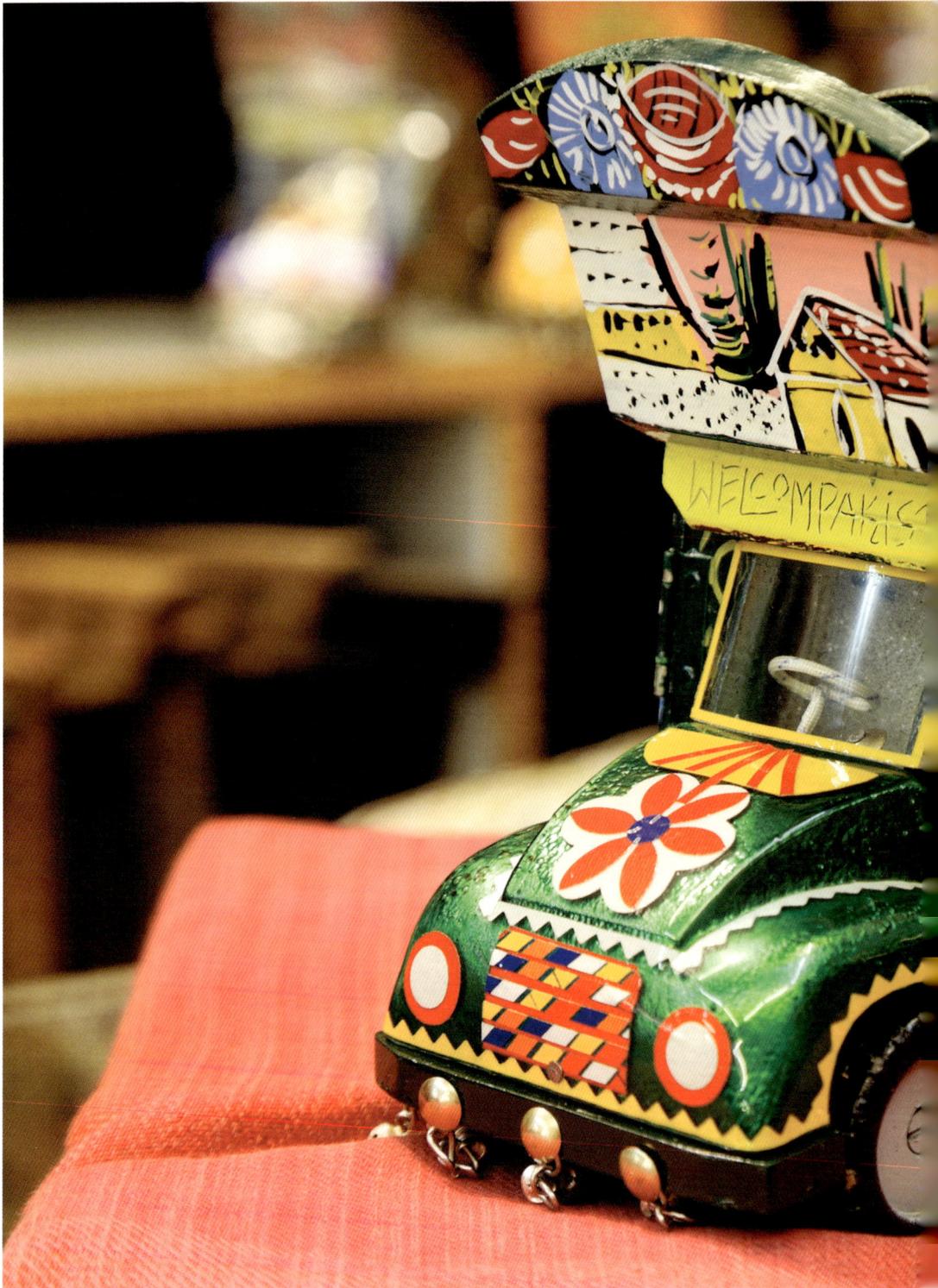

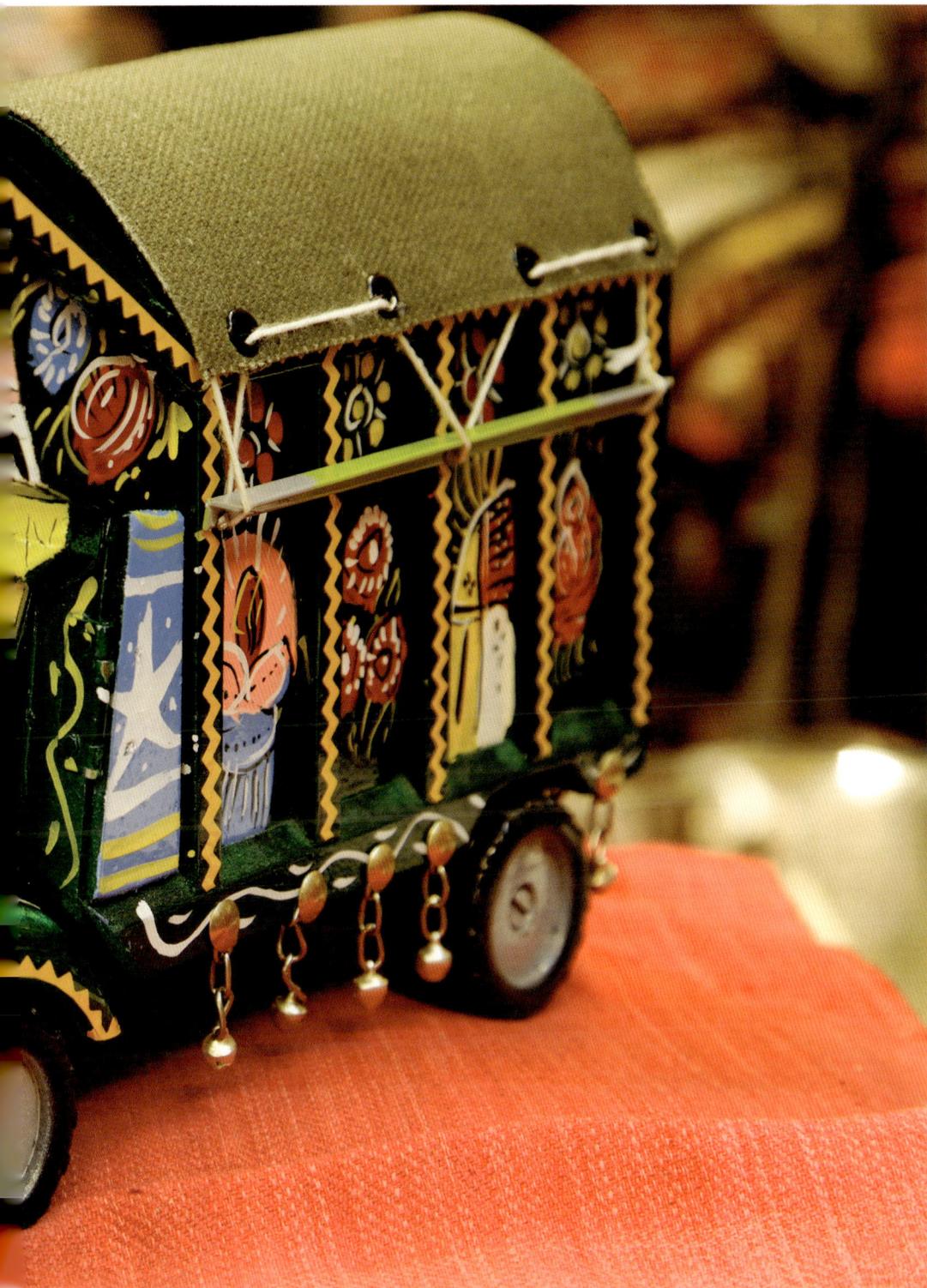

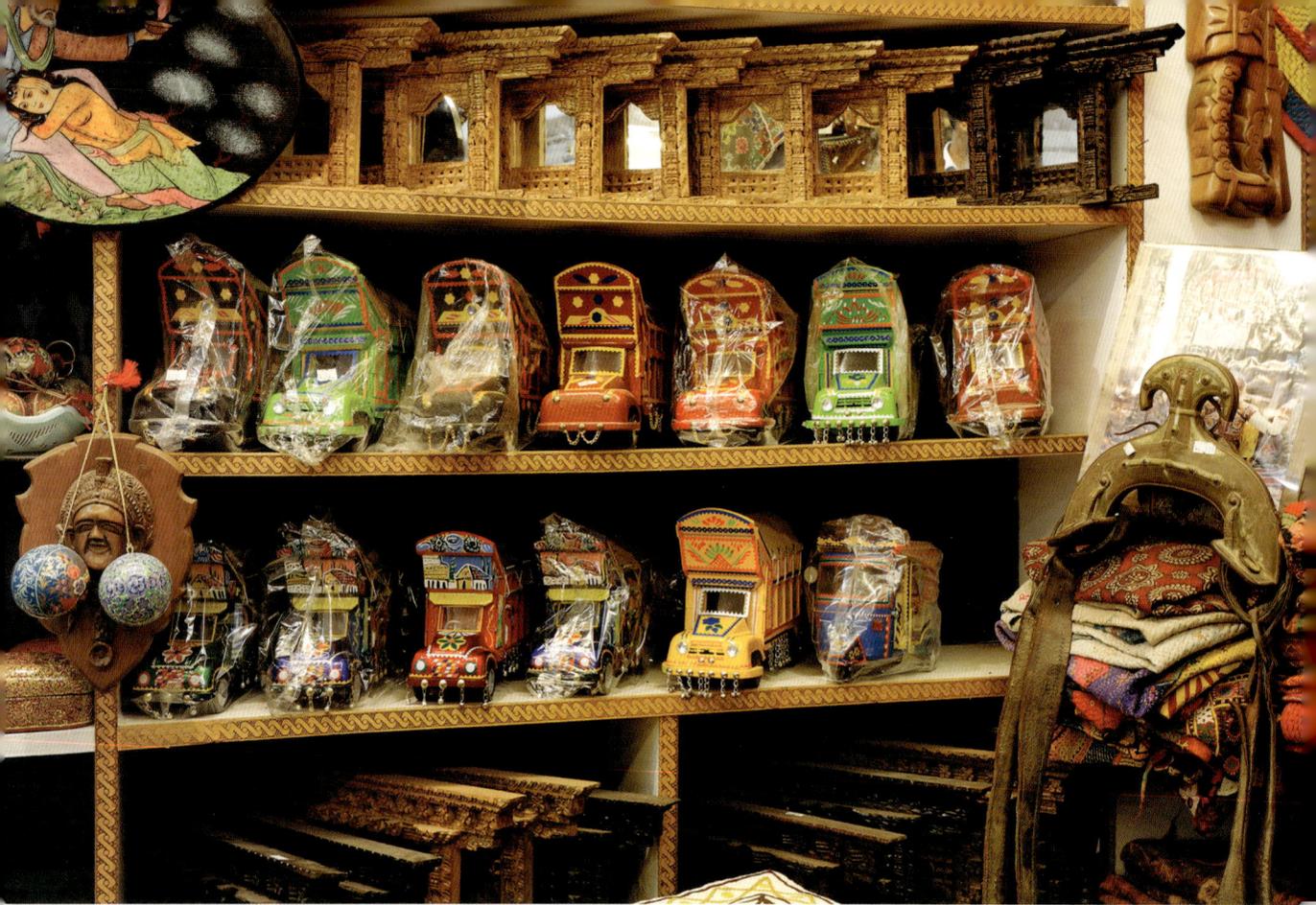

However, the shift of focus and institutional identity brought about by the departure of the British and their replacement by an indigenous Anglophone elite is laid out very clearly in the NCA's own description on its webpage:

In 1958, the school was upgraded by the then West Pakistan Government into the National College of Arts. The craft and industry oriented structure of the school, which had provided much-needed early nurturance to such diverse occupations as carpentry, lacquer-work, blacksmithy, goldsmithy, silversmithy, pottery, needlework, architectural draftsmanship, sanitation, plumbing, civil engineering and commercial art, was updated and confined to three departments[:] Fine Arts, Design and Architecture.

The changed structure of the College allowed proper focus on Fine Arts. The departments began to train new talent in modern and traditional painting, graphic art and sculpture. The Department of Design began to turn out professionals in Textile Design, Publicity Design, Product Design and Ceramics. The rapidly growing demand in the building sector for architects began to be met by the College, together with other professional universities of the country.

△
Plate 102: Model trucks and a motor rickshaw displayed in a souvenir shop (Islamabad 2007)

▷
Plate 103: Detail of a door in the Balochi style displaying a variety of decorative techniques and media (Turnol 2007)

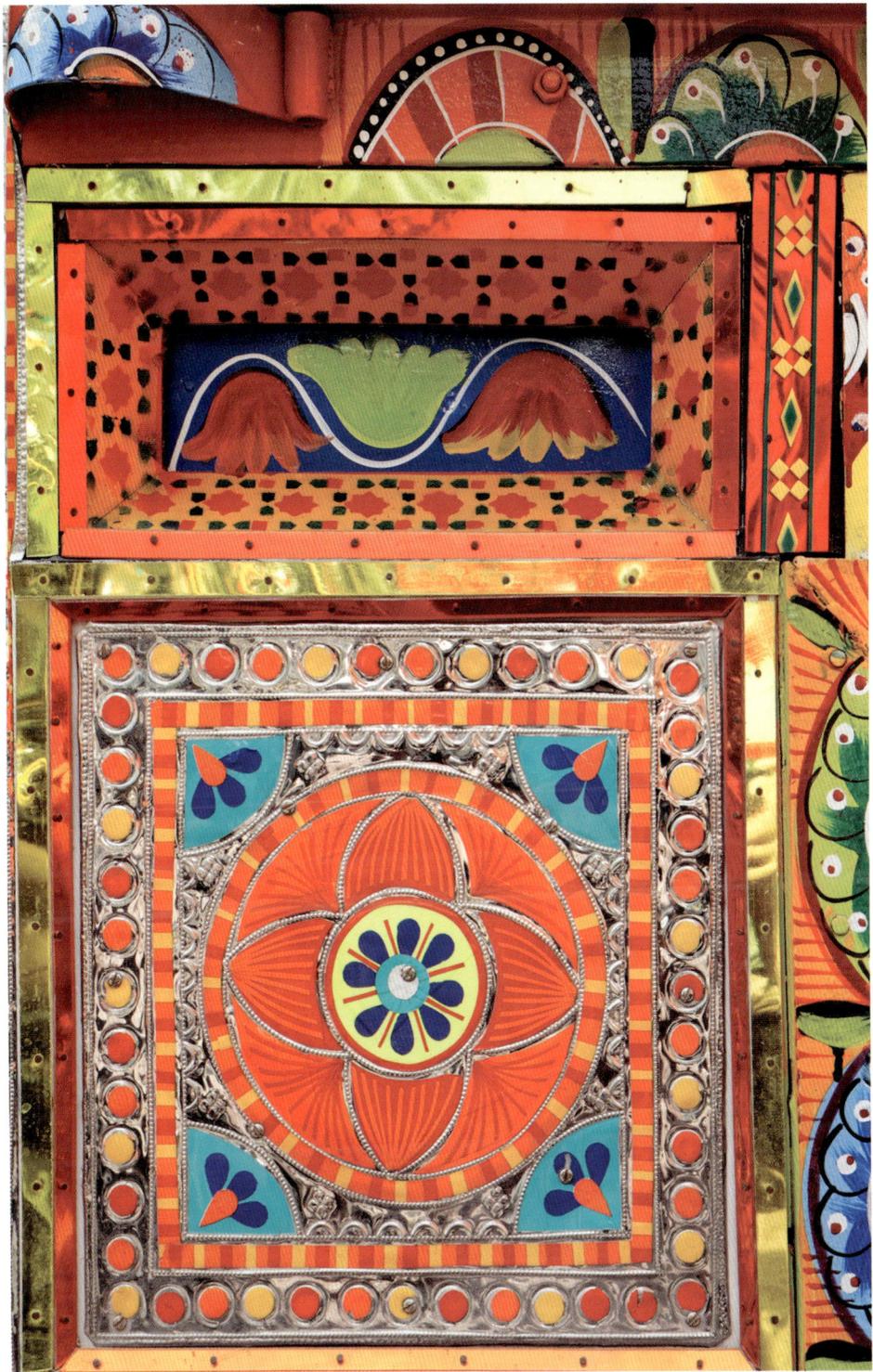

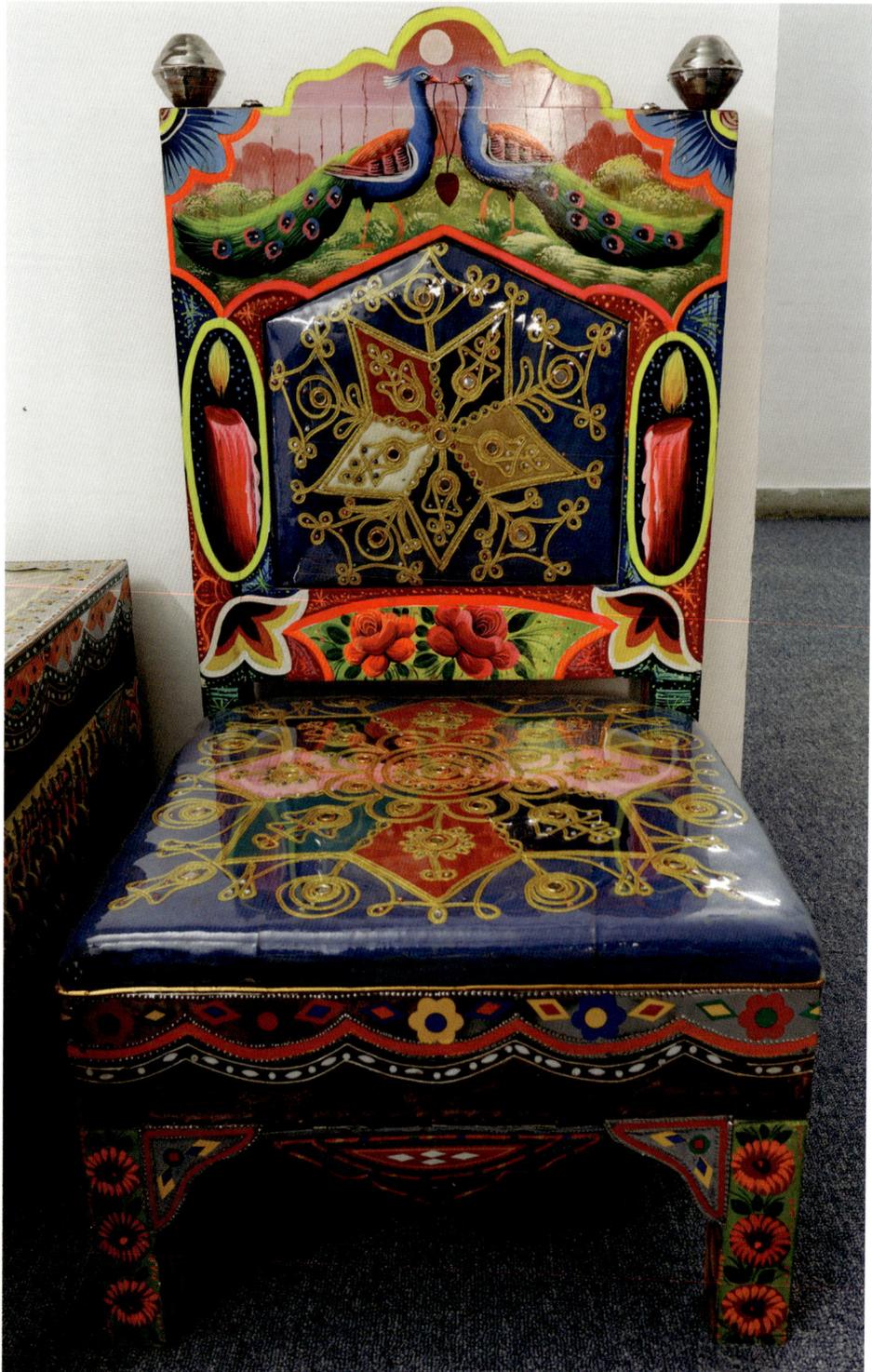

◁

Plate 104:
A chair decorated in
'truck art' style by the
primary artists who
worked on the truck
displayed at the
Smithsonian Folklife
Festival in Washington.
The chair (with another
like it and a table in the
same style) is located in
the offices of the
American Institute of
Pakistan Studies in
Islamabad (Islamabad
2007)

In 1963, the Government recognized the College as a premier arts institution in Pakistan, [sic] was taken away from the Department of Industries and placed under the Education Department with its own Board of Governors.[22]

Through the development of indigenous elites and their control over the definition of native tastes, crafts and professions, the NCA has moved from a vocational school – with the proletarian implications the term carries in modern society – to a school of Fine Arts. It maintains a concern with the employability of its graduates and the economic relevance of education in the arts, but has replaced artisanal training with high-status artistic expertise. In place of architectural drafting one has architecture, potters are now ceramic artists in the Fine Arts department, and – in a somewhat more circuitous way – 'blacksmithy, goldsmithy [and] silversmithy' have been replaced by sculptors who work with metal. The NCA and its principal competitor in Karachi, the Indus Valley School of Art and Architecture, prepare their students for careers as graphic artists, architects, and textile designers working for good wages in urban centers. Almost exclusively, they cater to members of privileged classes, especially the Anglophone bourgeoisie, and, like elite institutions of higher learning elsewhere, serve the important function of reaffirming their graduates' membership in this privileged class. Not only are the skills required for truck decoration not taught at the national art schools, but talented artists from a background in vehicular arts would be painfully out of place in such institutions, since the boundaries of class remain nowhere more visible than they do in the world of 'fine arts'. Yet, despite the complete exclusion of truck arts and artists from the curriculum of the art schools, the incorporation of 'truck art' as *design* remains a constant factor and inspiration, manifesting itself in student projects in textiles as well as graphic and fine arts. 'Truck art' has become the most accepted visual representation of a Pakistani folk authenticity.[23]

Pakistani vehicular arts, as an identifiable scheme of design, have also moved into international so-called 'ethnic art' circles. A tram in Melbourne was decorated after the fashion of a Pakistani minibus in anticipation of the 2006 Commonwealth Games; a bus was painted in a similar fashion as part of the 2008 South Asian Heritage Festival in Mississauga, Canada, which also featured an exhibition entitled 'Moving Art: South Asian Truck Art'. The most significant example of the movement of Pakistani truck decoration into an international arena was represented by the commissioning of a truck to be part of the 2002 Smithsonian Folklife Festival exhibition on the National Mall in Washington DC, entitled 'The Silk Road: Connecting Cultures, Creating Trust'.

At the Smithsonian, the truck displayed was positioned at the entrance to the festival grounds and was consciously designed so as to combine elements of regional styles: 'carved wooden doors common in Swat and Peshawar, camel bone and white plastic

inlay typical of Sindh, peacock motifs found mostly in the Punjab and Sindh … The paintings include scenes from throughout Pakistan and a few done at the Folklife Festival.'[24] Two truck artists, Haider Ali and Jamil Uddin, both from Karachi, did most of the decorating in Karachi and then came to Washington to complete the rest of the work as part of the live, ethnographic component essential to the program of the Folklife Festival, the largest annual cultural event in the United States.

Mark Kenoyer, an archeologist whose work focuses on Pakistan and who has been documenting Pakistani trucks for three decades, was responsible for all arrangements, including the purchase of the truck, identifying appropriate artists, and overcoming the many logistical hurdles involved in getting the truck from Karachi to Washington. To this end, a secondhand Bedford was purchased and had its front and back fenders decorated in Karachi with stainless steel grillwork as well as hanging chains with leaf-shaped pendants and bells. A carved front panel and a set of carved wooden doors were prepared. In addition, preliminary paintwork was done in Karachi by the two artists commissioned by Kenoyer after a lengthy search. This included the background decoration and basic design elements, as well as some of the outlining for the painted graphics. Other decorative elements, such as appliqué, mirrors, hammered metalwork, reflectors, lighting, upholstery, as well as beadwork and other hanging decorations were all completed in Karachi.

The two artists selected for this project were Haider Ali, son of Mohammad Sardar, originally from Jullunder in East Punjab and now settled in Karachi, who specializes in fine painting on trucks, and Jamil Uddin, son of Islamuddin, a bodywork specialist who served as the overall designer of the truck. He had 25 years' experience and learned the craft from his father, an immigrant from Delhi to Karachi. The artists were selected for their skills, but also for the likelihood that they would qualify for US visas (which are notoriously difficult for Pakistanis to get), and their temperament and overall character, since they would be required to interact with the many visitors expected at the festival and were to serve as goodwill ambassadors for Pakistan. The painting was estimated to cost Rs. 30,000–40,000 ($500–670) and would take one month, with an additional two weeks for the fine paintings (which could be rushed to one week if needed). The total cost of the bodywork was estimated at Rs. 200,000–250,000 ($3000–4300).[25]

The Smithsonian Folklife Festival bears many characteristics which place it squarely in the tradition of the DSA and the mission to preserve the parameters of culturally authentic means of production, thereby defining the authentically foreign as that which is completely distinct from the local (American), which is itself implicitly identified with the modern and industrialized metropolitan center. Thus China is represented in the festival by its folk music and blue and white ceramics as opposed to its prodigious industrial output, and Bangladesh and India by blockprint textiles and *Jamdani* saris rather

than the functional, modern Western-style clothes produced by their many garment factories and found in department stores all across the United States.

One important distinction between this modern American festival and the earlier British expositions lies in the Folklife Festival's emphasis on culture and cultural diplomacy. The stress is explicitly political as opposed to economic, as is apparent from all the official literature associated with the event:

> The Smithsonian Folklife Festival is an international exposition of living cultural heritage annually produced on the National Mall … The Festival is an exercise in cultural democracy, in which cultural practitioners speak for themselves, with each other, and to the public. The Festival encourages visitors to participate – to learn, sing, dance, eat traditional foods, and converse with people presented in the Festival program.[26]

Cultural understanding and its political dimension are brought up as a major theme in the essay written for the occasion by the Director of the Center for Folklife and Cultural Heritage at the Smithsonian Institution, Richard Kennedy:

> One reason the Smithsonian staff has been particularly excited to work on a Silk Road project at this time is the political transformations that have taken place in the region over the previous two decades. The opening of China and the collapse of the Soviet Union have enabled researchers, businessmen, and travelers alike to visit a vast area little known to Westerners in the past hundred years. A new Silk Road is being traveled. The modest victories of democracy and capitalism at the end of the second millennium allowed strangers once again to meet along the ancient roads of silk and once again exchange ideas and products.[27]

The political relevance of the moment is emphasized in the essays written for the booklet accompanying the exhibition by the Secretary of the Smithsonian Institution (Lawrence M. Small), the musician Yo-Yo Ma (who served as the Artistic Director of the Silk Road Project, a major sponsor for the event), Luis Montreal (the General Manager of the Aga Khan Trust for Culture, another major sponsor),[28] and by the then-Secretary of State of the United States, Colin Powell, who spoke at the opening of the festival.[29] In the example of the Smithsonian Folklife Festival, the purpose of the exposition has changed from earlier times, from an emphasis on goods, crafts, and industry to one that valorizes the prospects of diplomacy and a better future through observing (and interacting with) people from distant and exotic lands, and that views seeing 'authentic' products from those lands as holding the promise of better cultural understanding. The Pakistani truck was so popular with visitors to the festival that it was left standing on the

National Mall even after the festival ended. However, its need for cosmetic rehabilitation a few years later was hampered by the inability of the truck artists to secure US visas (the aspirations of cultural diplomacy take a backseat to more pressing political realities), and the truck was moved into a storage facility.

The truck commissioned for the Smithsonian Folklife Festival incorporates the main visual elements that make a Pakistani truck *Pakistani*. Across the top of the front – which is decorated in the 'disco' style – are large medallions with the Ka'ba on the left of the truck and the Prophet's Mosque on the right. In the center there is a representation of the Minar-e Pakistan tower in Lahore together with the phrase 'O God! Aid Us!' (*Yā Allah madad*). The sides of the truck are true to the spatial and locational functions of those spaces in Pakistani truck decoration, in that they are decorated with the phrase '2002 Smithsonian Folklife Festival Silkroad Program' (note the American spelling, which is not used in Pakistan). As a sum of its parts, this truck is faithful to Pakistani truck decoration as a visual syntactical system, and credit for this goes to Mark Kenoyer, who exercised a great deal of control over the decorative program of the truck. At a conceptual level, the Smithsonian truck is different from other examples of the movement of Pakistani truck art into the world of international folk art and design in

*Plate 105:
A detail of the side of the Pakistani truck at the Smithsonian Folklife Festival in Washington DC (image courtesy of the Smithsonian Institution Center for Folklife and Cultural Heritage)*
▽

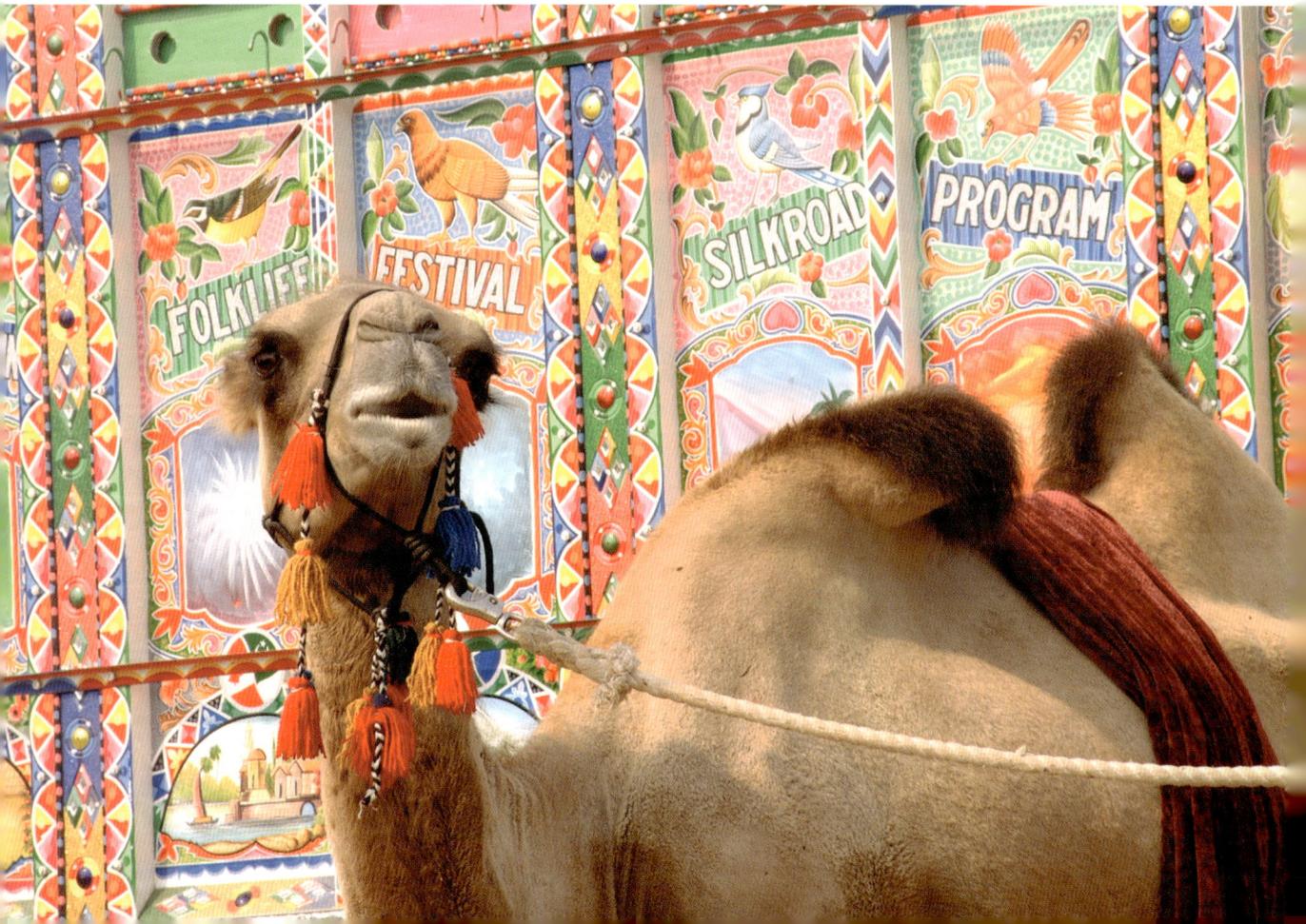

that, reflecting the philosophy of the Folklife Festival, the Smithsonian truck is conceived not as an example of Pakistani 'truck art', but rather, the *truck itself* serves to exemplify an important aspect of Pakistani cultural uniqueness. In contrast, the phenomenon of 'truck art' serves to isolate certain design elements that are perceived as 'popular' and render them into static artifacts of an authentic national folk culture.

But the 'folk' do not live 'folk culture' either with a wistful nostalgia or with a fear of the modern. Whereas the term 'Pakistani truck art' holds particular meaning in the spheres of popular and folk art to the urban consumers of such arts, within the world of its own production and consumption, 'truck art' is unrecognizable as a descriptor and useless in its ability to convey meaning. Trucks themselves are invariably decorated, but the art *on them* is not 'truck art'. 'Truck art' only becomes such when it leaves the *habitus* of truckers and enters the entirely separate arena of art appreciation and consumption by the national Anglophone bourgeoisie and, through them, a consumerist transnational market for folk art.

The decorated truck is not the work of an artist, or even a group of artists, working autonomously to produce an object. Instead it is two distinct but interrelated phenomena: in some ways, it is a collaborative piece of mobile and performative installation art in which the combined vision of those involved in building it up until it leaves the workshop blends with the ongoing decorative and ornamental changes made by and at the request of the owner and driver so as to take a form that is always evolving and therefore never reaching the status of a finished work. At the same time, the truck is the culmination of a syntagmatic chain, which begins with the raw material comprised of the bare chassis, and on which the individual artists and technicians are separate links, as are the owners and drivers and all others who make ongoing contributions to the truck. Each given stage of decorative modification is influenced by the environment and the (real or perceived) responses of the audience, but it also depends on the input of all those who worked on the truck before. The truck is, therefore, not a static artifact of so-called 'popular' or 'folk' art traditions, or even necessarily of vernacular expression, but a manifestation of the processes of societal change that get reflected, projected, re-absorbed, and reflected again through the decorative and epigraphic program of the vehicle.

Appendix

Examples of Truck Verse

The following examples of truck verse are provided as a representative sample with no pretense at being comprehensive in terms of theme. Unless otherwise noted, the verses were gathered by the author during the course of his research. Where available, vehicle registration numbers and locations and dates of documentation are included. Verses quoted from a collection of vehicular poetry are acknowledged as *Pappu*.[1]

In all God's creation Muhammad was made first,
There was no Adam, there were no angels, God was
not apparent.
(*bane sārī khudāī men Muhammad Mustafā pehlē
na Ādam thā na farishtē thē na zāhir thā khudā pehlē*)

If you are faithful to Muhammad, then I am yours.
What is this world after all, the pen and the tablet are yours;
(*kī Muhammad sē vafā tū nē tō ham tērē hen
ye jahān chīz hē kyā lūh-o qalam tērē hen*)

Burn away in silence under the blazing sun, but
Never ask your relatives for the shade of a simple wall.
(*jal jāo khāmushī sē kaṛī dhūp men lēkin
apnōn sē kabhī sāya-e dīvār na māngō*)

Who ever notices the tears of the morning dew?
Everyone is busy looking at the smiling rosebud.
(*shabnam kē ānsū kō kab dēkhtī hē dunyā
kartē hen sab hī nazzāra hanstī hūi kalī kā*)

Lips that cannot smile – what do they know of
blooming flowers?
Eyes that cannot cry – what do they know of keeping secrets?
(*jis lab pe hansī ā na sakē vo gul khilānā kyā jānē
jis ānkh men ānsū reh na sakē vo rāz chupānā kyā jānē*)

Bow down and salute the threshold of Zahra,
Who nurtured Husayn and gave him to the world.
(*jhuk kar salām karō Zahrā kē āstānē ko*
pāl kē Husayn diyā jis nē zamānē ko)

Never vow more in love than someone can bear,
For undeserved kindness can cause great harm.
(*kisī kē zarf sē baṛh kar na rakh mehr-e vafā hargiz*
ke is bējā sharāfat kā baṛā nuqsān hōtā hē)

The one I had held by the hand to show the way –
On reaching his destination showed me the finger.
(*unglī pakaṛ kē jis kō dikhāyā thā rāsta*
manzil milī tō ham kō angūṭhā dikhā gyā)

Stone idols carved by my own hands
Are today resting in the temple as gods.
(*mērē hāthōṇ kē tarāshē hūē paththar kē sanam*
āj but-khānē mēṇ bhagvān banē bēṭhē hēyṇ)

Leave some light of your memory with me;
Who knows in which alley night will fall on my life?
(*ujālē apnī yādōṇ kē hamārē pās rehnē dō*
na jāne kis galī mēṇ zindagī kī shām hōgī)

No mortal man is apprised of his death,
With supplies for a hundred years, unaware of the toll bridge.
(*āgāh apnī mōt sē kōī bashar nahīṇ hē*
sāmān sō bars kā pul kī khabar nahīṇ hē)

You are a rose and I am in love with your fresh bloom;
Your picture is in my heart, so why bother with your veil?
(*tū phūl hē gulāb kā mēṇ 'āshiq hūṇ tērē shabāb kā*
tērī tasvīr hē mērē dil mēṇ kyā fāida hē tērē niqāb kā)

(RIJ1595, Turnol 2001)

You see my sins but you don't lessen your blessings,
I can't understand why you are so generous!
(*khatāiṇ bhī dēkhtā hē 'atāiṇ kam nahīṇ kartā*
samajh nahīṇ ātā itnā meherbān kyūṇ hē)

(RIN6394, Islamabad 2003)

Eyes closed, beauty in repose –
All behold – Fairy Blue has come!
(*āṇkhayṇ band hēṇ ke husn qarār mēṇ*
dunyā samajh rahī hē ke nīlam ā gaī hē)

(GLT670, Rawalpindi 2001)

209

I'll play the game of love on one condition:
If I win, you are mine, if I lose, you take me.
(*ik shart sē khēlūṇ gī piyā pyār kī bāzī
jītūṇ tō tujhē pāūṇ hārūṇ phir bhī piyā tērī*)

<div align="right">(GLT670, Rawalpindi 2001)</div>

One heart met another and my whole being smiled;
Someone burned up in envy, someone prayed for blessings.
(*dil dil sē milā zindagī muskurā dī
koī dēkh kar jal gyā kisī nē du'ā dī*)

<div align="right">(TKN778, Turnol 2007)</div>

Like a cloud, she came, rained and went away;
She did not even notice how long the tree cried.
(*bādil kī tarah āyā baras kē chal paṛā
us nē dēkhā hī nahīṇ kitnī dēr tak rōyā hē shajar*)

<div align="right">(TKL352, Rawalpindi 2001)</div>

Who gives comfort to a broken heart?
Even trees get rid of dried up leaves.
(*kōn dētā hē ṭūṭē hūē dil kō āsrā
darakht bhī sūkhē hūē pattōṇ kō girā dētē hēṇ*)

<div align="right">(MNA9943, Islamabad 2001)</div>

Don't give your heart to a driver – their homes are far away.
It's not that they are fickle, but they still go away.
(*na kar ḍrēvar sē dil lagī us kā ṭhikānā dūr hōtā hē
ye bēvafā nahīṇ hōtē un kā jānā zurūr hōtā hē*)
My fate took something of a loss, some of my dreams were smashed,
People broke me down somewhat, some of my loved ones deserted me.
(*kuch hār gaī taqdīr mērī kuch ṭūṭ gaē sapnē mērē
kuch lōgōṇ nē barbād kiyā kuch chōṛ gaē apnē mērē*)

<div align="right">(K5565, Turnol 2003)</div>

Your eyes have no calmness, your heart has no kindness,
When others call you, you run to them, when I call you, you have no time.
(*akh tērī vich chēn koī neṇ dil tērē vich rehm neṇ
lōkī bulāvan bhaj bhaj jāvēṇ asī bulāiyē tē ṭēm neṇ*)

<div align="right">(RIG9560, Islamabad 2001)</div>

The torments of the world and the sadness of fate must be borne in any event;
Even when complaints are on the tip of one's tongue, one has to remain silent.
(*dunyā kā sitam taqdīr kā gham har hāl mēṇ sehna paṛtā hē
shikvē bhī zubān par ātē hēṇ khāmōsh bhī rehnā paṛtā hē*)

<div align="right">(RIG9560, Islamabad 2001)</div>

The blisters on tired feet said to the heart as they travelled along:
She lives so far away, the one who lives in my heart.
(*chaltē chaltē thak pūchā dil sē pāoṇ kē chālōṇ nē
bastī kitnī dūr basā lī dil mēṇ basnē vālōṇ nē*)

<div align="right">(RIG9560, Islamabad 2001)</div>

210

You speak of strangers, I've even tested my loved ones:
Others are careful only of thorns, I've been injured
by blossoms.
(*tum tō ghayrōṇ kī bāt kartē ho ham nē apnē bhī āzmāy hēṇ*
lōg kāṇṭōṇ sē bach kar chaltē hēṇ ham nē phūlōṇ sē zakhm khāy hēṇ)

(AJKA3889, Islamabad 2001)

Just to stay alive, I swear
I have to see you just once, my love!
(*zinda rehnē kē liyē tērī qasam*
ēk mulāqāt zarūrī hē sanam)

(AJKA3889, Islamabad 2001)

If cold winds didn't blow, flowers wouldn't fall from
their branches,
If I didn't drive a truck, I wouldn't be far from my friends!
(*na chaltīṇ sard havāyṇ na girtē phūl bahārōṇ sē*
na kartē ham ḍrēvarī na bicharṭē apnē yārōṇ sē)

(AJKA3889, Islamabad 2001)

I fought with everyone else just to make you my own,
I'll remember to my dying day that I gave my
heart to someone.
(*hazārōṇ sē bigāṛī thī tujhē apnā banāyā thā*
rehē gā yād qiyāmat tak kisī kō dil lagāyā thā)

(RIH6486, Islamabad 2001)

My heart aches – get a prescription filled and send it –
My beloved, draw your picture on a scrap of paper
and send it.
(*yē kalēja dard kartā hē koī davā banā kar bhējō*
sanam kisī kāghaz kē ṭukṛē par apnī tasvīr banā bhējō)

(RIH6486, Islamabad 2001)

Who knows why the girls of today wear so much makeup –
Girlfriends when you are young, then they abandon you.
(*na jāne āj kal kī laṛkiyāṇ itnī surkhī kyūṇ lagātī hēṇ*
bachpan mēṇ yār banā kar na jāne bichaṛ kyūṇ jātī hēṇ)

(RIH6486, Islamabad 2001)

Beg forgiveness for your sins before departing,
Who knows, it might be your last journey.
(*jāne sē pehlē apnē gunāhōṇ kī māfī māng lō*
shāyad tumhārī zindagī kā ākhrī safar hō)

(K2979, Taxila 2007)

It was not my destiny to be united with my lover,
No funeral was held for me, no marker for my grave.
(*na thī hamārī qismat ke visāl-e yār hōtā*
na uṭhtē kahīṇ janāzē na koī mazār hōtā)

(RIL3755, Islamabad 2001)

211

He is angry with me and I accept it –
But friends, tell him not to abandon my town.
(*vo mujh sē rūṭhā hē qabūl hē mujhē*
yāro usē kahō ke mērā shehr na chōṛē)

<div align="right">(GLTA599, Gilgit 2001)</div>

I don't care about my burden,
I only care about the dollars,
I've come from England, Bedford is my name,
If the driver feels up to it, passing is my game!
(*mujhē vazan kī parvāh nahīṇ*
mujhē ḍālar kī talāsh hē
inglēnḍ se āī hūṇ bēḍfōrḍ mērā nām hē
tamannā hō ḍrēvar kī pās karnā mērā kām hē)

<div align="right">(GLTA5476, Rawalpindi 2001)</div>

The nature of life itself is based in parting –
Even water hugs the shore for only so long.
(*judāī par qā'im hē nizām-e zindagānī bhī*
bichar jātā hē sāhil sē galē mil mil ke pānī bhī)

<div align="right">(RPT5563, Rawalpindi 2003)</div>

Just look at me with your sultry eyes, if you really
want to torment me;
I was already senseless in love, so why did you
need to laugh?
(*mast nazrōṇ sē dēkh lē agar tamannā thī āzmānē kī*
ham tō pehlē sē mad-hōsh thē kyā zarūrat thī muskurānē kī)

<div align="right">(GLT690, Rawalpindi 2003)</div>

Others destroy one's mind, disease destroys one's body;
A man doesn't die on his own, his own people destroy him.
(*'aql kō lōg mār dētē hēṇ javānī kō rōg mār dētē hēṇ*
ādmī khud tō nahīṇ martā usē apnē hī lōg mār dētē hēṇ)

<div align="right">(AJKA4525, Rawalpindi 2001)</div>

Do not walk on this earth with your head held so high:
God has destroyed many worlds like this after making them.
(*ay insāṇ na chal zamīṇ par sar uṭhā uṭhā kar*
khudā nē ēsē kaī naqshē miṭā diyē banā kar)

<div align="right">(Rawalpindi 2001)</div>

Do not lose yourself in love at the start of the journey –
If you lose her, every thought of her will torment you.
(*mat ṭūṭ kar chāhō kisī kō āghāz-e safar mēṇ*
bichar giyā tō us kī ik ik adā tang karē gī)

<div align="right">(Turnol 2003)</div>

I may be acting badly but you should not be
happy either:
Your candle will also go out someday – the winds belong
to no one.
(*agar āj mēṇ zid mēṇ hūṇ to khushgumāṇ tū bhı nahō*
bujhēṇ gē chirāgh tērē bhī ye havāiṇ kisī kī nahīṇ)

(Turnol 2003)

Guarded, as it were, within a glass lamp –
How can that flame go out which God Himself has lit?
(*fānūs ban kar jis kī hifāzat huā karē*
vō shama' kyā bujhē jise rōshan khudā karē)

(RIN330, Rawalpindi 2001)

It would only be a crime if I told what's in my heart –
Loving someone madly is not itself a sin!
(*khatā tō tab hō ke ham hāl-e dil kisī sē kehēṇ*
kisī kō chāhtē rehnā koī khatā tō nahīṇ)

(AJKD3313, Rawalpindi 2001)

For the ways of love to remain – that would suffice –
No one ever belonged to another forever.
(*yehī bohat hē qā'im rehē vafā kā bharam*
koī 'umr bhar kē liyē kisī kā huā bhī hē)

(AJKD3313, Rawalpindi 2001)

Everyone has the same end,
Even if we all travel alone.
(*manzil da ṭolo yo de*
khu safar juda juda)

(C1634, Rawalpindi 2001)

The light of Muhammad is no spectacle,
It is the rose that has no thorns.
(*Muhammad kā jalva koī tamāsha nahīṇ*
ye vo phūl hē jis mēṇ kāṇṭā nahīṇ)

Not from wealth, not from things, not from having a family –
The heart finds comfort only in recollecting the Lord.
(*na dunyā sē na dōlat sē na ghar ābād karnē sē*
tasallī dil ko hōtī hē khudā ko yād karnē sē)

Torment me, be good to me – I will never complain,
You are not going to find a lover like me again.
(*sitam karō karam karō ham gilah nahīṇ kartē*
ham jēsē 'āshiq dōbāra milā nahīṇ kartē)

(RIN8568, Turnol 2003)

True, I was already infamous before, but
My disgrace found wings as soon as I met you.
(*khayr badnām tō pehlē hī buhat thē lēkin*
tujh sē milnā thā ke par lag gaē rusvāī kē)

<div align="right">(RIN8568, Turnol 2003)</div>

You have come here after so long, and still you talk of leaving,
Sit awhile so that my heart settles down – though you belong to someone else.
(*itnī muddat kē bā'd āy hō phir bhī jānē kī bāt sāth lāy hō*
itnā to ṭhēr jāo ke dil ṭhēr jāy mānā ke parāy hō)

<div align="right">(RIN8568, Turnol 2003)</div>

No memory of your warm breath, nor of your dark tresses,
I remember nothing but my broken, scattered dreams.
(*sānsōṇ kī mehek yād na zulfōṇ kī ghaṭāyṇ*
ab kuch nahīṇ bikhrē huē khābōṇ ke sivā yād)

<div align="right">(RIN8568, Turnol 2003)</div>

Be not angry with a poor beggar, my friend,
In case you call out one day, and not even this wretch is around.
(*ay dōst ik gharīb sē itnā khafā na hō*
shāyed ke tū bulāy to yē bēnavā na hō)

<div align="right">(RIN8568, Turnol 2003)</div>

My aim is set so high that I don't fear stray flames,
I only worry that the glowing rose will set the garden on fire.
(*mērā azm itnā buland hē ke parāy shōlōṇ kā ḍar nahīṇ*
mujhē khōf ātish-e gul sē hē kahīṇ chaman kō jalā na dē)

<div align="right">(RIN2125, Rawalpindi 2001)</div>

I would have found peace in utter hopelessness –
By giving me some hope, she tormented me forever.
(*nā umīdī mēṇ guzar jātī to mil jātā sukūn*
kuch āsrā dē kar kisī nē ōr tarpāyā mujhē)

<div align="right">(RIN2125, Rawalpindi 2001)</div>

Eyes are crazy things –
They reveal everything.
(*āṇkhēṇ baṛī pāgal hēṇ*
har bāt batā dētī hēṇ)

<div align="right">(RIN2125, Rawalpindi 2001)</div>

I am no one to others, and none shares my pain,
I was thrown out, exiled, as my lover wished.
(*asī kisē dē kuj na lagdē na koī sāḍhā dardī*
vatnōṇ kaḍ pardēsī kītā jēvēṇ sajjan dī marzī)

<div align="right">(RIN1882, Rawalpindi 2003)</div>

You wearing a veil – what's the point of hiding your face?
I can see your eyes – what's the point of hiding your lips?
(*ay niqāb karnē vālī tērē niqāb karnē kā kyā fāyda*
ānkhēṇ to nazar ātī hēṇ mūṇ chupānē kā kyā fāyda)

(Rawalpindi 2001)

O Lord don't leave me needy in this world –
It is not as if your treasury lacks anything!
(*ay rabb na kar muhtāj mujhē is zamānē mēṇ*
kamī kyā hē yā rab tērē khazānē mēṇ)

(Rawalpindi 2001)

My enemies can wish a thousand ills upon me –
What God wants to happen, happens.
(*mudda'ī lākh burā chāhē tō kyā*
vohī hōtā hē jō manzūr-e khudā hōtā hē)

(Rawalpindi 2001)

I should be the one to cry, with no peace in my life –
The dew fell and turned to pearls, then a tormentor came and smashed them.
(*rōnā to hamēṇ chāhiyē jinkī zindagī mēṇ sukūn nahīṇ*
girī shabnam banē mōtī koī zālim ākē tōṛ gyā)

(RIM4595, Rawalpindi 2007)

O Lord! Do not lay my desires bare!
Forgive me! Do not count my sins!
(*yā ilāhā mērī ārzū ko bēniqāb na karnā*
bakhsh dēnā mērē gunāhōṇ ko hisāb na karnā)

(GLT 9587, Gilgit 2001)

The morning breeze plays in the garden with the dawn –
One person's dying breath is another person's love sigh.
(*bād-e nasīm sehr-e gulshan sē khēltī hē*
kisī kī ākhrī hichkī kisī kī dillagī hōgī)

(RIY3162, Rawalpindi 2001)

Possessing you in a picture, I am forever happy –
Like a candle, I burn, but I am forever silent.
(*tasvīr mēṇ tujh kō pā kar hamēsha khush rehtā hūṇ*
misāl-e shama' jaltā hūṇ magar khāmōsh rehtā hūṇ)

(GHE153, Skardu 1998)

Nightingale, why do you weep, don't you have a flower at your lips?
I should be the one to cry – there is no peace in my life.
(*ay bulbul tū kyūṇ rōtā hē kyā tumhārē mūṇ mēṇ phūl nahīṇ hē*
rōnā to hamēṇ chāhiyē ke hamārī zindagī mēṇ sukūn nahīṇ hē)

(GLTA3615, Skardu 1998)

Ask the corners of his bed about his restlessness,
The one who passed the night tossing in longing.
(*bistar kī har shikan sē pūch uskī bēqarārī kā
kāṭī ho rāt jis nē karvaṭ badal badal kar*)

(GLT7323, Skardu 1998)

Some flowers even blossom atop graves –
I have not – nor will I – find comfort in life.
(*kuch phūl to khiltē hēṇ mazārōṇ kē liyē bhī
na milā hē na milē gā zindagī mēṇ ārām kahīṇ*)

(TKN755, Turnol 2007)

Some came to my home to rob me, others invited me to
theirs to rob me;
Whoever couldn't rob me as an enemy, became my friend to rob me.
(*kisī nē ghar āke lūṭā kisī nē ghar bulā ke lūṭā
jo ban ke dushman lūṭ na sakā usnē dōst banā ke lūṭā*)

(TKN755, Turnol 2007)

You gave me neither love nor charity of your own free will.
That's fine – I may be a poor wretch, but begging doesn't suit me.
(*khayr-o muhabbat che pakhpala khwasha ra na kaṛo
khayr ka zah gharib yam kho da sawal sara me na lagi*)

(C1652, Karachi 2003)

Turn around and look, my tormentor – I too desire:
You might be a college girl, but I am a truck driver!
(*palaṭ kar dēkh ay zālim tamannā ham bhī rakhtē hēṇ
agar tum kālij mēṇ paṛtī hō ḍrēvarī ham bhī kartē hēṇ*)

(*Pappu* 1: 14)

You'll have to carry the burden, it's no use being fussy,
You'll have to be a bride and leave Karachi for Mianwali.
(*lākh nakhrē dikhā lōḍ uṭhānā paṛēgā
ban ke dulhan Karachi sē Mianwali jānā paṛēgā*)

(*Pappu* 1: 21)

Last night was the full moon, I saw your reflection
in a bucket –
And then I shook the bucket and made you dance!
(*kal chōdvīṇ kī rāt thī bālṭī mēṇ tērā 'aks dēkhā
ōr phir bālṭī ko hilā hilā kar tērā raqs dēkhā*)

(*Pappu* 1: 25)

I've been given quite the punishment for giving my heart to you,
Here I sit at the wheel, waiting for you to come.
(*achchī sazā milī hē tujhē dil lagānē kī
bēṭhā hūṇ isṭīring par intizār hē tērē ānē kī*)

(*Pappu* 1: 56)

Kill me with your glances – who needs swords?
Love the ones close to you – who needs strangers?
(*qatl kar nazrōṇ sē talvārōṇ mēṇ kyā ra<u>khkh</u>ā hē*
muhabbat kar apnōṇ sē ghērōṇ mēṇ kyā ra<u>khkh</u>ā hē)

(*Pappu* 1: 61)

Veil from those who have a sense of shame –
Come without your veil, I'm already drunk.
(*parda tō unsē kiyā jātā hē jō niqāb mēṇ hō [sic]*
bēniqāb chalē āo mēṇ to nashē mēṇ hūṇ)

(*Pappu* 1: 65)

Some lovers leave in sadness, some leave in grief:
Let beautiful girls stay hidden, faith leaves those who see them.
(*koī ghamgīn chalā jātā hē koī parēshān chalā jātā hē*
hasīnōṇ ko pardē mēṇ rehnē dō dē<u>kh</u>nē vālōṇ kā īmān chalā jātā hē)

(*Pappu* 1: 68)

You shot an arrow and pierced an innocent heart,
You went away, but left this driver crazy for your love.
(*tīr mārā bēkhatā dil kō nishāna banā diyā*
tum to apnē ghar chalī ustād kō dīvāna kar diyā)

(*Pappu* 1: 70)

Life is fickle, one day it will spurn you;
Death is a true lover, she'll be with you forever.
(*zingadī tō bēvafā hē ēk din ṭhukrāy gī*
mōt mehbūba hē apnē sāth lē kar jāy gī)

(*Pappu* 1: 71)

My heart tells me to do all sorts of things,
My wallet tells me not to be a fool.
Pretty girl, *you* tell me, what should I do?
(*dil kehtā hē bohat ku<u>chch</u> karūṇ*
jēb kehtī hē bakvās na kar
khūbsūrat laṛkī ab āp hī batāo ham kyā karēṇ)

(*Pappu* 1: 84)

Pass me if you can,
Otherwise, live with it!
(*himmat hē to āgē baṛh*
varna bardāsht kar)

(*Pappu* 1: 105)

I only got to have four days of this fleeting life,
Two were spent in a Nissan, two waiting for a Hino.
(*umr-e ravāṇ sē milē thē chār din*
dō kaṭ gaē nīsān mēṇ dō hīno kē intizār mēṇ)

(*Pappu* 1: 107)

217

Plate 106: Example of decoration in the Gulkārī style (Taxila 2007)
▽

Notes

Chapter 1

1 Jean-Charles Blanc (1976a), *Afghan Trucks*, New York, Stonehill Publishing; Renata von Oppen (1992), *Art on Wheels*, Lahore, Ferozesons, presents photographs of Pakistani trucks together with those of buses and other smaller vehicles, such as carts.

2 Jürgen Grothues (1990), *Automobile Kunst in Pakistan*, Suderberg, Schrader.

3 Examples of these are Micheline Centlivres-Demont (1976b), 'Les peintures sur camions en Afghanistan', *Afghanistan Journal* 2: 60–64; Jean-Charles Blanc (1976b), 'Camions afghans', *Zoom* 40: 48–53; S. Hallet (1973), 'Afghanistan's Hot Roads', *Revue Architecture Plus*, New York: 27–32.

4 'Dure, parfois tragique, la vie du routier et de son homme de peine est égayée par les guirlandes, le bouquets de rose et de tulips qui tapissent les flancs du camion. Le camion afghan est comme une galerie de peinture déambulant dans un décor de deserts et des montagnes arides' (Jean-Charles Blanc [1976b], 'Camions afghans').

5 Hallet: 34.

6 Hasan-Uddin Khan (1975), 'Mobile Shelter in Pakistan', in *Shelter, Sign and Symbol*, edited by Paul Oliver, London, Barrie and Jenkins: 183–196.

7 M.-B. Dutreux (1978), *La Peinture des camions en Afghanistan*, PhD thesis, Paris I Sorbonne, Section Arts Plastiques.

8 Micheline Centlivres-Demont (1976a), *Popular Art in Afghanistan: Paintings on Trucks, Mosques and Tea-houses*, trans. Robin R. Charleston, Graz, Akademishe Druck-u. Verlagsanstalt: 17–18.

9 George W. Rich and Shahid Khan (1980), 'Bedford Painting in Pakistan: The Aesthetics and Organization of an Artisan Trade', *Journal of American Folklore* 93(369) July–September: 257–275.

10 A. Lefebvre (1989), 'The Decorative Truck as a Communicative Device', *Semiotica* 75(3–4): 215–227.

11 Anna Schmid (1995), *Pakistan Express: Die Fliegenden Pferde vom Indus*, Hamburg, Dölling und Galitz Verlag. There are also several websites with good images of trucks, including Martin Sökefeld, *Colours on the Road: Truck Painting in Pakistan* (http://www.asienhaus.org/galerie/lkws/english/lkw.htm), and my own *On Wings of Diesel: Vehicle Decoration in Pakistan* (http://www.arttrucks.com).

12 Examples of studies of vehicular culture include James L. Brain (1968), 'Moto Moto Tanzania: Truck and Bus Slogans in Tanzania', *Tanzania Notes and Records* 68: 95–96; Eric Dregni and

Ruthann Godollei (2009), *Road Show: Art Cars and the Museum of the Streets*, Golden, CO, Speck Press; Thomas B. Hansen (2006), 'Sounds of Freedom: Music, Taxis, and Racial Imagination in Urban South Africa', *Public Culture* 18(1): 185–208; Tomoyuki Kato (2008), *The Art Trucks of Japan*, Tokyo, Cocoro Books; Joanna Kirkpatrick (1984), 'The Painted Ricksha as Culture Theater', *Studies in Visual Communication* 10(3): 73–85, and by the same author (2003), *Transports of Delight: The Ricksha Arts of Bangladesh*, CD-ROM, Bloomington, Indiana University Press; France Lasnier (2002), *Rickshaw Art in Bangladesh*, Dhaka, Dhaka University Press; H.F. Moorhouse (1991), *Driving Ambitions: An Analysis of the American Hot Rod Enthusiasm*, Manchester and New York, Manchester University Press; Elias Petropoulos (1976), *La voiture grecque*, Paris; Jack Pritchett (1979), 'Nigerian Truck Art', *African Arts* 12(2) February: 27–31; Ellen Shapiro and Kurnal Rawat (2005), 'Fashion Plates', *Print* January–February: 58–63; and Tony Wheeler and l'Anson Richard (1998), *Chasing Rickshaws*, Melbourne, Lonely Planet.

13 Brenda Jo Bright (1995), 'Remappings: Los Angeles Low Riders', in *Looking High and Low: Art and Cultural Identity*, ed. B.J. Bright and L. Bakewell, Tucson, University of Arizona Press: 96. See also Brenda Jo Bright (1994), *Mexican American Low Riders: An Anthropological Approach to Popular Culture*, PhD Dissertation, Houston, Rice University; and her (1998), ' "Heart Like a Car": Hispano/Chicano Culture in Northern New Mexico', *American Ethnologist* 25(4) November: 583–609.

14 In the use of the term 'hybridization', I am following Néstor García Canclini, who succinctly defines it as follows: '*I understand for hybridization socio-cultural processes in which discrete structures or practices, previously existing in separate form, are combined to generate new structures, objects, and practices. In turn, it bears noting that the so-called discrete structures were a result of prior hybridizations and therefore cannot be considered pure points of origin*'. (N. García Canclini [1995; reprint 2005], *Hybrid Culture: Strategies for Entering and Leaving Modernity*, Minneapolis, University of Minnesota Press: xxv; italics in the original).

15 David Freedberg (1989), *The Power of Images: Studies in the History and Theory of Response*, Chicago, University of Chicago Press: xxii.

16 Freedberg: 70.

17 Important recent attempts to rectify this bias include Saima Zaidi, editor (2009), *Mazaar, Bazaar: Design and Visual Culture in Pakistan*; and Iftikhar Dadi (2010), *Modernism and the Art of Muslim South Asia*.

18 Pierre Bourdieu (1977; reprint 2006), *Outline of a Theory of Practice*, trans. Richard Nice, Cambridge, Cambridge University Press: 72. Bourdieu's concept of *habitus* as it relates to the production of art and material culture is developed further in his book (1990), *The Logic of Practice*, trans. Richard Nice, Stanford, Stanford University Press, especially the third chapter.

19 Alfred Gell (1998), *Art and Agency: An Anthropological Theory*, Oxford, Clarendon Press: 127.

20 IRI (2009), *Pakistan Public Opinion Survey, March 7–30, 2009*, International Republican Institute, Washington, DC: 3. Information concerning household income is not a subject of the survey but one of the demographic indicators insuring that the survey is representative.

21 In my use of the term 'vernacular religion' I am influenced by Leonard Primiano (1995), 'Vernacular Religion and the Search for Method in Religious Folklife', *Western Folklore* 54(1): 37–56.

22 Kajri Jain (2007), *Gods in the Bazaar: The Economies of Indian Calendar Art*, Durham, NC, Duke University Press: 14.

23 Néstor García Canclini (1993; reprint 2000), *Transforming Modernity: Popular Culture in Mexico*, trans. Lidia Lozano, Austin, University of Texas Press: 106.

Chapter 2

1 Semezdin Mehmedinović (2003), *Nine Alexandrias*, trans. Ammiel Alcalay, Pocket Poets Series No. 56, San Francisco, City Lights Books: 16.

2 For more on the Arab conquest and early Islamic history of Sindh and the remainder of South Asia, see André Wink (1990), *Al-Hind: The Making of the Indo-Islamic World*, Leiden, E.J. Brill.

For historiography concerning Muhammad ibn Qasim, see Manan Ahmed (2008), *The Many Histories of Muhammad Bin Qasim: Narrating the Muslim Conquest of Sindh*, PhD dissertation, University of Chicago, Chicago.

3 M.D. Zafar's *A Textbook of Pakistan Studies* claims that Pakistan 'came to be established for the first time when the Arabs under Muhammad bin Qasim occupied Sind and Multan' (quoted from Ayesha Jalal [1995], 'Conjuring Pakistan: History as Official Imagining', *International Journal of Middle East Studies* 27[1]: 79).

4 For more on the birth of Pakistan and Jinnah's role in it, see Ayesha Jalal (1985; reprint 1994), *The Sole Spokesman: Jinnah, the Muslim League and the Demand for Pakistan*, Cambridge, Cambridge University Press. Among the many books on the history of the Pakistan movement, two noteworthy ones are Stephen P. Cohen (2004), *The Idea of Pakistan*, Washington, DC, Brookings Institution; Farzana Shaikh (2009), *Making Sense of Pakistan*, New York, Columbia University Press.

5 For more on the Pakistani military and the manner in which it has infiltrated all sections of the Pakistani economy, see Ayesha Siddiqa (2007), *Military Inc.: Inside Pakistan's Military Economy*, London, Pluto Press.

6 For a study of stereotyping based on ethnicity and language in Pakistan, with special reference to the Balochis and Pushtuns, see Paul Titus (1998), 'Honor the Baloch, Buy the Pushtun: Stereotypes, Social Organization and History in Western Pakistan', *Modern Asian Studies* 32(3) July: 657–687. For historical and ethnographic writings on the Pushtuns in Pakistan and Afghanistan, see A.S. Ahmed (1980), *Pukhtun Economy and Society*, London, Routledge and Kegan Paul; (1977), *Social and Economic Change in the Tribal Areas,* Karachi, Oxford University Press; (1976), *Millennium and Charisma among Pathans*, London, Routledge and Kegan Paul; M. Bannerjee (2000), *The Pathan Unarmed: Opposition and Memory in the North West Frontier*, New Delhi, Oxford University Press. For a history of Pushtun migration, though without a specific focus on the trucking industry, see Robert Nichols (2008), *A History of Pushtun Migration, 1775–2006*, Karachi, Oxford University Press, especially the fifth and sixth chapters.

7 For more on the Ahmadiyya, see Yohann Friedmann (1989), *Prophecy Continuous: Aspects of Aḥmadī Religious Thought and its Medieval Background,* Berkeley, University of California Press.

8 The most comprehensive treatment of issues of charisma in Islamic society is in Michael A. Williams, ed. (1982), *Charisma and Sacred Biography*, Journal of the American Academy of Religion, Thematic Series, XLVIII, nos. 3 and 4. For a rich and nuanced study of devotion to saints in Pakistani society, see Katherine Pratt Ewing (1997), *Arguing Sainthood: Modernity, Psychoanalysis and Islam*, Durham, NC, Duke University Press. See also C. Lindholm (1998), 'Prophets and *Pirs*: Charismatic Islam in the Middle East and South Asia', in *Embodying Charisma: Modernity, Locality and the Performance of Emotion in Sufi Cults*, edited by P. Werbner and H. Basu, London, Routledge: 209–233; and M. Geijbels (1978), 'Aspects of the Veneration of Saints in Islam, with Special Reference to Pakistan', *Muslim World* 68: 176–186.

9 For the importance of the evil eye in cross-cultural perspective, see Edward S. Gifford Jr (1958), *The Evil Eye: Studies in the Folklore of Vision*, New York, Macmillan; Alan Dundes, ed. (1981), *The Evil Eye: A Folklore Casebook*, New York, Garland Publishing; Clarence Maloney, ed. (1976), *The Evil Eye*, New York, Columbia University Press; Amica Lykiardopoulos (1981), 'The Evil Eye: Towards an Exhaustive Study', *Folklore* 92(2): 221–230. References to the concept of the evil eye occur in passing in many anthropological studies of South Asia and the Islamic world, although there are few studies that address the phenomenon as a primary subject. For a good discussion of the subject in Egyptian society, see Gregory Starrett (1995b), 'The Political Economy of Religious Commodities in Cairo', *American Anthropologist* 97(1) March: 51–68.

10 For examples of the use of magic spells (*tawnā*) in Pakistan, see Ewing (1997), especially pp. 97–125.

11 For more on the hybridity of religious identities in the Punjab, see Harjot Oberoi (1994; reprint 1997), *The Construction of Religious Boundaries: Culture, Identity and Diversity in the Sikh Tradition*, Oxford, New York and New Delhi, Oxford University Press, especially pp. 92–203.

12 For more on Ahmad Riza Khan and the Barelvi movement, see Usha Sanyal (1999), *Devotional Islam and Politics in British India: Ahmad Riza Khan Barelwi and his Movement, 1870–1920*, New York and Delhi, Oxford University Press; and by the same author (2005), *Ahmad Riza Khan Barelwi: In the Path of the Prophet*, Oxford, Oneworld Publications.

13 For a comprehensive history of the early Deobandi school, see Barbara D. Metcalf (1982), *Islamic Revival in British India: Deoband, 1860–1900*, Princeton, NJ, Princeton University Press. For the impact of the Jami'at-e 'Ulama'-ye Islam on Pakistani politics before General Zia ul-Haq came to power, see Sayyid A.S. Pirzada (2000), *The Politics of the Jamiat Ulema-i-Islam Pakistan: 1971–1977*, Karachi, Oxford University Press.

14 Barbara D. Metcalf (2004), '"Traditionalist" Islamic Activism: Deobandis, Tablighis, and Talibs', *Islamic Contestations: Essays on Muslims in India and Pakistan*, New Delhi, Oxford University Press: 278.

15 Metcalf (2004): 275ff.

16 The best prospect one has of securing a job coming out of a *madrasa* is if one possesses a degree in Arabic, with the consequence that individuals who pursue a *madrasa* education out of economic concerns assert their social status through knowledge of the liturgical language of Islam (Jamal Malik [2002], 'The Mullā and the State: Dynamics of Islamic Religious Scholars and their Institutions in Contemporary Pakistan', *Islam in the Era of Globalization: Muslim Attitudes Towards Modernity and Identity*, ed. Johan Meuleman, London and New York, Routledge Curzon: 225–232). For the socially disruptive impact of such *madrasa* education on local communities, see Magnus Marsden (2005), *Living Islam: Muslim Religious Experience in Pakistan's North-West Frontier*, Cambridge, Cambridge University Press: 126ff.

17 M. Khalid Masud, ed. (2000), *Travellers in Faith*, Leiden, E.J. Brill: 11. Others have argued that the origins of the movement are a decade earlier (cf. Barbara D. Metcalf [1993], 'Living Hadith in the Tabligh-i Jamaat', *Journal of Asian Studies* 52: 584–608; Christian W. Troll [1985], 'Five Letters of Mawlana Ilyas (1885–1944)', *Islam in India: Studies and Commentaries*, ed. C.W. Troll, Delhi, Vikas. The most detailed early history of the Tablighi Jama'at is found in Yoginder Sikand (2002), *The Origins and Development of the Tablighi-Jama'at (1920–2000)*, New Delhi, Orient Longman.

18 It has become an article of faith among Pakistan's westernized elites that all *'ulama* were opposed to independence, a belief that undergirds their viewpoint that supporters of Islamization in Pakistan are fundamentally disloyal and should not have a voice in state building. In a similar vein, though with greater scholarly underpinnings for his views, Veli Reza Nasr argues that the Deobandi followers of Husayn Ahmad Madani, who initially opposed the creation of Pakistan but later found themselves in the new country, then sought to legitimize their patriotic credentials by calling for Islamization of the state, mostly through the persecution of the minority Ahmadiyya and the Shi'as (V.N. Nasr [2000], 'The Rise of Sunni Militancy in Pakistan: The Changing Role of Islamism and the Ulama in Society and Politics', *Modern Asian Studies* 34[1]: 169–180).

19 For a brief survey of radicalized religious groups, see M. Qasim Zaman (2002), *The Ulama in Contemporary Islam: Custodians of Change*, Princeton, NJ, Princeton University Press: 118ff. An encyclopedic coverage of such groups (albeit with no documentation) is found in Muhammad Amir Rana (2007), *A to Z of Jehadi Organizations in Pakistan*, trans. Saba Ansari, Lahore, Mashal.

20 For estimates on the number of dead and wounded, see the news coverage of the incident: 'Scores Killed in Pakistan Attacks', BBC News, 19 July 2007 (http://news.bbc.co.uk/2/hi/south_asia/6905808.stm); 'Lal Masjid Women, Children Also Killed: G-6 Curfew to be Lifted Today', *Dawn* 14 July 2007 (http://www.dawn.com/2007/07/14/top1.htm).

Chapter 3

1 Government of Pakistan (2009), 'Economic Survey 2008–09', Finance Division Economic Advisor's Wing, Islamabad, Pakistan: Education, Section 10.2. The share of education as a percentage of total spending was projected to fall in 2009–2010 as a result of Pakistan's weakened economic situation.

2 Statistics Division, Ministry of Economic Affairs, Government of Pakistan, Population Census Organization: Statistics – Literacy Ratio by Sex (http://www.statpak.gov.pk/depts/pco/statistics/other_tables/literacy_ratio.pdf).

3 The Pakistan Social and Living Measurement Survey (PSLM) of 2007–2008 places the overall literacy rate for citizens aged 10 and above at 56 percent (69 percent for males and 44 percent for females).

4 Census 1984, Table 4.7, p. 33, quoted from Tariq Rahman (2002), *Language, Ideology and Power: Language-learning among the Muslims of Pakistan and North India,* Karachi, Oxford University Press: 11.

5 For more on the multi-tiered system of education in Pakistan, see Tariq Rahman (2004), *Denizens of Alien Worlds: A Study of Education, Inequality and Polarization in Pakistan*, Karachi, Oxford University Press; and by the same author (2002), *Language, Ideology and Power*, especially Chapters 8 and 9. Rahman refers to the top tier of English medium schools as 'elitist' rather than 'elite' to emphasize their function in reinforcing the class privileges of the upper echelons of Pakistani society. See also Muhammad Khalid Masud (2002), 'Religious Identity and Mass Education', in *Islam in the Era of Globalization: Muslim Attitudes towards Modernity and Identity*, ed. Johan Meuleman, London and New York, Routledge Curzon: 233–245.

6 Rahman (2002): 263.

7 For more on the Punjabi elite and its role in Pakistani society, see Anita M. Weiss (1991), *Culture, Class, and Development in Pakistan: The Emergence of an Industrial Bourgeoisie in Punjab*, Boulder, CO, Westview Press.

8 Rahman (2002): 265.

9 Rahman (2002): 287.

10 Rahman (2004): 24.

11 See Rahman (2002): 293ff. for statistics on the disparities in expenditure on education in Pakistan.

12 Rahman (2002): 296. An Urdu medium boys high school in Islamabad cost Rs. 6.52 million at that time.

13 Rahman (2002): 297–298.

14 National Commission on Terrorist Attacks upon the United States (2004), *The 9/11 Commission Report*, New York, W.W. Norton: sec. 12.2, p. 367.

15 International Crisis Group, *Pakistan: Madrasahs, Extremism and the Military*, Asia Report No. 36, 29 July 2002. The report had originally claimed that 'about a third of all children in Pakistan in education attend madrasas' but this was amended in response to the research of Andrabi, Das, Khwaja and Zajonc.

16 Ahmed Rashid (2000), *Taliban: Militant Islam, Oil and Fundamentalism in Central Asia*, New Haven, CT, Yale University Press: 89.

17 The latter figure was published by C. Kraul in 'Dollars to Help Pupils in Pakistan', *Los Angeles Times*, 14 April 2003. For more on the coverage of religious education in Pakistan in major English-language newspapers, see Tahir Andrabi, Jishnu Das, Asim Ijaz Khwaja and Tristan Zajonc (2006), 'Religious School Enrollment in Pakistan: A Look at the Data', *Comparative Education Review* 50(3): 446–477, especially Appendix A, Table A1.

18 Jessica Stern (2000), 'Pakistan's Jihad Culture', *Foreign Affairs* 79(6): 115–126.

19 Andrabi et al.: 447. See also by the same authors (2010), '*Madrasa* Metrics: The Statistics and Rhetoric of Religious Enrolment in Pakistan', in *Beyond Crisis: Re-evaluating Pakistan*, edited by Naveeda Khan, Critical Asian Studies, London and Delhi, Routledge: 430–451.

20 For a list of the major organizations governing *madrasas* in Pakistan, see Rahman (2002): 18ff.

21 Andrabi et al.: 458.

22 Andrabi et al.: 459.

23 Andrabi et al.: 466.

24 Andrabi et al.: 463, italics added.

25 Andrabi et al.: 465–466. Andrabi, Das, Khwaja and Zajonc found that the higher likelihood that a 'radically Islamic' household would send their child to a *madrasa* was statistically insignificant, although they acknowledged that their method was not completely reliable: there is

no satisfactory way of measuring degrees of religiosity and religious radicalism in a society such as Pakistan.

26 Tahir Andrabi, Jishnu Das, Asim Ijaz Khwaja, Tara Vishwanath et al. (2007), *Pakistan: Learning and Educational Achievements in Punjab Schools (LEAPS): Insights to Inform the Education Policy Debate*, Final Report, February 20, 2007 (http://www.leapsproject.org/assets/publications/ LEAPS_Report_FINAL.pdf). An executive summary of this report is available (see: http:// www.leapsproject.org/assets/publications/LEAPS_Report_ExecSummary.pdf).

27 For examples of some of the most egregious misrepresentations, see Rahman (2004): 24–32. For a discussion of problems with the teaching of history in Pakistani schools in the last century, see K.K. Aziz (1993) *The Murder of History: A Critique of History Textbooks Used in Pakistan*, Lahore, Vanguard.

28 Rahman (2004): 36–40; 57–62. Not surprisingly, militaristic attitudes are more common among students at military schools than they are at elite English schools, and roughly parallel those among students at the Urdu-medium schools. There is a modest amount of scholarship analyzing the content of textbooks in Pakistan: in addition to the works mentioned already, see A.H. Nayyar and A. Salim, eds (2003), *The Subtle Subversion: The State of Curricula and Textbooks in Pakistan*, Islamabad, Sustainable Development Policy Institute; P. Hoodbhoy and A.H. Nayyar (1985), 'Rewriting the History of Pakistan', *Islam, Politics and the State*, ed. Asghar Khan, London, Zed Books: 164–177; Rubina Saigol (1995), *Knowledge and Identity: The Articulation of Gender in Educational Discourse in Pakistan*. Lahore, ASR Publications; and by the same author (2000), *Symbolic Violence: Curriculum, Pedagogy and Society*, Lahore, Society for the Advancement of Education.

Chapter 4

1 *Pakistan Transport Plan Study*, Final Report, Japan International Cooperation Agency (JICA) and National Transport Research Centre (NTRC), Ministry of Communications, Government of Pakistan, March 2006: sec. 2.2.1.

2 *Transport Plan*: Tables 2.2.4 and 2.2.5.

3 *Transport Plan*: sec. 2.2.2 (2).

4 There were 7791 km of railroad *route* in Pakistan in 2001–2; there are actually 11,515 km of railroad *track* in the country. The amount of freight carried by trains has been declining steadily, from 7769 metric tons per year in 1992–93 to 5866 tons in 2001–02 (*Pakistan Statistical Yearbook 2003*: 214ff., 223, 228; a more recent source states that 4573 tons were transported by rail in 2001–02, and that the figure had risen to 5453 by 2006–07 (Government of Pakistan [2009], 'Economic Survey 2008–09': Table 14.4, p. 211]).

5 *Transport Plan*: sec. 2.2.2 (1).

6 *Transport Plan*: Table 3.5.2.

7 This figure is down from 48 percent in 1996; the change is accounted for by a rapid increase in the number of cars. Of vehicles with two or more axles, 9 percent are buses and another 15 percent are minibuses (*Transport Plan*: Figure 2.2.6).

8 *Pakistan Transport Plan Study* (PTPS) in the Islamic Republic of Pakistan (2006): sec. 3.5.1, Figure 3.5.2, Ministry of Industries, Government of Pakistan.

9 The National Logistic Cell is a prime example of the Pakistani military's involvement in the civilian economy. Sometimes called the National Logistic Corporation, it is a highly profitable company with diversified interests on account of the preferential treatment it receives in financial arrangements, untaxed imports of trucks and other machinery, and no-bid contracts for a variety of enterprises including highway toll collection. For more on the NLC, see Siddiqa (2007).

10 John L. Hine (1989), 'Financing Pakistan's Trucking Industry', National Transport Research Centre (NTRC), Document No. NTRC-125, Government of Pakistan: 2.

11 Hine: 2.

12 *Transport Plan*: Table 3.5.3.

13 Resham Khan, tractor-trailer truck owner from Chakwal, interviewed in Turnol, August 2007.

14 Hino has a 75 percent market share of new truck and bus sales in Pakistan. They also sell a smaller 4909cc truck for Rs. 1.2 million; this vehicle has a load capacity of 10 tons, is modified to carry 15 tons, and is popular for local use in urban areas (interview with Tayyib Nawaz Malik, Sales Manager, Hino Islamabad, Turnol, August 2007). In December 2003, Mr Nasir Ud Din and Haji Shahzada of Kohistan Goods Forwarding Agency, Taxila, both quoted the price of a Hino truck as Rs. 2.5 million, delivered; the difference in the two prices is accounted for by taxes and registration fees.

15 Mazhar Ali Khan, owner of three Hinos, interviewed in Turnol, December 2003.

16 These are 2007 costs, which were up by between 10 and 20 percent across the board from the costs reported in 2003. At that time, the truck in Plates 31 and 32 was purchased for Rs. 750,000, and an additional Rs. 150,000 was spent on building it up and decorating it (interviews with Raja Muneer Hussein, owner, and Haji Noor Alam, master painter, Rawat, December 2003). In 2001, the figures quoted for building and decoration were between Rs. 100,000 and Rs. 135,000 in the Rawalpindi area (Sartaj Khan of Islamuddin and Sartaj Painters, Pir Wadhai, Rawalpindi and Muhammad Yunus of Yunus Brothers *Likhāivālē*, Carriage Factory Road, Rawalpindi, both interviewed August 2001).

17 *Transport Plan*: Figure 2.2.8.

18 *Transport Plan*: sec. 2.2.2 (6). Bedford Rockets have a design capacity to carry 7 tons, but they are almost always modified to carry 11 tons. Similarly, two-axle Japanese diesels designed to carry 12 tons are made to carry 16 tons (Hine: 3).

Chapter 5

1 'Booming Japanese Yen Triggering Car Prices', *Pakistan Observer* 18 December 2008 (http://pakobserver.net/200812/18/news/topstories07.asp). Upper-level government and private sector jobs frequently provide an automobile as part of an individual's package of benefits which would suggest that the number of actual households with cars is higher than the ownership rate implies. However, the majority of households that have access to a car through an employer also have a privately owned car of their own.

2 Population Census 1998, Population Census Organization, Statistics Division, Ministry of Economic Affairs and Statistics, Government of Pakistan (http://www.statpak.gov.pk/depts/pco/index.html).

3 There is no scholarship on the role of the automobile as a class marker or symbol of modernization in Pakistani society. For information on the topic in another former European colony with a large Muslim population (Lebanon), see Akram Zaatari, ed. (1999), *The Vehicle: Picturing Moments of Transition in a Modernizing Society/Al-markaba: taswīr lahzāt al-intiqāl wa'l-tahawwul fī mujtamiʿ al-hadātha*, Beirut, Arab Image Foundation.

4 Interviews conducted over the course of December 2003 at the head office of Kohistan Goods Forwarding Agency in Taxila with the Director Mr Nasir Ud Din, and his assistant manager and elder cousin, Haji Shahzada.

5 Interviews with Malik George Zaman and Malik Shafique, Taxila, December 2003. I was introduced to Zaman by Haji Shahzada of Kohistan Goods, and the dynamics of the introduction colored my subsequent conversations with him. Zaman continued to try and impress me with the way in which his aesthetics were more refined than those of his drivers, despite the fact that he was clearly on very good terms with Malik Shafique, a second-generation truck painter in Taxila who did all Zaman's decorating. It is possible that there was some truth to Zaman's assertions concerning his lack of interest in truck decoration relative to that of his drivers: Zaman is Christian and, in light of the precarious position of non-Muslims in Pakistani society, cannot be free to decorate his vehicles with Christian iconography. As such, it makes complete sense that the specific content of some of the most important decorative elements would not be of his choosing.

6 Interviews with Mazhar Ali Khan, conducted in Turnol in December 2003.

7 Hine: 5.

8 Interviewed at Sabzi Mandi, Rawalpindi, 15 December 2003.

9 Interviewed in Turnol, August 2007.

10 My analysis takes as a premise that the choice of what truck to purchase is ultimately an economic decision. It is very likely that, on occasion, other factors go into the decision-making process (such as windfall opportunities, assumption of family obligations, etc). It is also conceivable that more complex choices such as those involved in the purchase of automobiles might play a part. However, I proceed from the assumption that truck ownership and truck driving are first and foremost means of generating wealth, and that other questions, such as personal preferences in truck models, colors, or decorative choices play secondary roles.

11 Hine: 5ff.

12 Schmid: 70ff.

13 Dutreux: 33ff.

14 Lefebvre (1989).

15 Sohail Agha (2000), 'Potential for HIV Transmission among Truck Drivers in Pakistan', *AIDS* 14, October: 2404–2406 (http://journals.lww.com/aidsonline/Fulltext/2000/10200/Potential_for_HIV_transmission_among_truck_drivers.24.aspx).

16 In September 2008, under a newly elected government, the police in Karachi attempted to (re)inforce the Provincial Motor Vehicles (Amendment) Ordinance 2008 passed by the previous government in March of that year. It was only in force for a day before the ordinance was suspended under pressure from the transportation unions. The Deputy Inspector General of Police in charge of traffic, Wajid Ali Durrani, insisted that it had been extremely effective in curbing violations by all forms of traffic. Opposing the ordinance, Irshad Bukhari, President of the Karachi Transport Ittehad (a union), threatened a ten-day strike if the ordinance was enforced against trucks. Clearly placing the entire responsibility of traffic problems on the police and the truck drivers, he declared: 'The traffic police take heavy bribe[s] from us and they also blackmail us for minting money … We are innocent as [sic] we have to pay the price of the drivers' mistake. The traffic police should take money out of the pocket of the driver but we have to face the loss at the end of the day' ('Traffic Police Department Determined to Re-inforce Ordinance to Curb Traffic Violations' *Regional Times* 25 September 2008 [http://regionaltimes.com/25sep2008/metrokarachinews/traffic.htm]).

17 See, for example, 'Truckers' Strike Cripples Business at Pakistan Port', Reuters 23 August 2008 (http://www.reuters.com/articlePrint?articleId=USISL28291320080823).

18 Rashid: 22ff.

Chapter 6

1 Gell (1998): 74.

2 Hasan-Uddin Khan distinguishes between only four different specialized crafts, the carriage maker, painter, calligrapher, and glass decorator (187–188); Rich and Khan expand the list to nine specialists (263).

3 Dutreux, following H. Khan (1975: 186), claims that the master–disciple relationship follows familial lines and that crafts remain within families (Dutreux: 36). This not only contradicts my findings but also those of Rich and Khan, whose fieldwork was carried out only shortly after that of Dutreux.

4 There is an untenable and unsubstantiated tradition that gives credit for the entire phenomenon of Pakistani truck decoration to one man, a certain Haji Hussein. According to this account Hussein was 'a court artist from the palaces of Kutch Bujh who, unable to find many palaces in the new Pakistan, was decorating horse carriages in Karachi. He added painted elements which grew into the elaborately painted trucks [sic] we are familiar with today. All trucks have to come to Karachi, the main port of Pakistan. Soon Haji Hussain had students, or *shagirds* who spread the practice to other cities, each city adding its own style' (Durriya Kazi, 'Dreaming' [http://www.pakistanifilmfest.com/hee0405_article_dreaming.html]; see also by the same

author [2002], 'The Spirited Act of Truck Decoration', *City* 1, July, Karachi, City Press, 67–74).

5 There is evidence from fieldwork in rural Egypt that misfortune normally strikes means of livelihood such as farm animals and capital equipment (Amitav Ghosh [1983)], 'The Relations of Envy in an Egyptian Village', *Ethnology* 22: 211–224). There is no equivalent study for Pakistan, although anthropological research in that country suggests similar attitudes with the additional belief that misfortune can also strike offspring (Ewing [1997]).

6 For an excellent study of the social role of images in India, which has many cultural similarities to Pakistan, see Christopher Pinney (2004), '*Photos of the Gods': The Printed Image and Political Struggle in India*, London, Reaktion Books. The political role of graphic art in relevant contexts is explored in Peter J. Chelkowski and Hamid Dabashi (1999), *Staging a Revolution: The Art of Persuasion in the Islamic Republic of Iran*, New York, New York University Press.

7 Much has been written about the religious propriety of portraiture in Islamic societies. In brief, there is no one attitude toward portraiture that applies accurately to all Muslim societies across time. The majority of Pakistani (as well as Afghani and other South Asian) Muslims have an aversion to the production and display of portraits of major religious figures. For some proportion of the population this aversion carries into portraits of lesser religious figures and, much less frequently, of ordinary people such as family members or tribal and national heroes. Nonetheless, chromolithographs of famous Sufi saints are widely available at shrines all across the country. In many ways, their religious function is similar to that of figural religious art in American Protestantism. Furthermore, the majority of Pakistani men one encounters are eager to have their pictures taken (women are frequently keen to be photographed as well but are shy because of deeply ingrained notions of female modesty). As far as I am aware, there is no research on the changes in attitudes toward portraiture since the advent of photography in Pakistan or any similar Islamic society. For more on portraiture in Pakistani popular art, see Jürgen W. Frembgen (1998), 'Saints in Modern Devotional Poster-portraits: Meanings and Uses of Popular Religious Folk Art in Pakistan', *RES* 34: 183–191; and Pierre Centlivres and Micheline Centlivres-Demont (1997), *Imageries populaires en Islam*, Geneva, Georg Editeur. For recent work relating to the question of portraiture in Islamic society see, among other works, Priscilla Soucek (2000), 'The Theory and Practice of Portraiture in the Persian Tradition', *Muqarnas* 17: 97–108; Gilbert Beaugé and Jean-François Clément, eds. (1995), *L'image dans le monde arabe*, Paris: CNRS; as well as the pioneering work of Oleg Grabar (1973), *The Formation of Islamic Art*, New Haven, CT, Yale University Press. For an introduction to the role of religious images in American Protestantism, see David Morgan (1998), *Visual Piety: A History and Theory of Popular Religious Images*, Berkeley, University of California Press, and R.B. St George (1998), *Conversing by Signs: Poetics of Implication in Colonial New England*, Chapel Hill, University of North Carolina Press. The analogy between visual piety in Protestant Christianity and Islam, albeit in a context far removed from that of Pakistan, is drawn in Mary N. Roberts and Allen F. Roberts (2000), 'Displaying Secrets: Visual Piety in Senegal', in *Visuality Before and Beyond the Renaissance*, ed. Robert Nelson, New York, Cambridge University Press: 224–251.

Chapter 7

1 Dutreux: 47ff.

2 For a discussion of the various woods used in truck construction in Afghanistan in the 1970s, see Dutreux: 52ff. She relies on the earlier work of Centlivres-Demont, who claimed that the *nishtar* pine was felled in the area of Gardez and the *shisham* in Jalalabad (both places border Pakistan). Centlivres-Demont also records seeing much more walnut during her research in Afghanistan over a quarter of a century ago than one encounters in Pakistan today, not surprisingly given the difference in overall climate between the two countries and the ongoing and extensive deforestation. (Micheline Centlivres-Demont [1976a], *Popular Art in Afghanistan: Paintings on Trucks, Mosques and Tea-houses*, trans. Robin R. Charleston, Graz, Akademissche Druck: 17; Dutreux: 51–52).

3 The narrower specialization in interior as opposed to exterior truck decoration is not a new phenomenon. According to Dutreux (44), the interiors of trucks in Afghanistan were made in Pakistan.

4 According stable meanings to symbols is a frustrating, if not impossible task, and there is no reliable work on this subject dealing with an Islamic society. For a good discussion of religion and symbols in general, see Mary Douglas (1970; 2nd edn, 1982), *Natural Symbols: Explorations in Cosmology*, New York, Pantheon Books. An unsatisfactory attempt at defining 'Islamic' symbols is made in Malek Chebel (1995), *Dictionnaire des symboles musulmans*, Paris, Albin Michel.

5 In this, I am following Barthes, who pondered the linguistic qualities of images on several occasions: 'We know that linguists refuse the status of language to all communication by analogy – from the "language" of bees to the "language" of gesture – the moment such communications are not doubly articulated, are not founded on a combinatory system of digital units as phonemes are. Nor are linguists the only ones to be suspicious as to the linguistic nature of the image; general opinion too has a vague conception of the image as an area of resistance to meaning – this in the name of a certain mythical idea of Life: the image is re-presentation, which is to say ultimately resurrection, and, as we know, the intelligible is reputed antipathetic to lived experience. Thus from both sides the image is felt to be weak in respect of meaning: there are those who think that the image is an extremely rudimentary system in comparison with language and those who think that signification cannot exhaust the image's ineffable richness' (Roland Barthes [1977], 'Rhetoric of the Image', in *Image-Music-Text*, trans. Stephen Heath, New York, Hill and Wang: 32). I would, however, go one step further than understanding trucks and truck decoration as a linguistic system containable within a dichotomy of image and text, or even a dialectic between the two. As I try to illustrate throughout this book, individual and collective dispositions – the naturalization of belief and attitudes captured in the notion of *habitus* – that are expressed and shaped through notions of class, *nazar*, *barkat* and other things, provides a semiological dimension that transcends the purely linguistic. As such, it is better to think in terms of a 'language *plus*' model, one which has been developed brilliantly by Alfred Gell, especially in his book *Art and Agency*.

6 The most erudite theoretical discussion of the concept of ornament as a mediator of meaning in the Islamic context is found in Oleg Grabar (1992*), The Mediation of Ornament*, Bollingen Series, no. 38, Princeton, NJ, Princeton University Press. John Renard has attempted to develop Grabar's ideas and apply them to architectural themes in ornamentation in a comparative religious context (John Renard [2001], 'Picturing Holy Places: On the Uses of Architectural Themes in Ornament and Icon', *Religion and the Arts*, 5[4]: 399–428). My own distinction between ornament and decoration contradicts theirs in some fundamental ways. For more on ornament in the visual arts, see James Trilling (2003), *Ornament: A Modern Perspective*, Seattle, University of Washington Press.

7 *Nīlam* is the name of the Sapphire Fairy in a popular tale, a river in Kashmir, and a retired Indian actress, all of which are likely to be evoked by the reading of this couplet.

8 Gregory Starrett (1995), 'The Political Economy of Religious Commodities in Cairo', *Anthropologist* 97(1) March: 58.

9 David Chidester (1992), *Word and Light: Seeing, Hearing, and Religious Discourse*, Urbana, University of Illinois Press: 1. I do not see the truckers' refusal to admit to any great significance in the choice of design as truly representative of their beliefs in this regard, but as an unavoidable and limiting aspect of fieldwork. It is common in ethnographic interviews in many societies for individuals to resist giving researchers answers they believe the researchers do not want to hear. Furthermore, as already described in Chapters 3 and 5, Pakistani society has strict class distinctions in which truckers are likely to see a member of the urban, Western-educated class (which I represent to them) as disapproving of their tastes in several registers: as coarse, backward, and superstitious. It is not surprising, therefore, that they actively choose to underemphasize tastes and beliefs that they presume would make me, as the interviewer, look at them less favorably.

10 Margaret Miles (1985), *Image as Insight: Visual Understanding in Western Christianity and Secular Culture*, Boston, Beacon Press: 34.

11 Nelson Goodman (1976), *Languages of Art: An Approach to a Theory of Symbols*, 2nd edn, Indianapolis, Hackett Publishing: 68.

12 Interview with Abdullah Khan Achakzai Alizai, Turnol, August 2006.

13 The writing on the panel above reads: 'The game of fate will be decided at the destination' (*manzil par hōgā fēsla qismat kē khēl kā*).

14 The semiology of the behind is an important topic awaiting serious study. There are numerous publications on buttocks and behinds, but very few works make even the most limited attempt to discuss the signification of the behind, and none that I am aware of compare it to the face (cf. H. Mérou and G.P. Fouskoudis [1982], *La fanny et l'imagerie populaire*, Grenoble, Terre et mer; and J.L. Hennig [1995], *Brève histoire des fesses*, Cadeilhan, France: Zulma, translated into English as *The Rear View: A Brief and Elegant History of Bottoms through the Ages*, London, Souvenir Press).

Chapter 8

1 Paul Ricoeur (1974), 'The Question of the Subject: The Challenge of Semiology', trans. Kathleen McLaughlin, in *The Conflict of Interpretations: Essays in Hermeneutics*, ed. Don Ihde, Evanston, IL, Northwestern University Press: 254.

2 It is possible that this name is a reference to yet another Sufi shrine, Lāhūt-e Lāmakān, from Lasbela in Baluchistan. There is a shrine near that of Lāhūt-e Lāmakān of a saint named Bilal Nurani, who could be the same as the Sakhi Bilawal Nurani invoked on the truck.

3 The pen and tablet refer to the divine pen with which God wrote the Qur'an on a protected divine tablet (*al-lawh al-mahfūz*) where it remains as the eternal word of God.

4 For representations of the pigeon in popular art in Pakistan, see P. Centlivres and M. Centlivres-Demont (1997), *Imageries populaires en Islam*, Geneva, Georg Editeur. In certain Islamic contexts there is a connection between the pigeon (or dove) and the archangel Gabriel – mirroring the Christian connection between doves and the Holy Spirit, although I have never heard this explicitly mentioned in Pakistan. The connection with Gabriel in West Africa is made in A.F. Roberts and M. Nooter Roberts (2003), *A Saint in the City: Sufi Arts of Urban Senegal*, Los Angeles, UCLA Fowler Museum of Cultural History. Doves appear frequently on the front of trucks in Bangladesh, which has a visual regime distinct from that of Pakistan, despite their shared history.

5 In a strict sense, none of the signifiers on a truck are unrelated to a notion of place. In this discussion I am limiting myself to relatively narrow geographical and social notions of implacement. For more on the concept of place, see Edward S. Casey (1997), *The Fate of Place: A Philosophical History*, Berkeley, University of California Press; as well as the chapter on place memory in Casey (1987), *Remembering: A Phenomenological Study*, Bloomington, Indiana University Press: 181–215.

6 The medallions on the outside of the bumper carry the popular wish 'Come safely, go safely' (*khayr nāl ā khayr nāl jā*), and the text at the bottom of the truck, immediately below the registration number, says 'God willing, may you be well' (*shallāh tērī khayr hōvē*).

7 M. Rafique body maker, Dilbar *shōmēkar* (decorator), and Yasin motor mechanic, all of Jhang Road, Faisalabad.

8 M. Niaz Brothers Painters, Jhang Road, Faisalabad, Saudi Auto Electrician Faisalabad, Lala Tariq Frame Maker, Jhang Road, Faisalabad, Akram Abid *poshishmēkar* (upholsterer).

9 The tailgate also says 'Speed limit 50 km per hour' and 'Model 2003'. The mud-flaps advertise the names of the owners (Rana Brothers). The name of the truck, Gojra Coach, appears on a plaque directly below the registration plate, and the name of a transportation company (New Karachi Goods, Matta Swat) directly above it.

Chapter 9

1 W.J.T. Mitchell (1994), *Picture Theory*, Chicago, University of Chicago Press: 16.

2 There is a wide variety of literature on Muhammad's ascension (*mi'rāj*): for its treatment in Sufism, see Frederick S. Colby (2002), 'The Subtleties of the Ascension: al-Sulamī on the Mi'rāj of the Prophet Muhammad', *Studia Islamica* 94: 167–183; James W. Morris (1987), 'The Spiritual Ascension: Ibn 'Arabī and the Mi'rāj', *Journal of the American Oriental Society* 107(4) October–December: 629–652 and 108(1) January–March 1988: 63–77. For the *mi'rāj* in Islamic art, see Christiane Gruber (2003), 'L'Ascension (*Mi'rāj*) du Prophète Mohammed dans la peinture et la littérature islamique', *Luqman* 39(1) fall–winter: 55–79; and by the same author (2010), *The Ilkhanid Book of Ascension: A Persian-Sunni Devotional Tale*, London, I.B. Tauris. For the significance of the Dome of the Rock in early Islamic history, see Oleg Grabar (1959), 'The Umayyad Dome of the Rock in Jerusalem', *Ars Orientalis* 3: 33–62; Nasser Rabbat (1989), 'The Meaning of the Umayyad Dome of the Rock', *Muqarnas* 6: 12–21; and by the same author (1993), 'The Dome of the Rock Revisited: Some Remarks on Al-Wasiti's Accounts', *Muqarnas* 10, Essays in Honor of Oleg Grabar: 67–75.

3 The red panel at the bottom of the truck has the following verses written right to left:

Who has seen tomorrow, so why should we waste today?
In those moments when we cannot smile, why should we cry?
(*kal kā din kis nē dēkhā hē āj kā din ham khōēṇ kyūṇ*
jin ghaṛiyōṇ mēṇ haṇs nahīṇ saktē un ghaṛiyōṇ mēṇ rōēṇ kyūṇ)

Come or don't come, as you please – I will keep hoping;
Keep hiding a hurricane in eyes that thirst to see you.
(*tū āy na āy tērī khushī ham ās lagāy bēṭhē hēṇ*
dīd kī pyāsī āṇkhōṇ mēṇ tūfān chupāy bēṭhē hēṇ)

Stay happy with your own thing, don't go to someone else's home;
But whoever bothers you, set fire to their home.
(*mast rē [sic] apnī mastī mēṇ na jā kisī kī bastī mēṇ*
jo chēṛē tērī hastī kō āg lagā dē uskī bastī kō)

4 The big panel with a coat of arms on the truck in Plate 74 has the name of the company: 'Prince Haji Aslam Khan Goods Transport, Karachi'. Above it is the aphorism 'It is all Your grace, O Lord, that things are going as well as they are' (*sab tumhārā karam hē āqā ke bāt abtak banī hūī hē*).

5 Dutreux: 166.

6 Wirali is a tribal name from the Mianwali region of the northern Punjab; the truck itself is done in the Dera Ghazi Khan style from further south along the Indus. The writing on the windshield says 'O Allah!' and 'O Muhammad!' toward the outside, as well as the formulas 'There is no god but You, may You be glorified!' (*lā ilāha illā anta subhānaka*) and 'Indeed I am one of the sinners' (*innī kuntu min az-zālimīn*).

7 The roses on either side of the eyes say 'O Allah!' and 'O Muhammad!' The blue panels on either end of the *Ma'shallah* advertise the name of the body maker (M. Iqbal Islam of Khushab). The red band on either side of these plaques says 'How Amazing, the name of God!' (*vāh vāh nām-e khudā*), and 'It is all Your grace, O Lord, that things are going as well as they are' (*ye sab tērā karam hē āqā ke bāt abtak banī hūī hē*).

8 The remaining epigraphy on the back of the vehicle advertises the owners and builders: Abu Faisal Goods, Company Mor, Wah and Khwaja Stone Crushers, Carriage Contractor, Margallah. The spray painters are Zubayr Brothers from Taxila and the fine painters (*likhāī vālā*) are Tariq Salim Brothers of Rawalpindi, a respected painter of dump trucks.

9 The body painter is different in this instance: Sarfaraz Khan of Gujar Market, Taxila. The owner is Malik Taj, also of Taxila.

10 For more on the commemoration of Husayn's martyrdom in Pakistan, see Vernon J. Schubel (1993), *Religious Performance in Contemporary Islam: Shi'i Devotional Rituals in South Asia*,

Columbia, University of South Carolina Press. There are a number of scholarly works and video recordings documenting Muharram rituals in different societies (for Iran, see Peter J. Chelkowski, ed. [1979], *Ta'ziyeh: Ritual and Drama in Iran*, New York, New York University Press).

11 The remaining epigraphy advertises the owners (Pindi Karvan Goods, Margallah, Head Office Rawalpindi), Tariq Salim fine painters (*likhāī vālē*) Rawalpindi, and Zubayr Brothers Spray Painters, Taxila. The four stickers advertise petroleum and security companies.

12 The circular medallions on either side of the horse in Plate 84 advertise the body painter and fine art painters of the truck: Tariq Salim Brothers on the left, and Zubayr Brothers Spray Painters, Taxila, on the right. The writing in Plate 85 also advertises Tariq Salim but a different spray-painting shop, Shakil and Khalil of G.T. Road, Taxila.

13 Both the body painting and artwork are by Javed Brothers of Railway Workshop, Rawalpindi. A couplet appears above the horse:

Life has two realms, one this realm, one the other;
The distance between the two is just one breath.
(*zindagi kē hēṇ dō jahāṇ ik ye jahāṇ ik vō jahāṇ*
in dōnōṇ kē darmiyān bas fāsla ik sāṇs kā)

The panel with the eyes below the horse says 'Look, but with love!' (*dēkh magar pyār sē*) and 'Sweetheart! Pray for me!' (*sājan du'ā karnā*); and the bottom panel has the sobriquet 'Amin the Stranger' (*pardēsī*).

14 The blue medallion at the bottom of the large panel with the flag contains a name (Gul Farooq). The bottom of the truck back advertises the name of the company that owns the vehicle: Ejaz and Company Building Material Suppliers, Haripur.

15 The name 'Major Raja Aziz Bhatti' appears in the medallions on either side of his portrait, with the title '*shahīd*' (martyr) after the name. The two smaller medallions on either side advertise the name of the vehicle: 'Rajput Flyer' (*tayyāra*) and the fine artist (*likhāi vāla*) who worked on the truck, Haji Awrangzeb. The writing on the bottom advertises the spray painters, Haji Nur Alam and Sons of Rawat (east of Islamabad). The numbers on the far left and right indicate the order in which the planks are supposed to be placed for the artwork to appear correctly. This truck serves as a fine example of *gulkārī* flower painting.

16 The bottom of the painting advertises the painters, Haji Faqir Muhammad and Sons and Muhammad Ayyaz of Kohat Road, Peshawar. The name of the truck, 'Tariq Flyer' (*tayyāra*), appears on either side of Captain Sher Khan's head.

17 Iftikhar Dadi (2009), 'Ghostly Sufis and Ornamental Shadows: Spectral Visualities in Karachi's Public Sphere', *Comparing Cities: The Middle East and South Asia*, ed. Martina Rieker and Kamran Ali, Oxford, Oxford University Press: 159–193.

18 For more on the importance of Pakistan's nuclear weapons program in the national imagination, see Itty Abraham, ed. (2009), *South Asian Culture of the Bomb: Atomic Publics and the State in India and Pakistan*, Bloomington, Indiana University Press.

19 The plaque at the top of the back has the truck's name, 'Adil Star' (*sitāra 'ādil*). Below that is 'Model 2007', for the year the coachwork was completed. At the base of the portrait is the subject's name, 'Nawab Tehmur [sic] Shah Jogezai' and, in smaller writing below, the name of the painters: Haji Akmal Javed, Ismat Nur and Wazir Amjad of Dera Ghazi Khan.

20 The epigraphy on the portrait states the name of the subject (The Honorable Mahmud Khan Achakzai), identifies the artwork as 'Model 2006', painted by Ni'matullah Afghan at the request of Saidullah. The body painting is by Amir Shahid of Rawalpindi. Also note the prominent use of wristwatches as signs of modernity in Plates 95 and 90.

21 Jain: 319.

Chapter 10

1 Arthur C. Danto (1981), *The Transfiguration of the Commonplace: A Philosophy of Art*, Cambridge Massachusetts, Harvard University Press: 95.

2 Schmid: 9.
3 Personal communications from David Alesworth (1999 and 2003) and Iftikhar Dadi (2006 through 2009).
4 Descriptive caption of a postcard of 'Heart Mahal', 1999.
5 See: http://www.visualarts.qld.gov.au/linesofdescent/works/kazi.html# (upper case lettering in the original).
6 Artwork descriptions, The Third Asia-Pacific Triennial of Contemporary Art, The Queensland Art Gallery, 9 September 1999 –26 January 2000 (http://www.apt3.net/apt3/artists/artist_bios/durriya_kazi_a.htm).
7 Artwork descriptions, The Third Asia-Pacific Triennial of Contemporary Art, The Queensland Art Gallery, 9 September 1999 –26 January 2000 (http://www.apt3.net/apt3/artists/artist_bios/durriya_kazi_a.htm).
8 For more on the entry of Aboriginal artists into a mainstream art market, see Fred R. Myers (2002), *Painting Culture: The Making of an Aboriginal High Art*, Durham, NC, Duke University Press.
9 'Pak Truck Art Exhibition at Indian Art Gallery', *Deccan Herald* 6 December 2007 (http://www.deccanherald.com/Content/Sep62007/scro112007090623716.asp?section=scrollingnews).
10 Zarminae Ansari, 'Bringing Pakistan's Truck Art into Your Living Room! Anjum Rana's Personal Journey' (http://www.pakistanifilmfest.com/hee0405_article_AnjumRana.htm; punctuation errors are from the original). Rana has held such entrepreneurial exhibitions in Pakistan as well. The press coverage from one such event held in Lahore in 2004 reads: 'An exhibition titled "Tribal Truck Art" commenced at the Alliance Française de Lahore on Saturday. The exhibition is unique since it displays truck paintings on various household items. Over 100 objects were on display including wooden boxes, stools, chairs, benches, wall hanging carts, lanterns, lamps, mirrors, buckets and kettles' ('Tribal Truck Art – Ridiculed but Unique', *Daily Times* 21 November 2004 [http://www.dailytimes.com.pk/default.asp?page=story_21–11–2004_pg7_21]).
11 Personal communication from Anjum Rana, Karachi, December 2003.
12 García Canclini (1995): 42.
13 García Canclini (1995): 136.
14 García Canclini (1993): 76.
15 'Cultural power plays a key role between [classes]: (1) it imposes ideological-cultural norms that prepare members of society for an arbitrary economic and political structure (arbitrary in the sense that there are no biological, social or "spiritual" reasons, derived from a supposedly "human nature" or "order of things," which makes a particular social structure necessary); (2) it legitimates the dominant structure, which is seen as *the* "natural" form of social organization and thus conceals its arbitrariness; and (3) it also covers up the violence involved in the assimilation of individuals to structures set up without their participation and makes the imposition of such structures appear as the level of socialization or assimilation necessary to live in society (and not in a preconceived society). Thus, cultural power not only reproduces sociocultural arbitrariness but also represents such arbitrariness as necessary and natural; it conceals economic power and aids the exercise and perpetuation of such power' (García Canclini [1993]: 15).
16 Garía Canclini (1993): 43.
17 On the history of art schools in colonial South Asia, see Tapati Guha-Thakurta (2004), *Monuments, Objects, Histories: Institutions of Art in Colonial and Postcolonial India*, Ranikhet, Permanent Black, especially the second chapter.
18 Arindam Dutta (2007), *The Bureaucracy of Beauty: Design in the Age of its Global Reproducibility*, New York and London, Routledge: 2. To date, the DSA remains the largest bureaucracy ever to claim and exert authority over questions of material culture in a way that has a direct bearing on economic and political policy (34).
19 Dutta: 4.
20 Dutta: 247.

21 For more on the early history of the National College of Arts, see Nadeem O. Tarar, Samina Choonara and Tahir Mahmood (2003), *'Official' Chronicle of Mayo School of Art: Formative Years under J.L. Kipling (1874–1894)*, Lahore, National College of Arts; Nadeem O. Tarar (2008), 'Aesthetic Modernism in the Post-colony: The Making of a National College of Art in Pakistan (1950s–60s)', *International Journal of Art and Design Education* 27(3) October: 332–345; Sherezade Alam (1975), 'The NCA through Time', *The Herald* (Karachi) 7(6) June: 12–17.

22 'National College of Arts: Introduction' (http://www.nca.edu.pk/intro.htm, last visited February 10, 2009).

23 For an example of the attempts to reconcile truck decoration with the world of fine arts, see M. Imran Qureshi and Naazish Ata-Ullah (2009), 'The Semiotics of the Nation's Icons: The Art of Truck and Miniature Painting', in *Mazaar, Bazaar: Design and Visual Culture in Pakistan*, edited by Saima Zaidi, Karachi, Oxford University Press: 22–35.

24 Mark Kenoyer (2003), 'Truck Painting', unpublished paper.

25 Project report submitted by Mark Kenoyer to the Center for Folklife and Culture Heritage, Smithsonian Institution (courtesy of Richard Kennedy and Mark Kenoyer).

26 'Smithsonian Folklife Festival', Smithsonian Center for Folklife and Cultural Heritage (http://www.folklife.si.edu/center/festival.html).

27 Richard Kennedy (2002), *The Silk Road: Connecting Cultures, Creating Trust*, 2002 Smithsonian Folklife Festival, Washington, Smithsonian Institution: 14.

28 Lawrence M. Small, 'The Silk Road on the Mall': 6; Yo-Yo Ma, 'A Journey of Discovery': 7; Luis Montreal, 'The Silk Road Today': 8–9; Richard Kurin and Diana Parker, 'The Festival and the Transnational Production of Culture': 10–11; all of these are in *The Silk Road: Connecting Cultures, Creating Trust* (2002), Smithsonian Folklife Festival, Washington, Smithsonian Institution.

29 Colin L. Powell, 'Remarks at the Opening of the Silk Road Festival', 26 June 2002, Speeches and Remarks, Former Secretary of State Colin L. Powell, US Department of State (http://www.state.gov/secretary/former/powell/remarks/2002/11453.htm).

Appendix

1 PARCO: Pak-Arab Refinery Ltd (1999), *Pappū yār tang na kar: chaltī phirtī 'avāmī shā'irī*, Karachi, PARCO; and vol. 2 (2001), *Ghālib kē uṛēṇgē purzē*.

Bibliography

Abraham, Itty, ed. (2009). *South Asian Culture of the Bomb: Atomic Publics and the State in India and Pakistan*. Bloomington, IN, Indiana University Press.

Ahmed, A.S. and D.M. Hart (1984). *Islam in Tribal Societies: From the Atlas to the Indus*. London, Routledge and Kegan Paul.

Ahmed, Rafiuddin (1994). 'Redefining Muslim Identity in South Asia: The Transformation of the Jama'at-i-Islami', in *Accounting for Fundamentalisms: The Dynamic Character of Movements*, edited by Martin E. Marty and R. Scott Appleby. Chicago, University of Chicago Press: 669–705.

Agha, Sohail (2000). 'Potential for HIV Transmission among Truck Drivers in Pakistan', *AIDS* 14, October: 2404–2406 (http://www.aidsonline.com/pt/re/aids/fulltext.00002030–200010200–00024.htm;jsessionid=JT5B6ty4PFLPx5YS8VlnnncG31Mc5HZX8zK8V2FPQvv0QyTYCTLd!1204955331!181195628!8091!-1#P26).

Ahmed, Manan (2008). *The Many Histories of Muhammad Bin Qasim: Narrating the Muslim Conquest of Sindh*, PhD dissertation, University of Chicago.

Alam, Sherezade (1975). 'The NCA through Time', *The Herald* (Karachi) 7(6) June: 12–17.

Andrabi, Tahir, Jishnu Das, Asim Ijaz Khwaja, Tara Vishwanath et al. (2007). *Pakistan: Learning and Educational Achievements in Punjab Schools (LEAPS): Insights to Inform the Education Policy Debate*, Final Report, 20 February (http://www.leapsproject.org/assets/publications/LEAPS_Report_FINAL.pdf)

Andrabi, Tahir, Jishnu Das, Asim Ijaz Khwaja and Tristan Zajonc (2006). 'Religious School Enrollment in Pakistan: A Look at the Data', *Comparative Education Review* 50(3): 446–477.

—— (2010). '*Madrasa* Metrics: The Statistics and Rhetoric of Religious Enrolment in Pakistan', in *Beyond Crisis: Re-evaluating Pakistan*, edited by Naveeda Khan, Critical Asian Studies, London and Delhi, Routledge: 430–451.

Anzieu, Didier (1989). *The Skin Ego*, trans. Chris Turner. New Haven, CT, Yale University Press.

Appadurai, Arjun (1986). 'Introduction: Commodities and the Politics of Value', in *The Social Life of Things: Commodities in Cultural Perspective*, edited by A. Appadurai. Cambridge, Cambridge University Press: 3–63.

Aziz, K.K. (1993). *The Murder of History: A Critique of History Textbooks Used in Pakistan*. Lahore: Vanguard.

Bakewell, Liza (1995). '*Bellas Artes* and *Artes Populares*: The Implications of Difference in the Mexico City Art World', in *Looking High and Low: Art and Cultural Identity*, edited by B.J. Bright and L. Bakewell. Tucson, University of Arizona Press: 19–54.

Barthes, Roland (1977; reprint 1989). 'The Death of the Author', in *Image-Music-Text*, trans. Stephen Heath. New York, Noonday Press: 142–148.

—— (1977; reprint 1989). 'Rhetoric of the Image', in *Image-Music-Text*, trans. Stephen Heath. New York, Noonday Press: 32–51.

Batool, Farida (2004). *Figure: The Popular and the Political in Pakistan*. Lahore, ASR Publications.

Baudrillard, Jean (1988). *Selected Writings*, edited by M. Poster. Stanford, Stanford University Press.

Beaugé, Gilbert and Jean-François Clément, eds (1995). *L'image dans le monde arabe*. Paris, CNRS.

Blanc, Jean-Charles (1976). *Afghan Trucks*. New York, Stonehill Publishing.

—— (1976). 'Camions afghans', *Zoom* 40: 48–53.

—— (1976). *Lastwagenkunst in Afghanistan. Bilder die fahren*. Frankfurt, Dieter Fricke.

Bourdieu, Pierre (1990). *The Logic of Practice*, trans. Richard Nice. Stanford, Stanford University Press.

—— (1993). *The Field of Cultural Production: Essays on Art and Literature*, edited by R. Johnson. New York, Columbia University Press: 215–237.

—— (1977; reprint 2006). *Outline of a Theory of Practice*, trans. Richard Nice. Cambridge, Cambridge University Press.

Bowden, Ross (2004). 'A Critique of Alfred Gell on Art and Agency', *Oceania* 74: 309–324.

Brain, James L. (1968). 'Moto Moto Tanzania: Truck and Bus Slogans in Tanzania', *Tanzania Notes and Records* 68: 95–96.

Bright, Brenda Jo (1994). *Mexican American Low Riders: An Anthropological Approach to Popular Culture*. PhD Dissertation, Rice University, Houston.

—— (1995). 'Remappings: Los Angeles Low Riders', in *Looking High and Low: Art and Cultural Identity*, edited by B.J. Bright and L. Bakewell. Tucson, University of Arizona Press: 89–123.

—— (1998). '"Heart Like a Car": Hispano/Chicano Culture in Northern New Mexico', *American Ethnologist* 25(4) November: 583–609.

—— and Liza Bakewell, eds (1995). *Looking High and Low: Art and Cultural Identity*. Tucson, University of Arizona Press.

Campbell, Shirley (2001). 'The Captivating Agency of Art: Many Ways of Seeing', *Beyond Aesthetics: Art and the Technologies of Enchantment*, edited by C. Pinney and N. Thomas. Oxford and New York, Berg: 117–135.

Campo, Juan E. (1987). 'Shrines and Talismans: Domestic Islam in the Pilgrimage Paintings of Egypt', *Journal of the American Academy of Religion* 55(2): 285–305.

Casey, Edward S. (1997). *The Fate of Place: A Philosophical History*. Berkeley, University of California Press.

—— (1987; reprint 2000). *Remembering: A Phenomenological Study*. Bloomington, Indiana University Press.

Casey, Ethan (2004). *Alive and Well in Pakistan: A Human Journey in a Dangerous Time*. London, Vision.

Centlivres, Pierre and Micheline Centlivres-Demont (1997). *Imageries populaires en Islam*. Geneva, Georg Editeur.

Centlivres-Demont, Micheline (1976). *Popular Art in Afghanistan: Paintings on Trucks, Mosques, and Tea-houses*, trans. Robin R. Charleston. Graz, Akademische Druck-u. Verlagsanstalt.

—— (1976). 'Les peintures sur camions en Afghanistan', *Afghanistan Journal* 2: 60–64.

—— (1976). *Volkunst in Afghanistan*. Graz.

—— (1994). 'Images populaires islamiques au Moyen-Orient', *Universalia*. Paris, Encyclopedia Universalis: 385–387.

Chelkowski, Peter J. and Hamid Dabashi (1999). *Staging a Revolution: The Art of Persuasion in the Islamic Republic of Iran*. New York, New York University Press.

Chidester, David (1992). *Word and Light: Seeing, Hearing, and Religious Discourse*. Urbana, University of Illinois Press.

—— (2005). *Authentic Fakes: Religion and American Popular Culture*. Berkeley, University of California Press.

Cohen, Stephen P. (2004). *The Idea of Pakistan*. Washington, DC, Brookings Institution.

Dadi, Iftikhar (2009). 'Ghostly Sufis and Ornamental Shadows: Spectral Visualities in Karachi's Public Sphere', *Comparing Cities: The Middle East and South Asia*, edited by Martina Rieker and Kamran Ali. Oxford, Oxford University Press: 159–193.

—— (2010). *Modernism and the Art of Muslim South Asia*, Islamic Civilization and Muslim Networks Series. Chapel Hill, University of North Carolina Press.

Danto, Arthur (1981). *The Transfiguration of the Commonplace*, Cambridge, MA, Harvard University Press.

Donnan, Hastings and Pnina Werbner, eds (1991). *Economy and Culture in Pakistan: Migrants and Cities in a Muslim Society*. New York, St Martin's Press.

Douglas, Mary (1970; 2nd edn 1982). *Natural Symbols: Explorations in Cosmology*. New York, Pantheon Books.

Dregni, Eric and Ruthann Godollei (2009). *Road Show: Art Cars and the Museum of the Streets*. Golden, CO: Speck Press.

Dundes, Alan, ed. (1981). *The Evil Eye: A Folklore Casebook*. New York: Garland Publishing;

Dutreux, Marie-Bénédicte (1978). *La Peinture des camions en Afghanistan*. PhD dissertation, Paris I Sorbonne, Section Arts Plastiques.

Dutta, Arindam (2007). *The Bureaucracy of Beauty: Design in the Age of its Global Reproducibility*. New York and London, Routledge.

Elias, Jamal J. (2002). 'Queens of the Road', *Art India: The Art News Magazine of India* 7(3): 20–21.

—— (2003). 'On Wings of Diesel: Spiritual Space and Religious Imagination in Pakistani Truck Decoration', *RES: Anthropology and Aesthetics* 43, spring: 187–202.

—— (2005). 'Truck Decoration and Religious Identity: Material Culture and Social Function in Pakistan', *Material Religion* 1(1) March: 48–71.

—— (2007). '(Un)Making Idolatry: From Mecca to Bamiyan', *Future Anterior: Journal of Historic Preservation, History, Theory and Criticism* 4(2) winter: 13–29.

—— (2009). 'Islam and the Devotional Image in Pakistan', in *Islam in South Asia in Practice*, edited by Barbara D. Metcalf. Princeton, NJ, Princeton University Press: 120–134.

Ewing, Katherine Pratt (1983). 'The Politics of Sufism: Redefining the Saints of Pakistan', *Journal of Asian Studies* 42(2) February: 251–268.

—— (1997). *Arguing Sainthood: Modernity, Psychoanalysis and Islam*. Durham, NC, Duke University Press.

—— (1998). 'Crossing Borders and Transgressing Boundaries: Metaphors for Negotiating Multiple Identities', *Ethos* 26(2): 262–267.

Fletcher, Roland (1989). 'The Message of Material Behavior: A Preliminary Discussion of Non-Verbal Meaning', in *The Meanings of Things: Material Culture and Symbolic Expression*, edited by I. Hodder. London, Unwin Hyman: 33–40.

Freedberg, David (1989). *The Power of Images: Studies in the History and Theory of Response*. Chicago, University of Chicago Press.

Frembgen, Jürgen W. (1998). 'Saints in Modern Devotional Poster-portraits: Meanings and Uses of Popular Religious Folk Art in Pakistan', *RES* 34, autumn: 183–191.

—— (2006). *The Friends of God: Sufi Saints in Islam – Popular Poster Art from Pakistan*. Karachi, Oxford University Press.

—— (2003). 'Wedding Chariots from Pakistan. An example of Modern Folk Art', *Münchner Beiträge Zur Völkerkunde* 8: 247–254.

237

Friedmann, Yohann (1989). *Prophecy Continuous: Aspects of Aḥmadī Religious Thought and its Medieval Background*. Berkeley, University of California Press.

Gaffney, Patrick D. (1992). 'Popular Islam', *Annals of the American Academy of Political and Social Science* 542, November: 38–51.

García Canclini, Néstor (1993; reprint 2000). *Transforming Modernity: Popular Culture in Mexico*, trans. Lidia Lozano. Austin, University of Texas Press.

—— (1995; reprint 2005). *Hybrid Cultures: Strategies for Entering and Leaving Modernity*, trans. Christopher L. Chiappari and Silvia L. López. Minneapolis, University of Minnesota Press.

Geijbels, M. (1978). 'Aspects of the Veneration of Saints in Islam, with Special Reference to Pakistan', *Muslim World* 68(3): 176–186.

Gell, Alfred (1988). 'Technology and Magic', *Anthropology Today* 4(2) April: 6–9.

—— (1992). 'The Technology of Enchantment and the Enchantment of Technology', *Anthropology, Art and Aesthetics*, edited J. Coote and A. Shelton. Oxford, Clarendon Press: 40–63.

—— (1993). *Wrapping in Images: Tattooing in Polynesia*. Oxford, Clarendon Press.

—— (1998). *Art and Agency: An Anthropological Theory*. Oxford, Clarendon Press.

—— (1999). *The Art of Anthropology: Essays and Diagrams*. London, The Athlone Press.

Ghosh, Amitav (1983). 'The Relations of Envy in an Egyptian Village', *Ethnology* 22(3) July: 211–223.

Gifford Jr, Edward S. (958). *The Evil Eye: Studies in the Folklore of Vision*. New York, Macmillan.

Glassie, Henry H. (1997). *Art and Life in Bangladesh*. Bloomington, Indiana University Press.

Goffman, Erving (1967). *Interaction Ritual: Essays on Face-to-face Behavior*. Garden City, NJ, Anchor Books.

Goodman, Nelson (1976). *Languages of Art: An Approach to a Theory of Symbols*. 2nd edn. Indianapolis, Hackett Publishing.

Government of Pakistan (1995). 'The Cultural Policy of Pakistan'. Ministry of Culture, National Commission on History and Culture, Sports and Tourism, Government of Pakistan.

—— (2006). 'Pakistan Transport Plan Study', Final Report, Japan International Cooperation Agency (JICA) and National Transport Research Centre (NTRC), Ministry of Communications, Government of Pakistan, March.

—— (2009). 'Economic Survey 2008–09'. Finance Division Economic Advisor's Wing, Islamabad, Pakistan.

Grabar, Oleg (1992). *The Mediation of Ornament*. Bollingen Series, no. 38. Princeton, NJ, Princeton University Press.

Grima, Benedicte (2004). *Secrets from the Field: An Ethnographer's Notes from North Western Pakistan*. Bloomington, IN, Author House.

Grothues, Jürgen (1990). *Automobile Kunst in Pakistan*. Suderburg, Schrader.

—— (1993). 'Lastwagen-Kunst in Pakistan', *Südasien* 8: 62.

—— (1993). 'Pakistanische Kunstwerke', *Das Deutsche Lackiererblatt* (Stuttgart) 2: 10–15.

Guha-Thakurta, Tapati (2000). 'Review: Camera Indica: The Social Life of Indian Photographs by Christopher Pinney', *Journal of Asian Studies* 59(3) August: 779–781.

—— (2004). *Monuments, Objects, Histories: Institutions of Art in Colonial and Postcolonial India*. Ranikhet, Permanent Black.

Hallet, S. (1973). 'Afghanistan's Hot Roads', *Revue Architecture Plus* (New York): 27–32.

Hanaway, William L. and Wilma Heston, eds (1996). *Studies in Pakistani Popular Culture*. Lahore, Sang-e-Meel Publications.

Hansen, Thomas Blom (2006). 'Sounds of Freedom: Music, Taxis, and Racial Imagination in Urban South Africa', *Public Culture* 18(1): 185–208.

Hennig, Jean Luc (1995). *Brève histoire des fesses*. Cadeilhan, France, Zulma; translated into English as *The Rear View: A Brief and Elegant History of Bottoms through the Ages*. London, Souvenir Press.

Hine, John L. (1989). 'Financing Pakistan's Trucking Industry'. National Transport Research Centre (NTRC), Document No. NTRC-125, Government of Pakistan.

Hirschkind, Charles (2001). 'The Ethics of Listening: Cassette-Sermon Audition in Contemporary Egypt', *American Ethnologist* 28(3): 623–649.

International Crisis Group (2002). *Pakistan: Madrasahs, Extremism and the Military*, Asia Report No. 36, 29 July.

International Republican Institute (2009). 'IRI Index: Pakistan Public Opinion Survey, March 7–30, 2009'. Washington, DC, IRI.

Jain, Kajri (2007). *Gods in the Bazaar: The Economies of Indian Calendar Art*. Durham, Duke University Press.

Jalal, Ayesha (1985; reprint 1994). *The Sole Spokesman: Jinnah, the Muslim League and the Demand for Pakistan*. Cambridge, Cambridge University Press.

—— (1995). 'Conjuring Pakistan: History as Official Imagining', *International Journal of Middle East Studies* 27(1): 73–89.

—— (2008). *Partisans of Allah: Jihad in South Asia*. Cambridge, MA, Harvard University Press.

Kalim, M. Siddiq (2001). *Studies in Pakistani Culture*. Lahore, Vanguard.

Kato, Tomoyuki (2008). *The Art Trucks of Japan*. Tokyo, Cocoro Books.

Khan, Hasan-Uddin (1975). 'Mobile Shelter in Pakistan', in *Shelter, Sign and Symbol*, edited Paul Oliver. London, Barrie and Jenkins: 183–196.

Khan, Muhammad Nawaz (2001). *Da nawe zamane ṭappe*. Peshawar, Hamza Press.

Kirkpatrick, Joanna (1984). 'The Painted Ricksha as Culture Theater', *Studies in Visual Communication* 10(3) summer: 73–85.

—— (2003). *Transports of Delight: The Ricksha Arts of Bangladesh*. CD-ROM. Bloomington, Indiana University Press.

Kraul, C. (2003). 'Dollars to Help Pupils in Pakistan', *Los Angeles Times*, 14 April.

Kreutzmann, Hermann (1989). 'The Karakorum Highway: The Impact of Road Construction on Mountain Societies', *Modern Asian Studies* 25(4): 711–736.

—— (1989). 'Der Karakorum Highway: Ein Strasse der Freundschaft?' *Pakistan*. Wuppertal: 40–45.

Landau, Paul S. and Deborah D. Kaspin, eds (2002). *Images and Empires: Visuality in Colonial and Postcolonial Africa*. Berkeley, University of California Press.

Lasnier, France (2002). *Rickshaw Art in Bangladesh*. Dhaka, Dhaka University Press.

Lefebvre, Alain (1989). 'The Decorative Truck as a Communicative Device', *Semiotica* 75(3–4): 215–227.

—— (1999). *Kinship, Honour and Money in Rural Pakistan: Subsistence Economy and the Effects of International Migration*. Richmond, Surrey, Curzon Press.

Lindholm, C. (1998). 'Prophets and *Pirs*: Charismatic Islam in the Middle East and South Asia', in *Embodying Charisma: Modernity, Locality and the Performance of Emotion in Sufi Cults*, edited by P. Werbner and H. Basu. London, Routledge: 209–233.

Long, Charles H. (1986). *Significations: Signs, Symbols, and Images in the Interpretation of Religion*. Philadelphia, Fortress Press.

Lykiardopoulos, Amica (1981). 'The Evil Eye: Towards an Exhaustive Study', *Folklore* 92(2): 221–230.

Malik, Iftikhar (2006). *Culture and Customs of Pakistan*. Customs and Cultures Series, ed. Hanchao Lu. Westport, CT, Greenwood Press.

Malik, Jamal (1996). *Colonization of Islam: Dissolution of Traditional Institutions in Pakistan*. New Delhi, Manohar.

—— (2002). 'The Mullā and the State: Dynamics of Islamic Religious Scholars and their Institutions in Contemporary Pakistan', in *Islam in the Era of Globalization: Muslim Attitudes Towards Modernity and Identity*, edited by Johan Meuleman. London and New York, Routledge Curzon: 225–232.

Marcus, George E. (1995). 'Middlebrow into Highbrow at the J. Paul Getty Trust, Los Angeles', in *Looking High and Low: Art and Cultural Identity*, edited by B.J. Bright and L. Bakewell. Tucson, University of Arizona Press: 173–198.

Marsden, Magnus (2005). *Living Islam: Muslim Religious Experience in Pakistan's North-West Frontier.* Cambridge, Cambridge University Press.

Masud, Muhammad Khalid, ed. (2000). *Travellers in Faith.* Social, Economic and Political Studies of the Middle East and Asia. Leiden, E.J. Brill.

—— (2002). 'Religious Identity and Mass Education', in *Islam in the Era of Globalization: Muslim Attitudes towards Modernity and Identity*, edited by Johan Meuleman. London and New York, Routledge Curzon: 233–245.

Mérou, H. and G.P. Fouskadis (1982). *La Fanny et l'imagerie populaire.* Grenoble, Terre et Mer.

Metcalf, Barbara D. (1982). *Islamic Revival in British India: Deoband, 1860–1900.* Princeton, NJ, Princeton University Press; reprinted (2002) New Delhi, Oxford University Press.

—— (1993). 'Living Hadith in the Tablighi Jamaat', *Journal of Asian Studies* 52(3) August: 584–608.

—— (1994). ' "Remaking Ourselves": Islamic Self-fashioning in a Global Movement of Spiritual Renewal', in *Accounting for Fundamentalism: The Dynamic Character of Movements.* edited by M. Marty and R.S. Appleby. Chicago and London, University of Chicago Press: 706–725.

—— (2004). *Islamic Contestations: Essays on Muslims in India and Pakistan.* New Delhi, Oxford University Press.

Miles, Margaret (1985). *Image as Insight: Visual Understanding in Western Christianity and Secular Culture.* Boston, Beacon Press.

Mills, Margaret (1991). *Rhetorics and Politics in Afghan Traditional Storytelling.* Philadelphia, University of Pennsylvania Press.

Moorhouse, H.F. (1991). *Driving Ambitions: An Analysis of the American Hot Rod Enthusiasm.* Manchester and New York, Manchester University Press.

Morgan, David (1998). *Visual Piety: A History and Theory of Popular Religious Images.* Berkeley, University of California Press.

Myers, Fred R. (2002). *Painting Culture: The Making of an Aboriginal High Art.* Durham, NC, Duke University Press.

Nasr, S. Vali Reza (1994). *The Vanguard of the Islamic Revolution: The Jama'at-i Islami of Pakistan.* Berkeley, University of California Press.

—— (1996). *Mawdudi and the Making of Islamic Revivalism.* New York and Oxford, Oxford University Press.

—— (2000). 'The Rise of Sunni Militancy in Pakistan: The Changing Role of Islamism and the Ulama in Society and Politics', *Modern Asian Studies* 34(1): 139–180.

National Commission on Terrorist Attacks upon the United States (2004). *The 9/11 Commission Report.* New York, W.W. Norton.

Nichols, Robert (2001). *Settling the Frontier: Land, Law, and Society in the Peshawar Valley, 1500–1900.* Karachi, Oxford University Press.

—— (2008). *A History of Pushtun Migration, 1775–2006.* Karachi, Oxford University Press.

Oberoi, Harjot (1994; reprint 1997). *The Construction of Religious Boundaries: Culture, Identity and Diversity in the Sikh Tradition.* Oxford, New York and New Delhi, Oxford University Press.

Ong, Walter (1982; reprint 1991). *Orality and Literacy: The Technologizing of the Word.* London, Routledge.

Pakistan Transport Plan Study (PTPS) in the Islamic Republic of Pakistan (2006). Ministry of Industries, Government of Pakistan.

PARCO: Pak-Arab Refinery Ltd (1999). *Pappū yār tang na kar: chaltī phirtī 'avāmī shā'irī.* Part 2 (2001). *Ghālib kē uṛēngē purzē.* Karachi, PARCO.

Pinney, Christopher (1992). 'The Iconography of Hindu Oleographs: Linear and Mythic Narrative in Popular Indian Art', *RES* 22: 33–61.

—— (1997). 'The Nation (Un)Pictured? Chromolithography and "Popular" Politics in India, 1878–1995', *Critical Inquiry* 23(4): 834–867.

—— (2001). 'Piercing the Skin of the Idol', in *Beyond Aesthetics: Art and the Technologies of Enchantment*, edited by C. Pinney and N. Thomas. Oxford and New York, Berg: 157–179.

—— (2004). *'Photos of the Gods': The Printed Image and Political Struggle in India*. London, Reaktion Books.

Petropoulos, Elias (1976). *La Voiture grecque*. Paris.

Pirzada, S.A.S. (2000). *The Politics of the Jamiat Ulema-i-Islam Pakistan, 1971–77*. Karachi, Oxford University Press.

Primiano, Leonard N. (1995). 'Vernacular Religion and the Search for Method in Religious Folklife', *Western Folklore* 54(1): 37–56.

Pritchett, Jack (1979). 'Nigerian Truck Art', *African Arts* 12(2) February: 27–31.

Pant, Pushpesh and Huma Mohsin (2005). *Food Path: Cuisine along the Grand Trunk Road from Kabul to Kolkata*. New Delhi, Lustre Press for Roli Books.

Qadeer, Muhammad A. (2006). *Pakistan: Social and Cultural Transformation in a Muslim Nation*. New York, Routledge.

Qureshi, M. Imran and Naazish Ata-Ullah (2009). 'The Semiotics of the Nation's Icons: The Art of Truck and Miniature Painting', in *Mazaar, Bazaar: Design and Visual Culture in Pakistan*, edited by Saima Zaidi, Karachi, Oxford University Press: 22–35.

Rahman, Tariq (1996). *Language and Politics in Pakistan*. Karachi, Oxford University Press.

—— (1999). *Language, Education and Culure*. Karachi, Oxford University Press.

—— (2002). *Language, Ideology and Power: Language-learning among the Muslims of Pakistan and North India*. Karachi, Oxford University Press.

—— (2004). *Denizens of Alien Worlds: A Study of Education, Inequality and Polarization in Pakistan*. Karachi, Oxford University Press.

—— (2005). 'Passports to Privilege: The English-medium Schools in Pakistan', *Peace and Democracy in South Asia* 1(1) January: 24–44.

—— (2009). 'True to Tradition', *Newsline* July: (http://www.newsline.com.pk/NewsJu12009/heritagejuly.htm).

Rana, Muhammad Amir (2007). *A to Z of Jehadi Organizations in Pakistan*, trans. Saba Ansari, foreword by Amir Mir. Lahore, Mashal.

Rashid, Ahmed (2000). *Taliban: Militant Islam, Oil and Fundamentalism in Central Asia*. New Haven, CT, Yale University Press.

Renard, John (2001). 'Picturing Holy Places: On the Uses of Architectural Themes in Ornament and Icon', *Religion and the Arts* 5(4): 399–428.

Rich, George W. and Shahid Khan (1980). 'Bedford Painting in Pakistan: The Aesthetics and Organization of an Artisan Trade', *Journal of American Folklore* 93(369): 257–275.

Ricoeur, Paul (1974). *The Conflict of Interpretations: Essays in Hermeneutics*, edited by Don Ihde. Evanston, IL, Northwestern University Press.

Roberts, Allen F. and Mary Nooter Roberts (2003). *A Saint in the City: Sufi Arts in Urban Senegal*. Los Angeles, UCLA Fowler Museum of Cultural History.

Roberts, Mary Nooter and Allen F. Roberts (2000). 'Displaying Secrets: Visual Piety in Senegal', in *Visuality Before and Beyond the Renaissance*, edited by Robert Nelson. New York, Cambridge University Press: 224–251.

Robinson, Francis (1996). 'Islam and the Impact of Print in South Asia', in *The Transmission of Knowledge in South Asia: Essays on Education, Religion, History and Politics*. Delhi, Oxford University Press.

St George, Robert B. (1998). *Conversing by Signs: Poetics of Implication in Colonial New England*. Chapel Hill, University of North Carolina Press.

Sanyal, Usha (1999). *Devotional Islam and Politics in British India: Ahmad Riza Khan Barelwi and his Movement, 1870–1920*. New York and Delhi, Oxford University Press, 1999.

—— (2005). *Ahmad Riza Khan Barelwi: In the Path of the Prophet*. Oxford, Oneworld Publications.

Schmid, Anna (1995). *Pakistan Express: Die Fliegenden Pferde vom Indus*. Hamburg, Dölling und Galitz Verlag.

Shaikh, Farzana (2009). *Making Sense of Pakistan*. New York, Columbia University Press.

Shaiq, S.M. (2007). *Dīvān-e ṭrānspōrṭ*. Karachi.

Shapiro, Ellen and Kurnal Rawat (2005). 'Fashion Plates', *Print* January–February: 58–63.

Siddiqa, Ayesha (2007). *Military Inc.: Inside Pakistan's Military Economy*. London: Pluto Press.

Sikand, Yoginder (2002). *The Origins and Development of the Tablighi-Jama'at (1920–2000)*. New Delhi, Orient Longman.

The Silk Road: Connecting Cultures, Creating Trust (2002). Smithsonian Folklife Festival. Washington, Smithsonian Institution.

Sökefeld, Martin (1997). *Ein Labyrinth von Identitäten in Nordpakistan: Zwischen Landbesitz, Religion und Kaschmir-Konflikt*. Cologne, Köppe.

—— (1998). 'On the Concept of "Ethnic Group" ', in *Karakorum-Hindukush-Himalaya: Dynamics of Change*, Part II, edited by Irmtraud Stellrecht. Pakistan-German Research Project, Culture Area Karakorum Scientific Studies, vol. 4. Cologne, Rudiger Köppe: 383–403.

—— et al. (1999). 'Debating Self, Identity, and Culture in Anthropology', *Current Anthropology* 40(4) August–October: 417–447.

Solomon, Robert C. (1991). 'On Kitsch and Sentimentality', *Journal of Aesthetics and Art Criticism* 49(1): 1–14.

Soucek, Priscilla (2000). 'The Theory and Practice of Portraiture in the Persian Tradition', *Muqarnas* 17: 97–108.

Starrett, Gregory (1995). 'Signposts along the Road: Monumental Public Writing in Egypt', *Anthropology Today* 11(4): 8–13.

—— (1995). 'The Political Economy of Religious Commodities in Cairo', *American Anthropologist* 97(1) March: 51–68.

Strellrecht, Irmtraud (1998). 'Economic and Political Relationships between Northern Pakistan and Central as well as South Asia in the Nineteenth and Twentieth Centuries', *Karakorum-Hindukush-Himalaya: Dynamics of Change*, Part II, edited by Irmtraud Stellrecht. Pakistan-German Research Project, Culture Area Karakorum Scientific Studies, vol. 4. Cologne, Rudiger Köppe: 3–20.

Stern, Jessica (2000). 'Pakistan's Jihad Culture', *Foreign Affairs* 79(6): 115–126.

Stewart, Susan (1984). *On Longing: Narratives of the Miniature, the Gigantic, the Souvenir, the Collection*. Baltimore, MD, Johns Hopkins University Press.

Tambiah, Stanley (1990). *Magic, Science, Religion, and the Scope of Rationality*. Cambridge, Cambridge University Press.

Tannenbaum, Nicola (1987). 'Tattoos: Invulnerability and Power in Shan Cosmology', *American Ethnologist* 14(4) November: 693–711.

Tarar, Nadeem O., Samina Choonara and Tahir Mahmood (2003). *'Official' Chronicle of Mayo School of Art: Formative Years under J.L. Kipling (1874–1894)*, Lahore, National College of Arts.

Tarar, Nadeem O. (2008). 'Aesthetic Modernism in the Post-colony: The Making of a National College of Art in Pakistan (1950s-60s)', *International Journal of Art and Design Education* 27(3) October: 332–345.

Tilley, Christopher, ed. (1990). *Reading Material Culture: Structuralism, Hermeneutics and Post-Structuralism*. Oxford, Blackwell.

Titus, P., ed. (1997). *Marginality and Modernity: Ethnicity and Change in Post-Colonial Balochistan*. Karachi, Oxford University Press.

Titus, P. (1998). 'Honor the Baloch, Buy the Pushtun: Stereotypes, Social Organization and History in West Pakistan', *Modern Asian Studies* 32(3) July: 657–687.

Troll, Christian W. (1985). 'Five Letters of Mawlana Ilyas (1885–1944)', in *Islam in India: Studies and Commentaries*, edited by C. W. Troll. Delhi, Vikas.

Verkaaik, Oskar (2004). *Migrants and Militants: Fun and Urban Violence in Pakistan*. Princeton Studies in Muslim Politics, edited by Dale F. Eickelman and James Piscatori. Princeton, NJ, Princeton University Press.

von Oppen, Renata (1992). *Art on Wheels*. Lahore, Ferozesons.

Warkins, F. (2003). ' "Save There, Eat Here": Migrants, Households and Community Identity Among Pukhtuns in Northern Pakistan', *Contributions to Indian Sociology* 37(1–2): 59–81.

Weiss, Anita M. (1991). *Culture, Class, and Development in Pakistan: The Emergence of an Industrial Bourgeoisie in Punjab*. Boulder, CO, Westview Press.

Werth, Lukas (2002). 'Pakistan: A Critique of the Concept of Modernity', in *Islam in the Era of Globalization: Muslim Attitudes Towards Modernity and Identity*, edited by J. Meuleman. New York, Routledge Curzon: 143–169.

Wheeler, Tony and l'Anson Richard (1998). *Chasing Rickshaws*. Melbourne, Lonely Planet.

Williams, Michael A., ed. (1982). *Charisma and Sacred Biography*, Journal of the American Academy of Religion, Thematic Series, XLVIII, nos. 3 and 4.

Wink, André (1990). *Al-Hind: The Making of the Indo-Islamic World*, vol. 1. Delhi, Oxford University Press.

Zaatari, Akram, ed. (1999). *The Vehicle: Picturing Moments of Transition in a Modernizing Society / Al-markaba: taswīr lahzāt al-intiqāl wa'l-tahawwul fī mujtami' al-hadātha*. Beirut, The Arab Image Foundation.

Zaidi, Saima, ed. (2009). *Mazaar, Bazaar: Design and Visual Culture in Pakistan*. Karachi, Oxford University Press.

Zaman, M. Qasim (2002). *The Ulama in Contemporary Islam: Custodians of Change*. Princeton, NJ, Princeton University Press.

Index